D0962232

DREAMING
THE
BEATLES

DREAMING THE BEATLES

THE LOVE STORY OF ONE BAND
AND THE WHOLE WORLD

ROB SHEFFIELD

DEY ST.

An Imprint of WILLIAM MORROW

HarperCollins books may be purchased for educational, business, or sales promotional use. For information, please email the Special Markets Department at SPsales@harpercollins.com.

FIRST EDITION

Designed by Paula Russell Szafranski

Library of Congress Cataloging-in-Publication Data has been applied for.

ISBN 978-0-06-220765-4

17 18 19 20 21 DIX/LSC 10 9 8 7 6 5 4 3 2 1

For Gavin Edwards

CONTENTS

"All the people around

were very worried about the girl,

because she was going insane.

So we sang to her."

DRAMATIS PERSONAE

THE BEATLES: John played guitar. Paul played bass. George played lead guitar, and Ringo drummed. They all sang. John and Paul wrote the songs; soon George wrote, too. Ringo wrote a couple. Formed in Liverpool, late 1950s; broke up in London, 1970.

JOHN LENNON: The Smart One. Born in 1940, raised by his Aunt Mimi after his parents split. Mother Julia died in 1958. Married Cynthia Powell in 1962, son Julian born in 1963. Wrote two books of poetry. Explored LSD, primal scream therapy, mantra, gita, yoga, etc. Married Yoko Ono in 1969, moved to New York City. Imagined. Son Sean born in 1975. Left music for a few years in the Seventies to be a house-husband. Murdered with a handgun, December 1980, in front of home. Best songs: "Strawberry Fields Forever," "Julia," "And Your Bird Can Sing," "God," "A Day in the Life," "Oh Yoko!," "New York City," "Girl," "Ticket to Ride," "I'm So Tired," "Tomorrow Never Knows." Worst song: "It's Only Love."

PAUL MCCARTNEY: The Cute One. Born in 1942, started playing guitar when his mother, Mary, died in 1956. Met John in 1957 and joined the band. Married Linda Eastman in 1969. Rumored to be dead later that year. Had success with Wings all through the 1970s and solo thereafter. Still the greatest live performer on earth. Married Nancy Chavell in 2011. Father of five, including designer Stella. Best songs: "Here There & Everywhere," "For No One," "Martha My Dear," "Hey Jude," "Blackbird," "I'm Looking Through You," "Two of Us," "Jet," "Friends to Go," "I've Just Seen a Face," "Queenie Eye." Worst song: "My Love."

GEORGE HARRISON: The Quiet One. Born in 1943, the youngest of the group. Married Patti Boyd in 1966. Studied the sitar, went to India, grew beard, sought truth. Had solo success with triple-album *All Things Must Pass* in 1970. Organized the Concert for Bangladesh in 1971. Friends with Bob Dylan and Monty Python. Married Olivia Arias in 1978, son Dhani born the same year. Joined the Traveling Wilburys in 1988. Survived attempted murder with knife, 1999, in England. Died of cancer, 2001. Best songs: "Here Comes the Sun," "I Want to Tell You," "Something," "Apple Scruffs," "Give Me Love," "Don't Bother Me," "Pure Smokey," "It's All Too Much," "Isn't It a Pity." Worst song: "Piggies."

RINGO STARR: The Drummer. Born Richard Starkey in 1940, grew up poor and sickly. Joined the band in 1962, after they dumped original drummer Pete Best; John made Ringo shave his beard. Married Maureen Cox in 1964. Became actor. Married Bond girl Barbara Bach in 1981, still together. Father of three. Best songs: "It Don't Come Easy," "Octopus' Garden," "Don't Pass Me By," "Early 1970," "Photograph," "Rory and the Hurricanes," his playing on "Rain" and "Drive My Car,"

his vocals on "Yellow Submarine" and "Good Night." Worst song: "Cookin' (In the Kitchen of Love)."

LIVERPOOL: The city where they grew up and started performing together. Tough Northern industrial port, "Scouse," heavily Irish, previously most famous for comedians. Site of Penny Lane, Strawberry Field, etc.

BRIAN EPSTEIN: The manager. Loved the band. Posh rich kid, went to acting school, closeted gay man, Jewish, tormented. Harassed by police for homosexuality. Wrote autobiography *A Cellarful of Noise* in 1964. Made terrible business decisions that cost the band fortunes, but his devotion made their whole story possible. Died of accidental drug overdose in August 1967. Lou Reed, 1970: "In his mansion Brian Epstein kept Spanish servants, none of whom could speak English. Let that be a lesson to us all in discretion."

GEORGE MARTIN: The producer. "Mr. Martin" to the band. Trained oboe player, background in classical music and comedy. Made heroic decision to let them play their own songs. Became the most renowned of music producers. His second-most-famous discovery: America (the band). Died in 2016.

ABBEY ROAD: The EMI studios in London. Formal place where engineers wore lab coats and ties; the Beatles turned it into a creative den of round-the-clock experimentation. Famously depicted on 1969 album cover.

PRELUDE:
"THANKS, MO"

January 30, 1969: Paul utters the words, "Thanks, Mo," which turn out to be his last words on the final Beatle album. His comment is easy to miss, like so many other details in the tumult of the Beatles' career, but it's there at the end of the song "Get Back," closing out *Let It Be*, released just a few weeks after he announced the band was breaking up. After the electric-piano coda of "Get Back," you hear scattered applause from their famous rooftop concert in London. John makes a quip: "I hope we passed the audition." The film crew laughs politely at the boss's joke, as they've had to do way too many times in the past month. It's an awkward moment.

"Get Back" isn't a favorite of mine, so it's not one I ever play on purpose, but it's not like I leave the room if it comes on. I can take it or leave it. I'd probably heard "Get Back" a few thousand times before I ever noticed Paul mumbling "Thanks, Mo," right before John's joke. He's thanking Maureen Cox

Starr, Ringo's wife, for applauding and cheering through their little rooftop concert. No doubt she was freezing her ass off, with nobody noticing her. Mo Starr might have been the only person there having a sincerely good time. Maybe she was grateful to be invited.

What a quintessential Beatle moment. They're staging this self-conscious historic occasion for the cameras, John's going into a bit of trusty banter, but Paul gets distracted by the sight of a girl clapping. Drop Paul in any situation, no matter how momentous or formal, and he'll find the clapping girl. He zeros in on her enthusiasm. She makes the song worth playing. He doesn't thank guest keyboardist Billy Preston, the boys in the band, or anyone else.

Mo's a Beatle fan, always has been. She was one of the original screaming Beatle girls in Liverpool—saw them regularly at the Cavern Club in 1962. She was the fan who crossed the sacred line and married one of the band. (She kissed Paul before she dated Ringo, but they worked that out.) The first time she met Ringo she was tapping on his car window to ask for an autograph. In later years, after the divorce, she sadly became the first Beatle spouse to die, shortly before Linda, inspiring Paul's tribute "Little Willow." She's an easily overlooked but beloved figure in their lore, the teenage hairdresser who lived out the fantasy of countless fans, yet remained down-to-earth, avoiding the media spotlight. She worshipped Frank Sinatra, so for her twenty-second birthday in 1968, Ringo got Frank to record a private tribute record, changing the lyrics of "The Lady Is a Tramp" to "Maureen Is a Champ." Old Blue Eyes croons, "There's no one like her, no one at all / As for charm, hers is like wall to wall / She married Ringo when she could have had Paul." Frank couldn't resist slipping in a little dig:

"I'm just F.S., but to me she's Big M / Mainly because she prefers me to them."

Paul has seen her in the front row so many times. But this show is different. It's the first Beatle live performance in years, and it's not going the way he hoped. None of them realized it would be so cold, so Ringo is playing in Maureen's red coat, while John dons Yoko's fur wrap and George wears Patti's jacket. The *Let It Be* project was supposed to be a renewal—playing old-time rock and roll, getting back to where they once belonged. But the Beatles are falling apart. John is mad that everyone's bitchy to Yoko. Paul is mad that he's the only one who showed up with any finished songs. George is mad that Paul keeps telling him how to play his guitar. George and Ringo recently quit for brief periods. Paul turns to Linda, John turns to Yoko. Brian Epstein is dead. Nobody could ever replace him—but Paul wants to install his brother-in-law, while the other three fall under the spell of one of the most serviceable villains in the music business, Allen Klein. And oh yes—John just released a solo album where he and Yoko stand naked on the cover. Everybody's upset about that. Sir Joseph Lockwood, president of their record company, pleads, "Why not show Paul in the nude? He's so much better looking." A Beatle publicist tries to look on the bright side: "Not only is he a brilliant songwriter, but he's probably done more for the cause of male frontal nudity than any one single show-business personality."

How could this project get any more miserable? There's also a film crew on hand, documenting every moment. The Beatles are staging their "back to our roots" retreat for a movie, in front of all these strangers, in the chilly confines of Twickenham Studios instead of good old Abbey Road. Every

argument is captured for the camera, along with all the canned mugging and servile laughter. They have no idea how to end this sorry fiasco, until they come up with the brainstorm to play a surprise rooftop gig. Their first concert in years.

Paul's idea—why don't we do it on the roof?—is a typically clever whim from a man who's gotten used to trusting his spontaneous impulses. The Beatles take to the roof on a Thursday afternoon, and they find it's stickier than they thought—after the "1-2-3" count into "Dig a Pony," they stop short because Ringo has to blow his nose. But they sound great, so great John can't resist saying "fuck yeah" in the final minute of "I've Got a Feeling." About half the forty-two-minute performance ends up in the movie. Engineer Glyn Johns wraps ladies' stockings over the mike to keep out the wind. They cut the album versions of "Dig a Pony," "One After 909," and "I've Got a Feeling" even though, as John says, "Hands too cold to play the chords." He has an assistant kneel in front of him with a clipboard so he can read the lyrics.

The scene they imagined might be some kind of career-capping resolution, or at least a big ending for the film, has ended up just hard work on a rainy January day. The Beatles play in front of a bunch of drab adult men, who try not to get in the way. No spontaneous Woodstock love-in down below, no panic in the streets of London, no shutting down the city with a flash-mob of screaming fans—just a few curious stockbroker types. Not even many girls, which must have pained Paul.

As the surviving Beatles admit in the *Anthology* documentary, they wanted to provoke a showdown with the cops, so at least they'd get a flashy final scene—maybe get led off in handcuffs like David Lee Roth in the "Panama" video. No such luck. The police don't crash in waving truncheons. A very un-

dramatic cop shuts off the power—not even on camera—and that's it. No, that's not how they wanted it at all.

They end with "Get Back," their third attempt of the day. It's not a tricky song, but with all the wind and rain and exhaustion, it sounds forced. For the album version, they go back to a studio take, recorded three days earlier but edited to end with John and Paul's banter, giving the impression that it's the rooftop jam. "Get Back," like the whole album/movie project, is a Paul whim that's gone too far. Everybody feels like he's pushing them around, he feels like he's stuck carrying the weight, and here they are in January with a crew they've come to loathe, further from the goal than they were at the start. In less than a month, the Beatles will be back at Abbey Road working on a new album (a much better one, named after the studio), leaving twenty-nine hours' worth of *Let It Be* sessions to be sorted into an album, which they'll keep working on after *Abbey Road* comes out—eventually released as a that's-all-folks farewell in May 1970. But right now, they're just trying to get through a job that used to come easy. By the final "Get Back," it's the end of a winter slog, the camaraderie a little strained, the spontaneity a little labored. It had to be a disappointing moment for all involved. Except for the clapping girl.

John fumbles for the chords, his hands getting number by the minute. He's done singing or remembering words. George hasn't sung all afternoon beyond a bit here and there in "I've Got a Feeling." Their breath freezes in front of their faces. Paul probably looks into the future and sees the end of the road. He sees solo careers. He sees his thirties. Married life on the farm. Not spending time with John anymore. All those years leading lesser bands, saying "take it away" to the guys in Wings, not fooling anyone. Jesus, maybe he even sees "Say

Say Say." He sees uncertainty, which is not Paul's scene. He doesn't know how to begin talking about this future. So instead, he says, "Thanks, Mo."

To them, it must have looked like the end of the story. But it's really where the story begins.

MEET THE BEATLES

(1962-1970)

The Beatles are far more famous and beloved now than they were in their lifespan, when they were merely the four most famous and beloved people on earth. With the words "Thanks, Mo," they began a strange new career—one where they just kept getting bigger, to their bewilderment and (at times) dismay. They sincerely tried breaking up—it just didn't work. They've gone from being the world's biggest group to the act that's bigger than all the rest of pop music combined. At this point, rock and roll is famous mostly because it's what the Beatles did, just as the theater is famous because plays are what Shakespeare happened to write.

The Beatles' second career has lasted several times longer than the first one. John, Paul, George, and Ringo remain the world's favorite thing. Yet every theory ever devised to explain why has failed. It wasn't their timing. It wasn't drugs. It wasn't that they were the voice of a generation. The vast majority of Beatles fans today weren't born when the records

came out—yet the allure of the music keeps on growing, nearly fifty years after the band split. When I was a little kid in the Seventies, my parents and teachers were already baffled at how my sisters and I loved the Beatles. Now it's my sisters' turn to be baffled when their kids say, "I want to sing the boat," which means "Yellow Submarine." How did this happen? The world keeps dreaming the Beatles, long after the Beatles themselves figured the dream was over. Our Beatles have outlasted theirs.

Even the band's most single-minded partisans never pictured a future like this. Definitely not the Fabs themselves. They never envisioned becoming the world's favorite thing— you can't limit it to "the world's favorite music" because there's no equivalent. There is no Beatles of movies. (*Star Wars* probably comes closest, which isn't too close—still a galaxy far, far away.) There is no Beatles of sandwiches or cars or cookies. (Oreos? Chocolate chip? Either way, not close.) There is no Beatles of anything else. When they began playing speed-fueled all-nighters in the red-light bars of Hamburg, they used to take the stage with the ritual chant "Where are we going, lads?" "To the top!" "What top?" "The toppermost of the poppermost!" But they zoomed right past the toppermost. "We reckoned we could make it because there were four of us," John said in 1970. "None of us would have made it alone, because Paul wasn't quite strong enough, I didn't have enough girl-appeal, George was too quiet and Ringo was the drummer. But we thought that everyone would be able to dig at least one of us, and that's how it turned out."

For some people, this music defined the Sixties. But the Beatles matter because of what they mean to *our* moment. You can't say they were in the right place at the right time, because the era that produced them produced zero others. The theory

used to go that the lads came along to cheer up America after the JFK assassination, but most people have had time to get over JFK, thanks, and only a tiny fraction of their audience saw them on *The Ed Sullivan Show* or has any idea who Murray the K was. Everybody used to assume the Beatle myth was driving the music—it turned out to be the other way around. These songs have escaped any decade or generation or culture that ever claimed them. The brash aggression of "And Your Bird Can Sing." The gaudy color-clash of "All You Need Is Love." The hair-curling harmonies of "I Don't Want to Spoil the Party." The girl-struck swoon of "If I Fell." The fabbermost perfection of "All My Loving." All of it.

The Beatles didn't plan it this way—they couldn't have. Nobody did. In 1964, their publicist Derek Taylor wrote liner notes for one of their albums predicting it would still sound fine to "the kids of AD 2000," a bold claim that looks hilariously small-potatoes now, since we know the kids' favorite album in AD 2000 was the Beatles *1* collection, which became a historic blockbuster even though everybody on earth already owned six or seven copies of the songs. *1* was the best-seller of 2000 and also the best-seller of 2001. It's the top-selling album of the twenty-first century so far, and considering the state of music retail, it'll still hold the title in 2099. Taylor upped the ante with his 1995 liner notes for *Anthology*, calling the Beatles' story "the twentieth century's greatest romance." How was he supposed to know the romance was just beginning?

I'm not looking to solve this riddle—just understand it better. It's one of the central mysteries of my life. I was born the week "We Can Work It Out" hit Number One. I have lived a full and happy life. But being born on the same planet as the Beatles is one of the ten best things that's ever happened to me.

A PARTIAL (BUT ONLY PARTIAL) EXPLANATION: THE BEATLES are the world's greatest rock and roll band. They had no choice—they were four working-class Liverpool boys, and they knew nobody would notice them if they were merely good. Over the years, the Cute One proved he was also the Smart One, the Smart One proved he could sound as cute as the Cute One, the Quiet One got mystical, and the Drummer grew a mustache. Yet for all their changes between 1962 and 1970, one constant is that they did not hold back. They bashed out their first album in a mammoth all-day session, saving nothing for later, knowing their first chance to get out of Liverpool could be their last. You can hear John completely blow out his throat in the last song they cut that night, "Twist and Shout."

The Beatles invented the self-contained rock and roll band, playing their own instruments and writing their own hits. They invented the idea that the world's biggest pop group could evolve into arty, innovative musicians. For that matter, they invented the idea that there was any such thing as the world's biggest pop group. They were already a tough bar band when they scored their first hit, "Love Me Do," but from *Please Please Me* to *Abbey Road*, from *A Hard Day's Night* to *Sgt. Pepper*, every Beatles album marked a surge forward. They kept challenging one another, as producer George Martin kept refusing to say no to their daft ideas. So in the summer of 1966, they began *Revolver* with a "1-2-3-4" count, just like they began *Please Please Me* in the spring of 1963, yet after those 1-2-3-4 years of creative convolutions, *anything* sounded possible, as long as there was a Beatle counting off the intro. John and Paul goaded each other on as writers. As Paul recalled, "Part of the secret collaboration was that we

liked each other. We liked singing at each other. He'd sing something and I'd say 'Yeah,' and trade off on that. He'd say, 'Nowhere land,' and I'd say, 'For nobody.' It was a two-way thing."

Even when they weren't trying hard, they could come up with off-the-cuff gems like "Day Tripper" or "Tell Me What You See." Sometimes they tried absurdly hard to sound like they weren't trying at all, as in "Ob-La-Di, Ob-La-Da," which somehow took more than forty hours to record. (Where did the first thirty-nine go?) Their throwaways became the foundation for other bands' careers. The power-chord thud of "She's a Woman"—there's the germ of Black Sabbath right there. The sex-and-death harmonies of "Baby's in Black"—that's John and Paul inventing David Bowie. And "Julia," man—as far as I'm concerned, if John Lennon never did anything in his life besides write "Julia," he'd still be one of the coolest humans who ever existed.

People love to argue about the Beatles' music, but in so many ways the argument has barely begun. Best vocals? *Rubber Soul*. Best guitar? *Revolver*. Best basslines? *Sgt. Pepper*. "It's All Too Much"—never a hit, not even a song they liked, just filler they buried on the *Yellow Submarine* soundtrack, yet a song any other band could have built up into a legend. *The Beatles at the Hollywood Bowl*—a live album released in 1977, one of the first records I owned as a kid, a huge hit then, an obscure footnote now, erased from the official canon for years. (It didn't resurface until 2016, to promote the movie *Eight Days a Week: The Touring Years*.) Yet I put on my beat-up vinyl copy now and it still sounds startling. So many screaming girls on that record, buzzing at fever pitch through every song, and not one of them is lying. She's so glad, she's telling all the world.

WHERE DO YOUR BEATLES START? MINE BEGIN WITH THE movie *Help!*, which isn't where the story is supposed to begin, but everybody's Beatles start somewhere different. They entered my life when I was five, watching *Help!* on Channel 56. This 1965 comedy is not a prestige item, as Fab artifacts go—John Lennon called it "crap." But everything I heard and saw onscreen, I instantly wanted to be part of it. The opening scene of the lads with their black turtlenecks and acoustic guitars, singing "Help!" in black and white. George singing "I Need You." Ringo slapping the bongos in "You're Gonna Lose That Girl." Channel 56 showed *Help!* three times a year; my sisters and I held a tape recorder up to the TV to catch the songs. We wanted more. Who wouldn't?

I met my first Beatle friend when I was ten. Flynn was the first kid I knew who worshipped them like I did, but he knew twice as much about them. He had adult siblings who'd left their vinyl collections behind—even the solo albums. So we were the kids listening to John's *Walls and Bridges* trying to figure out what "Going Down on Love" meant. We played "Revolution 9" backwards to hear the "turn around dead man" part. We never did get all the way through Wings' *Wild Life*. The Beatle records were a map of adulthood—okay, here's where you start, as fresh-faced moptop boys, then you get a little older and deeper, then you're men singing about walruses and raccoons and yellow custard mustard mojo and then The End.

And through it all, girls. Screaming girls, in the audience. Worshipped girls, in the songs. Girls, girls, girls. The girl is the whole reason these songs exist, right? Even when you're in psychedelic tangerine-trees mode, you still need her in the song. From "Please Please Me" in 1962 to "Don't Let

Me Down" in 1969, John Lennon's life changes in every way, except the most important way, which is that what he cares about most is singing to a girl and making her feel something. Because if he doesn't reach her, the song is worthless and so is he. It's a love that lasts forever, it's a love that has no past. Come on, come on.

The Beatles release a 1976 album called *Rock 'n' Roll Music*, with a cheesy Fifties cover, full of their fast songs. They also release a 1977 album called *Love Songs*, with a brown faux-leather earth-toned cover, full of romantic ballads. Both albums shock the music world by becoming massive hits. The Beatles have broken up by now. They have new solo records they want to sell. They have no idea why we—kids my age, who don't remember the Sixties—would rather listen to the Beatles than practically anything. "Got to Get You into My Life," the single from *Rock 'n' Roll Music*, becomes a Top Ten hit—ten years after it came out on *Revolver*. Boys who like Kiss like *Rock 'n' Roll Music*; their sisters who like Abba like *Love Songs*. I prefer *Love Songs*, a choice that teaches me things about myself I didn't know. Their map to adulthood is right there on the surface of the music, a guide to growing up year by year, becoming an adult who feels and thinks and suffers—and yet this map isn't buried anywhere, it's out in the world, accessible to anyone.

The songs are full of questions. Am I a Red Album kid (1962–1966) or a Blue Album kid (1967–1970)? Will I ever grow wise enough to solve riddles like "Who is the elementary penguin?" or "Is Paul dead?" or "What does 'in drag' mean?" or "Can you find the human skull hidden on the back of *Abbey Road*?" So many songs, so many questions, so many clues leading to bigger questions. What are "tarot" and "I Ching" and *"Jai guru deva om"*? Who is the creepy Shakespearean

voice who says "heavy metal duck"? Will pain lead to plea-
sure? What goes on? What is life? What drug makes you feel
like the guy in "A Day in the Life" and why would anybody
ever smoke it?

So many questions, so many girls. Does the "Martha My
Dear" girl fall in love with the boy? Or does she leave him like
the "For No One" girl does? Does the "Ticket to Ride" boy
ever get her back? If the boy who sings "This Boy" turned into
the boy who sings "You're Gonna Lose That Girl," would he
win her away from the boy who sings "You Can't Do That"?
Is Jude a boy or a girl? Is the "Day Tripper" girl secretly a boy?
Are Desmond and Molly both girls? At the end of "Norwe-
gian Wood," does he burn the house down?

For the Beatles, curiosity about girls led to curiosity about
the world. So many different female presences in their music—
the party girl who hires Paul to chauffeur her around and tell
her she's a star, the muse who flashes her kaleidoscope eyes
at John and disappears, the nurse selling poppies from a tray,
the madame publisher who won't read the manuscript, the
clerk in Paul's "Another Day" who gets so weary at work, and
who not another male songwriter alive in 1970 would have
noticed, much less devoted an entire song to. (His first solo
single! After leaving the Beatles!) This woman has a job. So
does the Swinging London hipster in "Norwegian Wood," the
one who stays up late drinking wine on her rug with John
and tells him she has to leave early for work in the morning.
She's got John Lennon in her bathtub—for that you'd think
she could call in sick.

To contemplate the mystery of girldom, the Beatles had to
pose new questions about sexuality. Their gender sacrilege
had a little to do with their hair, but much more to do with
how they sounded and how they felt. They invented a form of

rock and roll in which boys wanting to be girls (be as real as girls, as honest as girls, as deep as girls, as cool as girls, as rock and roll as girls) was the absolute crux of male identity. They sold the world on that fantasy. As Paul put it in 1966, "There they were in America, all getting housetrained for adulthood with their indisputable principle of life: short hair equals men, long hair equals women. Well, we got rid of that small convention for them."

My sisters were Paul girls. I was a Paul boy—it might be more accurate to say I was a Paul-girl boy, although I have a history with George girls. My wife only has eyes for George, or as she calls him, the Goth Beatle. When she looks at a band photo, it takes her a minute to notice the other three are even there. Even after he got religion, he had the band's nastiest wit—I will always love George in bitchy-wizard mode. My favorite line of his comes from 1970, when Paul was suing to get off their label, Apple. George replied, "You'll stay on the fucking label. Hare Krishna."

Rubber Soul was the "you are here" spot on the map for me. The Milton Public Library (where I spent an appalling percentage of my Saturday afternoons, instead of out beneath the blue suburban skies) had a vinyl collection, so it's where I went to study these records. (When I wasn't studying the LP covers of Linda Ronstadt or Olivia Newton-John. Yes, the Beatles were right—girls are interesting.) A stack of books, a pair of headphones, and a chair by the turntable. For some reason, the library had the British LPs, which were rare imports, although to me that made them seem inferior. This edition of *Rubber Soul* didn't even have the same songs—it began with "Drive My Car" instead of "I've Just Seen a Face." But *Rubber Soul* became my favorite record—I couldn't even decide which version I loved more, since "Drive My Car" was

the funniest song ever, while "I've Just Seen a Face" was the most romantic, except almost as funny as "Drive My Car." I found Nicholas Schaffner's *The Beatles Forever* at the library, adopted it as a holy text, and renewed it every two weeks for years. "Eight Days a Week" was the first time I caught the Beatles on the radio and recognized them on my own—heard those voices and just *knew*.

Over the years, your Beatles keep changing, because you keep changing. You grow up, you fall in in love, you lose love, you work, you fail, you parent, you suffer, you can't go on, you go on, etc. By the time you're an adult, you are no longer mystified by the paper bag on Paul's knee (just an airsick bag) or "heavy metal duck" (that's actually "Edmund, Earl of Gloucester"). But love? That's something you keep wrestling with—even if you're alone in your room, and the only people to discuss it with are the Beatles. The Beatles got a lot of things wrong. But they didn't lie about girls.

THE SUMMER OF 1978: THE BEE GEES ARE ON TOP OF THE music world, riding the success of the *Saturday Night Fever* soundtrack. How do they celebrate? By making a megabudget Hollywood production out of *Sgt. Pepper's Lonely Hearts Club Band*, starring the Bee Gees as the band and Peter Frampton as Billy Shears. There's no spoken dialogue: the movie stitches a two-hour medley of Beatle songs into a fairy tale about a magic place called Heartland. Billy Shears loves a maiden named Strawberry Fields, who tries to escape the clutches of Mean Mr. Mustard. Steve Martin sings "Maxwell's Silver Hammer." George Burns sings "Fixing a Hole." This movie really happened.

For the brothers Gibb, this crowns their victory, since

they've always seen themselves in a rivalry with the Beatles. "Kids today don't know the Beatles' *Sgt. Pepper*," Robin Gibb says, in one of the most remarkable statements of the Seventies. "You see, there is no such thing as the Beatles. They don't exist as a band and never performed *Sgt. Pepper* live, in any case. When ours comes out it will be, in effect, as if theirs never existed."

Don't laugh. You would have said the same thing. Most sane adults would have, whether they loved or hated the Bee Gees. The *Sgt. Pepper* movie was the smart-money bet. But it turned into one of the decade's biggest box-office bombs. For reasons the industry couldn't explain, the kids who flocked to buy *Rock 'n' Roll Music* or *Hollywood Bowl* had no interest in the new and improved model. Nobody bought the double-vinyl *Sgt. Pepper* soundtrack. (Which is a shame: Earth, Wind and Fire do a superfly "Got to Get You into My Life.") But it's too easy to mock the Bee Gees for thinking this way, because most experts did. Even the former Beatles did. George Martin ended his liner notes for *Hollywood Bowl* with an anecdote about his young daughter, who asked, "You used to record them, didn't you, daddy? Were they as great as the Bay City Rollers?" Martin wrote: " 'Probably not,' I replied. Someday she will find out."

A clever framing device—witty, elegiac, rueful, with the right note of self-deprecating irony. But the joke didn't work because the Beatles weren't forgotten enough and the Rollers were already crashing, even though they made their finest album in 1977, *It's a Game*. (You know a boy band is straining to grow up when they put extraterrestrial chess pieces on the cover.) Just two years after their global Number One smash "Saturday Night," the Rollers were the ones pleading, "Don't Let the Music Die." For Seventies kids like me, who loved

pop and cherished the Beatles as a vital part of it, it would have seemed silly to think of them as a thing of the past. But for years, that was conventional wisdom. Even in their most megalomaniacal moments, the Beatles and George Martin wouldn't have guessed what the music would mean to their daughters' daughters' daughters.

If you tell people you're writing a book about the Beatles, at first they smile and ask, "Another one? What's left to say?" So I mention "Baby's in Black," or "It's All Too Much," or Lil Wayne's version of "Help" or the Kendrick Lamar battle rhyme where he says "blessings to Paul McCartney," or *Hollywood Bowl*, or *Rock 'n' Roll Music*, or the Beastie Boys' "I'm Down"—but I rarely get that far, because they're already jumping in with *their* favorite overlooked Beatle song, the artifact nobody else prizes properly, the nuances nobody else notices. Within thirty seconds they're assigning me a new chapter I *must* write. And telling me a story to go with it. Every few days, I get into a Beatles argument I've never had before, while continuing other arguments that have been raging since my childhood. And though I've spent my whole life devouring every scrap of information about them, I'm constantly learning. I guarantee the day this book comes out, I will find out something new. Things like that used to pain me. But that's what it means to love the Beatles—you never run out of surprises.

There's your public Beatles—you will probably encounter their music somewhere in the next week, the supermarket or the laundromat or the car radio or a stranger's T-shirt. There's also your *private* Beatles—the song you love that isn't a hit, the classic you hate, the B-side nobody appreciates the way you do. People get fiercely protective about their personal Beatles.

How can we keep hearing our own secrets in these songs? How can they be the world's most passionately beloved band, yet still weirdly underrated? And how is there so much life in this music—oh, untimely life?

THE BEATLES ENDED THEIR FIRST CAREER, BECAUSE THEY felt they didn't have enough control, then began their second career, where they had no control at all. They tried to break the spell they'd cast and were genuinely surprised when they failed. When John Lennon sang "The dream is over" in 1970, he wanted to free his listeners and himself from the dream. But it didn't work, because the group didn't belong to these four men anymore. The dream wasn't theirs to break. As Morrissey would say, the dream is gone but the Beatles are real.

John renounced the band and everything it stood for, moving on to political and religious crusades, eventually settling into fatherhood and bread-baking in the Dakota. Paul formed a new group called Wings and toured for years refusing to play any Beatle songs. George devoted his life to Krishna, dismissing "Beatle George" as a suit he used to wear; on his 1974 tour, he sang "In My Life" and changed the words to "In my life I love God more." Ringo directed the film *Born to Boogie* and became a furniture designer. They all kept suing each other. They were sick to death of the band. They begged the world to get the fuck over it and let them get on with their lives, the least they could ask after everything they'd given. The world smiled politely and said, "I think I disagree."

The Beatles are what they are because they are the most beloved humans of their lifetimes and mine. They had a unique

talent for being loved, though they found it a strain and a puz-
zle and a trap and something they completely failed to under-
stand and desperately wished to escape. (And then chased
again. And tried to escape again.) But the fact that the Beatles
were so good at being adored changed a lot of things.

"DEAR PRUDENCE"

(1968)

The Beatles invented most of what rock stars do. They invented breaking up. They invented drugs. They invented long hair, going to India, having a guru, round glasses, solo careers, beards, press conferences, divisive girl-friends, writing your own songs, funny drummers. They invented the idea of assembling a global mass audience and then challenging, disappointing, confusing this audience. As far as the rest of the planet is concerned, they invented England.

The Beatles also innovated things other rock stars don't do, things that (as it turned out) *only* they did, because nobody followed them. Here's a big one: John and Paul both quit the Beatles to start new bands with their wives. Can you imagine the Stones breaking up at their peak so they could make music with *any* women? Mick and Keith splitting up to jam with Bianca and Anita? (What a shame—we missed out on the Plastic Pallenberg Band.) Can you imagine a timeline where Jimmy Page and Robert Plant quit Led Zeppelin to collaborate

full-time with their ladies, who have no previous musical experience? Any similar scenario involving Roger Waters and David Gilmour? Joe Strummer and Mick Jones? Brian May and Freddy Mercury? Well, that one might have been complicated.

But that still wouldn't be weird enough, because the weirdest twist wouldn't be knowable for another decade—both couples still together ten years later, still married and making music until death did them part. Paul didn't retire Wings until 1979, a year before John and Yoko made *Double Fantasy*, though Linda remained in the act till the end. (Who can forget her in the "Say Say Say" video?) There aren't many other rockstar love stories like these, to say the least. John and Paul spent their lives doing things nobody had tried before. Choosing women as artistic collaborators over the band, well, that's a case where they had no imitators.

The Beatles kept trying difficult, even impossible-seeming things, and made them sound so easy that everybody else figured out how to do them. Some of their most mysterious songs seem simple on the surface. "Revolution 9" might have been their big avant-garde statement, yet it's nowhere near as spooky as "Cry Baby Cry," which sits right next to it on the White Album and couldn't have taken John more than ten minutes to write. The world has always been fascinated by the question of *how* they did it. Practically everybody who ever shared a taxi with a Beatle has flogged a book or documentary about it, sharing the inside scoop of how they gave John this idea or taught George that chord, revealing what the song is *really* about. I love those stories, even when I don't believe a word—I eat that stuff up. Yet all that nowhere-mansplaining doesn't come close to solving the mystery. Interesting as the inside story is, I'm always more fascinated by the *outside*

story—not where the songs came from, but where they went, and how they live on in the world they helped create. When you get down to it, the stories behind the music aren't that hard to explain. What's weird are the stories *in* the music.

TAKE "DEAR PRUDENCE"—EVERYBODY KNOWS THE OFFICIAL explanation. John writes it in Rishikesh, India, where the Beatles are on retreat with the Maharishi Mahesh Yogi. One of their fellow pilgrims, Prudence Farrow (Mia's little sister), overdoes the meditation and gets spooked and won't come out of her hut for days at a time. So John writes this song to coax her to come out and play in the sun.

This tale is extremely famous, but much less well-known is the fact that Paul plays drums on it. And the reason: Ringo just quit the band.

It's the White Album sessions, when everybody's fighting. On August 22, 1968, Ringo has had enough, so he storms out and officially resigns. He's an ex-Beatle for two weeks (until September 4), though the press never finds out. Those were the days—a Beatle could abdicate for two weeks without any-one knowing. He's so eager to make the break final, he flees the country and takes his kids to Sardinia, while John, Paul, and George keep right on working. On August 28 they go into the studio to spend two days cutting one of their best songs, "Dear Prudence."

John, Paul, and George mesh beautifully, as if they're smoothing over the conflict, or looking for the sun beyond it. They have no idea how this crisis will play out—nothing like it has happened before. This is the first time any Beatle has quit, though it later became one of their favorite pastimes. (Ringo, ever the innovator.) They might be trying to remind themselves

why this used to be fun. John hiccups like Buddy Holly, as if this is the song Buddy would have written in 1968 if he'd given up his seat on that plane, lived into the Sixties, and tagged along with them to Rishikesh instead of that dweeb Mike Love. (If it sounds far-fetched to imagine Buddy Holly at an ashram, it's much *less* absurd than what really happened, which is that the Buddy Holly fans from Liverpool who sang "Please Please Me" in 1962 went on to sing this one.) When John, Paul, and George sing "look around," it sounds like they're wooing Ringo back, but it also sounds to me like they're urging themselves to lay down their arms and come out to play-ha-hey-hey.

Either way, this we know: this song documents in real time the music John and Paul and George would make on an occasion of traumatic loss. Ringo will come back a couple of weeks later, after much cajoling. The Beatles will find out where he's hiding (in the Mediterranean, on Peter Sellers's yacht) and send a telegram that says, "You're the best rock and roll drummer in the world. Come on home, we love you." He'll find his drum kit decorated with flowers and a "Welcome Back Ringo" banner, and they'll go back to being one big happy family, until they're in the studio together for a few minutes and they turn back into four stubborn men Mexican standoff–ing their way through every session, a band that can't get through a take of "Ob-La-Di, Ob-La-Da" without battling over it.

But at this point, they don't know if Ringo will return. Their way of dealing with this crisis is not to talk it out (are you *kidding?*) or think it over (more characteristic, but there's no time right now) or ask Brian Epstein what to do (because he's dead) but to play music. So they need to find a girl to serenade. It's the only way they know how to communicate.

The real-life Prudence Farrow, a child of Hollywood royalty, wasn't the least bit starstruck by the Beatles and didn't

appreciate hearing them sing outside her hut while she was trying to meditate. "They were trying to be cheerful," she once said. "But I wished they'd go away." She went on to teach meditation for the rest of her life. A true Sixties seeker, she came to India to find enlightenment, not to listen to a bunch of rock and roll boys sing about birds and raccoons. John never actually sang "Dear Prudence" to her, or told her it existed. Right before leaving, George mentioned John had written a song about her. But she didn't hear it until months later, back in New York, when her mother played her the White Album. Millions of people heard the song before she did. John just needed to imagine her madness to sing about his own.

Prudence has been a good sport over the years—hey, you'll never guess what she titled her memoir—but her story has no resemblance to the one in the song. She came to Rishikesh with her sister, already famous for *Rosemary's Baby*, soon to be the ex–Mrs. Frank Sinatra. They were the daughters of the great Hollywood film noir director John Farrow, a devout Catholic as well as a boozing, brawling, womanizing piece of work. Robert Mitchum (who starred in Farrow's nastiest and best noirs, *Where Danger Lives* and *His Kind of Woman*) said he was the only director who could outdrink him. When he wasn't hitting the bar, Farrow liked to discuss theology with visiting nuns and priests. Mitchum asked, "D'ya ever *dare* go to confession?" Farrow explained he confessed his sins to a Mexican priest: "The poor bastard doesn't speak a word of English." (A very Brian Epstein–like lesson in discretion.)

But Ringo is a more elusive presence in the song. For years, nobody knew Paul was on drums—the world didn't find out until Beatle scholar Mark Lewisohn published *The Complete Beatles Recording Sessions* in 1987. When Ringo quit, he went over to John's house to break the news, explaining, "I feel un-

loved and out of it, and you three are really close." John's reply: "I thought it was you three." As Ringo tells the story, "So then I went over to Paul's and knocked on his door. I said the same thing. 'I'm leaving the band. I feel you three guys are really close and I'm out of it.' And Paul said, 'I thought it was you three.' "

"Dear Prudence" sums up the fantasy of friendship that the world loved to project onto the Beatles—but as anyone can hear in this song, the Beatles fantasized about that friendship, too. They're giving that friendship a sound to lure Ringo back—you want to miss out on *this*? The first time the Beatles recorded it was right after they got back from India, doing acoustic demos for the next album at George's Esher bungalow. On the Esher demos, they sound like they're having fun. They don't realize all the tortures they'll inflict on each other making the White Album. John's life is changing so fast—his marriage in ashes, his romance with Yoko just starting—he can barely recognize it. So he sings about wooing a lost girl back to the world. He strums "Dear Prudence" with his mates. "Rishikesh, India," he announces over the final guitar lick, as the others chuckle. "No one was to know that sooner or later, she was to go completely berserk under the care of Maharishi Mahesh Yogi. All the people around were very worried about the girl, because she was going insane." He takes a deep breath. "So we sang to her."

This girl isn't the real-life Prudence, who wasn't in any danger of going berserk. (Considering the cast of characters around her, she might have been the most levelheaded person in sight.) But the Prudence in this song, the girl who's inside each of the Beatles, she needs this song desperately, which is why the invitation is irresistible. And that's why "Dear Prudence" gets stranger the closer you listen. In the face of a cri-

sis, the Beatles—almost instinctively—look for a girl to sing to. Maybe she needs the tune, maybe she doesn't, but they need her. "She was going insane, so we sang to her"—for a few minutes, it's that simple.

We are all that girl.

"I CALL YOUR NAME"

(1957)

The John/Paul bond is one of the central mysteries of this book, because it's one of the central mysteries of my life and probably yours. In any of your relationships, you know whether you're the John or the Paul. You do not have to think about it. Listening to the music means vicariously sharing in the communion between John and Paul, which was a mystery to them as well. Paul sings about their friendship in his recent song "Early Days." As he told *Rolling Stone* in 2014, "It's me remembering walking down the street, dressed in black, with the guitars across our back. I can picture the exact street. It was a place called Menlove Avenue. [Pauses] Someone's going to read significance into that: Paul and John on Menlove Avenue. *Come onnnnnnn.* That's what it's like with the Beatles. Everything was fucking significant, you know?"

But the menlove between them is where the mystique of the Beatles begins. John and Paul met in the summer of 1957.

Within weeks, they were writing songs. One of their first was "I Call Your Name," a song that was never a hit and that neither one regarded as any great shakes. They gave it away to Billy J. Kramer and the Dakotas, who rated it so highly they stuck it on a B-side. The Beatles never bothered to record it until they'd already released two albums—they were cramming to finish an EP of covers, so they pulled it from the reject pile. They'd just come back from their triumphant February 1964 visit to America. Nobody knows why—after hearing their names called out by more girls than they knew existed—they went back to this tune, over six years old. Or why they played it so fiercely, or why John sang it so intensely.

"I Call Your Name" is a song John dismissed later, but maybe he just scared himself at how deep he went singing it. In this tune, he's lying awake at night, all alone. He's so tired, he can't sleep a wink. He never weeps at night; he calls your name. John and Paul both loved writing songs where they called a woman's name. They both called the names of their mothers—Mother Mary and Julia. After they broke up, Paul went on to "The Lovely Linda" while John went on to "Oh Yoko!" But right from the start, they were two boys articulating that call.

John and Paul were very different personalities, but what they really agreed on was girls. No two boys have ever agreed on anything like John and Paul agreed about girls. From their earliest days together, they loved to sing about the sounds girls made. They enjoyed stepping onstage and getting enveloped in those girl sounds. (George came to hate it. Ringo? Fine with him. What's for lunch?) By the time they met, they were teenage boys who already knew heartbreak. They were both motherless boys—John's mother was still alive at that point, but she'd rejected him. After she'd left him to be raised by his

aunt Mimi, she resumed contact in his adolescence, visiting on weekends. Julia was killed in a car accident in 1958, right on Menlove Avenue, while on her way to visit John. Paul got to meet her while she was alive, and remembers her fondly in his biography. "John and I were both in love with his mum," Paul said. "John and I would go and visit her and she'd be very nice but when we left there was always a tinge of sadness about John."

THEY MET ON JULY 6, 1957, AT A VILLAGE FAIR WHERE JOHN'S skiffle group the Quarry Men were playing. The first time Paul laid eyes on him, John was onstage singing rock and roll—the Del Vikings' doo-wop classic "Come Go with Me," with John (as usual) getting the words wrong. ("Come go with me, down to the penitentiary.") Paul was fifteen, making him eighteen months younger than John, but he showed off his guitar skills, playing Eddie Cochrane's "Twenty Flight Rock" and Gene Vincent's "Be Bop a Lula." They bonded over music instantly. Even better, their elders disapproved. John's strict aunt Mimi dismissed Paul as a bad working-class influence, making him enter through the back door and calling him "your little friend." Paul's dad warned, "He'll get you into trouble, son."

Paul tells a story in *Anthology* about him and John hearing about a guy in Liverpool who knew a guitar chord they didn't know—B7—so they crossed town on a bus just so he could teach them. That's the kind of story that seems impossibly romantic to fans, like Morrissey and Johnny Marr driving 250 miles—from Manchester to Brighton and back—to score a copy of the obscure 1973 single "Good Grief Christian." They took trips together, hitchhiking, picking up gigs. They called

their band "Beatles," inspired by Buddy Holly's Crickets. Paul had started playing the trumpet, like his father, but soon after his mother died, he traded it for a guitar and wrote his first song, "I Lost My Little Girl"—"fairly obvious," he said later. John's mother had taught him banjo. After Paul played him "I Lost My Little Girl," they began composing together, sitting on John's bed ("The necks of our guitars were always banging"), writing the words in a school notebook, with "Another Lennon-McCartney Original" at the top of the page. One of the first songs they wrote in John's bedroom was "I Call Your Name." Paul recalled, "When I look back at some of these lyrics, I think, Wait a minute. What did he mean? 'I call your name but you're not there.' Is it his mother? His father? I must admit I didn't really see that as we wrote it because we were just a couple of young guys writing."

John later claimed he wrote "I Call Your Name" alone. In one of his final interviews, he said, "That was my song. When there was no Beatles and no group. I just had it around." He was insistent on that point. "The first part had been written before Hamburg, even. It was one of my first attempts at a song." (He and Paul had actually written quite a few songs before Hamburg—including "Love Me Do"—but this is one he remembered in terms of solitude.) He cited "Hello Little Girl" (a hit they gave to fellow Mersey band the Fourmost) as his very first, based on an old song his mother sang. "I remembered some Thirties or Forties song which was 'You're delightful, you're delicious and da da da. Isn't it a pity that you're such a scatterbrain?' That always fascinated me for some reason or another. It's also connected to my mother. It's all very Freudian. She used to sing that one. So I made 'Hello Little Girl' out of it."

The grief helped bring them together, but they put a lot of

energy into not talking about it. So what did they do with that energy? They sang about girls. In their twenties, when they sang an introspective song, they usually made sure it turned into a song about a girl. Girls gave them something to talk about. They preferred to sing their hearts rather than speak their minds. That's where the John/Paul connection came from, and that connection followed them around the rest of their lives, as they kept collaborating, battling, breaking up, trashing each other in public, writing new songs plumbing that friendship. Like "Hey Jude," one of the Paul songs John praised most—Paul wrote it while he was driving out to visit John's ex-wife, Cynthia, after the divorce, and son Julian. He sang the tune to console the boy: "Hey Jules, don't make it bad." Going to check up on his oldest friend's ex-wife and kid—was that a habitual way for one of the world's most famous rock stars to spend a day off?

It didn't take them long to find the trouble Paul's dad warned about—within a few years of meeting, they were playing their speedfreak late-night marathon gigs in Hamburg's Reeperbahn district, teenage leather boys popping Prellies and swilling beer and womanizing, hopped up to *mach schau* for eight hours at a time in front of an audience of sailors and hookers and cut-throats. John went onstage in his underwear, a toilet seat around his neck, as the gangsters in the front row cleaned their guns and yelled for "What'd I Say." This is where they honed their chops as a live band. As a teenager, Hunter S. Thompson typed out the whole text of *The Great Gatsby*, just to get the rhythm into his fingertips; that's what the Beatles were doing in Hamburg, playing rock and roll covers under fire, thriving on the violence in the crowd. It's also where their brotherhood was bonded. In Hamburg, the power dynamic was complicated by bassist Stu Sutcliffe,

John's art-school friend, a gauntly charismatic painter who rivaled Paul for John's attention. Sutcliffe left the band to settle in Hamburg with local artist Astrid Kirchherr, the girl who invented the Beatles' haircuts, before dying suddenly of a cerebral hemorrhage in 1962. John and Paul paired off—only to find themselves stuck together for life. For John, Paul was the boy who came to stay; for Paul, John was the sad song he couldn't make better. Even in the Seventies, when they went years at a time without seeing each other, they couldn't escape. As John quipped in 1975, "If I took up ballet dancing, my ballet dancing would be compared with Paul's bowling."

People still love to see themselves in the John/Paul spectrum. If you're the John in any relationship (I should specify the upper-case "j"), you wish the Paul could lighten up and stop nagging. If you're the Paul, you wish the John could take more responsibility. When Kanye West wrote "4–5 Seconds" with Paul in 2015, he announced why he was the John. "As you can see, I might be a little bit more angst than Paul," Yeezy said. "I'm angst a bit like John Lennon. And the tension, the salt and pepper—I mean, maybe that's bad because it sounds like 'black and white'—but the tension creates a new magic. The pressure creates the diamond from the coal." Not so different from how John put it in 1968: "Meeting Paul was just like two people meeting. Not falling in love or anything. Just us. It went on. It worked."

Were they in love? That's another question the world has kept wondering about. When Paul went on *Howard Stern* fifty years after he met John, Howard asked if John was just in love with him. "I *like* that theory," Paul said. "We used to sleep in the same bed, top to tails." In May 1964, they shared their first screen kiss in a BBC TV special, performing a scene from Shakespeare's *A Midsummer Night's Dream*. It's the

kind of video nugget that fans like me used to shell out stupid bootleg money for; now it's one click away for anyone with a phone. It's bracing to see how mirthfully they act out the Pyramus and Thisbe scene. Paul is the boy; John plays the boy playing the girl, in a dress and a blond wig. (Poor George gets stuck in the minor role of Moonshine, while Ringo roars it up as the Lion—already the kiddie's choice.) John and Paul rave about how pretty they both are—"these lily lips, that cherry nose!"—and snuggle up for the death scene.

The last time John Lennon set foot on a concert stage, it was Thanksgiving 1974, making a surprise appearance with his friend Elton John at a sold-out Madison Square Garden. When he and Elton cut "Whenever Gets You Thru" together, Elton proposed a bet—if it hit Number One, John would sing it with him live. John agreed, never thinking he'd get called on it. But he was. The performance sounds shaky—John's all nerves after a few years of hiding from live shows—but he steps up there to *mach schau* with Elton, doing the hit as well as Elton's remake of "Lucy in the Sky With Diamonds." John announces, "We thought we'd do one last number so I can get out of here and be sick. This is a number of an old estranged fiancé of mine called Paul."

They do "I Saw Her Standing There," their big finale. Even in the raw recording Elton released as a B-side, you can hear John get caught up in the crowd's excitement. It's his night to shine—onstage in New York, for the first time in years and the last time ever. Why is he doing a Paul song? Why is he making this moment about him and Paul, when all anybody wants is to cheer and shower John with love? But in the middle of the crowd, he calls Paul's name.

PLEASE PLEASE ME

(1963)

February 11, 1963: The Beatles record their first album, *Please Please Me*, in one day, a marathon thirteen-hour session. You can hear they've got winter colds, since they've been gigging every night all over England, but producer George Martin calculates their voices should hold up for ten hours. They spend the session sucking cough drops and chain-smoking. First thing in the morning, they do "There's a Place" and "I Saw Her Standing There," which they're still calling "Seventeen." At lunchtime, the studio staff knocks off to the pub for a pie and a pint. But to their surprise, the Beatles don't join them—they tell Mr. Martin they'd rather stay in the studio and rehearse, drinking milk. "We couldn't believe it," engineer Richard Langham says later. "We had never seen a group work right through their lunch break before." There's no time to waste—tomorrow it's back to the road with two gigs in one night, one in Sheffield and another forty miles away in Oldham. Ringo does the Shirelles' "Boys" in one take—it's the

first time he's ever sung in a recording studio in his life, but that's the version on the album, complete with his "All right, George!" into the guitar solo.

The clock is nearing ten—closing time, according to the rules at EMI Studios—but when everyone confers over coffee at the Abbey Road canteen, John reports he still has enough left in his voice for one song. He gargles with milk and takes off his shirt. The band rips into "Twist and Shout," doing their "oooh's" at top volume, as John shreds what's left of his vocal cords, one "come on" at a time. The Paul who slips out that victorious "hey!" over the final drum crash is thirteen hours past the "one two three *fuuuh!*" he screamed this morning. Mr. Martin makes them play it a second time, but John's voice is gone. Everybody listens to the playback, then the Beatles surprise the staff by asking to hear the whole thing again, forcing them to stay past closing time. They have now made an album.

The press kit includes quickie bios of the Beatles. John lists his ambition as "money and everything." Paul gives his as "money, etc." George, we are told, "wants nothing more than to retire with lots of money." The LP includes four songs they have already released—the hit singles "Love Me Do" and "Please Please Me," the corny B-side "P.S. I Love You," the even cornier yet strangely wonderful Smokey Robinson tribute "Ask Me Why." (John tells the girl plainly why he loves her—"because you tell me things I want to know." A line he'll rewrite his whole life.) Now that Lennon and McCartney get their names on the back of the LP, they realize that they've never settled whether it's Lennon-McCartney or McCartney-Lennon. John eventually gets his way by the time of their next album, *With the Beatles*. So *Please Please Me* becomes the first and last Beatle album crediting the songs to "McCartney-Lennon."

George Martin wants to call it *Off the Beatle Track*—a touching reminder that he's human. It goes to the top of the U.K. charts and stays at Number One for thirty weeks. Then it gets replaced by *With the Beatles*, which stays at Number One for the next twenty-two weeks.

"I SAW HER STANDING THERE" IS THE BEST FIRST SONG ON A debut album, ever. The longest, loudest, drunkest debate I've ever had about this was with Craig Finn of the Hold Steady, where we narrowed it down to the final two candidates: "I Saw Her Standing There" and Joy Division's "Disorder." Both songs by Northern English yobs, knowing they have only three minutes to seize their chance; both bar bands jittery at finding themselves in a real studio; both bands with maniac drummers; everyone jumping into the violence of it, getting faster now, getting out of hand, until it's impossible not to get swept along into the feeling feeling *feee-liiing*.

An *almost* unbreakable tie—yet my vote goes to "I Saw Her Standing There," just because "Disorder" remains Joy Division's peak, whereas "I Saw Her Standing There" works as a prophecy of even bigger things to come. It's a mission statement, a manifesto, a threat. It holds the promise of all the other first-song first-album breakthroughs: not just "Disorder" but GNR's "Welcome to the Jungle," The Smiths' "Reel Around the Fountain," N.W.A.'s "Straight Outta Compton," Patti Smith's "Gloria," Public Enemy's "You're Gonna Get Yours," the Hold Steady's "Positive Jam" (obviously disqualified that night), Led Zeppelin's "Good Times Bad Times," Eric B. & Rakim's "I Ain't No Joke," Liz Phair's "6'1"," the New York Dolls' "Personality Crisis," Metallica's "Hit the Lights," Suicide's "Ghost Rider," Oasis's "Rock & Roll Star."

(It still *might* be "Disorder," though. Let's call it a close one.) Very punk—the liner notes even mention "the do-it-yourself angle."

Like the rest of the album, "I Saw Her Standing There" is a radical act of faith on the part of George Martin. He let these nobodies from Liverpool sing their own songs, setting up in front of their amps and playing live to two-track tape. He let them choose their own cover material, ranging from raw American R&B ("Anna") to movie schmaltz ("A Taste of Honey") to girl-group rock ("Baby It's You," "Chains"). The Beatles called him "Mr. Martin"—or more cheekily, "The Duke of Edinburgh"—never suspecting he was a working-class North London lad who ditched his cockney accent in the service during World War II. He was the schoolmaster who knew how the business worked. But when he heard the Beatles, he had the wisdom to throw out all his hard-won expertise and let them make their own music. (Much as Brian Epstein loved the boys, he would have kept them singing "Besame Mucho.") Countless record labels had rejected the band's demo tape; the list of labels seemed to grow every time Brian Epstein told the story. The demo was tame stuff—biased toward their corniest material, in accordance with Epstein's taste. But Martin called them in for a Parlophone audition on June 6, 1962, where the lads did a few stabs at "Besame Mucho" before wisely pushing for "Love Me Do." When he asked them to tell him if there was anything they didn't like, George Harrison famously said, "Well, for a start, I don't like your tie."

When they cut the "Love Me Do" single that September, Martin hadn't even planned on letting them record it. In custom with the time, he had a song picked out for them to sing—a piece of pro hackwork called "How Do You Do It?" The Beatles, who had a lot to lose in their first session, stubbornly

held out for their own original song. When they played "How Do You Do It?" they sabotaged it, playing up its corniness until it was unreleasable. (It became a hit for British Invasion troopers Gerry and the Pacemakers.)

Martin had already changed his mind about a lot of things, like selecting a frontman, the way Andrew Loog Oldham decided Mick Jagger should stand in front of Brian Jones. After spending some time with the lads, Martin decided it was okay to permit the band *not* to have a frontman. That was a bold move in itself—but in the "Love Me Do" session, Martin made the equally bold decision to stop pushing for "How Do You Do It?" and trust the band. "Love Me Do" was still in rough shape, even though the song was four years old—it was Martin who added the harmonica fanfare, which we now think of as the whole song. John had always done the solo "love me do" vocal hook, but now that he was switching off to the harmonica, Paul took over—the first time he ever sang it was in the studio. A week later, Martin brought them back in to redo the song with a studio drummer—poor Ringo got demoted to tambourine.

George Martin was a man who was sometimes wrong. He was wrong thinking Ringo couldn't drum. He was wrong thinking "How Do You Do It?" was the song they should record. And he was wrong about that title (though he liked *Off the Beatle Track* so much, he used it for his own album, featuring orchestral remakes of the lads' songs). The decisive element of Martin's genius is how swiftly he changed his mind when he recognized he was wrong. He adapted his thinking to the Beatles' skill set, which was beyond anything a producer could have been trained to expect. But letting them write their own songs is the wisest decision George Martin ever made. And without helping himself to a slice of the songwriting

credits, which would have been standard practice. The failure of George Martin to rip them off remains one of the most bizarre elements of their story.

It's just barely possible to go back and hear what *Please Please Me* might sound like if this were the only Beatles album—though for one thing, "rock and roll albums" didn't exist yet. Even if they'd faded away after their first single, "Love Me Do," it wouldn't be difficult to hear they were special. They were Northern boys with provincial accents, no matter how much they obviously loved Buddy Holly, jumping at the chance to get their sound together on a record—"you'd kill for that bit of plastic," as Ringo said. They'd built their local cult at the Cavern. One of the kids there was a sixteen-year-old from Anglesey named Lemmy Kilmister, later the metal beast of Motörhead. "The Beatles was the most magical thing I've ever seen," he told *Mojo* in 2006. "This complete four-headed monster, each of them as good as the other. You could see them feeding on each other's energy, and you could see they were having fun. They'd swear at the crowd and when they'd make a mistake they'd crack up laughing—which bands didn't do at all back then." The band played afternoon gigs as well as evenings. "The Cavern wasn't licensed, so anybody could go. They used to have lunchtime shows as well, with three bands, and the secretaries would come in out of the offices with their hair in curlers under their scarves and dance around their handbags in their lunch hour."

One of those afternoons, a dapper adult named Brian Epstein, a Liverpool department-store heir and record salesman, stepped in to check out this band he'd heard about. The Beatles knew him by sight because they'd spent so much time in his shop—the girls behind the counter liked them. They'd backed up the local singer Tony Sheridan on a version of "My

Bonnie," a truly terrible record, like everything they did for Sheridan. After hearing customers ask for "My Bonnie," and after selling a hundred copies of the band's cover story in *Mersey Beat* magazine, Brian got curious enough to visit the Cavern, where he was hit by the thunderbolt. So now he was a beginner in the world of music hustling, and the Beatles had a manager who made up for his naiveté with his devotion—dreaming the Beatles became his all-consuming passion. He got them out of leather, dressed them up in suits, made them stop swearing and eating and drinking and belching onstage. Mr. Epstein's dream was so seductive, they began to share it. The fact that the Beatles were able to get that dream down on a piece of plastic was a tribute to both their Misters.

WHY *DID* THE BEATLES WANT TO WRITE THEIR OWN SONGS? Arrogance alone isn't really enough to explain it. "First of all, Paul and I wanted to be the Goffin and King of England," John said in 1970—but Carole King and Gerry Goffin were songwriters behind the scenes. They got their names on the *backs* of the records—the fine print on the label, not the toppermost. From the start, John and Paul aspired to the fine print—where the art was, not the glory. Why?

Their heroes Chuck Berry, Buddy Holly, and Little Richard wrote their own songs, cutting the money men in on the action. (Richard and Holly split credit with their producers, while Berry shared the credit for "Maybellene" with Alan Freed, the DJ who made it a hit.) John and Paul always wrote—as teens they even collaborated on a play. But the music they liked to play was American roots music. For English rock and rollers, the whole point was to sound faithful to the real thing—if you wanted to sound like Elvis or Ray Charles,

you had your work cut out for you just by being English. It's not like there was any mystique for songwriting down at the Cavern Club—just the opposite. "It was actually a bit of a joke to dare to try your own songs," McCartney said. "They didn't go down very well with Gerry and the Pacemakers and other groups. If they told us what they liked, it would be 'What'd I Say' or 'Some Other Guy' or Little Richard stuff that I did. It was the more genuine shit, not stuff you wrote yourself. For you to write it yourself was a bit plonky."

Mick Jagger scoffed at the idea of "a British-composed R&B number"—he and Keith didn't get into composing until their manager convinced them that that was where the money was. That *would* have been a motivation for John and Paul, if they had any idea that songwriters got paid. But they didn't. Their ignorance (and Epstein's) about music publishing meant they signed away most of the loot their songs would earn. John and Paul were strictly in it for the songs. They wrote the Stones' first hit "I Wanna Be Your Man," dashing it off in a few minutes right in front of Mick and Keith's astonished faces. They later admitted they made a show of "writing" a song they'd already come up with but didn't rate as a keeper. In John's words, "We weren't going to give them anything *great*, right?"

John explained to *Melody Maker* how their goals expanded, in January 1970: "At first we wanted to be Goffin and King, then we wanted to be Eddie Cochran, then Buddy Holly, and finally we arrived at wanting to be bigger than the biggest— and that was Elvis." Yet even as they moved up the ladder, they still wanted to do the writing, a task Elvis certainly didn't worry about. And from the beginning, they were writing originals like "There's a Place," the first song they cut the morning they began *Please Please Me*. You can hear John woke up with a stuffy nose; you can also hear how nervous he and

Paul are, their voices quavering as they stretch out the vowels, "*plaaaace*" and "*looow*" and "*goooo*," Ringo urging them on with his drum crashes. It's another Buddy Holly homage, one they wrote on their guitars in the front room of Paul's dad's house on Forthlin Road. John and Paul sing about escaping to the place you go when you feel low—in your mind, where you hear the voice of the girl who tells you things you want to know, the place you go to remember the things she said that swim around your head, the place you talk yourself out of the fears you wouldn't confess to your closest male friends. Except here are John and Paul, trading off the confession out loud. It's done and dusted in under two minutes—no time for waffling or kidding around, the voices say, this is it, this is how I feel, let's go, let's tell it.

If a double-decker bus had crashed through the Abbey Road wall at 11 a.m. and wiped out all four Beatles, leaving only the tape machine rolling, and "There's a Place" had been the last song they recorded, it would still represent a historic peak for rock and roll as a way of communicating, a way of feeling, a way of life. It would be astounding the Beatles got even this far. They already had a new sound, so enormous the world would have to make room to encompass it. By midnight, they had a whole album of it.

THE MYSTERY INSIDE
OF GEORGE

There were many George Harrisons: the bearded sitar sage, the eccentric English gentleman, the boyish folk-rock seeker. But my George was the first one I ever met, the one in the Beatles' 1965 movie *Help!* Remember the scene where they're playing "You've Got to Hide Your Love Away"? George is sitting on the couch with Eleanor Bron, the assassin girl with the pink revolver in the pink purse. He spends the song trying to get her attention: making eyes at her, smiling at her, swinging his acoustic guitar back and forth. But she just gazes rapturously at Paul, who doesn't even have to try. While John sings his painful lyrics about doubt and loneliness, George is living them out on the couch. I remember watching this scene when I was five and thinking, whoa, even when you're a Beatle, it's *still* that tough getting girls to smile back? George's sole song in the movie is "I Need You"; in the end credits, as the Beatles chatter over a snatch of classical music, there's a fleeting credit on the screen: "All songs by

Lennon-McCartney, except 'I Need You' by George Harrison." George keeps repeating " 'I Need You' by George Harrison!" over and over, louder each time. At first, it's just his little joke, but by the end, it sounds more like a mantra.

George sounded like he really did need you. He was the Beatle who wrote and sang the loneliest songs: "Don't Bother Me," "I Want to Tell You," "Long, Long, Long," "If I Needed Someone." He was the one shy boys could relate to, even if we never would have looked that rugged in the cowboy gear on the back of *Rubber Soul*. He could hit those mournful notes on his guitar because he felt them. He was the one Beatle who, in a true sense, had originally been a Beatles *fan*. He was the young kid tagging along behind the older, cooler guys, John and Paul, trying to become part of their bond. He wanted to act tough for them, but had to settle for impressing them with his guitar chops instead. He was the original Beatlemaniac, the first fan to chase John and Paul down the street. As John remembered in 1980 shortly before his death, in words that soon turned haunting, "When George was a kid he used to follow me and my first girlfriend, Cynthia—who became my wife—around. We'd come out of art school, and he'd be hovering around like those kids at the gate of the Dakota now."

So much of the Beatles' magic was John and Paul letting us in on their bond. They let the whole world listen in on their friendship, their memories of that friendship, and their mourning over the friendship's long and winding demise. George helped give that troubled, unmanageable, impossible friendship a sound, with a guitar that hiccupped like Buddy Holly and soared like the Chiffons. But George, unlike us, was stuck on the outside of that bond. It must have been a lonely place to live. That George was able to make so much beautiful music

out of that loneliness, instead of being destroyed by it, is why I think of him with joy and wonder.

George might have been the Quiet One, but he also had the most impeccable juvenile-delinquent credentials. He was a Teddy Boy from a rougher area than Paul or John. Aunt Mimi scoffed at the low-class McCartney and made him use the back door, but she wouldn't even let George in the house. "I eventually said he could come in one day," Mimi said in 1968. "He arrived with a crew cut and a pink shirt. I threw him out. Well, it wasn't done. I might have been a bit old-fashioned, but schoolboys dressing like that!" Note: this woman raised John Lennon.

George became famous as the Underrated Beatle, which raises the question of how famous it's possible to get for being overlooked and still qualify. But being a Beatle was a struggle for him, which was part of the reason he wrote such fabulously sulky songs. His cheeriest tune is "Here Comes the Sun," which has barely anything to say about the sun, but loads of complaints to file about the winter that's ending. He had that same moodiness going on in his solo work, with sublime beauties like "Give Me Love," "Blow Away," "Isn't It a Pity," the little-known B-side "Deep Blue," and "My Sweet Lord," which really does improve on "He's So Fine." He approached his songs as devotionals, in the same spirit as chanting "Hare Krishna" aloud. "It's really a method of becoming one with God," he explained in a March 1969 radio interview. "It's really the same sort of thing as meditation. But this is a thing that has more effect, I think, or quicker effect, because music is such a powerful force. God likes me when I work, but loves me when I sing."

His image as the Not So Famous Beatle is complicated by the fact that he was the foxiest one. He defined black

turtlenecks (and inspired my teen self to wear them tragi-cally often). He was the one who married Patti Boyd, after her memorable appearance as the lippy schoolgirl on the train in *A Hard Day's Night*. Paul flirts with her in the movie ("I'm shyyy") but George walked off with her in real life. He was boyish, vulnerable, pretty, and when he sang about being in a snit, he was attractively surly, whether working his hot-spoiled-princeling pout ("Don't Bother Me," "Love You To," "Wah-Wah") or his preachy-sage grimace ("Beware of Dark-ness," "Within You Without You," "If You Believe"). Even in 1965, his tension with Paul in *Help!* doesn't feel feigned—he bristles at him the whole movie, especially when Paul's doing one of his hammy bits and George sniffs, "Don't encourage him. You've got the part, Paul."

Despite everything he learned about songwriting from his mates, he was the one who had most to lose by remain-ing a Beatle and the most to gain by going solo. Although he enjoyed his elite status—he famously snapped at one of the engineers, "You don't talk to a Beatle like that"—he was the one the others underestimated. His lead-guitar solos were sometimes played by Paul; to make it more galling, Paul didn't claim the credit, leaving the world to spend years thinking George played the solos in "Taxman" or "Sgt. Pepper's Lonely Hearts Club Band." John called him "the invisible man," while George Martin admitted, "I was always rather beastly to George." As John said years after the breakup, "George's relationship with me was one of young follower and older guy. He's 3 or 4 years younger than me. It's a love-hate relation-ship and I think George still bears resentment toward me for being a daddy who left home." George did more complaining about the group than the other three combined. As he said in

the Eighties, "The whole Beatles thing is like a horror story, a nightmare. I don't even like to talk about it. I just hate it."

Even before he began messing with the sitar, his guitar was a spiritual instrument, descended from the Fifties sound of Santo & Johnny, the roughness of rockabilly and the dreaminess of the Shadows, like his delicate guitar fills on "Ask Me Why" on the very first Beatles album. Years of development would take this quest further—but it was there in the beginning, like his acerbic wit. When he had John and Paul over to the house to play one day, George's dad barged in to throw a fit about the scandalously tight jeans George was wearing. George just said, "How can I do my ballet without tight jeans?" and began dancing ballet poses until his parents laughed. He's just as funny in *A Hard Day's Night*, staring down authority figures with his cheeky deadpan, as when he tells the TV producer, "By all means, I'd be quite prepared for that eventuality."

He was the only Beatle who auditioned for the gig, playing the Fifties instrumental "Raunchy" for them, knowing so many chords they couldn't refuse him. He'd met Paul at the Liverpool Art Institute, inviting the older boy over to play guitar; Paul had a more instinctive touch, but George was the one who owned a guitar manual and studied hard. "He knew more chords," John recalled. "A lot more than we knew. So we got a lot from him. Every time we learned a new chord, we'd write a song round it." He was just seventeen when the Beatles went to raise hell in Hamburg, in August 1960; he was the one who lost his virginity there, with the others in the room. Alas, after four months in Hamburg, he got deported for being underage. But the others couldn't stop baiting the younger guy, couldn't stop making him audition. "I was al-

ways playing 'Raunchy' for them," George said. "We'd be going somewhere on the top of a bus with our guitars and John would shout out, 'Give us "Raunchy," George!' "

"DON'T BOTHER ME," HIS FIRST REAL SONG, BEGAN THE "George is in a bad mood" phase of his songwriting, which never ended. George, by all accounts a fun-loving guy with a sense of humor, liked to express extreme dourness in his music, whether he was feeling it or just forcing it. "Don't Bother Me" is a sentiment he kept rewriting his entire life. George needed a bad mood the way Paul needed a girl—just something to get a song going.

He wasn't like his mates, composing tunes in obscurity for years; he began writing them only after he had an opportunity to release them. (Ringo had already taken the first pass at "Don't Pass Me By," so George was the *fourth* Beatle to try songwriting.) "Don't Bother Me" was written on tour in 1963, while he was sick in bed in a hotel room. Though he'd already had a writing credit—the early instrumental goof "Cry for a Shadow" was a Harrison-Lennon original—"Don't Bother Me" was a real tune, one that expanded the band's emotional range; it certainly helped inspire John to write the moodier, darker songs that predominated on *A Hard Day's Night*. A slower learner, he had to work harder at putting a song together. He might have been the kid who earned his way into the band by knowing fancy chords, but in his songs he liked to linger on a one-chord drone like "If I Needed Someone" or "Blue Jay Way," refusing chord changes as if it were his stubborn protest. Sometimes it sounded like he was still sulking at John yelling "Give us 'Raunchy.' " Even his mother asked why he didn't smile when he played.

George wrote songs about hating being a Beatle—"Only a Northern Song" and "Blue Jay Way" basically translate to "Help, I'm being held prisoner in a rock group." "Northern Song" has the off-kilter feel of a Syd Barrett homage, except with no curiosity or energy, which means it sounds nothing like Syd Barrett; Ringo's uncharacteristically busy fills sound like he resents having to drum on a song about resentment. Yet these are anti-Beatle tracts that nobody would be interested in musically if they weren't by a Beatle.

As John said in 1968, "George himself is no mystery. But the mystery inside of George is immense. It's watching him uncover it all little by little that's so damn interesting." His guitar gave glimpses into that mystery. "Everyone else has played all the other bullshit," he liked to say. "I just play what's left." "It's All Too Much" might have been his most positive moment—which might also be why he considered it an idle detour from his real work. He wrote the finest rock and roll song ever about chocolate, "Savoy Truffle," except he's against it, because chocolate is his metaphor for the sinful material world. When the music was coming fast and furious, he was generous with it; he gave the great "Sour Milk Sea" to his Liverpool pal Jackie Lomax, who got a 1969 hit with it. He gave "Photograph" to Ringo, while playing gorgeously on "It Don't Come Easy" (and maybe helping a bit to write that one, too), along with John's "Oh My Love."

George was the one who burned out early on the rock life. "I try to do a job that's fairly plain, something worthwhile," he told *Rolling Stone* in 1975. "If this role as a silly pop musician is worthwhile, then I'd rather be silly jumping up and down chanting Krishna than silly jumping up and down with high-heeled mirrored boots on and eye makeup, but with all respects to all those silly rock and rollers who have high-

heeled mirrored shoes and eye makeup, there comes a time in your life when you have to decide what life is all about. There must be some other reason for being here than just jumping up and down, trying to become famous."

However, George was not willing to go back to being un-famous. Projects like 1979's *George Harrison* or 1987's *Cloud Nine* are the work of a big-name rock star who wants to keep his job, not because he needs the money but because he needs the audience, and he's willing to jump up and down for it. These records would have turned out better if George had sim-ply hit the studio for a week and banged out some psych-folk drones or ukulele solos, ignoring pop trends; he didn't need drum machines or Hawaiian shirts to reflect the Inner Light. (And hard as he was shading Bowie in that comment about the high-heeled boots, Bowie was much better at coked-out cosmic epics.) George wanted chart success; he was willing to perform only on his terms, as a star. If he couldn't play on the A-team, he wouldn't play at all. He found the right balance with the Traveling Wilburys, a band full of stars who deferred to him. But when he was sweating for a hit, he was quick to remind people he was in the Beatles, whether subtly ("Here Comes the Moon," now really) or not. Even in the Eighties, when he called the Beatle thing "a nightmare," his hits ranged from the 1981 Lennon eulogy "All Those Years Ago" to the 1987 MTV hit "When We Was Fab."

George's best music has a generosity of spirit that for some reason he distrusted and kept belted down. One of my favor-ites is the 1976 deep cut "Pure Smokey," where he thanks the Lord for giving the world Smokey Robinson. It's a virtually unknown ballad, from one of his all-but-unheard solo albums (*Thirty Three and a Third*) from the period when George's preachiness had driven off most of his audience. Yet "Pure

Smokey" has a gorgeous warmth his fans would have treasured, if they'd heard it. It's impossible to hear this song and *not* feel waves of love for George. Yet it's the side of himself he felt was morally and artistically inadequate, too frivolous for the task he had been given. It also sounds like it was an easy song to write, which no doubt was part of why he dismissed it.

He became rock's most notable gardener, lurking behind his lawn gnomes on the cover of *All Things Must Pass*. And yet his reclusive ascetic side went hand in hand with his hedonism and humor. He financed Monty Python's *Life of Brian* when no studio would touch it, because "I wanted to see the movie," and he wasn't the type who could only tolerate blasphemous chuckles if they targeted other people's beliefs; when John wrote "Sexy Sadie" to denounce George's man the Maharishi, George not only played guitar on it, he played brilliantly, which speaks well for both him and the giggling guru. He also served as a producer to the Rutles, an ideal vehicle for his ambivalence about his misspent youth.

He was a quiet and introspective kid who found himself at the center of a pop explosion, admired around the world but still treated as a little boy by his bandmates. He could have let himself get torn apart by the experience; lots of thin-skinned types get destroyed by much calmer levels of fame. Instead he decided to keep his wits about him and see what he could learn from the whole ride. Yet you can hear how deeply it wounded him, always following the cool kids around, yearning to be a Beatle, even though as far as the world was concerned, he always was.

"IT WON'T BE LONG"

(1963)

I f any song sums up the Beatles' embrace of girl noise, it's
"It Won't Be Long," their most fervent echo of the girl-
group sound. They never played "It Won't Be Long" live,
maybe because they were afraid of what they might unleash,
but it's one of their wildest "yeah" songs. *It won't be long!*
Yeah! Yeah! Yeeeeaaaah! They leap up into falsetto call-
and-response hysteria, bouncing "yeahs" off each other as if
they're playing badminton with a grenade. It's tough to pick
a favorite yeah, but the one that really gets it done for me is
the fourth-to-last yeah, the most savory yeah in a song with
dozens of them. Fifty-five, to be precise—that's one yeah per
2.4 seconds, which has to be maximum yeah density.

The Beatles loved girl groups with a passion—John Lennon
famously spent his first night in New York City in his hotel
room, calling up radio stations and asking them to play the
Ronettes. They craved the extravagant girliness of the Shirelles
(mentioned as the band's biggest influence on the back cover

of their first album) and the Shangri-Las and the Crystals—
the way these girl singers combined deep fervor and silliness
at top volume, acting out the run-mascara-run melodramas
scripted by the Brill Building masters, especially Gerry Gof-
fin and Carole King. As Goffin put it, "In the early Sixties,
God was a young black girl who could sing." The Chantels,
the Cookies, the Marvelettes, the Chiffons—the Beatles loved
them for their chaotic, uncontrollable, destructively loud pag-
eant of feminine angst. And the love was mutual. As the Crys-
tals once sang, girls can tell.

"We did the Shirelles' 'Soldier Boy,' which is a girl's song,"
McCartney recalled years later. "It never occurred to us. No
wonder all the gays liked John. And Ringo used to sing 'Boys,'
another Shirelles number. It was so innocent. We never even
thought, *Why is he singing about boys?* We loved the song. We
loved the records so much that what it said was irrelevant, it
was just the spirit, the sound, the feeling. The joy when you did
that 'Bab shoo-wap, bab bab shoo wop.' That was the great fun
of doing 'Boys.' " Yet there might be something disingenuous
about this claim. The Beatles paid attention to pronouns, tak-
ing care to work "you" and "she" into their hooks, so it seems
dubious they didn't know what they were doing when they
covered "Soldier Boy." But they loved the openhearted emo-
tion of it, the sophistication and realness of it. They wanted
to be part of that "bab shoo wop." So they went there. Most
of their peers were too intimidated to follow. The Stones cer-
tainly didn't play "Soldier Boy," and neither did Gerry and the
Pacemakers. But the Beatles threw themselves into "Boys," a
song that stayed in their live repertoire for years, well into 1965.
They loved turning themselves into those frenzied girls. Every
time the Shirelles dropped a new 45, the Beatles scrambled to
cover it—John sang "Will You Still Love Me Tomorrow," while

Paul took "Mama Said." John also claimed "Boys" until Ringo joined—that was Ringo's vocal spotlight in Rory and the Hurricanes. And they loved writing their own girl-group songs. Most smashingly, "It Won't Be Long."

The yeahs of "It Won't Be Long" are so splendid, it's easy to overlook the punch line, which is "Till I belong to you." It would have been simpler to make the hook "It won't be long yeah / Till you belong to me," which is what pretty much any other songwriters would have done, not that anyone else could have come up with this song. Yet they make such a twist feel inevitable by the end. Of *course* it's "I belong to you," not "you belong to me."

That's something else they loved about the girl groups—that supplicant stance, the sense of romantic devotion as utter rapture. The whole point of a classic like the Chiffons' "One Fine Day" (or the Ronettes' "Be My Baby," the Shirelles' "Baby It's You," the Shangri-Las' "The Boy," the Chantels' "If You Try," Rosie and the Originals' "Angel Baby," so many more) is that the guy on the receiving end has no clue this song is about him. He barely knows this girl's name, much less all the agony she's going through. He's just a disposable crush object—she's the one who rides the roller-coaster cycle of yearning and suffering and scheming; she's having all the fun. There's no room for him or his puny feelings in this song, *her* song.

The Beatles adopted this supplicant stance like no rock and roll boys before them, not even Buddy Holly. Goffin-King failed when they tried writing these songs for male singers, as in Bobby Vee's "Take Good Care of My Baby"—it just sounded limp, even when the Beatles covered it on their 1962 Decca audition tape. But when John screams right into "It Won't Be Long"—"*iiiit won't be long yeah!*"—he couldn't be further away from that mopey-boy sniffly shit. He lives up to

the spirit of Ronnie Spector herself. There's nothing hesitant about the way he burns for this girl, begs her to come back home, pleads for one more chance. If John had sung it as "Till you belong to me," it still would have been a great song. But it wouldn't have been *this* song.

If "It Won't Be Long" feels like a love song to the Ronettes, that's because it is—the Beatles basically invaded America as an excuse to meet Ronnie. Oceans have been crossed for less. She took them up to Spanish Harlem for barbecue. "Nobody bothered them because they thought they were just some Spanish dorks," Spector once said. "In my neighborhood, Spanish guys didn't get their hair cut for two weeks, because their parents couldn't afford it. So when the Beatles came to Spanish Harlem, people didn't even look up at them." Of course, if you walk into *any* room with Ronnie Spector, chances are you're not the one who's going to turn heads.

"IT WON'T BE LONG" KICKED OFF *WITH THE BEATLES*, THEIR second album to begin with a shout out of nowhere, and though it's flimsier than *Please Please Me*, it has their other towering girl group statement, their romp through the Marvelettes' "Please Mr. Postman." The highlights of *With the Beatles* are the Motown covers, like "You've Really Got a Hold on Me" and "Money (That's What I Want)," but for me "Please Mr. Postman" houses them both. It's another blizzard of *oh yeah* screams—in America "Please Mr. Postman" was on *The Beatles' Second Album* alongside "She Loves You" and "I'll Get You," making it a concept album about the word "yeah." The way John shouts himself hoarse at the climax of "Please Mr. Postman"—"de-liver de-letter, de-sooner de-better"—is desperate enough to make the Mar-

velettes sound like they're the ones rolling their eyes at it. There's self-mocking humor in "It Won't Be Long," but I don't hear any humor in "Please Mr. Postman" at all. The Marvelettes bring hip irony to this song—they're cool girls playing it cute. They're not the type to chase a guy, much less sit around waiting for him to write, because there's "Too Many Fish in the Sea." So there's a sly wit in their original. But John treats every "oh yeah" and "wait a minute" like the truth. This was no joke to him.

None of the Beatles ever lost affection for the girl groups, not even in their solo years—when John broke free with "God," he turned to Rosie and the Originals for inspiration just as George turned to the Chiffons for "My Sweet Lord." (The Chiffons had so many hits better than "He's So Fine"—"Out of This World," "Why Am I So Shy," "I Have a Boyfriend"— and it's a shame George never got around to rewriting those.) Just listen to an epiphany like "Eight Days a Week"—it's all vowels and handclaps, fading in after the band is already underway, sung in unison as if the boys can't spare time to work out harmonies. That's another trick they learned from the Shirelles. "Soldier Boy" happened because the Shirelles had five minutes of studio time left at the end of a session, so their producers dashed off a quickie and the girls sang it in one take. They didn't have time to rehearse any harmonies. That's what makes "Soldier Boy" so powerful—their boy is shipping out in a couple of minutes and the good-bye is just gushing out of them.

"Eight Days a Week" goes for that same one-take unison effect. The whole song feels so urgent yet so light, the way John moans "oh-ho-ho-hold me," the way they rev up a half-step for the last two "hold me, love me" bits (especially the eleventh and fifteenth "me"s), the way John sighs the final

"weeeeeee" like he's too out of breath to finish the consonant. (The same trick he did at the end of "I Want to Hold Your Hand.") But if you listen to outtakes from the sessions, you can hear the Beatles worked out harmonies for "Eight Days a Week"—beautiful harmonies, in fact. Yet they cut the harmonies and sang in unison, to make the song sound like it took less work than it did. They spent seven hours in the studio tinkering with "Eight Days a Week," adding and subtracting, until they got that unrehearsed feel. So much guile went into making the song sound like a moment's exhalation.

The Beatles respected the power of "bap shoo-wap." For them it was more than a sexy pop twirl; it was a trip into the heart of girlness, a way to summon emotional intensities they couldn't access anywhere else. Male singers had trouble bowing to the girl groups without turning it into a joke. When Bob Dylan did "Talking World War III Blues" at Lincoln Center on Halloween 1964, he flattered the audience with a quip about Martha and the Vandellas singing "Leader of the Pack," as if he couldn't tell the Vandellas from the Shangri-Las; he knew his audience would snicker at the mention of these girlie bubblegum records, the opposite of the lofty art experience they were having. That was a barrier the Beatles set out to smash. To them "Leader of the Pack" represented an achievement they revered. There's a primal pleasure in their boyish voices blending in girl worship—the "love you ev-uh-reee-day girl" in the last verse of "Eight Days a Week," or the final "I can't *hiiiiiiide*" in "I Want to Hold Your Hand," or the increasingly ragged "yeah"s of "It Won't Be Long." Hence the oft-repeated (and always-dumb) cliché that the Beatles "only" wanted to hold your hand. There's no "only" about it, since the way the Beatles sang about it, the boy-girl connection could be the most complex nook of the cosmos.

THE IMPORTANCE OF
BEING RINGO

Ever since the day he faced a New York press conference and declared himself a Beethoven fan—"especially his poems"—Ringo has been one of the holy wise men of rock and roll. Smarter than you, believe it. There are two schools of thought about Ringo: (1) he was a brilliant drummer who made the Beatles possible, or (2) he was a clod who got lucky, the biggest fool who ever hit the big time. In my view, Ringo was a genius, the Beatles were blessed to snag him, and anybody who thinks otherwise is . . . a drummer, probably. I know drummers who worship Ringo and others who don't even think he was competent, a debate that would never occur to the rest of us. But he's rightly one of the most beloved figures in the story. The gods made only one of him. Chances are you're smiling at the sight of his name. His bandmates always did. "He's very fussy about his drums, you know," George explains to a stagehand in *A Hard Day's Night*. "They loom large in his legend."

Ringo's bumpkin charm has always tempted people to underrate him as a musician, but he was the only Beatle hired strictly for his playing, a pro with his stage name emblazoned on his kit while the others were still scuffling around Liverpool. They couldn't have done it without him. Yet he was also the only Beatle who ever got to stand in the audience and see them play. He knew both sides. As critic Robert Christgau put it, "Ringo is our representative on the Beatles." Despite being the clown of the band, he was the one who was never kidding—how do you make a song about octopi 100 percent unimpeachably sincere? You have to be Ringo. Look at him backing George Harrison in the *Concert for Bangladesh* movie, pumping the pagan skins to kick off "Wah-Wah"—has any drummer looked cooler? No. He remains the kids' first favorite Beatle—as Paul called him, "a knockabout uncle."

Ringo had the roughest upbringing, in the poorest corner of Liverpool (he outraged locals when he said the N.W.A. biopic *Straight Outta Compton* reminded him of home), in such ill health as a child he wasn't expected to see his sixteenth birthday. The first time he banged a drum was in the hospital, when a kindly music teacher brought instruments to the children's ward where the young Ritchie Starkey spent years at a time. (He missed so much school, his cousin had to teach him to read.) He got to know the Beatles while playing for another local band, Rory and the Hurricanes; late nights in Hamburg, he'd sit up front and pepper them with requests for slow ones such as "Moonglow." When he replaced Pete Best in 1962, he turned them into a true foursome. The other three grew up together as schoolboys; Ringo stepped in as a freewheeling adult, but unlike Pete, he joined them emotionally. As he said, "I was an only child, and suddenly I felt as though I'd got three brothers. In the old days we'd have the hugest hotel

suites, the whole floor of the hotel, and the four of us would end up in the bathroom, just to be with each other."

The other three thrived on his presence as well as his backbeat. Ringo usually sang one change-up per album—"Boys," "I Want to Be Your Man," "Yellow Submarine," "With a Little Help from My Friends," "Good Night." When they got caught short of material at deadline time, they could count on him for something like "Honey Don't"—a Carl Perkins rockabilly shuffle stretched out to three minutes as a vehicle for his banter: "Aaaaw, rock on, George, for Ringo one time!" John had always sung "Honey Don't" onstage; they only recorded it as an excuse to lean back on the guy who couldn't sing. "Act Naturally" is the quintessential Hail Mary pass to Ringo—a recent country hit for Buck Owens, the only one of their recorded covers they never played onstage, whipped up at the last moment to fill out the *Help!* soundtrack. "Act Naturally" was pure desperation, yet he made it sound like a gesture of brotherhood. When they had no energy, no inspiration, no songs, no hope, they always had Ringo.

"Ringo was a star in his own right in Liverpool before we even met," John insisted in 1980. "Ringo's talent would have come out one way or the other, as something or other. I don't know what he would have ended up as, but whatever that spark is in Ringo that we all know but can't put our finger on—whether it's acting, drumming or singing, I don't know—there is something about him that is projectable. And he would have surfaced with or without the Beatles." He became a movie star with his big close-up in *A Hard Day's Night*, the film that introduced the Beatles as one of the screen's all-time great comedy teams. He stood out with his sad-eyed antics ("I'm going parading before it's too late!") and his head-bob dancing in the nightclub scenes. "I'm Mister Show Business, you

know," Ringo told the BBC in July 1970. "I quite enjoy all that entertaining. It's just strange for me when I'm up front after all those years in the back. Suddenly I'm up there dancing and singing. I have to get used to that a bit more." For him it started with a tap-dance lesson, when he was eight. "A friend and I went," he recalled. "But there was too many girls there for us. I've been trying to get back ever since! You know, when you're eight, you go into that, 'Well, they're only girls, you know. They're not really human.' When you get to nine, then you start to realize what it's all about."

Ringo was the Ron Wood/Joe Walsh/Bob Nastanovich principle in the band—the guy who holds it together because he can get along with the high-strung divas up front. My guitar friends will go off about how Ron Wood doesn't have the chops to deserve his spot in the Stones, but it's a fact that no band ever broke up because Ron Wood was in it. People just love to be around him. Woody described his role in the Stones as "diplomatic liaison officer"—the only guy on speaking terms with both Mick and Keith. Some musicians have that quality; they can play *with* people. The Smiths didn't have a Ringo, and neither did the Clash, which is why these bands imploded too soon. It's often the drummer's job, whether that's the Velvets' Mo Tucker, U2's Larry Mullen Jr., or R.E.M.'s Bill Berry. ("Michael said he liked my eyebrows," a bemused Berry told *Rolling Stone* in 1985. "He claims to this day that's the reason he wanted us to get together.") Michael Palin served that role in Monty Python—John Cleese said the group formed because "we all wanted to work with Michael." As the novelist Douglas Adams recalled, "Mike was always the one that at any given moment *all* of the others liked."

Ringo was the ultimate diplomatic liaison. His good cheer was contagious. One morning in 1969, the Apple office got a

call from Hollywood grande dame Lauren Bacall—she was in London and wanted to bring her kids to meet the Beatles. That day. Despite the short notice, Ringo was the one who said yes, and got there an hour early. "He was charming and chatty and amusing and so together that he created the illusion that they had met all four Beatles," one of the Apple crew marveled. "It was the nicest kind of PR job, done in the nicest way." On the way out, in the lobby, the family ran into George, who took one look and ran upstairs to escape. "That's all right," Bacall said. "I always knew George was the mean one." It's not that George was mean, of course—he just wasn't Ringo. Nobody was. He inspired his mates to hang on as long as they did. Toward the end, in the January 1969 sessions for John's raw confessional "Don't Let Me Down," he asks Ringo to hit the cymbal extra hard for support: "Give me a big *kssshhhh*. Give me the courage to come screaming in."

But Ringo wasn't hired for being a prince among blokes— he was hired because his skills put them over the top musically. As Paul McCartney recalled, "We were just like, slamming around and doing stuff, but he had a beard—that's professional. He had the suit. Very professional. And he would sit at the bar drinking bourbon and seven. We'd never seen anyone like this. This was like a grown-up musician." The first night he sat in with them, nailing the R&B groove in Ray Charles's "What'd I Say," the others looked at one another in awe. Said Paul, "That was the moment. That was the beginning, really, of the Beatles."

By the time of *Please Please Me*, he was already one of the all-time great rock and roll drummers, motorvating his mates to places they couldn't have gotten near without him—listen to how he drives early gems like "I Saw Her Standing There," "She Loves You," "Money," or "What You're Doing." Yet like

the rest of the band, he got hotter as the years went on. "I only have one rule and that is to play with the singer," he says in *Anthology*, and you can hear that in the way he elevates ballads from "In My Life" to "Tell Me What You See," from his insane bongos in "You're Gonna Lose That Girl" to his locked-groove Krautrock momentum in "Magical Mystery Tour." "Drive My Car" gets my vote for Ringo's peak—that cowbell alone would justify his drumming-is-my-madness legend—along with the 1966 B-side "Rain." "It's out of left field," Ringo said. "I know me and I know my playing, and then there's 'Rain.'" He recorded "Rain" on a Thursday night, April 14, a half hour after they finished "Paperback Writer"—they moved fast in those days—and just ten days after his galactic skull-crush kabooms in "Tomorrow Never Knows." When the 1995 *Anthology 2* included outtakes from the "Tomorrow" and "Strawberry Fields Forever" sessions, a drug-crazed London DJ friend told me, "Ringo invented acid house!" And maybe he did.

He was the one the others kept playing with after the breakup—all three donated spare songs to his solo records, knowing there was no harm since nobody would hear them twice. "We'll always be tied up with each other in some way, you know," Ringo assured fans at the end of 1968. "Because we've signed a lot of papers." "It Don't Come Easy" and "Photograph" are his most enduring hits, but his best might be the Number One smash "You're Sixteen," tarting it up with New Orleans piano, a Paul kazoo solo, Nilsson harmonies, and Ringo perving up the punch line into "You walked out of my dreams and into my car." Even if you'd trade all his solo records for one verse of "Yellow Submarine," his spirit kept him going, even in the Eighties when alcoholism threatened to finish him off; after getting sober, he became a hard-touring

spokesman for peace and love. I have an irresponsible fondness for his 1970 country record *Beaucoups of Blues*, where he recuperated from the Beatles' split by retreating to his childhood dreams of cowboy escape. He just flew out to Nashville and went into the studio to warble Music Row songs his producer picked out, with session guys he'd never met, yet generating his Ringo warmth. Turning strangers into friends was what Ringo's music was all about.

Ringo's definitive solo statement might be his 1995 Pizza Hut commercial, where he announces he's in favor of getting the band back together. "I'd do it in a second," he says over a snippet of "Twist and Shout." "The fans will dig it—they've waited long enough. I've just got to get the other lads to agree." Then he's joined by three of the Monkees, who help him finish the pizza perched on his drum kit. As Micky, Peter, and Davy help themselves to slices of delicious stuffed-crust pizza—now with free garlic dipping sauce!—Ringo shrugs to the camera. "Wrong lads." The dream is over.

THE SCREAM

My mother-in-law once told me a story about her cousin, another West Virginia coal miner's daughter who came to Washington, D.C., in the early 1960s, fresh out of high school. Teenage Appalachian girls were migrating to the city to find work. Her cousin got a job at the IRS opening mail, in a vast office full of country girls hunched over stacks of envelopes, elbow to elbow. For obvious reasons, security was tight. No whispers allowed, no eye contact—just rows of girls slicing envelopes in the strictest silence. One day, one of them started screaming hysterically. She couldn't stop. They fired her on the spot. She had just opened Elvis's tax return.

I have always envied this girl.

THE SCREAMERS HAVE ALL THE FUN. THE BEATLES, MORE THAN any other performers, tapped into the Scream, as the girls

they once imagined became real. The Beatlemaniac girls remain the most famous screamers in history—more than the teens who screamed for Elvis, the bobbysoxers who swooned for Frank, the Directioners who shriek for Harry or Louis. When you look at any footage of the Beatles live, you look for the girls in the crowd, convulsing in divine ecstasy. Those girls were heroes, pioneers on the rock and roll frontier. They invented the Beatles and all that followed. Once you step inside the Scream, you get transformed into a different person. The Beatles spent years there.

The live show meant a mad rush to get onstage, play for half an hour, bow, dash back to the helicopter and off to the next town. The live show is Euripides's *The Bacchae* as a comedy—the young god dances, the women dance madly, so what if a head or two gets severed? We'd all *love* to change your head. The girls scream for each other—to each other, about each other. And the Beatles know it. They're just the instrument the fans play. As George says in *Anthology*, "They used us as an excuse to go mad, the world did." Look at the shell-shocked faces on the cover of *Beatles for Sale*, from late 1964—Ringo's really got the thousand-yard stare, or considering what he's been through, the thousand-yeah stare. The Hamburg bars full of thugs stabbing each other—those were creampuff gigs compared to the physical punishment of spending a half hour inside that scream.

You can hear the Scream loud and proud on *The Beatles at the Hollywood Bowl*, where the girls are the lead instrument. The fans can't hear a note, and neither can the band. There's no room tone—it's a stadium full of girl tone. George Martin explains in the liner notes why the band keeps fumbling. "The Beatles had no 'fold back' speakers, so they could not hear what they were singing, and the eternal shriek from

17,000 healthy young lungs made even a jet plane inaudible."
One of the howlers at the Hollywood Bowl was the future
Olivia Harrison. This was one of the first records I owned, a
birthday present chosen from the LP racks at the Lechmere's
on Gallivan Boulevard. My dad told me to pick out any re-
cord I wanted; I narrowed it down to *Hollywood Bowl* or
The Beatles' Second Album, which both had "She Loves You."
When I got it home, I wondered if I'd made the wrong choice.
Though the band faced this every night, they sound dazed by
the whole scene. Paul says, "We'd like to carry on" over and
over. But I fell in love with that noise—one long scream, going
full blast before special guest Ed Sullivan said, "And now, here
they are, the Beatles!" and still raging when the record fades
out twenty-eight minutes later. When Paul says "now, now"
at the good-nights, he sounds only mildly concerned about
provoking a riot.

It's easy to hear why the Beatles deleted this album from
their catalog, because it's a glorious mess—the tempos sped up,
the vocals ragged. Capitol shelved it as unreleasable in 1965,
despite the fact that a live Beatles album would have been pure
profit. A subtle song like "Ticket to Ride," so powerful when
played live at the BBC, can't withstand a crowd like this. For
some reason they try "Things We Said Today"—never a hit,
too much of a downer, so minor-key and moody. It requires
the kind of delicate touch that gets lost under those condi-
tions; they can't duplicate the acoustic riff live. It's hard to
guess why they attempt this song at the Hollywood Bowl, but
they do, with John and Paul promising all those wild girls, "I
will remember the things we said today." The fans keep ulu-
lating, so they can't hear the words. But the Beatles feel a need
to state, for the record, that they will always remember what
the girls told them, which is a half hour of "*yeeeeaaaah!*"

THE BEATLES MADE THEIR AMERICAN DEBUT ON *THE ED Sullivan Show*, doing three songs at the top of the show: "All My Loving," "Till There Was You," and "She Loves You." All their *Sullivan* appearances are worth viewing, not just for the band, but to see what a sensory-deprivation tank the rest of the show is. A banjo-bothering dowager named Tessie O'Shea doing English music-hall tunes? Magic from the Great Fantasio? Mr. Acker Bilk doing a clarinet solo called "Acker's Lacquer"? Acrobats, jugglers, puppets—this is what people did for fun before the Beatles came along? The girls who stand up and tell it and make their own noise—they're the only halfway hip spirits in the room. After "She Loves You" crashes into its ten-yeah *sparagmos*, Ed Sullivan comes back out, holds up his hands sternly, and says, *"Quiet!"*

It chills the blood to see the guy who has to come out and follow them that first night—a Dutch magician named Fred Kaps, in white tie and tails, doing a card trick that drags on for long minutes of silence. You have never seen flop sweat like this. To the 93 million viewers, it looked like he was bombing live, but he taped his bit before the show, which just makes his awkward pauses more agonizing. "I should have rehearsed this," he mutters. Beads of existential despair condense along his forehead. When he woke up that morning, he was the luckiest magician in town. This was his big break. Now his whole face seems to ask, *Why, Lord? This salt shaker trick knocked them dead back home. I'm one of Europe's most acclaimed magicians, a three-time winner of the Grand Prix. When they told me I was going on after an English rock and roll group, I thought, it's almost too easy.* After the Beatles return for "I Saw Her Standing There" and "I Want to Hold Your Hand," Sullivan comes back out with a tight smile. "I want to congrat-

ulate you. You've been a fine audience. Despite severe provocation."

The girls were already the stars of the show. The Beatles didn't want to get left out—as they played bigger rooms, they kept working more "oooohs" and "yeeeeahs" into their music, as if they were foldback speakers for the audience. They reveled in the Scream, especially Paul, always the pro-girl conscience of the band. In the 1964 documentary *What's Happening!*, Paul, John, and Ringo sit in the back of a limo, just hours after landing in New York. On the drive from the airport to the hotel, Paul is already having the time of his life—he holds a transistor radio to his ear as it plays "I Saw Her Standing There" and says, "I *love* this." The DJ tells the fans to tune in tomorrow at seven to hear the Beatles read their poetry; all three look at one another as Paul says, "We ain't written no poetry." But he was the one who didn't tire of the pageant. Even in the footage of the chaotic Shea Stadium gig, Paul runs to the stage, while the other three trudge like they're off to the gallows—he can't *wait* to get there and bask in all that female attention.

The cliché used to go that they deteriorated as a live band, but that claim has been definitively debunked by the footage of their 1965 and 1966 tours in the film *Eight Days a Week*. Even at Shea, they sound great. Something you keep noticing in concert footage: their time onstage is the only part of the day where they can talk among themselves, knowing they have complete privacy. At their final show, in Candlestick Park in 1966, John announces, "This is about a naughty lady called 'Day Tripper.' " Paul makes a private joke: "We'd like to do the next number now, which is a special request from all the backroom boys on this tour: 'I Wanna Be Your Man.' " This quip might have raised eyebrows if anybody had heard it. But

nobody did. (Brian Epstein wasn't there—he was in L.A. re-
solving a legal crisis with a blackmailing ex-boyfriend, a sadly
frequent Epstein predicament.)

At Candlestick Park, they're in a giddy mood, because they
already know it's the end of their touring days. They play a
longer show than usual, even though they mention that they're
freezing cold, like most musicians who play outdoor summer
shows in the Bay Area. Most of the 1966 shows closed with
"I'm Down," but tonight they sign off with Little Richard's
"Long Tall Sally"—the song Paul played on guitar for John
the day they met, nine years earlier. "It's been wonderful be-
ing here in this wonderful sea air," Paul says. "Sorry about the
weather. And we'd like to ask you to join in and clap, sing,
talk—in fact, go on, do anything. Anyway, the last song is—
good night!" He doesn't mean "Good Night"; he means the
show is over and so are all the other nights like this one. But
after "Long Tall Sally," John plays an odd coda: the opening
guitar lick of "In My Life," dangling it in front of the crowd
as a to-be-continued. "In My Life" typifies the kind of song
the Beatles wanted to do next, the kind that didn't conform to
a setting like this. They really *did* want to carry on.

My favorite prototypical Beatlemaniac appears in the great
documentary *The Compleat Beatles*, in a TV news clip. A
Brooklyn girl—for all we know she could be Carole King's
niece—shows off an oil painting she's made. "The name of it
is 'Sprout of a New Generation,' " she says. In the painting,
Paul's giant head is growing out of the landscape, like a rose,
or perhaps a cabbage. "It shows Paul McCartney coming up
from the earth, like sprouting. A sprout, a start, a new dawn.
You see, the Beatles are the originals. They started the look,
everything. And here's the thing—if you notice, he's like,
growing." Then she asks the TV reporter if he can introduce

her to Paul. For all four Beatles, the Scream lingered in their bones. Even George wrote "Apple Scruffs," his affectionate fan tribute. Everybody else followed these girls after they discovered the band, but the girls got there first, and the Beatles never got over them.

One night in America, Brian Epstein gave himself permission to live out his deepest fantasy—he slipped to the back, under cover of darkness, just another anonymous body in the ocean, and let himself go. "He told me that just once he allowed himself to go to the back and stand at the back with all the girls in a concert in America," pop manager Simon Napier-Bell told biographer Debbie Geller. "I think it was one of those stadiums where there were probably 25,000, 30,000 people, and he went into the crowd of girls and he just screamed like one of the girls, which he said is what he'd always wanted to do from the first minute he'd ever seen them. He had spent his whole life being restrained and wearing suits and suddenly he just screamed and became the mad fan he wanted to be." Any fan who claims they don't share this desire has to be lying. When I listen to *Hollywood Bowl*, I do not imagine being one of the Beatles; I fantasize about being the girl in the upper-balcony cheap seats, ripping out my hair and shrieking, tapping into a ruinous eternal gnosis that not even the boys in the band could ever know.

"TICKET TO RIDE"

(1965)

Why do women leave you? Simply because. Women leave simply and they leave because.

Sometimes I hear John sing "Ticket to Ride" and the story goes: *He tried to change her mind about leaving. It didn't work.* Other times: *She wanted him to talk her out of it. He gave up.* Rarely, but now and then: *He's relieved. It was time.* Very, very often: *I hope to fucking fuck this never happens to me,* even after it already has. All these stories are there in John's voice.

"Ticket to Ride," like so many John songs, recalls what a woman said, after she's gone. As Richard Pryor said, "I don't mind them leaving, but they tell you *why.*" Well, this woman told John why. So he keeps repeating it to himself. He's not arguing with what she said—that'll come later—just trying to get the story straight in his mind, going back over it the way you do after a shock. Just the facts. He repeats her words, making sure he can remember it the same way twice. As his role model

Dylan might say, he's whispering to himself so he can't pretend that he don't know. Maybe later he'll write a song where he explains why she's wrong, or why he's better off alone—right now he's telling himself she's really gone, introducing himself to a bleak memory that will torment him a long time. He will do plenty of brooding over her voice. This is just the first time.

Hearing John sing this song in the *Help!* movie as a kid, over those droning guitars, I knew a full-grown man was giving me some bad news about how adulthood would feel. The same guy had just sung "You've Got to Hide Your Love Away" a few scenes earlier, another bereft confession. But "You've Got to Hide Your Love Away" comes after the girl has been gone for a while—John's able to reflect on his heartbreak (even pride himself on how earnestly and poetically he feels it, an emotion I already could relate to at that age). The John who sings "Ticket to Ride" has a world of misery to go through before he even gets there. "You've Got to Hide Your Love Away" is a clever song," while "Ticket to Ride" isn't clever at all—John has his hands full trying to understand what just happened. Feelings? He'll put those off as long as possible. (But they will come. He's John.) "I think I'm gonna be sad" might be the most ominous line he ever sang.

I felt wiser after hearing this song—I trusted this voice, because John didn't sound like he was pulling his punches, and neither did the men in his band respectfully hearing him out. Men—not boys in this song. Even now, I don't think, "These kids are still in their midtwenties. They have their whole lives ahead of them." They are *always* older than I am in this song. "Ticket to Ride" wasn't a story I wanted to hear. (The first time I'd heard it, I'd been a Beatlemaniac only about twenty minutes, but I'd already had time to decide I liked them happy. In the movie, they sang it on the ski slopes, with John's

breath turning to frost.) I could identify with the girl's desire to get free—so can John, which is why it's such a powerful song. He's not at all unsympathetic to her plight. Why does he bring her down? He just does. She said so. Turn his face to the wall? This John can't find the wall.

"Ticket to Ride" might be the first Number One hit about a man and woman living together—"living with me was bringing her down," not "loving me" or "being with me," in 1965—yet he's so blasé about it. The woman bought a ticket, so she has an escape route planned, but she doesn't care where. As the country song says, she ain't going nowhere, she's just leaving. This isn't a "she done me wrong" song or an "I should have treated her better" song. (John wrote plenty of those.) Sometimes when I hear "Ticket to Ride," it sounds as if John knew this bombshell was coming, but more often it came out of the blue. Technically, she hasn't told him good-bye yet—she hasn't used her ticket. But this isn't a girl who buys tickets as an idle threat. (In some other John songs, the girl probably buys a ticket or two a week.) Maybe once every three or four years I'll hear it and think, *There's still a chance she might not take the ride*, but that just means I'm too spooked to listen honestly. It probably also means I should switch to decaf and turn off my phone.

John and Paul wrote so many songs about tuning in to women's voices, but neither of them ever had much interest in what men say. John's idea of a male/male conversation is "Revolution," where he interrupts the guy every line, and for Paul it's the jailbird banter of "Band on the Run." (The joker who says "I hope you're having fun" during a prison break is probably the guy the others were trying to escape from.) The only men they truly cared about listening to were the Beatles. To hear "Ticket to Ride" (or "Two of Us" or "I Don't Want to Spoil the Party" or "Long, Long, Long") is to step into a

room full of men listening to each other. Even back then, they probably suspected they wouldn't find many other rooms like this. "Ticket to Ride" would be a different story if John were singing alone—but he's telling his story to other adults, and you can hear them listening. What a support player Paul is here—you never notice his harmonies in "Ticket to Ride," because if you noticed him, it'd step on the story, yet the song wouldn't work without him. (He eventually wrote his own version, "For No One.") The guitars sustain for an *ommmmm* of melancholy, over Ringo's pensive drum fills. Husker Du did an ace punk version in 1984, adding a fancy harmony—Grant Hart sings lead, Bob Mould adds a broken echo after each line, over his buzzsaw guitar. It brings something new—but it also illustrates how simple and direct the original is. The fact that Otis Redding never lived to sing this song is a tragedy in itself.

John is aiming for the world-weary gravitas of Bob Dylan in "Boots of Spanish Leather" or "One Too Many Mornings," but this is well beyond what Dylan was capable of writing at the time—it'd take him another ten years, until *Blood on the Tracks*. Dylan is definitely the key to John's singing—the grogginess of his voice, so punch-drunk with grief he can barely feel his feet, bumping his forehead on every chord change. Every live version I've heard has its own rhythm—every time John tells the story, he fumbles with different words, sighs in different places. Yeah sure, he'll tell his story again. Has he mentioned what she said about being free? Did he mention it's today? He'll take it from the top. It's not a long story but it's a long story. And you hear the other three listening, the way he listened to her. They're taking in his story, remembering when it happened to them (or hoping it won't). They don't know what to say, so they say nothing. It's some of the loudest listening they ever did.

"THINK FOR YOURSELF"

(1965)

Late night, Abbey Road. It's November 8, 1965. The world's most famous rock and roll stars are in the studio making a new album called *Rubber Soul*. Their last album, *Help*, came out just three months ago, but the label already has them back in the studio cranking out new product in time for Christmas. They're doing three-part harmonies for a song called "Think for Yourself." They're laughing too hard to get it right.

John, Paul, and George stand around a microphone. Behind the glass, the ever-patient George Martin. John, holding a guitar, keeps stumbling on the words. "Okay, I think I might have it now," he announces. "I get something in me head, you know, and all the walls of Rome couldn't stop me!" All three Beatles—Ringo isn't around for this bit—keep up a nonstop stream of chatter, faster than anyone else can follow. John slips into a mock-preacher voice. "It's Jesus, our Lord and Savior, who gave his only begotten bread to live

and die on! And that's why we're all here and I'll tell you brethren, there's more of them than there are of us!" Paul and George get in his face, yelling, "Why such fury? What is this wrath that beholds you?" They gasp with laughter until John mutters, "I can't go on, I really can't. Come on, let's do this bleedin' record." They try another take. They don't get this one right, either.

Harrison keeps trying to nudge the group back to the song—it's his song, after all, so it's his fault the harmonies are so difficult. George Martin's ready for another take. John looks around and asks, "Paul?" Where *is* Paul? He's ducked into the men's room to sneak a quick puff of cannabis—still playing the naughty schoolboys, the Beatles don't dare light up in front of Mr. Martin, though they're not fooling him for a minute. Paul comes back, and his voice sounds giddier. "I just got in from Olympia. I lit the torch!"

These lads are under pressure, but you can't hear it in their voices. Just a year ago, they were in this same studio cranking out an album for the holiday deadline—*Beatles for Sale*, the one where they look burned out on the cover. They got caught short of material, so they had to bang out a bunch of oldies covers the night before it was due. Nobody held it against them. It worked. They're under the same time pressure now, but they don't look or sound at all the same. They're four unbelievably confident young men, fired up with exuberance, knowing they're writing the songs of their lives. Their music has changed. They're heavily into Dylan. When they met him on tour in America, he introduced them to pot. Now they're writing songs about tricky adult emotions. They're using instruments nobody can pronounce.

They're behind schedule—the album needs to be in stores

in just a couple of weeks—so tonight George Martin is letting the tape roll, thinking he might end up using some of this studio chatter for the Beatles' annual Christmas fan-club greeting, in case there isn't time to do a proper one. None of this banter gets released, except a six-second snippet in the film *Yellow Submarine*. It's a bootleg treasure—nobody thought at the time there was any reason to preserve recordings of the Beatles just fooling around, so it's a rare chance to hear the Beatles in the studio, rehearsing and bantering and making stoned jokes about body odor. "I'm sorry—sometimes I feel less than useless at these sessions," John says. "I really do. Of course Cynthia understands. I often talk to her about it when we get home. I said, 'Sometimes Cynthia, I just can't get the note.' "

Paul lectures John in the tone of a stuffy British director. "Look Terence, if you want to resign from the Amateur Dramatics, do. Let's face it, you're crap," he says. "You were only doing walk-ons and you're farting those up!" John whimpers, "Give us a kiss."

You can hear it in the Beatles' voices tonight—they buzz on one another's company, tuning into some frequency nobody else can get. They keep working on "Think for Yourself"— what kind of title is that? Why don't the chord changes make sense? Why is John Lennon tripping over words like "opaque" and "rectify"? Why is the bass distorted through a fuzztone? Oh well—at least it's not a sitar. (A what?) Nobody knows if this crazy album will sell, not even them. But they don't sound worried. If you didn't know better, you might even suspect they're having fun.

As Lennon heads off to the loo, he sings one of the Beatles' earliest ditties, the one George sang on their first album, "Do

You Want to Know a Secret?" Though that song was barely three years ago, its coy innocence already seems a lifetime away.

But John has changed the words a little, snapping his fingers as he sings out loud: "Do you want to hold a penis? Doo-wah-ooo!"

RUBBER SOUL

(1965)

Rubber Soul will always be my favorite album—even if *Revolver* is slightly better. I've made my peace with that contradiction. It's the most out-there music they'd ever made, but also their warmest, friendliest, and most emotionally vivid. As soon as it dropped in December 1965, it cut the story of pop music in half—we're all living in the future this album invented. "Finally we took over the studio," John Lennon told *Rolling Stone*'s Jann S. Wenner in 1970. "In the early days, we had to take what we were given, we didn't know how you could get more bass. We were learning the technique on *Rubber Soul*. We were more precise about making the album, that's all, and we took over the cover and everything."

Rubber Soul is where the moptops grew up. It's also where they were smoking loads of weed, so all through these songs, wild humor and deep emotion go hand in hand, like George Harrison and cowboy hats. (No rock star has ever looked

less stupid in a cowboy hat than George on the back cover.)
In addition to everything else it is, *Rubber Soul* is their best
sung album. You can have a great time listening only to the
background vocals: Paul's harmonies on "Norwegian Wood"
are as rugged and worldly as John ever sounded, while John's
backup vocals to "Drive My Car" and "You Won't See Me"
prove he could sound as slinky as Paul. Their best album
cover. Their best songs. My favorite.

If there's a theme, it's curiosity, the most Beatlesque of emo-
tions, and specifically it's curiosity about women, the most
Beatlesque of mysteries to be curious about. *Rubber Soul* has
the coolest girls on any Beatle record. "I'm Looking Through
You," "Girl," "If I Needed Someone"—these are complex and
baffling females, like the ones the Beatles ended up with in
real life. The boys spend the album stretching and growing to
comprehend these women—just as their faces stretch out on
the cover. No happy romantic endings here, with the notable
exception of "In My Life"—but even when the girls are way
ahead of them, the boys spend the album straining to keep up.
Baby, you've changed.

Did anyone before *Rubber Soul* ever sing about female char-
acters like this? No, they didn't. For one thing, these women
have *jobs*, and this is 1965. The L.A. scenester who hires Paul
as her driver, the independent woman too busy with her ca-
reer to return his phone calls, the Chelsea girl who seduces
John and leaves for work before he wakes up alone. In late
1965, when this album came out, my mom, an eighth-grade
public-school teacher in Massachusetts, got fired for getting
pregnant (with me), because that's how things worked back
then. The very idea of women having careers was a social con-
troversy. But for the world's biggest pop stars, it was nothing
to get hung about.

The *Rubber Soul* woman stays up late drinking wine on her rug after midnight, until it's time for bed. She speaks languages he can't translate. ("I love you" in French is just *je t'aime*. It's not that hard.) She's not impressed by the Beatle charm—when you say she's looking good, she acts as if it's understood. She's cool. She makes the *Rubber Soul* man feel like a real nowhere boy. Yet even the sad songs are funny—nearly every song here is. I love the moment in "Wait" when Paul's girl asks point blank if he's been faithful on the road. "I've been good / As good as I can be"—*riiiiight*. "Wait" is the song that totally explains why Paul was Bill Clinton's favorite Beatle.

The men on this album often have major woman problems, but it's not a life sentence. The "Nowhere Man" isn't doomed to stay paralyzed forever—it's just time for him to snap out of it and ask for help. The bitter sulk of "Think for Yourself," the self-parodic machismo of "Run for Your Life"—these are moods they're suffering from, not terminal conditions. On *Revolver* and *Sgt. Pepper*, loneliness is a disease that can kill you, eating away at your soul. But on *Rubber Soul* it's just a matter of letting yourself change, which means letting these women change you. The *Rubber Soul* woman asks philosophical questions the boy can't answer. She has her own mind, her own apartment. She paid for the wine. She makes him ponder the places he's been, all the streets he's crossed just to end up here on her floor, wondering what happens next.

Most of the stories here continue on *Revolver*. "Norwegian Wood" turns into the full-on tabla trip of "Love You To." The pothead harmonium drone of "The Word" turns into "Tomorrow Never Knows." The "Girl" becomes the woman in "And Your Bird Can Sing." The "Nowhere Man" becomes the boy from "I'm Only Sleeping." The lovers and friends of *Rubber Soul* are all works in progress. But the intimate

candor of their voices, the wit of the guitars and drums—it all makes *Rubber Soul* my favorite story they had to tell. Even the American version—this is the only case where the shamefully butchered U.S. LP might top the U.K. original, if only because it opens with the magnificent one-two punch of "I've Just Seen a Face" and "Norwegian Wood." I still can't decide which *Rubber Soul* is my favorite, having had a mere lifetime to make up my mind.

GIVEN THE IMPACT OF *RUBBER SOUL* OVER THE PAST FIFTY years, it's startling how fast and frantic the sessions were. The Beatles didn't go into the studio with a mystic crystal vision—they went in with a deadline. They had to supply an album for Christmas 1965, which meant crunching it out in four frenzied weeks, from October 12 to November 12. So they holed up in Abbey Road around the clock, pouring out music as fast as they could, holding nothing back. They were willing to try any idea, whether it worked (the sitar, the harmonium) or not (the six-minute R&B instrumental jam, which they wisely axed). They wrote seven of the songs in one week.

But with their backs against the wall, the Beatles produced an album far ahead of anything they'd done before. Since these guys were riding new levels of musical fluidity and inspiration, firing on so many more cylinders than anybody else had, they stumbled onto discoveries that changed the way music has been made ever since. It was an accidental masterpiece— but one that stunned them into realizing how far they could go. After that, they went full-time into the masterpiece-making business. Yet unlike some of their later artistic statements, this one was fun to make, and it shows. It's where the Beatles

became the Beatles. For artists like Stevie Wonder and Marvin Gaye, it was a model of artistic independence. Brian Wilson was still writing surf hits until he heard this record. The morning after his first listen, he sat at the piano and wrote "God Only Knows." As he said, "We prayed for an album that would be a rival to *Rubber Soul*."

They spent the early part of 1965 making *Help!* The original title, *Eight Arms to Hold You*, changed after John wrote a new song, not exactly coy about his state of mind—it began with him screaming, *"Heeeeelp!"* But nobody seemed to get the message. "I meant it—it's real," he said. "It was just me singing 'Help' and I meant it." He wasn't the only one—in June, Brian Epstein disappeared in Rome, and didn't resurface until five days later, when he rejoined the tour in Madrid. "The Beatles thing had just gone beyond comprehension," John said. "We were smoking marijuana for breakfast. We were well into marijuana and nobody could communicate with us because we were all just glazed eyes, giggling all the time. In our own world. That was the song, 'Help!' "

The Beatles had good reason to worry about keeping up. The radio was exploding with epochal hit singles all year: Dylan's "Like a Rolling Stone," the Stones' "Satisfaction," Gaye's "Ain't That Peculiar," Smokey Robinson and the Miracles' "The Tracks of My Tears." The Byrds went Top Ten giving an electric jangle to Dylan's "Mr. Tambourine Man." Bands like the Who, the Kinks, and the Yardbirds started exploring guitar noise. There was a pop revolution going on, and no doubt about who had led the way. But by the end of 1965, the question was whether the Beatles could keep the pace. They must have wondered themselves. So they needed to prove they were still part of the action. What they proved was that they *were* the action.

THE *RUBBER SOUL* SESSIONS BEGAN ON OCTOBER 12, WITH George Martin producing. They needed the usual fourteen songs. They had one in the can, the *Help!* leftover "Wait." They brought a few ideas—some no more than sketches. But the most important thing they brought was a willingness to play around. "It was getting to be really exciting in the studio," Ringo said. "We did it all in there: rehearsing, recording, and finishing songs. We never hired a rehearsal room to run down the songs, because a lot of them weren't finished." Ideas weren't the only thing flowing—as George admitted, "*Rubber Soul* was the first one where we were fully-fledged potheads."

Strangely, the first track they cut was a total throwaway. " 'Run for Your Life' I always hated," Lennon said in 1970. "It was one of them I knocked off just to write a song, and it was phoney." He had a point. It's a tired man trying to jolt himself into feeling something and failing, going for emotional triggers (jealousy, mainly) that used to work for him but just don't anymore. So he turns his exhaustion into a goof, with those comic falsetto backing vocals. But John probably started with a joke because he frightened himself with how vulnerable he got in the other song he brought in that day: "Norwegian Wood." As he admitted, "I was trying to write about an affair without letting me wife know I was writing about an affair. I was writing from my experiences, girls' flats, things like that." It was popular for Swinging London trendies to decorate their homes with Norwegian pine. "So it was a little parody really on those kinds of girls who when you'd go up to their flat there would be a lot of Norwegian wood," Paul explained years later. "It was pine really, cheap pine. But it's not as good a title, 'Cheap Pine,' baby."

Yet even if it's a groupie tale, it's an adult one: Lennon is the one pursued and seduced, sitting nervously on the girl's floor until she tells him, "It's time for bed." George's sitar was part of "Norwegian Wood" from the beginning. Ironically, he'd first heard the sitar on the set of *Help!*, filming a scene where Indian musicians played parody Beatles covers in a restaurant scene. Intrigued, he picked up their sitar, "messed around" with it, then bought his own at the London shop India Craft. It set him off on a lifelong spiritual journey. Meanwhile, John and Paul whipped up an R&B ode to the aggressive young ladies they were meeting on the West Coast. "Suddenly there was a girl there, the heroine of the story," Paul said. "To me it was L.A. chicks." Ringo never played so savagely—"Drive My Car" looms large in his legend, right up there with "Rain." (Listen to him in the last bar before the chorus—every time it rolls around, Ringo slays with something different.) "Drive My Car" was also their first session to stretch past midnight, taboo in the stuffy studio world of 1965. As the sessions wore on, this became all too common.

They were on a roll now, and they knew it. They spent eleven hours making the single "We Will Work It Out"—a record for them, although soon to be shattered as studio marathons became their style. They debuted "We Can Work It Out" just a few days later in a BBC special, *The Music of Lennon and McCartney*, with an offbeat highlight: John and Paul introduce their comedy idol Peter Sellers, who does "A Hard Day's Night" in the style of *Richard III*, declaiming the lyrics as a Shakespearean monologue and making them sound even filthier.

"In My Life" began as John's attempt to write an autobiographical poem. "It was the first song that I wrote that was really, consciously, about my life," Lennon said. George Martin played what sounded like a harpsichord, really a piano solo

with the tape sped up. And while nobody ever mentions how great Ringo is on this song, his drumming is pure brotherly empathy—he keeps encouraging John to push on to the next line. It's impossible to imagine "In My Life" without Ringo in it, which is one of the reasons every cover version falls flat. The instrumental telepathy could be what John meant when he remembered "just being able to sort of blink or make a certain noise and I know they'll all know where we are going." "In My Life" sums up the album's heart and soul. It's the only song where Lennon and McCartney seriously disputed who did the actual writing—but it's easy to tell why both men fell so deeply in love with it.

BY NOW THE BEATLES WERE FEELING THE STRAIN—JUST weeks from the release date. But they took a day off on October 26 for Beatle duty—they headed to Buckingham Palace to receive medals from Her Majesty, honoring them as Members of the British Empire. The Beatles wore crazy grins through the ceremony. John later claimed they ducked into the royal bathroom for a quick weed break (rather than a bellyful of wine). They also recorded their annual message to the fan club. The take they ended up using was the tail end of a late-night session going to 3 a.m., where the lads sing an out-of-tune "Yesterday," with the words changed to "Bless you all on Christmas Day." They're tired, but their spirits sound high. Perhaps because they were.

PAUL: Gotta thank everyone for all the presents this year.
JOHN: Especially the chewed-up pieces of chewing gum and the playing cards made of knickers!

At one point, when Ringo muses "same old guitar, same old faces," John starts strumming the then-current Motown hit by the Four Tops, "It's the Same Old Song," in the style of an Irish folk ballad. The others sing along before Harrison bursts in with a horrified warning: "Copyright, Johnny!"

They started scrounging for inspiration everywhere. Ringo sang the country trifle "What Goes On," his first songwriting credit. Asked in 1966 what he contributed, Ringo said, "About five words." They jammed till half past three on the R&B instrumental "12 Bar Original," proving they weren't a band for jamming. It was a knockoff of Booker T. and the MGs' 1962 classic "Green Onions," but the fandom was mutual—the MGs did their own Beatles tribute a year later, backing Otis Redding on his great version of "Day Tripper." (In 1970, they released *McLemore Avenue*, an album-length remake of *Abbey Road*.) The pressure got so desperate that studio engineer Norman Smith pitched the band one of his songs. After he played it on the piano, they smiled and said they might give it a go sometime. Smith, a former World War II RAF pilot, was well into his forties, so square the Beatles dubbed him "Normal." It's a tribute to their charm—maybe also their powers of deception—that they were able to humor him, instead of taking it as an insult. But it says something about the sessions that he got up the nerve to ask. (To his credit, Smith didn't give up. He went on to score an international hit in 1972—at the age of forty-nine—with "Oh Babe What Would You Say," which hit Number Three in *Billboard*. John sent him a congratulatory telegram.)

They went down to the wire with one final all-nighter—a marathon from 6 p.m. to 7 a.m., on November 11. They rose to the occasion by bringing in two of their greatest disenchanted love songs: Paul's "You Won't See Me" and John's "Girl."

Their voices sound weary, but that just adds the rough Dylan-esque tone they were hoping for. "Wait," rescued from the *Help!* sessions, got spruced up with new vocals, guitar over-dubs, and some of Ringo's finest tambourine work. By dawn, it was all over but the mixing. The title came from a private joke—during the June session for "I'm Down," the flip side of "Help!" Paul ended by muttering, "Plastic soul, man. Plastic soul." (To give a sense of how fast the Beatles worked in those days, he recorded "I'm Down" the same day he recorded "I've Just Seen a Face" and "Yesterday"—three completely different McCartney vocal styles.)

While in retrospect it seems like a no-brainer that the world would embrace the new grown-up Beatles, this was by no means clear. As Geoff Emerick, later their engineer, reports, "There was almost no buzz at all in the Abbey Road corridors about *Rubber Soul*. Though everyone agreed that it had quite a few good songs and a crisp, clean sound, the general feel-ing among the staff that were working on it was that it was a pleasant diversion into the realm of folk and country mu-sic." Early reviews were mixed—the U.K. music press called it "monotonous" and "not their best."

Even Paul seemed to have doubts. In the holiday message, he says, "That looks like as though that's about it for this year. We certainly tried our best to please everybody. If we haven't done what we could have done, we tried." But the kids weren't turned off by the experimentation—it was an instant hit, even though it was their first without any singles. It topped the U.S. charts for six weeks, replacing Herb Albert & the Tijuana Brass' *Whipped Cream and Other Delights*. (Some accused Capitol of editing the U.S. version to cash in on the folk-rock trend, but it's not possible given the timing—when they is-sued the doctored *Help!* in August, Capitol had no idea how

the next album would sound, since the songs weren't written yet.) Out in California, *Rubber Soul* set off shock waves in a rising youth bohemia. "More than ever the Beatles were the soundtrack of the Haight-Ashbury, Berkeley and the rest of the circuit," Charles Perry wrote in his chronicle *The Haight-Ashbury.* "You could party-hop all night and hear nothing but *Rubber Soul.*" The as-yet-unnamed hippie kids considered themselves far out, yet they were taken aback by this record. "Could it be—was it crazy to think—that they might be getting *stoned*?"

Robert Freeman's cover photo summed up the tone—the four Beatles in John's backyard, looking bemused and pensive in suede jackets, their hair longer than ever. Out of the eight Beatle ears, the only one still partially visible was Paul's leftie. Freeman had done the iconic black-and-white portrait for *With the Beatles* (in America, *Meet the Beatles*). When he was showing the band his new snaps, he projected slides onto a white cardboard. "Bob inadvertently tilted the card backwards," McCartney recalled. "The effect was to stretch the perspective and elongate the faces. We excitedly asked him if it was possible to print the photo this way. Being Bob, he said 'Yes.' "

Those four distorted faces were peering out from record racks a few weeks later. For the first time, the band name was nowhere to be seen—only the title and those cocky mugs. The scared kids who looked so miserable a year earlier, on the cover of *Beatles for Sale*? Now brimming with arrogance. On fire with belief in their new music. Not really caring if you liked the old songs better. Full-grown men, full of emotion and on top of the world. Meet the Beatles.

INSTRUMENTAL BREAK

26 Songs About the Beatles

1. Lil Wayne, "Help!" (2006)

Lil Wayne's mixtape version of "Help!" never got officially released—there's no legal way that could have happened. But John would have loved it. The New Orleans MC was ruling hip-hop, dropping street bootlegs like *The Drought Is Over 2* faster than fans could keep track. Weezy raps over a loop of John screaming, "You know I *need* someone!" Down in New Orleans, he's hearing his own soul in John's voice, making the connection between Liverpool and the Dirty South: "I'm from the dirt where the Beatles and John Lennon be at."

He claims "Help" for Lil-Weezy-Ana with the same irreverent spirit of the Beatles in their early Hamburg days, where John Lennon used to change "Shimmy Shimmy" to "Shitty Shitty." "We were hicksville . . . like the American Midwest," John said in 1970, remembering Liverpool. "Even London was something we used to dream of, and London's nothing. I came

out of the fuckin' sticks to take over the world." You can hear that same attitude in Weezy's voice.

2. The Replacements, "Mr. Whirly" (1983)

The Minneapolis punk heroes (still unknowns when they recorded this in 1983) desecrate a few different songs in "Mr. Whirly"—writing credit on the label: "mostly stolen"—but they're mostly manhandling "Oh! Darling" from *Abbey Road*. Down in the basement, Bob Stinson plays the "Strawberry Fields" intro on guitar, then the extremely drunk hardcore boys rip into "The Twist" before Paul Westerberg starts to wail "Oh! Darling." But he changes the words so he's singing his love ballad to the darling he'll end up with tonight—the toilet he'll be facedown in, although it'll be spinning too fast for him to hurl into it. "Missss-tah Whirly, please don't call me. I been drinking alone."

Westerberg sounds ravaged and scared, with so much Lennon in his voice. Maybe tonight won't go down the drain the way last night did. Maybe he'll stop at three beers. Maybe he'll meet a girl. But he can already see where tonight is turning and he's pleading for it not to happen. "Whirly—*pleeease* don't follow me home!" Then the band kicks in, playing "The Twist" again. Too late now to beg Mr. Whirly for mercy. The whole room is spinning so hard it's doing the twist.

The Replacements' next album was the creative breakthrough that made them notorious around the world. They called it *Let It Be*. On the cover, Tommy Stinson is picking his nose.

3. Aretha Franklin, "The Long and Winding Road" (1970)

I'd nominate this as the most a Beatles cover has ever improved on the original. Until I heard Aretha sing it, I thought this song was sniveling slush, even without the gooey strings and choirs Phil Spector imposed upon it. But while Paul puts a brave face on a song of trial and tribulation, Aretha sings it as a song about loss and defeat. It's not a matter of her vocal chops alone—she didn't sing "Eleanor Rigby" as well as he did—but she feels the song deeper and brings more emotional courage to it. For Paul, it's a sad song with a happy ending. For Aretha, it's a sad song.

Paul doesn't want to talk much about the road, because it brought him to your door. Why grumble—he got here, didn't he? Aren't you pleased to see him? Glad that's behind us now. Aretha, however, is not so relieved to be here. She does not look on the bright side. She spent too long on that road; it took a lot out of her. As she sang a few years earlier in a song her sister wrote, "Ain't No Way," she paid too much for what she got. Aretha ends the song still out on the stoop—"don't leave me standing here"—and you wonder, as you never do in Paul's version, if she's ever getting through the door.

4. Beastie Boys, "I'm Down" (1986)

The Beasties intended this for *Licensed to Ill*, except it got censored, because copyright owner Michael Jackson didn't approve of lines like "I keep a loaded pistol inside my pants / Find a def girl and do the new dance." It made the rounds as a bootleg—Rick Rubin samples the original track,

with each Beastie taking a verse and all three singing spec-
tacularly badly: *I'm down! Oh yeah I'm down! Because I'm
fully D! I'm Brooklyn down! I'm Gucci down!*

At the time, "I'm Down" was a fairly obscure B-side—
Aerosmith were on the verge of using it as a cred move on their
1987 comeback *Permanent Vacation*, giving it a professional
polish that makes it meaningless. (Aerosmith, like the Beas-
ties, owed their commercial stature to the sponsorship of Run-
D.M.C., who famously rapped "There's three of us but we're
not the Beatles" because they counted wrong, which was bad-
ass in itself.) But the Beasties live up to the garage-band van-
dalism of the original, replacing John's inept organ solo with
an even more inept guitar solo, ripping up the Beatles the way
Paul ripped up Little Richard. This was hardly the first time
hip-hop made a claim on the Beatles—but it was the first time
anyone claimed the Beatles were secretly hip-hop all along.

5. David Bowie, "Young Americans" (1974)

A lament for the Seventies kids the Beatles left behind—they
don't have the band to unite them anymore, just one another.
When Bowie has the backup girls coo, "I heard the news today,
oh boy," it's already yesterday's papers. These kids need their
own teenage news, and they need Bowie to carry it to them.
All the Beatles had a Bowie fixation in the Seventies; even
Paul went through a period of wearing platform boots and
spangled jumpsuits, not to mention writing one of the glam-
miest Bowie rips ever, "Jet." "Young Americans" comes from
the year Bowie was obsessively courting Lennon—they wrote
"Fame" together, and John played guitar on Bowie's "Across
the Universe." In John's presence, not even Bowie could play
cool.

6. Ella Fitzgerald, "Ringo Beat" (1964)

A tribute from the elder generation—a jazz grande dame try-ing to get with the times. Ella raves about that cool cat named Ringo, singing "yeah yeah yeah," and offering a bluffer's guide to rock and roll ("It started back with Elvis with his hips and guitar / Chubby Checker got to twistin' and became a star") and warning her peers, "Don't knock the rhythm of the kids today / Remember they're playing the Ringo Way." (The *Bill-board* review said, "Swingin' Fitzgerald takes off on that all too famous beat.") This isn't a case of a jazz artist pressured into a pop novelty, either—she wrote "Ringo Beat" and had to talk her label Verve into releasing it.

Six months before "Ringo Beat," Ella grazed the U.K. charts with a stiff version of "Can't Buy Me Love"—you can hear she's not comfortable. The melody isn't Ella-worthy, to say the least, and while she's too much of a hipster to not be curious about the song, she's wondering what's so special about it. She latches on to the blasé "my friend" as the only hip detail. "Can't Buy Me Love" hardly reflects the Beatles' at-titudes about money or love, both of which they were rolling in, considering they wrote it after a nine-day binge with Mi-ami Beach's finest groupies. As Paul said, "It should have been 'Can Buy Me Love,' actually." But for Ella, it's about being cool enough to breeze your way out of a morning-after scene with an air-kiss and a "my friend." It's the only sentiment in the song she can relate to. She's glad "my friend" is there—in a way, she's why Paul put it there. But when she sings "Ringo Beat," she gives the drummer some.

7. Fiona Apple, "Paper Bag" (1999)

Fiona's finest moment, and though it's all her, it's also the sound of a great Nineties songwriter getting inspired by the Beatles in wildly different ways from how they inspired songwriters in the Eighties. "Paper Bag" isn't a pastiche or an allusion—she plays with those White Album piano chords to tell a new story. She builds on the Beatles the way songwriters couldn't in the Eighties—well, "couldn't" is a strong word, so let's just say "didn't"—because the Beatles were so dangerously overwhelming an influence. "Paper Bag" is the perfect summary of the Beatles' Nineties ascendance—really, the triumph of their music *over* nostalgia. Also, for me this song sounds like the "Norwegian Wood" fling, except from her perspective. She thought he was a man, but he was just a little boy.

8. Kendrick Lamar, "Control" (2013)

His instant-classic battle with Big Sean and Jay Electronica, though there's no doubt Kendrick owns it, rapping about how he's determined to be the best MC ever, wiping all others off the map. When he slips in the line "Blessings to Paul McCartney," it's a startling moment, but he means it. "You called me a black Beatle, I'm either that or Marley." (Rapper Danny Brown claimed that if Kendrick is McCartney, he's Harry Nilsson, which is truly next-school.) Many artists have aspired to be the Black Beatles, from Rae Sremmurd to Lionel Richie, who described the Commodores this way a couple of years ago on *The Voice*. But Kendrick is the first rapper who compares himself to Paul McCartney in order to *scare* you.

9. The Muppets, "Exit" (1974)

Sesame Street did lots of Beatle tributes—"Letter B," "Hey Food"—but this one is truly disturbing. A long-haired Muppet rock star named Little Chrissy sits at the piano, doing a Lennon-style ballad that teaches you how to read an EXIT sign. There's a *Plastic Ono Band* feel to the piano and the morose vocals. He sings, "You don't have to stay there, you know you can split / Just get up and walk right out that good old exit." The Muppets in the audience take his advice; one by one they get up to leave. Cookie Monster walks out. Grover walks out. Bert and Guy Smiley leave together. (Condolences, Ernie.) The whole band exits. By the final verse, everybody's walked out on Little Chrissy. He wails, "Exit is the way out, way way out," until he looks up and realizes he's the only one left. But he can't find the exit.

"Exit," written by longtime *Sesame Street* songwriter Christopher Cerf, resembles his John Lennon parody for *National Lampoon*'s *Radio Dinner* album, "Magical Misery Tour." But it's even darker. In all the years between my childhood and the invention of YouTube, I never got over it. We know John spent the Seventies watching *Sesame Street*—he quotes Cookie Monster on *Plastic Ono Band*, in the song "Hold On," and sings about watching it with Sean in "I'm Steppin' Out." But did he ever hear "Exit"? And did it remind him of anyone? It's uncannily like the story John told in May 1970, right after Paul quit. "The cartoon is this: four guys on a stage with a spotlight on them; second picture, three guys on stage breezing out of the spotlight; third picture, one guy standing there, shouting, 'I'm leaving.' " But it's hard to leave when you can't find the door.

10. Sylvester, "Blackbird" (1979)

One of the great Seventies disco queens (the first gay black pop star who was out of the closet, as far as the rest of the music world knew) does a virtually unrecognizable "Blackbird" on *Living Proof*, one of my favorite live albums ever. I first heard it in 1988, when I was trading tapes with my disco-scholar co-worker Peter, just a few months before Sylvester died of AIDS. In the album, Sylvester's back on his home turf, San Francisco, to celebrate after breaking big nationwide. He dedicates Billie Holiday's "Lover Man, Where Can You Be" to "my lover, who's here tonight." It's a warm and benevolent performance—he tells the roadies, "Shine the light on the folks, honey, I wanna see them"—and sings "You Are My Friend" to his backup singers Martha Wash and Izora Rhodes, the Two Tons of Fun (later the Weather Girls). Sylvester sings "Blackbird" as a falsetto-disco anthem for himself and his gay audience and San Francisco in 1979—this is their moment, they're not hiding anymore, they're taking flight. This song was always meant for them to take it over and make it theirs. "You were only waiting for this moment to arise," he tells the crowd. The moment was too good to last.

11. Prince, "While My Guitar Gently Weeps" (2004)

Prince played this the night he was inducted into the Rock & Roll Hall of Fame, as part of an all-star tribute to George Harrison. For the first few minutes, it's just a well-intentioned snooze: Tom Petty and Jeff Lynne sing, Dhani Harrison plays acoustic guitar, everyone reverently imitates the original. Then Prince jumps in and takes over: for the next three minutes, he makes his guitar shed tears of purple rain. He tumbles

into the audience; a bodyguard lifts him back up; he doesn't stop playing. You can hear echoes of all the bands who turned this riff into hard rock (Led Zeppelin with "Babe I'm Gonna Leave You," Chicago with "25 or 6 to 4," David Bowie with "Moonage Daydream," etc.) but none of them got *this* heavy. Then he stops playing, tosses his guitar in the air (did it come back down? no sign of it), and does the world's coolest pimp strut off the stage, as the other musicians stand there looking stunned. What just happened? Prince just happened. This is what it sounds like when guitars weep. George got his due that night.

12. Stars on 45, "Stars on 45 Medley" (1981)

The old-school hippie Beatle fans must have thought the game was up this time—a worldwide Number One smash, a Euro-cheese disco medley from a team of anonymous Dutch studio hacks, covering Beatle songs both well-known ("We Can Work It Out," "Drive My Car") and not ("No Reply," "I'll Be Back") along with two songs that aren't even by the Beatles (the Archies' "Sugar Sugar" and Shocking Blue's "Venus"), ending with a choir of alien castrati chanting, "Those stars on 45 keep on turning in your mind! Saying 'We Can Work It Out'! Remember 'Twist and Shout'!" In its way, "Stars on 45" was as avant-garde as "Revolution 9," an admirably tacky pop scam (except never actually all that fun to listen to) that came out within weeks of John Lennon's death, increasing the sacrilege factor. But within a year, it was utterly forgotten. "No Reply" and "I'll Be Back" turned back into deep cuts; it's strange to think either was part of a Number One hit.

Figuring "if you can't beat 'em, come together," Capitol responded to Stars on 45 with "The Beatles Movie Medley"

in 1982, their knockoff of a knockoff. They used the original recordings, yet somehow that gave it less artistic integrity than Stars on 45. "Movie Medley" was promoting *Reel Music*, a barrel-bottom compilation of songs in Beatle movies, including the movies (like *Let It Be* and *Magical Mystery Tour*) they still refused to make available to fans in any way. "Movie Medley" duplicated one song from "Stars on 45" ("I Should Have Known Better") along with "Get Back," "Ticket to Ride," "A Hard Day's Night," and "You've Got to Hide Your Love Away." Guess you couldn't blame Capitol for trying. But "Movie Medley" missed the Top Ten, peaking at Number Twelve, making it an official flop—a clear-cut rejection from a pop audience who considered "Stars on 45" a more crass and therefore more authentic Beatle rip.

13. The Chemical Brothers, "Setting Sun" (1996)

Everybody's favorite song in the fall of 1996, uniting rockers, ravers, clubbers, druggers, all factions of the pop massive. The Chemical Brothers turn "Tomorrow Never Knows" into a banging techno loop, warping Ringo's block-rocking beats into something new. "Setting Sun" is unaccountably obscure these days, considering what a fact of life it was for a year or so, but it's a song that accurately predicted the future. There was nothing retro about it; instead of capitulating to the past, the Chemicals complimented it enough to ransack it. In this song, the Beatles aren't legends or saints or icons—they're a nasty drum break. The vocals were by Oasis's Noel Gallagher, then Britannia's biggest rock star, yet he sounded more antique than Ringo's drums did. It was the ultimate Nineties statement of the Beatles as a right-now thing as opposed to a good-old-days thing.

14. T. Rex, "Ballrooms of Mars" (1972)

The glam-rock starchild Marc Bolan does the kind of Lennon ballad that Lennon was no longer writing in 1972, not because he'd lost the knack but because it seemed so easy to him it wasn't worth doing. The biggest compliment Marc Bolan can offer the girl in this song is, "John Lennon knows your name and I've seen him." He also name-drops Bob Dylan and Alan Freed, just a fanboy arranging his pinup diamonds in the sky. "Ballrooms of Mars" is one of my wife's favorite songs of all time, so I hear it several times a week.

15. Nancy Sinatra, "Run for Your Life" (1966)

"You know that I'm a wicked chick and I was born with a jealous mind," Nancy coos, until you can see the blood on her go-go boots. If any John song demanded to be gender-pretzeled, it was this one; Nancy turns it into a gangsta classic. While John sang "Run for Your Life" as a joke, his voice full of weariness he's trying to shake off, she takes it at face value—she really *would* rather see her little boy dead than with another girl, and there's a mobbed-up edge to the way she promises she knows how to get the job done. "I loved turning this song around," Nancy once told *Mojo*. "It was important for my whole Nasty Jones persona. 'Run for Your Life' just let me stay right in character." Hide your head in the sand, baby boy.

16. The Isley Brothers, "This Old Heart of Mine (Is Weak for You)" (1966)

The Isley Brothers influenced the Beatles, especially their version of "Twist and Shout." But they steal some magic back

in this Motown hit—a case of the Beatles inspiring the artists who inspired them. The Isleys steal the Beatle trick of the head-to-head falsetto "oooooo!" into the chorus, alternating the girlie squeals with the manly unison bass when they yell, "Darling I'm! Weak for you! Darling I'm! *Maaaad* about you!" The "ooooo!" squeals are so funny, this might have even started out as a parody. (Richard Price wrote about a 1964 Motown package tour where the Spinners did a comedy interlude in wigs as the "Brown Beatles.") Ernie Isley watched the Beatles on *The Ed Sullivan Show* at the family home in New Jersey. Sitting next to him was the group's new guitarist, a twenty-one-year-old named Jimi Hendrix. A few years later, Jimi would open his London concert with "Sgt. Pepper's Lonely Hearts Club Band," two days after the album came out, with Paul and George in the audience.

17. Weird Al Yankovic, "This Song Is Just Six Words Long" (1988)

One of the only Weird Al parodies where the joke is how much he despises the original. If you're under forty, you're lucky in that you've possibly never heard George's huge 1987 comeback hit, "Got My Mind Set on You." Words cannot describe its wretchedness. The video forces George to sit in an armchair, lip-synching by the fireplace. Then his body double gets up to dance. It lingered at Number One for weeks. Weird Al pays tribute by chanting the endlessly repeated headache of a chorus—"This song is just six words long! This song is just six words long!" Which is seven words long.

You really have to love George to hate one of his songs this much.

18. The Bangles, "Dover Beach" (1984)

The sound of mod California miniskirt girls who love the Beatles, strumming their Rickenbackers and crushing out over boys with unruly bangs. To listen to "Dover Beach" is to fall for a tambourine girl who will discard you for not being George. The Bangles epitomize the Seventies/Eighties wave of American fans—when *Rolling Stone* did its 2003 poll asking artists their favorite albums of all time, Susanna Hoffs's Number One was *Yesterday and Today*, a much cooler pick than any of the U.K. originals could have been. On MTV's indie showcase *The Cutting Edge* in 1985, the Bangles proved how punk they were by singing "All Together Now" in the back of the van. (The Bangles were also fascinating to me because I was a boy, and they epitomized the kind of Beatle fan I wished I were listening to Beatle records with.)

I love how the Bangles took their fandom to the logical extreme with their Number One hit "Eternal Flame," goop heaven, just piling it on, repeating that first verse over and over. And in response to Susanna Hoffs's questions: (1) yes, I feel your heart beating; (2) totally understand; (3) same; (4) not dreaming; (5) eternal. So eternal.

19. Lifter Puller, "Nassau Coliseum" (1997)

Craig Finn (later to form the Hold Steady) in one of his funniest songs, the plaint of a run-of-the-mill indie loser dude caught in a cop riot at a Grateful Dead show on Long Island, pissed that his girl took off with a hippie who had better drugs. "I've got a feeling like I'm in the Beatles / Bigger than Jesus, I'm getting shot at," he sings in his Minnesota holler, as if feeling like a Beatle is the loneliest fate he can imagine. It means

feeling chased down the street, cornered by mobs, spied on, trapped. And never getting that girl back. The paranoia in this song always makes me think of a Beatle press conference from their U.S. tour, in September 1964. A reporter asks, "Are you scared when crowds scream at you?" John cracks, "More so here than other places, perhaps." The city where he says this is Dallas.

20. Bob Dylan, "4th Time Around" (1966)

Right after *Rubber Soul* dropped, Bob Dylan recorded *Blonde on Blonde*, where he sang this scorchingly funny parody of "Norwegian Wood." Dylan unkindly played "4th Time Around" for John in London. As Lennon recalled in 1968, "He said, 'What do you think?' I said, 'I don't like it.' " Yeah, well—talk about the anxiety of influence. All over *Blonde on Blonde*, you can hear how hard Dylan was feeling *Rubber Soul*—especially in songs like "I Want You," "Just Like a Woman," and "Sad-Eyed Lady of the Lowlands." So he probably wrote "4th Time Around" as a diversion to keep people from noticing how much "Norwegian Wood" there was in "Visions of Johanna."

21. Bauhaus, "Who Killed Mister Moonlight?" (1983)

The goth community claims John Lennon as one of its own. "Mr. Moonlight" is indeed one of the Fabs' creepiest moments—it might sound like an English music-hall chestnut, but it's an obscure 1962 B-side from Georgia bluesman Piano Red. Of all the first-take covers on *Beatles for Sale*, "Mr. Moonlight" was the one track they put time and effort into, transforming it into a lurid dirge with a tastelessly mor-

bid Hammond organ solo. The Beatles never explained why they cared about "Mr. Moonlight" so much, but for Bauhaus, it's just proof that John was a child of the night.

22. Billy Joel, "Scandinavian Skies" (1982)

B.J. pays tribute to solo Paul and solo John in the same song, as if he's trying to put the band back together. It says something about the mind-altering effects of the Beatles that they could inspire even Billy Joel to get psychedelic.

23. Harry Nilsson, "Don't Forget Me" (1974)

Like many people, Nilsson convinced himself he was a Beatle, and got burned trying to keep the pace. After they called him their favorite American artist, the beloved singer and songwriter ("Jump into the Fire, "Driving Along," "One") became Lennon's drinking buddy in the L.A. "Lost Weekend" days. They made the album *Pussy Cats* on a bender, with the motto, "Everything is the opposite of what it is." But while John came out on the other side to go back to Yoko and fatherhood and (eventually) more music, Nilsson blew out his voice and never scored another hit. "Don't Forget Me" is his hoarsely gorgeous ballad about how lonely he'll be when John (plus his other reprobate pals, his groupies, his ex-wives) have all gone their separate ways. On *Pussy Cats*, that voice—a ravaged shell of what it had been a few months earlier—croaks out his fears about whether John and the others will remember him: "When we're older and full of cancer / It doesn't matter now, come on get happy." Though never a hit, "Don't Forget Me" became a posthumous signature song in the years after Nilsson's death.

Lennon did remember him, giving him a shout-out in one of his final interviews. ("Everything is the opposite of what it is, isn't it, Harry?") Despite "Don't Forget Me," Harry outlived John by thirteen years. After December 8, 1980, he spent the rest of his life campaigning for handgun control, because he didn't forget.

24. The Rutles, "Cheese and Onions" (1978)

A legend to last a lunchtime. The Rutles were the perfect Beatle parody, starring Monty Python's Eric Idle and the Bonzos' Neil Innes in their classic mock-doc *All You Need Is Cash*, with scene-stealing turns by George Harrison, Mick Jagger, and Paul Simon. (Interviewer: "Did the Rutles influence you at all?" Simon: "No." Interviewer: "Did they influence Art Garfunkel?" Simon: "Who?") "Cheese and Onions" is a psychedelic ersatz Lennon piano ballad so gorgeous, it eventually got bootlegged as a purported Beatle rarity. Innes captures that tone of benignly befuddled pomposity—"I have always thought in the back of my mind / Cheese and onions"—along with the boyish vulnerability that makes it moving. Hell, he even chews gum exactly like John.

The Beatles' psychedelic phase has always been ripe for parody. Witness the 1967 single "The L.S. Bumble Bee," by the genius Brit comedy duo Peter Cook and Dudley Moore, from *Beyond the Fringe* and the BBC series *Not Only . . . But Also*, starring John Lennon in a cameo as a men's room attendant. "The L.S. Bumble Bee" sounds like the ultimate *Pepper* parody—"Freak out, baby, the Bee is coming!"—but it came out months before *Pepper*, as if the comedy team was reeling from *Pet Sounds* and wondering how the Beatles might respond. Cook and Moore are a secret presence in *Pepper*—

when the audience laughs in the theme song, it's taken from a live recording of *Beyond the Fringe*, produced by George Martin.

25. Rae Sremmurd, "Black Beatles" (2016)

The hip-hop duo score a Number One hit with a party anthem about rocking their John Lennon lenses to boast "me and Paul McCartney related"—high on the fame, the money, the sex, the drugs, the excitement of blowing up worldwide with a new beat. No wonder Paul declared himself a fan. Proof, as if any more were needed, that there is no end to the bizarre allure of the Beatles.

26. Ringo Starr, "Early 1970" (1971)

The flip side of his hit "It Don't Come Easy"—here our beloved drummer sings in the voice of a Beatle fan in the immediate aftermath of the breakup. He devotes a verse to John, Paul, and George, describing their separate lives and taking pains to say nice things about their wives. He hopes he'll still get to see them and maybe play drums with them. He slips in a few jokes on himself ("I play guitar, A-D-E / I don't play bass 'cause that's too hard for me") but he has cheery words for his mates, making private jokes and even quoting John quoting Cookie Monster. "Early 1970" starts the long tradition of ex-Beatles writing songs about the band, which nobody else made such a habit. Ringo's just starting to accept the demotion from Beatle to Beatle fan, and he doesn't try to hide that he's scared about it. But the warm humor in his voice offers a clue about how they managed to stay together as long as they did.

"TOMORROW NEVER KNOWS"

(1966)

It's the spring of 1966 and the Beatles are on the move. Paul finds a townhouse in St. John's Wood, after crashing the attic of Jane Asher's parents for two years, and becomes a fixture of the London avant-garde scene. The drugs are getting harder—Paul dabbles in cocaine, John dabbles in acid. George, also having dabbled with LSD, marries Patti Boyd, who he's been living with for a year, and gets serious about playing the sitar, studying Indian music and religion. Ringo starts up a construction business called Bricky Builders.

Rubber Soul is at Number One, but the Beatles already have bigger things on their minds. For the first day of work on their new album, in April 1966, John brings in a tune called "Mark One," based on a book he just found a few days ago, when Paul brought him around to check out the happenings at London's Indica Bookshop. John asks if they have any Nietzsche (pronouncing it "Nitz-gah") and reclines on a suttee with *The Portable Nietzsche*, *The Tibetan Book of the Dead*, and Timothy

Leary's *The Psychedelic Experience*, a how-to guide for acid trips, with the words "Beyond the restless flowing electricity of life is the ultimate reality—The Void." John cribs lines from the book into a one-chord dirge. "Turn off your mind," he sings in the opening line. "Relax and float downstream." John announces he wants his voice to sound like the Dalai Lama chanting to a thousand monks on a mountaintop. "John had complex ideas which he could never organize," George Martin sighs years later. "He couldn't change a lightbulb." Fortunately for history, John is in the studio with a wizard who routinely invents new kinds of lightbulbs on demand, and so George Martin sets out to make the Dalai Lama thing happen. "It was my job to get inside John's brain, to find out what he wanted and deliver it." Martin and the new engineer, a lad of nineteen summers named Geoff Emerick, filter John's voice through a rotating speaker inside a Hammond organ, while Ringo goes absolutely insane on the drums. The Beatles end up naming the track after a Ringo proverb, "Tomorrow Never Knows."

Instead of a guitar solo in the middle, the Beatles want something more ambitious, so Paul decides to put together a "tape solo," and stays up till the wee hours putting loops together at Wimpole Street, bringing the tangled piles of magnetic tape in a plastic shopping bag to Abbey Road the next afternoon. (They don't fit on tape reels.) They want to run all these loops at the same time, live in the studio with all five tape machines rolling, so every available body gets drafted into Studio Two to hold the loose tape aloft at different corners of the room, while John and Paul manipulate the faders. The result screeches like a flock of drug-crazed seagulls. "Tomorrow Never Knows" sounds like nothing they or any other band have ever come up with. It's madly distorted electronic

noise. But it's also rock and roll. It's got special effects *and* soul, enough of both to dazzle the senses. It's got that un-mistakable George drone, that Ringo thump. This is a band, but it's also more—it's "the restless flowing electricity of life." They have officially started work on *Revolver*. They have also officially begun their acid phase.

Paul gets an acetate copy cut so he can take it home, and in early May he makes a point of bringing it to the Mayfair Hotel for a private audience with a visiting American enter-tainer, name of Bob Dylan. He can't wait to lay this on Dylan. Paul beams with pride as the white-label vinyl spins on the portable turntable and Dylan gets an earful of "Tomorrow Never Knows." Dylan snickers behind his shades. (I guess it's possible Bob wasn't wearing shades but I've fantasized this scene so many times and it's tough to picture it any other way.) "Oh, I get it," he says. "You don't want to be cute anymore." Dylan has acetates of his own in his luggage, which he's been blowing minds with on his travels—the first pressings of his new album *Blonde on Blonde*. Anybody else in the rock world—even most of the Beatles—might have been crushed by Dylan's derision, especially if he topped it off with a taste of mind-strangling new material like "Visions of Johanna" or "Stuck Inside of Mobile with the Memphis Blues Again." No-body actually knows whether Dylan put on the *Blonde on Blonde* acetate. As historian Clinton Heylin has said, "If—as is likely—he played McCartney the studio cut of 'Visions of Johanna' that evening, it would have convinced a lesser man than Paul to stop kidding about and join the Foreign Legion."

But for once, Dylan is slightly behind the times. *Rubber Soul* was the one where they didn't want to be cute, and that was six months ago. The Beatles are well beyond the point where their tambourine-man hero wants to pin them. *Rubber*

Soul is also where they took their Dylan worship places he couldn't go himself, and he couldn't hide that it made him quake in his bootheels—there was no way he could fail to take "Girl" as a challenge for him to write his own version, "Just Like a Woman." They're moving too fast for even Dylan to get a bead on them. They're also coasting on a level of super-human confidence epitomized by the way Paul McCartney leaves the hotel with his copy of "Tomorrow Never Knows" and his ego both intact, gleaming with unsquashable enthusiasm for the music he and his mates have recorded in the past month. (For instance: "Taxman," "And Your Bird Can Sing," "Paperback Writer," "Rain," and "Love You To.") He's even more enthusiastic about whatever they might come up with next in the month ahead. (Which turns out to be "Here, There and Everywhere," "For No One," "I Want to Tell You," "Got to Get You into My Life," and "Eleanor Rigby.") He can't wait to get back into Abbey Road with the boys and hear what happens next. The Beatles have become the tomorrow nobody knows.

IT'S A WELL-KNOWN STORY HOW LSD ENTERED THE BEATLE orbit—John and George, along with their wives, got dosed in April 1965 at dinner by their dentist, who slipped it into their coffee without warning them. So many things about this story have always been perplexing. Why were the Beatles dining with their dentist? Do you have dinner with your dentist? No. And the Beatles were busier than you are. (Also, your dentist is probably doing a better job.) They fled the apartment (after he tried to get an orgy going) and drove around London. But it didn't take long for John and George to try the drug again. Ringo eventually tripped with them at

the August 1965 party in Hollywood, the party where Peter Fonda kept saying "I know what it's like to be dead" until John had him thrown out—an experience he turned into one of his first and best acid songs, "She Said She Said."

The Beatles probably numbered among the last people on earth to try LSD without having first heard about it via the Beatles. Within a couple of years, they'd made the drug famous, even if the connection was easy to overestimate. *Sgt. Pepper* might be pegged as the ultimate LSD artifact, but it's really a pot album. Paul, *Sgt. Pepper*'s commanding officer, was no acidhead—he'd tried it only once, without liking it, before the sessions began. The only song he and John wrote for *Pepper* after their first trip together was "With a Little Help from My Friends," hardly its spaciest track. George Martin didn't touch drugs, but he's the one who sequenced the album, without any input from the band or even their physical presence; he and fellow non-head Geoff Emerick did the stereo mix that inspired so many headphone visions. Acid is probably why John's a muted presence on the album; it distracted him more than it inspired him. His fellow initiate Harrison barely appears beyond his solo track; Ringo spent most of the sessions learning to play chess with the roadies, waiting until he got called in for a drum part.

The *Sgt. Pepper* sessions were also the only time any of them tripped in the studio—John, of course, the night they were doing vocal overdubs for "Getting Better." It was an accident—he thought he was taking speed, until he started feeling loopy. Mr. Martin, not suspecting a thing, sent him up to the roof for some fresh air. "He's looking at the stars," he told the others. Paul and George, figuring out what was wrong, rushed up and grabbed him before he took flight eight miles high over Abbey Road. Then Paul took John home to babysit

him and decided he too would drop some acid, so he could understand what John was going through. Paul was the last holdout, although—typically—he started acting like the whole lysergic thing was his personal discovery, around the time he became the first Beatle to announce (without consulting the others) that LSD was where it was at.

You could make a case that acid was the worst thing that ever happened to psychedelia, at least as far as music is concerned. Everything adventurous about hippie rock probably would have happened on pot if acid had never been invented, and obviously too many of the musicians switched on by pot got burned by the harder stuff. John could have been a casualty; he later estimated, "I must have taken a thousand trips." He had to quit because of the bad trips, though by the time the band broke up, John had gotten strung out on heroin, while Paul went back to cannabis with a vengeance, to the point where the BBC banned his 1972 single "Hi, Hi, Hi," which Paul insisted with a straight face was about "a natural high." During the years when he still indulged, Paul was to weed what Winston Churchill was to alcohol—his body chemistry was designed to flourish on a daily intake that would turn anyone else into a turnip.

The Beatles' drug experience will always be part of their story that's blocked off to me. My acid expertise is zero—my college friends and housemates who were into psychedelics agreed I was way too melodramatic and jittery for that sort of thing. Because they were wise and kindly hippie souls, they refused to invite me on their magic swirling ship. (A few offered to babysit me if I did want to try, but that was more like a warning.) Even my most gratefully dedicated friends could spot my psyche across the room as a fragile little eggshell that wouldn't hold up to a heavy drug experience. John Lennon

himself would have taken a look in my eyes and said, "I'd love to turn you on, but I won't, at least not until after a barrel of tricyclic antidepressants and several years' worth of the therapy you so clearly need."

Which, to his credit, John Lennon *did* say. He probably wasn't the first rock star to go to shrinks, but he was surely the first to talk about it and even boast about it, in his Primal Scream phase, as if therapy was just part of his artistic awesomeness arc. How many people's lives have been changed (however indirectly) by such a minor footnote of his life story? The way John talked about psychotherapy was so unprecedented—yet that's not even one of the top thousand things he's most renowned for. At any rate, my bright-college-years drug turned out to be nortriptylene, a tricyclic antidepressant that turned down the volume on my brain static and permanently opened up my horizons, though nobody will ever write a cool song about it.

My straightedge teen self idolized the Clash for their moral rigor, so I assumed they looked down on bourgeois intoxicants like pot ("Janie Jones") or cocaine ("Koka Kola") or worse ("Hateful"). I never dreamed the Clash might have their own drug habits until after they split up. I read an interview where Joe Strummer accused Mick Jones of living in "a marijuana-induced fairyland"; Strummer himself boasted that he quit ganja six months earlier. I remember reading that in the paper, walking out into my folks' back porch and staring vacantly into the sky, processing that bombshell. That was me—a Clash fan who played all six sides of *Sandinista!* without once imagining that drugs were involved. Yes, even the dub loop of sheep bleating. I remained capable of being shocked well into my thirties, when I saw tabloid photos of Jones blowing rails with Kate Moss and Pete Doherty. I identified with Morrissey

when he sang, "I never even knew what drugs were." I would have been scandalized to learn Morrissey was known to guzzle red wine to the point of falling offstage, while the other three Smiths were fond of various substances as well. Honey pie, you're not safe here.

But during all the time I spent sipping blackberry tea and reading Walter Pater's *Studies in the Renaissance* while my friends down the hall were tripping their eyebrows off, I did learn drugs had an awful lot to do with the music I loved. As my edge got bent, I ended up liking cannabis in my early twenties—for a few months I had my own stash, a parting gift from a friend's ex-girlfriend when they broke up, which was just to make him mad (though he ended up smoking much of it). I'd smoke on the back porch, reading John Ashbery and listening to Al Green or the Stylistics. I finally emptied the baggie in one all-night blowout, playing the Jungle Brothers' hip-hop opus *Done by the Forces of Nature* on my Walkman, then I was done. The last time I smoked was in the Nineties, while visiting New York to interview one of my favorite British bands, some of whose members invited me back to their hotel. When they found out I lived in Virginia, they wanted to ask millions of questions about the climate there, since (like everyone else in the Nineties) they were obsessed with Timbaland, Missy Elliott, and Teddy Riley. If I'd used my brain for a minute, I would have realized these guys had much better herb than my pitiful lungs had ever seen. While the roadies wedged towels under the door, the band rolled it up in a cigar, so we could discuss the legacy of Jimi Hendrix and the genius of Aaliyah with *The Long Good Friday* muted on the TV. The second puff made me a happy man. The third puff made me think, "Oh sweet holy mother of the saints and stars and all the ships at sea, I need to get back to my hotel across town,

while I still remember what a hotel is," so I excused myself clumsily (shivering in a Phat Farm '99 hoodie my hosts had kindly supplied me with) and a few "nice one, mates" later was somersaulting down the stairs to a cab, attempting to blink both eyes in unison. I spent the rest of the night on the floor of my Gramercy Park Hotel bathroom, hyperventilating into a wicker basket and promising myself and any eavesdropping deities that if I survived this motorpsycho nightmare, I would never smoke again, and while I do not regard promises made under such duress as binding, I have postponed further drug experimentation until my eightieth birthday, when I look forward to throwing caution to the wind and gambling whatever marbles remain unto me with any hallucinogens I can get my withered fingers on. I still have the Phat Farm '99 hoodie. I wear it whenever I need to remind myself I'm an idiot.

But I recently discovered that I consumed marijuana at the age of eight, at my First Holy Communion. I heard this story just a few years ago, from one of my groovy older second cousins, who I idolized. She told the tale at a family picnic. "I used to smoke a lot of pot in the Seventies," Tammy confessed somewhat unnecessarily. She baked herself a batch of magic brownies one afternoon, when her mom walked in and said, "Hurry and get dressed for your cousin's First Communion. Oh, good—we can bring brownies." Tammy could not talk her way out of this pickle, already being quite stoned, so instead of confessing what was in these chocolate-y treats, she decided to eat as many as possible herself, before the guests got to them, but since it was my party and I had first crack at the dessert table, she saw me munch at least three. I remember my first communion well—it's a big deal for Irish Catholic kids, and my Uncle Eddie was the priest administering the sacrament—and I was in giddy spirits before the ceremony even

began, so I can only guess what I was like afterward when I started in on the desserts. (I have never in my life stopped at three brownies, no matter what's in them.) My cousin was a little hesitant sharing this story, but I laughed and said, "Oh, the varieties of religious experience." All I asked was that she not tell my mom, but then her mom told my mom, so the cat's out of the bag now. This incident might have something to do with the fact that religion became my teen drug of choice.

Given John's state of mind in the Sixties, it's no surprise that so many of his drug songs are also about depression. "Lucy in the Sky with Diamonds" isn't that hard to decipher—you look for a dream girl, catch a glimpse of her, and she's gone. (Thump. Thump. Thump.) As with so many other songs on *Sgt. Pepper*, the vocals are so downbeat, it's hard to see how anyone ever listened and said, "Man, this drug thing sounds like a hoot. I'll have what they're having." As a kid, I felt foolish to learn that the initials stood for LSD, even though that wasn't how John meant it. As he told *Rolling Stone* in 1970, " 'Lucy in the Sky with Diamonds' which I swear to God or swear to Mao, or anybody you like, I had no idea spelled L.S.D." The inspiration was a picture that his four-year-old son Julian drew of Lucy O'Donnell, the girl who sat next to him at nursery school. "He had sketched in some stars in the sky and called it 'Lucy in the Sky with Diamonds.' Simple." When Julian began his own music career in the mid-Eighties, nearly every interviewer brought up this incident, and he backed up his dad's story, remembering both Lucy and the drawing (though he confessed he didn't remember Paul singing "Hey Jude" to him, so it's not like he was co-signing any old scrap of Beatle lore). Over the years, many Beatle associates have claimed they were there in John's kitchen the day Julian brought that picture home, to the point where John's

kitchen would have had to be the size of a palace to hold them all. Even after the original drawing was published, some fans claimed John was lying and the drawing must be a fake because no four-year-old could have done it. That's right—the Beatles have Lucy truthers.

Sadly, the real-life Lucy died of lupus in 2009, aged only forty-six. Julian Lennon paid tribute with a benefit single, "Lucy," and auctioned off the original drawing for lupus research. When she bragged to her teen friends she was the girl in the song, they laughed at her—didn't she know it was about LSD? "I was too embarrassed to tell them that I didn't know what LSD was." That's why I identify with Lucy, because I don't really know either, and for me it stands in for all the Beatle experiences that are beyond my ability to understand. Not necessarily stoned, but beautiful.

REVOLVER

(1966)

1966: the most manic of the Beatlemania years. The lads get chased around the world, playing twenty-five-minute sets that have nothing to do with the increasingly complex music they're exploring in the studio. A long-forgotten John quote about religion—"we're more popular than Jesus now"—gets dug up and creates a scandal in America. A Ku Klux Klan protest outside their Memphis show draws eight thousand people. The butcher cover gets censored. Murder threats. Harder drugs. Uglier mobs. Dreadful flights. And in their spare time, the Beatles make the greatest rock album ever, *Revolver*.

The moptops are gone, yet they decide not to return to the *Rubber Soul* sound, either. Not many acoustic guitars on *Revolver*; not many love songs, either. The album's distinctive sonic flourish is that abrasive electric rush—"Taxman," "She Said She Said," "Tomorrow Never Knows"—yet there's also more piano than ever, their first horn section, attempts at raga,

chamber music, R&B, whatever pops into their expanding heads. *Rubber Soul* had come as a surprise to them—crashing it out in a few weeks for Christmas, the Beatles stumbled into a revelation of how far they could travel over the course of a full-length LP. *Revolver* marks the first time they set out to make a masterpiece on purpose, arrogant bastards sure that any idea they try will turn out brilliant. And this time, at least, they're right. A certain insolent serenity has kicked in—in a word, cool. You can see it on their faces in the videos for "Paperback Writer" and "Rain." (Video clips—in case they can no longer spare the time to show up and promote their record in person.) Having dashed off *Rubber Soul* in a few weeks, they have lost any remaining doubts about their ability to summon greatness at will.

Revolver is all about the pleasure of being Beatles, in the period where they still thrived on each other's company. Given the acrimony that took over the band in the last two years, it's easy to overlook how much all four of them loved being Beatles at this point and still saw their prime perk as hanging with the other Beatles. Despite the fact that all doors of society and celebrity were open to them, the Beatles' main human contacts were one another, four lads tuned into some wavelength other people could sense but couldn't share. As John told biographer Hunter Davies, "We have met some new people since we've become famous, but we've never been able to stand them for more than two days."

The whole album gives off the vibe of the studio as a clubhouse, with everyone feeding off one another's ideas. The competition is friendly (at this point) but fierce. John responds to "Yellow Submarine" by leaving Paul a note: "Disgusting!! See me." Paul is getting seriously into the London avant-garde

scene, or at least he's into getting high with these guys who are friends with his girlfriend's older brother; they run an art gallery, or maybe it's a bookstore, but they know all this cool shit he's certainly not going to miss out on ("I vaguely mind people knowing anything I don't know" is the way he puts it) and that's that. Paul gives an interview to longtime friend Maureen Cleave for the *Evening Standard*: "I'm trying to cram everything in, all the things I've missed. People are saying things and painting things and writing things and composing things that are great, and I must know what people are doing." She reports, "He is most anxious to write electronic music himself, lacks only the machines." That might not even have been a joke.

There's an endearing hubris all through the music—captured perfectly in the eight-second guitar break that cuts in at the end of "Got to Get You into My Life," flipping it into a whole new song, or the dizzying guitar frills in "And Your Bird Can Sing," or the finger-snap that comes out of nowhere to punctuate the final "love never dies" at the end of "Here, There and Everywhere." Every track is packed with these details: I must have heard "And Your Bird Can Sing" thirty or forty thousand times before I noticed the girl-group handclaps that sneak in for the middle guitar break, and then just as mysteriously vanish. You can hear that hubris in the band's press conferences from their summer tour, as when a reporter in L.A says, "In a recent article, *Time* magazine put down pop music. They referred to 'Day Tripper' as being about a prostitute and 'Norwegian Wood' as being about a lesbian. And I just wanted to know what your intent was when you wrote it, and what your feeling is about the *Time* magazine criticism of the music that is being written today." Paul replies with a

straight face. "We're just trying to write songs about prostitutes and lesbians, that's all."

Arrogance like that doesn't happen often, but without it, an achievement like *Revolver* would be unthinkable. George Martin brought their craziest ideas to life—as he put it, "I've changed from being the gaffer to four Herberts from Liverpool to what I am now, clinging on to the last vestiges of recording power." One of the most important sonic innovations on *Revolver* was a sweater—Geoff Emerick stuffed Ringo's wool sweater into his bass drum, giving Ringo's drums that distinctive *thwomp* everybody else spent years trying to copy. Never having tried a substance harder than lager, Emerick became the kid who made the magic happen, in the white-coat sterility of the EMI studios "He was always experimenting and the bosses at EMI didn't like it," Martin said. "He got severely reprimanded when they found him putting a microphone in a pail full of water to see what the effect was." The Beatles got everyone in Abbey Road thinking along the lines of improv—never saying "no," responding to every idea with "yes, and . . ."

That call and response was going on all over the world; 1966 was a watershed year for rock LPs: it was the year of the Stones' *Aftermath* and the Kinks' *Face to Face* in London, Bob Dylan's *Blonde on Blonde* in New York, the Beach Boys' *Pet Sounds* in L.A., Otis Redding's *Dictionary of Soul* in Memphis. It was also the year of the Byrds' *Fifth Dimension* and the Who's *A Quick One*, Donovan's *Sunshine Superman* and the Yardbirds' *Roger the Engineer* and Martha & the Vandellas' *Watchout!* plus the Fugs and the Miracles and the Monkees. The Velvet Underground made their debut album, which sat unreleased for nearly a year, though it reached well-

placed hipsters from David Bowie to Brian Epstein. There was a sense of competition, as these artists set out to top each other.

Paul moved into his new bachelor pad on Cavendish Avenue in St. John's Wood, near Abbey Road; he now had no problem coming into the studio earlier than anyone else and pushing his ideas. His new pad gave him a place to play and write, a place to have his smart new friends over, and a place to entertain the chic and cultured Jane Asher (when she was in town) as well as every other single female in London (when she was out of town). She exposed him to classical music and theater; her brother Peter introduced him to scenesters like the Indica Bookshop's Barry Miles and John Dunbar, reading Robert Crumb comics or the *Evergreen Review*, flipping through the *L.A. Free Press* and *East Village Other*, listening to Ornette Coleman's *Free Jazz* and Albert Ayler's *Spiritual Unity*, which Paul enjoyed playing to annoy George Martin when he came over for dinner. Paul began making primitive tape loops with a pair of reel-to-reel machines. He and his new friends spent stoned hours recording loops they considered avant-garde sound collage; they rarely played them back the next day. *Revolver* comes right out of this heady milieu; when Paul played it for Miles and Dunbar, expecting to wow them, he was put out that their initial reaction was groaning at the silly pun of the title. Dunbar told him the title *Rubber Soul* was "not very cool," either, making Paul even madder.

A more dangerous influence was cocaine, which Paul flirted with heavily that year. Cocaine was so little known at the time, the cops who raided Keith Richards's Redlands mansion in 1967 threw away his stash because they had no idea what it was, while seizing his collection of hotel soaps. Paul's

hookup was the posh art dealer Robert Fraser, who got busted for heroin in that same infamous Redlands raid, around the same time he helped the Beatles select the faces on the *Sgt. Pepper* cover. Fraser dashed around town carrying a pair of test tubes, one filled with pure cocaine and the other coke-and-smack speedballs. (He does everything he can, Doctor Robert.) Paul became quite fond of the contents of the first tube, though he gave it up because he couldn't take the crashing comedowns—"dreadful melancholy," he called it, not the kind of emotion he was used to handling. "You didn't stay high," he complained years later, exasperated at the drug's inefficiency—a very Paul reason to quit.

Meanwhile, John was looking on enviously from his stately suburban home out in Weybridge, bored in his crumbling marriage, lounging in bed or watching TV all day, hiding his inner turmoil behind the flashy wit of "I'm Only Sleeping" or "She Said She Said." His nearest neighbor was Ringo, who lived just around the corner, so he was the one John visited most, usually dropping in unannounced and sitting in his garden. When John wasn't with the band, he'd go two or three days at a time without speaking a word. Once he went off to visit Aunt Mimi and spent four days sitting by himself on her roof, while she fetched him drinks. All the non-Beatles in his life got used to his silence. "I have to see the others to see myself," he told Davies. "I have to see them to establish contact with myself and come down. Sometimes I don't come down." People who weren't Beatles didn't really cut it for him. "Most people don't get through to us."

But when they were together, there was a cocky joy only they could share—John's "And Your Bird Can Sing" influenced by George's new spiritual interests, Paul's "Eleanor Rigby" a reach for John-style gravitas. They weren't neces-

sarily trying to outrage the straight world, just overflowing with a kind of energy that the straight world could only gape at from afar. They loved being Beatles so much they felt pangs of pity for everyone else.

IN MARCH, DAYS BEFORE THE SESSIONS START, THE BEATLES pose for their "butcher cover" photo shoot, posing in blood-stained white smocks with knives, raw meat, and dismembered baby dolls. It seems like a lark to them—when the picture gets plucked out by Capitol as an LP cover (nobody knows quite how that decision happened), they profess themselves surprised at the controversy. Yet it's also a joke they took to out of a tangible weariness with (or hostility toward) the outside world. Their smiles suggest they know full well how shocking this photo is. Even Ringo looks fiendish, and get a load of George's demented grin—he has sadism stamped all over his bloated British kisser. There's an outtake where they look calm and serious, which is somehow even more unnerving. It gets withdrawn as the cover art of *Yesterday and Today*, replaced with the photo where Paul is sitting in a trunk (and where George looks exactly like Keith Richards). That same month, John gripes to Maureen Cleave, "Famous and loaded though I am, I still have to meet soft people." But it's another quote from this interview that comes back to make trouble: "We're more popular than Jesus now. I don't know which will go first—rock and roll or Christianity. Jesus was all right but his disciples were thick and ordinary. It's them twisting it that ruins it for me." The controversy months later, complete with record burnings and murder threats, just confirms the Beatles' no-longer-covert suspicion that people who aren't Beatles are basically dolts.

VERY YOUNG AND NERVOUS-SOUNDING FEMALE REPORTER AT L.A. PRESS CONFERENCE, AUGUST: I'm sure you've all heard of the many Beatle burnings and Beatle bonfires, and I was wondering: Do you think American girls are fickle?

RINGO: All girls are fickle.

THE SESSIONS START IN EARLY APRIL, WITH "TOMORROW Never Knows." They go on to record their bitchiest music ("And Your Bird Can Sing"), their prettiest ("Here, There and Everywhere"), their friendliest ("I Want to Tell You"), their harshest ("She Said She Said"), their jauntiest ("Got to Get You into My Life"), and their jolliest ("Yellow Submarine"). They also knock off another hit single with "Paperback Writer." For the superior B-side "Rain," they come up with a backward-vocal section, an innovation so impressive that John, Paul, and George Martin all claim solo credit for thinking it up (an uncommon three-way contradiction). *Revolver* has the best outtakes of any Beatle album, with different approaches to "And Your Bird Can Sing" and "Got to Get You into My Life" (the first more Byrds, the second more Beach Boys, both on *Anthology* 2) that would have been great on their own (though not as great as the ones they chose for the album).

George contributes three of the highlights—the Quiet One's big breakthrough as a writer. "Love You To" marks his first full-on foray into Indian music, with sitars and tablas played by the North London Asian Music Circle, breaking down his mystic detachment with his splendidly sullen vocals. "I'll make love to you, if you want me to," George informs the

people of Earth. "Taxman" tweaks British politicans by name. ("Mr. Wiiiiilsoooon! Mr. Heath!") George might not have a firm grasp on how taxation works—they tax your car to pay for the street, not the other way around—but there's no arguing with the aggression of the music. "I Want to Tell You" is one of his most underrated gems, with that jangling dissonant piano (played by Paul) to echo the noise in a shy boy's head.

John's songs are the best, but Paul has the funniest line, the wonderfully snide tongue-twister from "Got to Get You into My Life": "If I am true, I'll never leave, and if I do, I know the way there." Paul's songs have a new realism, even the piano ballad "For No One," lamenting "a love that should have lasted years"—a very different sentiment from "mine forevermore." It's the ultimate "you stay home, she goes out" breakup song, in the lineage that runs from "Long Gone Lonesome Blues" to "Hotline Bling." Paul sits in his empty room, replaying her voice in her head, thinking up snappy comebacks for arguments that ended months ago, while she keeps wearing less and going out more. The woman isn't arguing back—she doesn't want in on this conversation at all. When his name comes up in company, she smiles politely because she has nothing negative to say—she doesn't care enough. She remembers his name and that's it.

John sings mostly about tuning out the intrusions of the outside world—please don't spoil his day, he's miles away. "She Said She Said" is one of those songs where the vocals are all George and John—a surprisingly rare but effective vocal duo, from "You've Really Got a Hold on Me" to "You're Gonna Lose That Girl." John never cared for "And Your Bird Can Sing," but it's one of his best songs ever, so caustic and yet also so empathetic. It's a hipster-baiting putdown like the ones Mick Jagger was perfecting on *Aftermath*, an album whose

influence looms large on *Revolver*—they even toyed with the idea of calling it *After Geography*. "And Your Bird Can Sing" has Mick-levels of disdain, yet after John sneers that your whole phony world will come crashing down, he also assures you that he'll be around—the last thing Mick would ever say.

The Beatles come off as a self-sufficient commune, sharing secrets that outsiders will never get, whether that means taking a sip from Doctor Robert's magic cup or pondering the material world. They're so assured in their hipness that it doesn't even occur to them to argue the point, which is how *Revolver* can sound so arrogant yet so suffused with warmth. If you play "And Your Bird Can Sing" or "Love You To" back to back with "Ballad of a Thin Man" or "19th Nervous Breakdown," Dylan and the Stones can sound like sophomores trying a little too hard to impress the seniors. *Revolver* creates that community (Paul: "Abbey Road was somewhere we *loved* to go") as a place we can visit by listening—we crave the Beatles' company, just as they craved it from one another. Even the kiddie song "Yellow Submarine"—just Ringo on his boat, his friends all aboard—makes a candid joke about being Beatles together, blithely aloof from the rest of the human race. Every one of us has all we need. Back in Liverpool, their old stomping ground of the Cavern Club closed, but they weren't there to mourn the occasion and probably had no idea it happened. They were miles away.

"We do need each other a lot," John explained to Davies. "When we used to meet again after an interval we always used to be embarrassed about touching each other. We'd do an elaborate handshake just to hide the embarrassment. Or we did mad dances. Then we got to hugging each other. Now we do the Buddhist bit, arms around. It's just saying hello, that's all." That Beatle bond was at its closest on *Revolver*, and

would remain that way for another year or so, right up until Brian Epstein died. No other album gives such an immediate sensation of hearing them think on their feet together, hearing them communicate so fluently, madly in love with being Beatles. They talked about calling it *Magic Circles*, then went with the pun *Revolver*, but either way the title presents a good idea of how tight the Beatles' revolving circle was, yet how open it remains to anyone who wants to listen—which turned out to be everyone.

LIKE ALL THE PRE-*PEPPER* ALBUMS, *REVOLVER* GOT BUTCH-ered by the U.S. record company, but it bled worse than any of them. Capitol cut three John songs—"And Your Bird Can Sing," "Dr. Robert," "I'm Only Sleeping"—leaving him with only two, fewer than George. To make it more confusing, those three came out in the U.S. six weeks before *Revolver*, on *Yesterday and Today*, the LP with the butcher cover. Nothing wrong with *Yesterday and Today*, which holds up as one of their finest records if you count it as one. But it muted the impact of *Revolver*, which made *Sgt. Pepper* more shocking for U.S. listeners than it should have been. Ever since the 1987 CD release, *Revolver* has climbed in public esteem, earning its reputation as the best album the Beatles ever made, which means the best album by anybody.

Revolver was one of the Eighties' most influential album releases, up there with *Thriller* and *Legend* and *Straight Outta Compton*, up there with *1999* and *Appetite for Destruction* and the *Big Chill* soundtrack. It might sound strange to call *Revolver* an Eighties album, but like *Legend* or *The Big Chill*, it created new ways to access pop history as a living thing. You can trace the whole Britpop explosion of the Nineties

(see Oasis, Pulp, Blur, Radiohead, The Verve, and countless others) to the revisionary experience that went with the 1987 *Revolver* CD. It also begat a more analytical breed of Beatle fan, especially since EMI rolled out the discs in installments, rather than dumping the whole catalog on the market like the Stones did.

The *Revolver* CD ended the era when sophisticated adult fans were supposed to condescend to the moptops. It encouraged the wild notion that the Beatles had always been artists, rather than growing up overnight with the *Pepper* big bang. So it opened people's ears to what the Beatles had been doing all along on albums like *Rubber Soul* or *A Hard Day's Night*. All the conventional wisdom coating these records blew away like a puff of dust. (The *Help!* album has never gotten any boost from this revisionary perspective, which pains me. People still don't like it much. I'm probably just wrong.) But this was a pivotal moment. After decades of adulation, the world found out we had been *underrating* the Beatles. And that's a cultural shock that hasn't worn off.

"STRAWBERRY FIELDS FOREVER"

(1967)

Ozzy Osbourne once explained to *Rolling Stone* why "Strawberry Fields Forever" was his favorite song. His complete statement: "I used to work in a slaughter-house, and across the street was a meat-pie shop, and this was on the radio there all the time."

I love this because it's the least psychedelic thing anybody has ever said about "Strawberry Fields Forever." That's not the scene most of us might picture when we hear the song, but it's exactly the kind of authentically drab English ordinariness that John wanted to both capture and transcend. All the innovation in "Strawberry Fields," all the introspection, this is what it comes down to—lunchtime for Ozzy, a few minutes of escape from Birmingham's most metal slaughterhouse, a pop hit on the radio to buoy him through the afternoon. Let me take you down, indeed.

JOHN WROTE "STRAWBERRY FIELDS FOREVER" WHILE THE Beatles took off three months after the release of *Revolver*. He went to Spain to take a minor role in the film *How I Won the War*, the first time he'd been apart from the others. For him it was supposed to be a first step in terms of establishing an independent identity. "I did try to go my own way after we stopped touring," he said. "I had a few laughs and games of Monopoly on my film, but it didn't work. I didn't meet anyone else I liked."

The whole idea of a sabbatical was a novelty, and they all seized it—Paul immersed himself in the London art underground and composed a movie soundtrack, George went to India for six weeks to study sitar at the feet of Ravi Shankar, Ringo played with film cameras in his garden. John didn't have the same passion for his acting project, but it was something to do, so he cut his hair and wore round granny glasses for *How I Won the War*, directed by Richard Lester, who'd done *A Hard Day's Night* and *Help!* Two months on a set was an isolating experience. John discovered acting is even more tedious when you're not the star, especially if you find out you don't like actors. He strong-armed roadie Neil Aspinall into tagging along to keep him company and play Monopoly, but the only Beatle to visit was Ringo. So he was driven to pick up his guitar and look inside himself. He worked on this song for the entirety of the film shoot, finishing it up one night on the beach at Almeria. At that point it was a folkie ballad, strongly reminiscent of Dylan's "It's All Over Now, Baby Blue."

Off the road for the first time since his teens, without the distractions and temptations of touring, John looked back to his difficult childhood. As he told *Rolling Stone* in 1968, "Strawberry Fields was a place near us that happened to be a

Salvation Army home. But Strawberry Fields—I mean, I have visions of Strawberry Fields . . . Because Strawberry Fields is just anywhere you want to go." Strawberry Field (Lennon added the "s") was a Liverpool orphanage, near where he grew up with Aunt Mimi. He used to climb over the wall and play in the wild gardens around the orphanage—an unusual playground for a boy abandoned by his parents. It was a place he revisited in his mind while he was in Spain, filming a showily unglamorous role—his character Private Gripweed gets shot and killed, turning to the camera for his dying words: "You knew this would happen, didn't you?" He'd entered a volatile phase. Two days after getting back to the U.K., he went to the Indica Gallery and met Yoko Ono.

"Strawberry Fields" was an unusually open song for him—it's hard to imagine he could have written it with the others around—exorcizing the social anxiety he'd made a coy joke about on *Revolver* with "I'm Only Sleeping." However estranged John became in his last two years as a Beatle, at this moment he was the one who got most clingy about the other three and the most dependent on them for his emotional needs. He had no ability or desire to make new friends. The Beatles were the human faces he saw, along with devoted attendants Aspinall and Mal Evans and his Liverpool school chum Pete Shotton. The Moody Blues held a regular Saturday-night house party near Kenwood where he ventured to pick up women, but he'd dropped out of the nightclub scene. He couldn't remember his phone number, screening calls with his just-invented answering machine. Paul and George went out on the town; John seldom talked to anyone, including his wife and son, whom he rarely saw without the television on.

Cynthia had understandable worries about his fixation on

the other three. Hence the remarkable conversation in Hunter Davies's book, between John and Cynthia:

"What I would like is a holiday on our own, without the Beatles. Just John, Julian, and me."

"You what?" said John smiling. "Not even with our Beatle buddies?"

"Yes, John. Don't you remember we were talking about it last week?"

She pressed the idea. He protested, "But it's nice to have your mates around!" She shook her head. "They seem to need you less than you need them."

John didn't dispute the point. He felt lost in Spain without them. "I was never so glad to see the others. Seeing them made me feel normal again." He couldn't just fly off to visit the Haight-Ashbury on the spur of the moment, like George and Patti. As far as he was concerned, hanging around the set confirmed he couldn't relate to people outside the band. "We talk in code to each other as Beatles. We always did that, when we had so many strangers round us on tours. We never really communicated with other people. Now that we don't meet strangers at all, there is no need for any communication. We understand each other. It doesn't matter about the rest."

That was his condition when he wrote "Strawberry Fields"—missing the others, finding it hard to be someone. Aspinall tried to get out of coming, the first time he said no to any Beatle order. But John insisted, so there he was, and so was his chauffeur, Anthony. John was surprised when Anthony gave an interview to the Sunday papers revealing that all the hours he'd spent driving the boss around Spain, John never spoke a word to him. It hadn't occurred to John that was unusual behavior. But the time alone in Spain forced him to confront feelings he usually kept at bay, and the song

that spilled out was so strong, not even he could make light of it or treat it as a joke. The song came out and there it was.

On returning to England, he played it for the band. As engineer Geoff Emerick recalled, "There was a moment of stunned silence, broken by Paul, who in a quiet, respectful tone said simply, 'That is absolutely brilliant.' " They were inspired to start recording it that very night, expanding John's acoustic ballad into a whole new thing. It ends with a fragment of a long jam session where Lennon says "Cranberry sauce" twice, followed by, "Calm down, Ringo." Only one "cranberry sauce" made it into the official version; it took a couple of years for people to speculate he was really saying "I buried Paul." Despite the introverted vocals, it's a true collaboration that showcases all four Beatles, not to mention their wizardly producer and engineer. You can hear them communicate in the "Beatle code" John talked about. He's not even thirty, but he sounds old and weary, confessing his adult male depression in a voice so plain it sounds defenseless—the way he sighs "you know"—as if he's given up hiding it, which in real life he hadn't; he didn't even seem to realize until later how nakedly he exposed himself. The human connection he yearns for is all around him, in Ringo's drums or George's guitar or Paul's keyboards, in the strings and trumpets, yet they seem so alien he can't be sure if they're benign or evil presences. It doesn't matter much to him.

The John who sings "Strawberry Fields" is far from the abrasive loudmouth he'll become with Yoko. This John is adrift, bottling it up as husbands do, not knowing whether it's temporary or permanent, not knowing whether talking about it would help or whether it would blow up his only remaining refuge, the places he hides in his brain. He's still the John who hatches a complicated plan in 1967 for the Beatles to buy

their own island, so the four of them can go off by themselves, untroubled by the outside world. Along with the roadies, of course, and Brian Epstein and Derek Taylor and ah yes, naturally, the wives and kids. Their own private compound. Their own recording studio. Just the four of them, like their pad in the *Help!* film. Sounds like a stoned fantasy, but he's dead serious. John even picks out a Greek island for the purpose, having sent Alastair Taylor from Brian's office to scout real estate in the Mediterranean. The island John chooses is called Leslo, eighty acres, four beaches—perfect. "It'll be fantastic, all on our own on this island," he announces. "There's some little houses which we'll do up and knock together and live sort of communally."

The other Beatles hope this whim will blow over fast. "For Paul this was a nightmare," Marianne Faithfull recalled later. "The last thing Paul wanted was to live on some fucking island."

But in July 1967, all four Beatles really do fly out to Greece, with their wives (except Maureen Starr, who's about to give birth), Julian, Mal, Neil, Alastair Taylor, Jane Asher, and Patti's sixteen-year-old sister Paula. The hanger-on Magic Alex is already there, having played a huge role in encouraging this whole scheme, boasting that his father has some skeevy connection to the fascist military junta. The colonels hope their celebrity guests will improve the regime's image. The Beatles travel via yacht to visit their new island commune, deciding who gets which beach. They look forward to chopping wood and painting. Taylor handles the legal details of buying a Greek island for an English rock group. (Price: ninety thousand pounds.) But after a couple of weeks in the sun, dropping acid and swimming, the novelty wears off. They figure there's

no need to go back. As Paul shrugged, "We went out there and thought, we've done it now."

It was John's idea—but the fact that it went so far proves he wasn't the only Beatle with this fantasy. (The colonels must have been disappointed, but they got a more influential ambassador a year later, when their American friend Spiro Agnew became Richard Nixon's running mate, out of gratitude for certain campaign contributions. Agnew lasted until October 1973, the colonels until July 1974, Nixon until a couple of weeks after that.) Less than a month after the Greek adventure, the Beatles met the Maharishi Mahesh Yogi, who turned out to be the island they were looking for, the big unifying all-together-now project, with all four hopping the train to his Bangor, Wales, retreat the day after meeting him. But that was the weekend Brian Epstein died and everything changed. Within nine months, John was a completely different person, in love with Yoko and out of love—permanently—with the band. "Strawberry Fields" was his good-bye to his old self, which meant his good-bye to the boys.

Leslo isn't the only island John bought in this phase. He closed on a tiny Irish rock of thirty acres, off the coast of County Mayo; he visited once and never went back. "No, I can't remember where," he said in 1967. "Just somewhere off Ireland." Dorinish, it's called. But moving to an island involved more manual and emotional labor than he was prepared to follow through on. He needed a hideaway closer to home. The refuge he found was this song, an ode to the barricaded zone in his brain, where he'd curled up in a depressive stupor, resigned to a lifelong siege. As his namesake Winston Churchill said the year he was born, in words he would have grown up knowing well, "We shall defend our island." "Strawberry

Fields" is his fantasy of retreating to a place where he belongs. A place where no one gets in his tree.

"STRAWBERRY FIELDS" WAS THE FIRST TRACK CUT DURING what became the *Sgt. Pepper* sessions, but the record company rushed it out as a single in February 1967. The flip side was McCartney's "Penny Lane," another childhood memory of another Liverpool landmark, which he'd gotten inspired to write by hearing "Strawberry Fields." Both songs were instant classics, and prime examples of how far these two songwriters could go by trying to top one another.

Paul wasn't planning to write about Liverpool—until he heard "Strawberry Fields" and it lit up his competitive edge. These memories were something he and his dearest friend still shared—Paul remembered Strawberry Field, and he knew John well enough to know what it meant to him. "It was a little hideaway for him where he could maybe have a smoke, live in his dreams a little." But he also knew what Penny Lane meant to John—that was the street where he lived with his mother, Julia, before she left him. Strawberry Field was down the road from his auntie's house—the place he'd go to contemplate his exile from the home he'd known on Penny Lane.

These twin songs went together as halves of a concept single. Sometimes the Beatle seven-inches formed units like "Help!"/"I'm Down"—John and Paul trading off downitudinous vocals. Other times the flip sides were mismatched, like "Yellow Submarine"/"Eleanor Rigby"—who'd be in the mood to play them back to back? But "Strawberry Fields" and "Penny Lane" are their most famous A/B combo, linked together forever though it's been decades since they've existed in that form. They play off each other as a John/Paul dialogue.

"Penny Lane" is about walking down a street you've known all your life, but seeing it with new eyes. It's the most Brian Wilson thing he ever recorded—more than any track on *Pepper*, it shows how much Paul got out of *Pet Sounds*—yet with none of Wilson's melancholy. Instead it's all inquisitive zest. If you keep changing, letting your perspective get altered by time or drugs or a little imagination, you can find new marvels anywhere—the barbershop, the bank, the fire station, the nurse selling poppies—even on a street as ordinary as this one.

"Strawberry Fields" is John dreaming about a place that's all him; "Penny Lane" is a crowd scene that's all everybody else and no Paul. (The narrator is "we," not "I"; that "we see" pops out of the final verse as if he's narrating a documentary or whispering into the pretty nurse's ear.) One night during the sessions, Paul watched a BBC performance of Bach's Brandenburg Concertos, rather fancied the piccolo trumpet, and with his magnificent presumption, had George Martin track down the player and bring him in to play high notes. If John's a Churchill vowing to defend his island, Paul's the slick FDR who represents the tantalizing New World where there are no invaders to fear, nothing to fear but fear itself, until (in Churchill's words) the New World steps forth to the rescue and the liberation of the old.

While Paul does his people-watching on Penny Lane, John is a mile away, hiding in the tall grass of Strawberry Field. His voice is shell-shocked with grief. His childhood has followed him everywhere, leaving him stranded in an adult life where nothing is real. He does not want to be rescued.

THE COVER OF *SGT. PEPPER*

(1967)

March 30, 1967: the Beatles have a photo shoot for the cover of their new album, *Sgt. Pepper*, which they've already decided is going to be the Greatest Album of All Time. That's the concept behind the album, and that's the narrative the outside world has already decided to impose on it. All over the globe, people are eagerly awaiting this album, because it's going to blow their minds. People have already decided the Beatles are right—this *is* the Greatest Album of All Time.

Or at least it will be when the Beatles get around to finishing it. A sticky subject at this point—there's still a song left to do, the Ringo song. After the shoot for the cover, at the Chelsea studio of photographer Michael Cooper, they'll troop back to Abbey Road to pull an all-nighter on "With a Little Help from My Friends." And then they'll have an album. THE album. The Greatest. And the concept demands no less than a cover that sums up Western civilization and

then some, a gallery of the Beatles surrounded by heroes and villains from all over history.

The Beatles stand at the center of a crowd of faces who might look, to the casual observer, like a photo collage, except they're doing it the hard way—the photos have been blown up to life-size cardboard cut-outs. Albert Einstein is there, but you can't see him, because John is blocking him. Same thing with Bette Davis—in the outtakes, you can see her as Elizabeth I in *The Virgin Queen*, except in the final photo she's behind George. The cover is a canon, which is fitting for the album that came to symbolize canon-formation. The album will be famous primarily for being the Greatest Ever, and then it's going to be famous as the album that makes people argue over whether it's really the Greatest or not, which will permanently make it hard for people to put aside their overarching historical narratives and just listen to the fucking music. It's poetic justice that the cover will get even more famous than the songs.

The Beatles let designer Peter Blake select many of the faces along with the American artist Jann Haworth (then Blake's wife) and Robert Fraser, so there's a glut of modern visual artists. The Beatles come to these faces as upwardly mobile autodidacts, not experts. Paul wants Stockhausen and Burroughs; John wants Wilde and Joyce. George's list is all Indian gurus. Ringo says, "Whatever the lads want, that's fine." John wants to add Hitler, just for a laugh. They go so far as to create a Hitler blowup, which can be seen in some of the outtakes, but fortunately they stashed him off in a corner of the room before the shoot. Gandhi's on the cover, but EMI's Sir Joseph Lockwood puts his foot down and airbrushes him out behind a palm leaf—he wants to sell the record in India.

It's a dorm shrine of a photo, loaded with in-jokes only the

Beatles get. There's Stu Sutcliffe, their doomed original bass-
ist. The Beatles haven't forgotten him. John is wearing medals
he borrowed from Pete Best's mom. The doll on the rocking
chair wears a shirt that says, "Welcome the Rolling Stones
Good Guys." There are pot plants, a hookah, a trombone.
John brought in his TV. Wax statues of their earlier moptop
selves from Madame Tussaud's. Bob Dylan. Marilyn Monroe.
Marlon Brando. In the 1980s, I pointed out the faces of Oscar
Wilde and Edgar Allan Poe to my fourteen-year-old cousin
Heather; within a few months she'd read their books, so we
spent Christmas 1988 discussing how Wilde invited Yeats over
for Christmas dinner in 1888, except he made fun of Yeats for
wearing yellow shoes. This conversation happened because of
the Beatles and I know I won't forget it. The Beatles take you
everywhere.

A few important people NOT pictured, even though it
looks like they are: Phil Spector (that's the writer Terry South-
ern in the Spector shades, yet I always think it's Spector), Pete
Townshend (that's Ringo in wax), Paul Weller (that's Victo-
rian aesthete Aubrey Beardsley with the proto-mod hair),
the white-hatted Dallas cop who watched Jack Ruby shoot
Oswald (that's artist Max Miller in the silly hat), the great
modernist poet Mina Loy (just a fictional flapper in a cloche).
James Joyce is blocked, though you can barely spot a corner
of his forehead under Dylan. Timothy Carey, the film noir
tough guy, is hidden behind George, from the scene in Stanley
Kubrick's *The Killing* where he shoots the horse Red Light-
ning. I wish the band had jostled around an inch or two to
make room for Joyce, Einstein, and Bette Davis—yet that's
how canons work. One actor from the Bowery Boys got cut
because he had the gall to demand a fee, erasing his face from
history forever. Hardly any women in the mix, surprisingly,

just a few movie stars, plus fictional pinup girls (a sad waste of space), Snow White and the goddess Lakshmi. Not even the erotic muses they had crushes on—no Brigitte Bardot, no Juliette Greco. On Paul's original pencil sketch for the cover design, Bardot is not only there, she's ten times larger than anyone else. Given the Beatles' Irish roots, it's quizzical that the only English statesman is Sir Robert Peel, who presided over the potato famine.

It's poignant to see Oscar Wilde and Lenny Bruce, since Oscar and Lenny define the opposite extremes of the You Had to Be There factor. Lenny Bruce is the ultimate "you had to be there" artist; Oscar Wilde is the ultimate "no, you didn't" artist. Lenny and Oscar had similar legends: iconoclastic wits, flamboyant rebels, martyrs hounded to an early grave by a society that didn't deserve them. Lenny changed countless lives, for people who are still around and have told me to my face why he mattered. However, it's beyond dispute that he doesn't mean the same to those of us who weren't alive then. There aren't any Lenny Bruce lines people can quote. He didn't leave any famous jokes or books or records behind, just a celebrity presence that his artifacts hint at. If you weren't born yet, you missed your shot. You had to be there.

Oscar Wilde, on the other hand, is far more famous and influential now than he was in his not-exactly-quiet lifetime. You might not have read his great works (the plays, the novel, essays like "The Decay of Lying" or "The Critic as Artist") or not-so-great works (the poetry) but you can quote a Wilde line or recognize one when you hear it. You could probably make up your own. At the Academy Awards a couple of years ago, Benedict Cumberbatch announced, "Oscar Wilde said no good deed goes unpunished," and it was a beautiful moment because (1) Oscar most certainly did *not* say that; (2) he de-

serves the credit anyway because it's pure faux-Wilde; (3) oh, how Oscar would have loved hearing his name roll off the Cumberbitch lips, a century after his death. He translates well. He travels well. (Though he never travels without his diary, because a girl should always have something sensational to read on the train.) Even people who've never read his work have an accurate idea of what it's like, because the superficial perceptions are true. (Oscar would say they're the truest of all.) He's famous because he deserves to be. He's talked about, and you know what's the only thing worse than being talked about.

The Beatles turned out to be an Oscar rather than a Lenny. It's *Sgt. Pepper* itself, the album, that turned out to be more like Lenny. It's the only Beatle album that raises any question of the You Had to Be There factor.

SGT. PEPPER'S LONELY HEARTS CLUB BAND

(1967)

Even before *Sgt. Pepper* came out, people loved to debate whether it would stand the test of time. You can't even begin talking about the music before you make it past the Easter Island–size obstacle of a question history has left in its path: is *Pepper* the Greatest Album of All Time? When it came out on CD in 1987, EMI ran ads proclaiming it "the most important record ever issued on compact disc" and "the Beatles' first great album." But *Sgt. Pepper* was already hailed as their magnum opus before anyone heard it—indeed, before virtually any of the songs were written. The Greatest question is embedded right there in the music. You can't argue the lads didn't plan on making the Greatest Album Ever—that was practically the *only* idea they brought into the studio.

Sgt. Pepper was the first album I ever saw acclaimed as the Greatest. Boston's rock station, WBCN-FM, celebrated its tenth anniversary by counting down the Top 104 albums of all time. For the next 104 nights, they'd play an album in full

at midnight (way past my bedtime). No suspense—they announced the top twenty in the paper. Most were bands I'd never heard of, with names like It's a Beautiful Day or the Joy of Cooking. I was too young to realize this was a freakazoidal account of rock history—It's a Beautiful Day and the Joy of Cooking were obscure even in hippie FM-radio terms, and neither was ever again accused of representing a high-water mark in the art of album-making. The list also had the dauntingly named Chicago Transit Authority, who turned out to be the same band as Chicago—what a letdown. But I was astounded by Number One. It wasn't some occult totem I didn't know, and it wasn't a band too terrifyingly adult for me, like Black Sabbath or the Rolling Stones. Nope, it was the Beatles. I had actually heard this album—silly me, not to recognize that it was their peak, since I didn't think it was half as good as *Meet the Beatles*.

My gut response was that I loved seeing it at the top, partly because they were my favorite band, yet also because it suited the album's grandness. *Sgt. Pepper* feels (and looks) (and sounds) like a special occasion. But what really blew my boyish mind was the revelation there was any such thing as a Greatest Album. As a junkie for charts and lists and countdowns, Casey Kasem and baseball-card stats, a boy who could at any given moment tell you the Number One hit on *American Top 40* and the top five ERA leaders in both leagues, I felt awed to realize there were people out there (adults, even) pondering the artistic achievements of pop music. Since two of my favorite things were the Beatles and making lists, the combo seemed too good to be true. This was the "Bee Girl finds the garden of dancing Bee People" moment in the Blind Melon video of my life.

The Beatles also topped the list in *Bananas* magazine, the

successor to *Dynamite* in terms of schoolroom kiddie mags. "The 10 Greatest Rock and Roll Albums of All Time!!!" was in the 1977 issue that had Starsky (but not Hutch) on the cover. *Bananas* had two lists, one by the editors and the other from a readers' poll. The adults' choice was *Abbey Road*; the kids voted for *Frampton Comes Alive!* (It was the Seventies, after all.) The editors offered hip picks, especially considering the list was aimed at sixth-graders, which gives you an idea of how pervasive these debates were at the time: *Abbey Road* was followed by the Rolling Stones' *Hot Rocks*, Bob Dylan's *Blonde on Blonde*, The Band's *Music from Big Pink*, Stevie Wonder's *Talking Book*, Aretha's *Never Loved a Man*, Van Morrison's *Moondance*, Otis Redding's *Dock of the Bay*, Elvis' *Golden Records*, and *Ray Charles Live*. I felt validated by the Stevie and Elvis picks (*Talking Book* is still my favorite) but also by all the albums I'd never heard of, because they proved this list wasn't watered down to pander to me. These adults took the question seriously and took me seriously. The readers' picks were more populist—in addition to Peter Frampton at Number One, the kids voted for Kiss (*Destroyer* and *Alive!*) plus Elton John (*Goodbye Yellow Brick Road* and *Greatest Hits*). And then there was *Sgt. Pepper*, which hadn't made the grown-ups' list at all. The rest of the kids' picks overlapped with the editors: *Abbey Road*, *Hot Rocks*, Elvis and Stevie. "Looks like we all agree that the Beatles, Elvis, Stevie Wonder, and the Stones have made vast contributions to rock music," the editors noted. "And there's one other thing we can agree on—that practically no two people can agree on a list of the All-Time Great Rock Albums!" That was a valuable lesson in itself.

But *Sgt. Pepper* was the album that got famous for topping those lists, like *Citizen Kane* for films, Muhammad Ali for

boxers, or "Stairway to Heaven" for songs. The comprehensive poll in the 1978 book *Rock Critics' Choice* had *Sgt. Pepper* at the top (along with *Revolver, Rubber Soul,* and *Abbey Road* in the Top Ten). This poll reached me via the second installment of *The Book of Lists*—I pored over the film lists, despite never having seen any of the films, much less sampled any of the Top 9 most popular sex positions. On Labor Day 1978, at my aunt Cathy's house, I sneaked off to find a radio because my 12-year-old self could not miss the thrilling climax of WRKO's countdown of the Top 680 Songs of All Time. "Stairway" was the unsurprising Number One, followed by Fleetwood Mac's "Dreams," the Bee Gees' "Stayin' Alive"— and "Hey Jude," which I'd called in to vote for. (When I told my dad this, he mentioned that he would have voted for Elvis's "Old Shep," so I called the listener line again to vote for that one, too.) You either have the list-geek gene or you don't, and I get why many of my friends roll their eyes at this Top Ten kind of thing—as my old riot-grrrl pal Jeanine used to call it, "boy list language"—but unto myself I must be true, and lists are on my list of the best things in life. As soon as fans began making lists, *Pepper* was there to top them—really, it was *Pepper* that created the lists. The fact that the Kiss and Elton fans of *Bananas* rallied for *Pepper* says a lot about its appeal. It really is the *Kiss Alive!* of psychedelia—what is the *Pepper* theme but a more elegant way of saying "You wanted the best and you got it"?

I will never concede *Pepper*'s greatness over *Rubber Soul* or *Revolver*—but the Sergeant frames the terms of the debate, because *Pepper* made albums matter in this way. Bey's *Lemonade* and *Beyoncé,* Taylor Swift's *Red* and *1989,* Radiohead's *In Rainbows* and *Kid A,* Prince's *Purple Rain* and *Sign O' the Times,* Kanye's *Yeezus* and *My Beautiful Dark Twisted*

Fantasy—these modern classics sound nothing like *Sgt. Pepper*, but the music is juiced by the desire to climb a *Pepper*-size mountain and plant a flag. That's the thing about all that Greatest talk—it can be really inspiring for artists as well as audiences.

There was a backlash against *Sgt. Pepper*, especially after 1987, when the uncut *Revolver* came out in the U.S. and took over as the people's choice. *Pepper* seemed trapped in its reputation, or the reputation of its reputation. (Nobody would argue any other album is a failure *because* it's not the Greatest Ever.) It's a cliché to claim it's overrated, but Robert Christgau has persuasively argued that it's their most *underrated* music, because the commentary gets so distracted by the context. Denouncing *Pepper* became a sign of rock realness, for purists such as Keith Richards ("a mishmash of rubbish") or Bob Dylan ("a very self-indulgent album") or even John Lennon. "With *Sgt. Pepper* we wrapped the chocolates up in nice paper, or wrapped two together," he told a press conference in 1969. "All we had, in fact, was still a box with chocolates." *Pepper* tempts people to overreact to its flaws with a slightly comical sense of hysteria. That's okay. Hysteria is part of what the album's about.

THOUSANDS OF MILES AWAY IN L.A., IN EARLY 1967, BRIAN Wilson was working around the clock in the studio, trying to beat *Pepper* into the shops with *Smile*. One day when Paul McCartney was visiting California, he dropped by the studio, and couldn't help sitting mischievously at the piano to play a new tune for Brian—"She's Leaving Home." Then he smiled and said, "You'd better hurry up." That's the level of anticipation *Pepper* built up while the band was still working

on it. In the weeks before it came out, the English music press was already running thinkpieces asking if *Pepper* was going to ruin music (actual *Melody Maker* headline: "The Danger Facing Pop")—an early example of "hot take" culture.

The arrogance of the album is deeply lovable—the Beatles went into the studio with hardly any tunes, no clever concept, no special ideas, just the presumption that they were about to make history. Now they could work at their own pace; for the first time, they weren't running to catch a plane or hiding in a hotel room. The first day of the sessions in November, hundreds of devotees were already camped outside the studio. The world couldn't wait to hear it, and neither could the Beatles. They had promised themselves a masterpiece, even more than they'd promised it to the world.

Less assured men might have sweated a drop or two under this pressure. The Beatles relished it. They figured it was just a matter of showing up at the studio and waiting for genius to strike. There is no evidence any of them (besides George Martin in a few dark moments) entertained the idea this project might be a letdown. They even discussed plans to turn each song into a movie. "It started with 'Let's get Antonioni to film a track, and let's get Jean-Luc Godard to film a track,' " their press agent Tony Bramwell recalled. "But there was no budget for it." That innovation was left to Beyoncé, fifty years later.

Aside from "A Day in the Life," the words and melodies are skimpier than on *Revolver, Rubber Soul,* or even *Help!* They ran out of songs during the sessions, and had to throw last-minute ideas together, and though they'd been in that situation often before (and would be there again), the writing is more slapdash than usual, with George Martin laying on the special effects to fix Albert Hall–size holes. Keith Richards came up with a perfect explanation for how it sounds:

sheer sexual exhaustion. "Three thousand screaming chicks could just wail you out of the whole place. Just looking at the crowd, you could see them dragging the chicks out, sweating, screaming, convulsing." All those years of screamers took their toll—especially since the Beatles were way ahead of the Stones when it came to on-the-road girlie action. "They talk about us, but the Beatles, those chicks wore those guys out. They stopped touring in 1966—they were done already. They were ready to go to India and shit."

Well argued, Keith. Certainly there's a drop in the hormonal levels. Nobody's getting lucky on this album—even the Ringo song is about toughing it out through a midlife crisis. The Beatles were in the dark, leaving them with the question "What do you see when you turn out the light?" It's a question many of us ask ourselves at turning points, moments when we're forced to start over. *Pepper* has a sense of an event—getting dressed up for a night out, something fancy, the audience bustling in anticipation. Yet the tone is kindly, promising to win you over and treat you special. Even when George announces that we're all a bunch of assholes because we don't share his religious beliefs, he ends the screed with a snippet of the audience laughing at him (which was his idea, and the best moment in the song). There's no elitism—none of the songs are long or difficult to follow. If anything, *Pepper*'s naggingly keen to entertain—it takes pride in not testing your patience. It feels festive, even when the vocals are glum.

For me, the artist who's really nailed this aspect of the album is, of all people, Henry Rollins, the punk warrior of Black Flag. "I thought the Beatles made childrens' records because they were friendly, and their faces were not scary like my father's." I wouldn't have pegged Rollins as a Pepper loyalist, but he makes a heartfelt case. " 'Being for the Benefit

of Mr. Kite' is one of the best songs ever. It always felt like something really fun was gonna happen and you didn't have to be scared. I cannot overexplain to you how much of my life I spent trembling in fear of everything: parents, mother's boyfriends who didn't like kids, father's new wife who hated kids or at least hated this one, other kids in the playground. Records never threw a ball at your head."

I can't agree about "Mr. Kite," but that statement gets the mood of the record beautifully. Another surprising fan: Sterling Morrison of the Velvet Underground, in a 1970 interview reprinted in the Clinton Heylin anthology *All Yesterday's Parties*. Morrison is hilariously abrasive in the interview, skewering all sorts of rock artistes who dare to consider themselves as sophisticated as the Velvets. The interviewer brings up Frank Zappa and his *Pepper* parody, *We're Only in It for the Money*. Morrison is not impressed. "Yes. But let me see him come out with something as good as *Sgt. Pepper*. If he comes out with one song that is as good as any song on *Sgt. Pepper* I can revise my opinion. I can make fun of *Sgt. Pepper*. Anyone can. What Zappa saw in *Sgt. Pepper* was something good which showed real perception and talent, and lacking those attributes himself, he decided to do something else, and make fun of it." The interviewer is taken aback, and defends Zappa for his social realism. "Yes. But *Sgt. Pepper* is still a great album." Maybe Morrison was just sticking up for it to score points against Zappa, but his argument strikes a nerve, especially "I can make fun of *Sgt. Pepper*. Anyone can." Those must have been fighting words in the Warhol Factory scene he came from, where mockery was coin of the realm.

For me it breaks down into three songs I love ("A Day in the Life," "Fixing a Hole," "With a Little Help from My Friends"), five I like (both "Pepper" themes, "Lucy," "Get-

ting Better," "When I'm 64") and five that leave me tempera-
tures ranging from lukewarm to nipple-hardeningly cold. But
I hear it all the time these days, because it's my wife's favor-
ite, and it sounds punchier in mono. That's another reason for
its fluctuating reputation: the *Pepper* that blew minds out in
1967 was mono, but later generations heard it in the diffuse,
watered-down stereo mix, missing details like Paul's scatting
at the end of the "Pepper" reprise. The mono version was the
one the Beatles, Martin, and Emerick spent three weeks mix-
ing. The stereo mix was a quickie afterthought, with none of
the Beatles involved or even present. I never heard *Pepper* in
mono until a couple of years ago, when Duran Duran's John
Taylor cheerfully assured me the reason I didn't like it was
that I'd never heard it, the real thing that is, and kindly sent
me *The Complete Mono Recordings* box, which made me re-
alize, among other things (like the fact that John Taylor is a
gent as well as a serious fucking Beatle geek) that I had indeed
never heard the real *Pepper*, very much to my own loss.

THE FIRST THREE SONGS THEY RECORDED IN THE SESSIONS
were "Strawberry Fields," "Penny Lane," and "When I'm
64"—not a bad start. But Brian Epstein was fretful about
how long they'd gone between singles, so George Martin
said, "I've got these three tracks around. I'll give you the
two great ones." The Feburary single racheted up the antici-
pation. As critic Greil Marcus wrote, "If this extraordinary
music was just a taste of what the Beatles were up to, what
would the album be like?" Yet that left the cupboard bare.
After two months, the Beatles were back to square one with
"When I'm 64"—a good tune, but not the mythic stature
they'd decided to attain. The next song they cut was "A Day

in the Life," which looms over the rest of the album like a monolith. "It's a bit of a *2001*, you know," Lennon told *Rolling Stone* in 1968.

He started writing it at the piano, with the newspaper propped up in front of him for inspiration, reading about the death of a drug buddy named Tara Browne. And there really was a story in the *Daily Mail* about four thousand potholes in the roads of Blackburn, Lancashire. It was a true Lennon-McCartney collaboration, rare by then. "It was a good piece of work between Paul and me," John said in 1968. "I had the 'I read the news today' bit, and it turned Paul on, because now and then we really turn each other on with a bit of song, and he just said 'yeah'— bang bang, like that. It just sort of happened beautifully, and we arranged it and rehearsed it, which we don't often do, the afternoon before." (You have to admire the way John presents the idea of *rehearsing* a song as a radical new breakthrough.)

"A Day in the Life" is overpoweringly heartsick—not a young man's song, but a song by an adult who feels his life is a waste, staring blankly at the people he passes on the street. John sings in his most spectral voice, treated with what he called his "Elvis echo," à la "Heartbreak Hotel." The echo is the substance of the song—all the empty space in the music, as a very few instruments (John's acoustic guitar, Paul's piano) occupy a massive abandoned void, reverberating in the room tone of the brain. They cut the track on January 19, with Ringo's tom-toms as the heartbeat. They used a real alarm clock—Lennon brought it into the studio as a gag, saying it would come in handy for waking up Ringo when he was needed for a drum overdub. For the next step, they brought in an orchestra— the studio full of balloons, party hats, and guests including Mick Jagger, Keith Richards, Marianne Faithfull, and Mike

Nesmith. George Martin had the formally attired orchestra members play from the lowest note on their instrument to the highest. "I said, I don't want you to climax too quickly—as the actress said to the bishop—and that at the various points I'd marked they mustn't be on the same note as the person next to them. They thought I was mad, but they got into it." Two weeks later, the Beatles added the final touch: the piano crash that hangs in the air for nearly a minute. George Martin had every spare piano in the building hauled down to the studio, where five men (John, Paul, Ringo, Martin, and Mal Evans) played the same E-major chord, as Geoff Emerick turned up the mikes to catch every last trace. By the end, the levels were up so high you can hear Ringo's shoe squeak.

I found "She's Leaving Home" unlistenable as a kid—I took the parents' side, still do, and felt threatened by the whole *Dawn: Portrait of a Teenage Runaway/Go Ask Alice* scenario. That song came from another newspaper story, about a posh London seventeen-year-old who disappeared. The real-life Melanie Coe went back home after a week. Pregnant, of course; she had an abortion and went on to a real-estate career after briefly going to Hollywood and dating *Batman* star Burt Ward. The song must have sounded stronger in Brian Wilson's studio, with Paul alone on the piano, because the orchestra spoils it—Paul hired an outside arranger, who delivered the kind of tearjerky goop George Martin always avoided. But there's pathos in the overlapping John/Paul dialogue. In Geoff Emerick's book, he describes them singing in the studio at the same time, facing each other, sitting on stools. Paul speaks for the girl, John for the parents, neither really hearing the other—two men staring at each other, lifelong friends who want to communicate but aren't sure how anymore. "With a Little Help from My Friends" came at the very end, right after

that cover shoot. At dawn, Ringo begged to go home ("I'm knackered!") but the others goaded him into doing his lead vocal right then and there, all three standing around his microphone for moral support.

Now that the album was finished, with a cover to match, it was only a matter of time before the public got to hear it, whereupon everyone decided it was even greater than everyone had already decided it would be. After *Pepper*, every band had to try their own—most comically the Rolling Stones, who responded with a 3-D album cover featuring Mick in a wizard hat. The four Beatle faces were hidden on the cover of *Satanic Majesties*, in response to the "Welcome the Rolling Stones" doll on *Pepper*. Dylan's response was the stripped-down masterpiece *John Wesley Harding*, released the day before Christmas 1967, a reaction against anything ornate or frilly, with a black-and-white cover. (People claimed it was another cover where you could see the Beatles' faces, hidden in the trees, though I've never been able to spot them.)

Sgt. Pepper popularized the idea of the concept album, inspiring many dreary debates about whether that honor really belonged to Frank Sinatra or whoever. But before the Beatles, concept albums were the norm. Blockbuster LPs tended to be soundtracks from shows, like *My Fair Lady* or *South Pacific*, or a comedian's nightclub act, as in the chart-topping LPs of Bob Newhart, Shelley Berman, and Mort Sahl. Twelve-inch records were worth adult money only if they had a unified theme, reproducing a live show from start to finish. What the Beatles had really innovated was the *non*-concept album—the idea that an LP could be a work of art despite not having a plot or characters, despite not duplicating a live event in real time, despite being just a bag of rock and roll songs. If any-

thing, *Sgt. Pepper* was a throwback to the pre-Beatle idea of albums—an Original Cast Recording.

The album always had the aura of a high-prestige format, ever since it had been invented. Disposable pop singers made singles; albums were for loftier occasions. As the publisher of *Billboard* wrote in July 1963, "The general public identifies the 33 as 'good' music, while it classified the 45 with the black leather jacket and motorcycle set." The 33 was the world George Martin came from. As Ringo said, Martin was "very twelve-inch"—in other words, class.

When music first went digital in the early 2000s, people pronounced the death of the album—from now on, à la carte tracks were the thing, which meant long-form albums were obsolete. We were all wrong. Instead, we live in times when the album means more than ever, to both artists and audiences. Nobody has ever framed an album-as-statement more painstakingly than Beyoncé, who made her 2013 masterpiece in complete secret so she could drop it on an unsuspecting world on a Thursday night. She got even more ambitious in 2016 by releasing *Lemonade* on a Saturday night, so fans could share the *Pepper*-like experience of worldwide simultaneous discovery. When Taylor Swift moved from *Speak Now* to *Red* to *1989*, each album marked a new stage in her creative journey. These days artists in every genre take their albums seriously as the way to chart their evolution. More than ever, we're living in the album culture that *Pepper* created.

"IT'S ALL TOO MUCH"

(1967)

My money's on "It's All Too Much" as the great lost Beatles song—the one that deserves to be infinitely more famous than it is, one of the all-time great psychedelic guitar freak-outs. None of the Beatles thought it was anything special. But they were so wrong. It's where they really nailed the *Sgt. Pepper* sound—that combination of acid-rock momentum and quaint brass-band frippery. "It's All Too Much" would have been the second or third best song on *Sgt. Pepper*—but alas, they recorded it in May 1967, just a couple months late. All four ride a solid Ringo groove for eight minutes, and all four sound ferocious. It proves they could jam, even though they couldn't—they just accidentally pulled it off here. Even George, so touchy about not getting his due as a songwriter, didn't regard it as more than a candy-colored trifle. The effusive eight-minute jam got trimmed to six and a half minutes for the *Yellow Submarine* soundtrack album, to fill out a half-assed piece of movie merch. They decided it was

too minor to include on *Magical Mystery Tour*—which means they rated it below "Flying" or "Blue Jay Way."

I got to know this song from *Yellow Submarine*, which has the movie-only "time for me to look at you" verse. George sings his funniest mystic lyrics, with a wry English touch. "Show me that I'm everywhere and get me home for tea," indeed. It opens with that Sonic Youth guitar clang and a bit of John chatter, as Paul lingers on that one-chord bass drone like a monster. The other Beatles join in with their "*tooooo* much! *tooooo* much!" chant. They spent two days making it in the last days of May 1967, in an unfamiliar studio, with Martin and Emerick both absent, in effect producing themselves. The Beatles were in a restless frame of mind, waiting for *Pepper* to drop on June 1. The other songs they recorded that May were silly ones—"All Together Now," "Baby You're a Rich Man," "You Know My Name (Look Up the Number)." "It's All Too Much" might seem silly too, but it rocks, which the Beatles weren't much interested in doing in 1967, a chance to hear all four Beatles concentrating on a single idea for a stretch of time. They show off individually (at any moment, you can pick out what any particular Beatle is doing) yet slip into the collective groove.

It's a psychedelic love song, with George dazed by the hippie minx on his futon. More than any other George song, it sounds like his tribute to Patti Boyd, the puffy-lipped sex priestess he married. (In later years, she adopted the spelling "Pattie.") The words get pretty dippy—"all the world is birthday cake" is bakeditude worthy of "MacArthur Park" but he has no shame, because he's soaring on Patti's mind-expanding hallucinatory impact, reviving his "too much" motif from "You Like Me Too Much." It's a George song about making out, which is a rarity, to say the least.

Patti is one of rock and roll's most legendary muses—she was born to stir the songwriting juices of her helplessly doting guitar boys. She became the blondest corner of rock's most famous love triangle when George's best friend Eric Clapton fell in love with her, inspiring "Layla," but "It's All Too Much" has to be the greatest song she ever coaxed into being. Only she could have turned such reserved English gents into tormented soul men. In Sixties photos, George looks much happier when he's standing next to her, the Savoy-est of truffles. I love their wedding photos, especially the one where the blushing bride stands between George and his best man, a cheery-looking Brian Epstein. Brian and George reach around her for an awkward handshake. George beams in Patti's radiance. The smile on his face says, *This, baby. This is why a boy from Liverpool learns to play guitar. This is why you sit down and practice those chords.*

So I always hear "It's All Too Much" as his ode to Patti. Maybe that's why he had mixed feelings about it—he gets carried away, with the whole band picking up a pheromone contact high. Patti got him into the Maharishi—she became a devotee after she and George visited India together. She was the worldliest of the four Beatle first wives—the one who wasn't pregnant at the wedding. She's also the only one who went on to snag another rock star. There's a great photo where she and George exit the courthouse after the cops raided their pad on a trumped-up pot bust. She looks glossier walking out of a police station than most stars look on their finest day. By sheer coincidence, this bust happened the day Paul married Linda. You look at the photos—Paul and Linda on one side of town, George and Patti on the other—and it's hard to tell which couple is having a groovier time.

Patti inspired such uncharacteristic fits of passion from

these guys. Clapton was a pious little blues scholar until he met her and turned into a frothing lunatic—the *Layla* album stands out from the rest of his music like a skyscraper, the guitars screaming in agony. After he won her away, he wrote sedate tributes like "Wonderful Tonight"; it's hard to connect those to the vixen who wrenched "Bell Bottom Blues" out of him or "For You Blue" out of George. Unlike John with Prudence, Clapton made a point of playing "Layla" for Patti in the flesh, making her weak in the knees. "The song got the better of me," she confessed in her autobiography. "I had inspired such passion and such creativity. I could resist no longer." When she left in 1974, George announced he was "very happy" about it, "because he's great. I'd rather have her with him than with some dope." Her older sister, Jenny, married Mick Fleetwood; her younger sister, Paula, had a not-at-all-disastrous fling with Clapton before taking up with another member of Derek and the Dominos. (There ought to be a movie about the Boyd sisters—but where would you find three mere movie stars who could live up to a myth like this?) When Patti and Clapton got married in May 1979, George, Paul, and Ringo jammed at the wedding, playing "Get Back" and "Sgt. Pepper." John called Clapton to complain he hadn't been invited.

It's strange how George was always a little stingy with the love songs. When you've got Patti sharing your stash box and leaving her sandals under your bed, yet you'd rather write all your songs about Lord Krishna, you can't blame the girl for getting restless—it's understandable she would upgrade her muse glimmer with some other rock star, preferably your best friend. No doubt Patti did it all for the songs. We owe her so much.

MAGICAL MYSTERY TOUR

(1967)

One night in 1967, at the end of the Summer of Love, George Martin fled London for a break in the madness, going to the cottage in the country with his wife (Judy, formerly the receptionist at Abbey Road) and their newborn daughter, Lucie. As Martin recalled years later, "We walked into the village pub on the first night and there was a hush and the barman said to me, 'Very sorry to hear about your friend.' " News had just come over: Brian Epstein had been found dead in his apartment, a drug overdose. When Martin and his wife got home to London, they found a bouquet of dead flowers—sent by Brian to congratulate them on Lucie's birth.

The Beatles were off in Bangor, Wales, on their first retreat with the Maharishi. When they returned, they got back to business, which meant Paul getting them back to business, which meant forcing themselves through *Magical Mystery Tour*, which seemed like a good idea at the time. The fun

drop-off between *Pepper* and *Mystery Tour* is tangible—the Beatles were a totally different band without Brian Epstein. Paul took over his role as the "keeny" who leads the charge. The Beatles barely survived two years in this new arrangement; Paul was not skilled at giving orders and the other three were even less skilled at taking them. It was only after Brian's death that Paul's imperious side became intolerable for the others. Their unity depended on Brian—he shielded his boys from lepers and crooks, but more importantly, he shielded them from one another. Eighteen months later, in the World War III of the *Get Back* sessions, Paul was pleading, "We've been very negative since Mr. Epstein passed away."

The lonesome death of Brian Epstein came when the four boys were more into one another than they'd ever been. The Bangor retreat was a spontaneous adventure, traveling as a group, without Brian or their roadies; it was only after the train pulled out of London that they realized none of them had any idea how to be ordinary train passengers. (They hid in their compartment for a while, then decided to go forth bravely and ride with the guru.) They'd attended the Maharishi's London lecture the night before, and liked it so much they'd unanimously decided to drop everything and go to Bangor for ten days, along with Patti, Jane, Mick Jagger, and Marianne Faithfull. They invited Brian; he declined. (There's a classic photo of this lecture with Mick in the audience, sitting still between Patti and Marianne. He's slunk way low in his seat, eyes gazing upward, arms folded, playing his role as a humble seeker of truth. If you can find another photo of Mick trying to look inconspicuous, I'll shake your hand.) Bangor was a bonding road trip, an example of how close the Fabs still were and wanted to be, just weeks after their Greek

island expedition. Then Sunday, they got the phone call from London.

Sgt. Pepper was the last gasp of the Epstein years. It was possible only because he had renegotiated their EMI contract to give them unlimited recording time at the label's expense, early in 1967—as Clinton Heylin has said, "nearly the last useful thing he did for them." In that sense *Pepper* was his unlikely monument, even if he hated the whole thing and begged them to release it in a paper bag. He was bereft when they quit the road—he now had no day-to-day function for the boys he lived to serve, adding to his already shaky temperament, with his downward spiral of pills and brandy and gambling, along with his attraction to thug types who kept shaking him down for blackmail payoffs. When *Sgt. Pepper* came out, he was in rehab at the Priory, though he checked out for a day to throw a release party. He died two months later from an accidental overdose of sleeping pills. Not a suicide, because it wasn't one big dose; he took too many over the course of three days, evidently losing track of how many he'd already swallowed. He was bored during a long weekend when the band was out of town and he had no ability to amuse or control himself. "Unconscious self-overdosage" was the coroner's verdict. He was only thirty-two.

Naïve as Epstein had been about business, the lads were hopeless without him. The Beatles fell for one of the most notorious sharks in the industry, Allen Klein, walking wide-eyed into the most obvious traps. Their Apple Corp project made them prey to a parade of hippie hustlers. This was also when the London cops began their crusade to put the Beatles behind bars, with allegations that police planted excess quantities of contraband on them. After the cops claimed they found hash in George's bedroom, hidden in a shoe tucked away in

a cupboard, he complained, "I'm a tidy sort of bloke. I don't like chaos. I keep records in the record rack, tea in the tea caddy, and pot in the pot box." One cop involved, Sgt. Norman Pilcher, went to prison in 1973 for perjury and falsifying evidence. It figures. When the Nixon Administration tried using John Lennon's bust as an excuse to deport him, the senator who led these efforts was Strom Thurmond, the white supremacist who went to his grave hushing up the secret black daughter he fathered with his housekeeper. The Beatles always had great taste in enemies.

Magical Mystery Tour was their first project after Brian's death, the next Paul brainstorm—hey, let's improvise a road movie on a bus. "Fuckin' Ada, I've never made a film," John said, but he went along with it; they all did. Paul had never been wrong; neither had any of them. It debuted the day after Christmas 1967 and got such derisive reactions it's been hidden away ever since; like most Americans who've seen it, I ponied up for a bootleg video, after hearing my whole life how bad it was, which turned out to be true. Paul didn't take the criticism well, huffing, "It was a mistake, because we thought people would understand that it was 'magical' and a 'mystery tour.' " The soundtrack in the U.K. was a six-song double EP—Capitol released it in the U.S. as a full album, adding singles that predated the movie: "Strawberry Fields Forever," "Penny Lane," "All You Need Is Love." The first track they recorded after Brian's death was one of their best, "I Am the Walrus," a song where you can hear young men blustering through a turbulent grief experience, along with varying levels of anger, boredom, spite, vanity, ebullience, and sarcasm. The turmoil in the song seems to have more to do with a friend's death (unspoken grief, anxiety over the future, wondering if they ever really knew him, typical Northern let's-get-on-with-it-ism, typi-

cal Beatle fuck-everybody-we're-still-the-greatest-ism) than whatever spiritual consolations they got from the Maharishi. What does it mean that the Beatles quit touring because they hated the road, but went right back to road-tripping together through Greece and Wales? And what does it mean that their next project without Brian was a road movie?

It's strange that the world of 1967 decided *Sgt. Pepper* was genius and *Magical Mystery Tour* was rubbish, but Brian Epstein's death instantly changed them in ways nobody could miss. It was the debut of a new band with different chemistry. When they filmed the "Hello Goodbye" video, they donned the *Pepper* suits for the last time. Just as they'd killed off the moptops, it was time to slay the Pepperoids. *Sgt. Pepper* celebrated their new adult freedom; *Magical Mystery Tour* was the sound of them having to live by it, and finding freedom was harder work than they imagined.

BEATLES OR STONES?

So: the eternal question. Beatles or Stones? The Rolling Stones were the only band the Beatles acknowledged as a rival, or bothered to worry about, even when they were making the scene together in the discotheques of Swinging London. "We were like kings of the jungle then, and we were very close to the Stones," John told *Rolling Stone* in 1970. "I was always very respectful about Mick and the Stones, but he said a lot of sort of tarty things about the Beatles, which I am hurt by, because you know, I can knock the Beatles, but don't let Mick Jagger knock them. I would like to just list what we did and what the Stones did two months after on every fuckin' album. Every fuckin' thing we did, Mick does exactly the same—he imitates us. And I would like one of you fuckin' underground people to point it out."

Sorry, John. "Beatles or Stones?" remains the central rock and roll rivalry, the question that sums up the rest of your worldview. The Stones styled themselves as the rebel-outlaw

version of the Beatles, the bad boys, the sophisticate's pick. They flaunted all the debauchery the Beatles felt obliged to tone down. Brian Epstein got his lads out of black leather and into suits, while the Stones publicized the fact that they got busted for pissing on a petrol-station wall. Epstein didn't even want John to admit he had a wife—the least of Brian Jones's worries, since he'd sired enough out-of-wedlock kids to start his own Stones tribute band.

So much of it comes down to Stones girls vs. Beatles girls. In my experience, hardcore Stones girls tend to be Paul girls, because they like their rock boys rock and their pop boys pop. The girl who made me a Stones obsessive wasn't just a Paul partisan—she was one of the most anti-John Beatle fans I've ever known. (To be a John girl means you're nearly a Stones girl but not quite.) For a dutiful, bookish Beatle boy like me, Stones girls meant trouble. She turned me on to early records like *Aftermath* and *Between the Buttons* and *December's Children*—listening to Mick and Keith harmonize for "Connection," or the Brian-vs.-Keith guitar duel at the end of "It's All Over Now," made me realize that the Stones were bad news from the start. What pleasant company: Mick, a blur of lips and ribs and hips, master of the demon flounce; his glimmer twin Keith; the doomed blond angel Brian; the witchy muse Anita Pallenberg; the fallen convent girl Marianne Faithfull; the silent hit men in the rhythm section. I disapproved of them all. She made me read Stanley Booth's book *The True Adventures of the Rolling Stones*, loaded with surreal scenes like Jagger's 1967 press conference, after his drug bust, the day he gets out of prison: "Mick, wearing a button that said MICK IS SEX, drank an iced vodka and lime and said, 'There's not much difference between a cell and a hotel room in Minnesota. And I do my best thinking in places without distractions.' "

Yet where you stand on the timeless "Beatles or Stones" debate depends on how you frame the question. It's a rookie cliché to look at it in terms of "Which band did a better job of being the Stones?" In that game, the Stones are always going to win. The Beatles are the band that brings you flowers; the Stones are the band you catch crabs from in the bathroom line. The Beatles are the band that passes you the bong and asks your opinion on the *Bhagavad Gita*; the Stones are the band that borrows your wallet to score pharmaceutical groovies in the alley, then disappears with your date and leaves you stuck with the bar tab. The Beatles are peace and love; the Stones are laughter and joy and loneliness, and sex and sex and sex and sex. The Beatles got an A for their term paper on transgressive performance art; the Stones broke up the professor's marriage. The Beatles are "I hope we passed the audition"; the Stones are "You don't want my trousers to fall down, now do ya?"

But the rivalry goes much deeper than that, because the bands were so tangled together musically. The Stones flourished during the all-too-brief phase when Mick Jagger thought he was Paul McCartney. "Dandelion" is easily the best faux-McCartney song of the Sixties. Alas, this phase has been underrated through the years, for the admittedly excellent reason that as soon as Mick gave up trying to be Paul he got ten times better at being Mick, which is when the Stones hit their prime. They made their greatest music in a five-year rush, starting in 1968: *Beggars Banquet, Let It Bleed, Sticky Fingers, Exile on Main Street*. I can't really argue that the Stones were *better* when they were ripping the Beatles; I'm not going to look you in the eye and claim that "Dandelion" beats "Gimme Shelter" or "Sympathy for the Devil" or "Rocks Off." But it's tempting. For a couple of years there, in 1966 and 1967, Mick was the bitchiest rock and roll singer who ever arched an eyebrow.

And just as *Aftermath* was the Stones racing to catch up with *Rubber Soul*, *Revolver* was the Beatles racing to catch up with *Aftermath*.

John wasn't kidding about the "two months later" principle—every time the Beatles discovered a new trick and proved it could be done, the Stones would breeze along a few months later to prove it could be done sarcastically. That included the whole idea of songwriting. For the Beatles, playing their own rock and roll songs was a defiant statement of artistic integrity; they were willing to throw away their career rather than compromise that. But for the Stones, it was the opposite—it meant selling out their blues roots. As Mick said in 1968, in the early days, "There were no hit groups and the Beatles were playing the Cavern. We were blues purists who liked ever so commercial things but never did them onstage because we were so horrible and so aware of being blues purists, you know what I mean?" When they played Elmore James covers for their fellow art-student bohos, the Stones had to hide the guilty secret that they dug pop. They only started playing original material after the Beatles made it look like a sucker's game to aim for anything easier. "We never thought we'd be big," Mick explained. "Thought we'd do blues for fanatics. When we heard 'Love Me Do,' right, we thought we might have rock and roll hits, because it was obviously changing."

London inspired the Stones with a constant supply of scenesters, groupies, debutantes, and sycophants, and as the Stones got bigger, they chronicled the nightworld they inhabited, doing for their sleepy town what the Velvets did for downtown New York. Mick's narcissism, way beyond any other rock star's, was his one true muse—only he would sneer, "The lines around my eyes are protected by a copyright law." While Keith held down the R&B groove, Brian colored

the music with sitar, koto, dulcimer, or whatever instrument he happened to find at George Harrison's pad the previous week. Mick blew barbed-wire kisses to all the thirsty phonies swarming around his rich, hot, and famous self, ripping them to shreds with his fop wit: "Dontcha Bother Me," "Ride on Baby," "Yesterday's Papers," "High and Dry," "Have You Seen Your Mother, Baby, Standing in the Shadow?" Mick always resented not being a Beatle, the way John resented not being a Stone; these songs were his dandy's revenge.

One of Mick's signature tricks was to make the lyrics nastier as his voice got girlier—hence a song like "Under My Thumb," where he tarts it up like a brazen showgirl over Brian Jones's fey marimba, adopting an outrageously swishy voice to mock his own craven terror of female power. Mick is truly the squirming Siamese cat he's singing about. (Check the Who's contemporary cover version for contrast—a tough guy like Roger Daltrey can't play the part, so it falls flat.) The Stones girls in my life have always had a special affection for this song—as my wife once said, "He sounds like the most pussy-whipped boy in the universe." It's obvious where Mick got the idea: John's "Run for Your Life," which came out five months earlier, going for the same butch/femme vocal ironies. But it's also obvious Mick does this trick better. Both songs are satires of rock misogyny, though both could also be heard as the real thing (with the singers as confused as anyone else). Yet "Under My Thumb" is a stronger song in every way—darker and funnier, flouncier and bouncier. Unlike John, Mick is enough of an authentically cold-blooded bitch to commit to the role.

I will always ride hard for Mick's Paul phase, summed up by the compilation *Through the Past, Darkly*, with its awesomely ridiculous octagonal cover. It's flower power, but the flowers are all painted black. This phase got out of hand when

the Stones tried to top *Sgt. Pepper* with *Their Satanic Majesties Request*. The Stones were embarrassed by *Satanic Majesties* and blamed it on their legal woes—as Mick said, it was made "under the influence of bail." True, there's nothing as great as "A Day in the Life," but "2000 Light Years From Home" isn't far behind, while "Citadel," "2000 Man," or "The Lantern" can hang with anything else on *Pepper*. The psychedelic Stones peaked with the August 1967 double-sided single of "Dandelion" and "We Love You," an "All You Need Is Love" parody with backing vocals from John and Paul. The Stones filmed a video for "We Love You" as a commentary on their drug trials, set in a Victorian courtroom. Mick plays Oscar Wilde, in the dock for crimes of love; Marianne Faithfull plays his boy toy Lord Alfred Douglas. And as the judge—Keith, of course, complete with wig, robe, and gavel.

But Mick got obsessed with the idea that the movies were where the Stones would outcool their rivals once and for all. Much more than the Beatles ever did, the Stones set out to become movie stars—except as serious actors, *bien sur*. As soon as "Satisfaction" topped the charts in 1965, they began shuffling their tour schedule to accommodate what they assumed would be a hectic schedule of film projects. They announced a five-picture deal in the London papers, as Mick sniffed, "We're not gonna make Beatles movies. We're not comedians." They planned art-cinema projects like *Only Lovers Left Alive*, where the Stones would play survivors of a nuclear apocalypse in London, and optioned the rights to *A Clockwork Orange*. Mick told *Melody Maker*, "I think the Beatles are very limited. Every group is limited, but I think they are *very* limited because I can't see, for instance, Ringo with a gun in his hand and being nasty in a movie and going to kill some-

body. It just wouldn't happen. But I don't think you'd think it was very peculiar if you saw Brian do it."

While the Stones aspired to a bit of the old droogy ultra-violence, John and Paul had lunch with Stanley Kubrick to discuss an adaptation of *Lord of the Rings* with John as Gollum, Paul as Frodo, Ringo as Sam, and do you even need to ask which Beatle would play Gandalf? None of these films happened; instead, Kubrick plucked *A Clockwork Orange* from the Stones, making Malcolm McDowell a star with his Jagger imitation. The closest the Stones came to this fantasy was when they hooked up with Jean-Luc Godard. The French director had wanted to film the Beatles recording, and met with Lennon to offer him the lead in a movie about Trotsky's assassination, but Lennon turned down both ideas. The Stones seemed like a better match—Jagger vs. Godard in a clash of the Sixties-alienation titans. "Godard is a very nice man," Mick said in 1968, tongue so far in cheek he could taste his inner ear canal. "I mean I've seen all his pictures and I think they're groovy." The director filmed the band in the studio on two historic nights, as they cooked up a new song that turned out to be "Sympathy for the Devil." Godard, having no clue what he'd just witnessed, cut up the footage and spliced it into a tedious student-protest drama called *One Plus One*. At the premiere, Godard announced the Stones had ruined his film and urged the audience to walk out. He then punched the producer in the face.

Amid all the Stones' legal, sexual, cinematic, and narcotic chaos, Keith fooled around with different ways to string his guitar and learned open tunings. That's when he truly became Keef, the Human Riff, as songs started spilling out of him. The immediate result: "Jumpin' Jack Flash," released in May

1968 and an instant U.K. Number One hit. Three seconds into "Jumpin' Jack Flash," you can hear the Stones have crashed into new territory: the change has come. *Beggars Banquet*, released a couple of weeks after the White Album, is the first record where it sounds like the Beatles might as well have never been born as far as the Stones know. Brian is no longer allowed anywhere near a dulcimer or harpsichord; his job is now to look hot, get wasted, and keep out of Keith's way, with his ghostly slide guitar in "No Expectations" as his final testament. He survived just long enough to get kicked out of the band before dying in his swimming pool. John said, "He was one of them guys that disintegrated right in front of you."

The Stones kept surging after the Beatles split—*Sticky Fingers* and *Exile* are fueled partly by the joy of having the top to themselves. They got flashier, filthier, and more famous. (It's easy to overlook what a commercial hit *Exile* was, since it was the one later generations adopted to rebrand the Stones as a cult band.) And that's really where the rivalry ended. They celebrated their new phase by hosting the December 1968 big-top extravaganza *Rock & Roll Circus*, a concert flick with a double irony: (1) now that they'd given up on acting, they finally made a worthy film as a rock and roll band, and (2) they reached a detente with John Lennon, who played "Yer Blues" in an ad hoc supergroup called the Dirty Mac, featuring Yoko, Keith, Mitch Mitchell, and Eric Clapton. The Stones mistakenly opted to bury the film, fearing they got upstaged at their own concert by the Who. (They didn't, though the Who were in top form that night.) Mick never looked prettier—he transforms into Scarlett Johansson during "You Can't Always Get What You Want"—while Keith appears impressively zonked, considering he'd been up for thirty-six hours by the time the Stones played. John boogies down to "Sympathy for the

Devil." He and Mick enjoy a minute of backstage banter, addressing each other as "Winston" and "Michael," reminiscing about old times: "Ah, those were the days—'I Wanna Hold Your Man.' " They look relaxed in each other's company—even affectionate. But neither lets down his guard for a moment.

One of the things I love about the Stones is that whenever they aimed for Beatle-style warmth—as in "The Singer Not the Song" or "Wild Horses"—they still sounded fabulously surly. That's what made them the Stones. They never got close to the unzipped exuberance of "I Want to Hold Your Hand" or "I Feel Fine" or "Eight Days a Week"—part of Mick's vast intelligence was to understand he didn't have that kind of sincerity in his empty heart, and he was too crafty to make a clown of himself trying to fake it. He knew he couldn't out-Beatle the Beatles. So the Stones chose different turf to conquer. The Stones were Stonesier. The Beatles were merely better.

THE WHITE ALBUM

(1968)

Abbey Road, 1968: The Beatles are working on a new album, which will go down in history as the White Album. The sessions have degenerated into open warfare. Paul is driving everyone batty with a song he's convinced is a hit, "Ob-La-Di, Ob-La-Da," which John dismisses as "granny music shit." Paul lashes them through it, night after night, trying to nail the ska offbeats. Tonight he announces a change in plan—after a week of "Ob-La-Di, Ob-La-Da," he's decided to scrap what they've taped so far and start from scratch. John storms out in a fit. He reappears a few hours later, making a surprise entrance through the upstairs studio door, screaming at the band from the top of the stairs.

"I AM FUCKING STONED!

"I am more stoned than you have ever been! In fact, I am MORE STONED THAN YOU WILL EVER BE!

"And THIS is how the fucking song should go!"

He marches downstairs and lunges for the piano. Not so

steady on his feet. He bangs on the keys in a rage, speeding up that jingle-jangle intro.

Paul stares John dead in the eye. But all he says is, "Okay then." Because that's it. That *is* how the song should go. And Paul, furious though he is, can't fail to hear it, because he's too obsessive about his songs (even this song) to ignore it. So he utters his five least favorite words—"Let's do it your way"—and lets John lead on the piano, faster and jumpier than before. And that's the version on the record. You listen to "Ob-La-Di, Ob-La-Da," a lighthearted ode to family life beloved by children of all ages, you're hearing John beat on the piano, pretending it's Paul's skull.

The next afternoon, Paul changes his mind again, makes them try it a couple more times while he drums. But then he gives up because they can't top last night's version. The three of them gather around the mike, put on the headphones, and sing the backing vocals, la-la-la-ing and cutting up like they're having the time of their lives. At the end John chirps, "Thank you!" "I fed tape echo into their headphones," engineer Geoff Emerick recalled. "That's all it took for them to suspend their petty disagreements; for those few moments, they would clown around and act silly again, like they did when they were kids, just starting out. Then as soon as they'd take the cans off, they'd go back to hating each other. It was very odd—it was almost as if having the headphones on and hearing that echo put them in a dreamlike state."

THE WHITE ALBUM IS THE BROKEN ALBUM, THE DOUBLE-VINYL mess, a build-your-own-Beatles kit forcing you to edit the album yourself. They even made the audience come up with the title. (Nobody has ever called it *The Beatles*.) In the pre-

digital days, everybody made their own cassette for actual listening, with each fan taping a different playlist. All four frown in their (separate) sleeve photos, only George giving the barest trace of a smile. Poor Ringo looks like he just spilled his eggs on toast. John gives his vacant-eyed stoneface shrug—you can see he was a guy with heavy internal weather, and you can also see how intimidating it must have been to try talking to him.

The White Album confronts you to make tough decisions about what kind of Beatle fan you are. You don't understand, but you must choose: which tunes you keep ("Julia" and "Martha My Dear" top the bill for me, plus "Dear Prudence" and "Savoy Truffle" and "Sexy Sadie" and "Cry Baby Cry") and which you leave out. (Even the justly maligned "Revolution #9" is more fun than "Bungalow Bill," "Honey Pie," or "I Will," though I know I'm on the wrong side of history with that last one.) Years after the fact, in the *Anthology* interviews, George Harrison still complains about how long it was. He thinks it should have been edited down to one airtight album. Ringo agrees. George Martin always felt that way. This makes Paul splutter with rage. "It's great! It sold! It's the Bloody Beatles White Album. Shut up!"

They began writing the album on retreat with the Maharishi in Rishikesh, India, a place where they had no electric instruments. They also had no drug connections, which might explain why they came up with their sturdiest tunes in years, written on acoustic guitars. As John said years later, "We sat in the mountains eating lousy vegetarian food and writing all these songs. We wrote tons of songs in India." John, the most distractible Beatle, had the hot streak of his life during his three months in Rishikesh, which is why it's their most John album. (The previous album with the mostest and bestest

John songs was *A Hard Day's Night*, four years earlier.) Paul lasted only four weeks, but it was a productive burst for him as well. Despite smuggling in a stash for a nightly smoke, they had considerably clearer brains.

When they regrouped back in England at the end of May, probably relieved to be back in a more corrupt environment, they gathered at George's bungalow in Esher to tape demos, on a newfangled two-track deck. John showed up with fifteen tunes, more than Paul (seven) or George (five). The Esher demos are a real treasure trove; they mined it for years. Songs that got worried to death on the album are played with a fresh one-take campfire feel, just acoustic guitars and handclaps. A couple of half-finished sketches got saved for the *Abbey Road* medley ("Polythene Pam," "Mean Mr. Mustard"), others for their solo albums (Paul's "Junk," George's "Not Guilty," John's "Child of Nature," later retitled "Jealous Guy"). They sit around George's living room, enjoying each other's songs—even "Honey Pie" rocks. They sound excited to hit the studio and knock something out in a few days, like they used to, back when they had to. Nobody knows the sessions will be an endless nightmare straining to duplicate the loose feel of the demos. "Ob-Li-Di, Ob-La-Da" will go through 47 takes. "Not Guilty" will require 102 takes and not even make the album.

Despite all the solo vocals, each using the others as a backup group, the White Album still sounds haunted by memories of friendship—that "dreamlike state" they could still zoom into hearing each other sing. They translated Rishikesh into their own style of English pagan pastoral—so many talking animals, so many changes in the weather. One of my favorite British songwriters, Luke Haines from the Auteurs and Black Box Recorder, once told me in an interview that his band

was making "our *Wicker Man* album." He was miffed I had no idea what he meant. "You can't understand British bands without seeing *The Wicker Man*. Every British band makes its *Wicker Man* album." So I rented the classic 1973 Hammer horror film, and had creepy dreams about rabbits for months, but he's right, and the White Album is the Beatles' *Wicker Man* album five years before *The Wicker Man*, a rustic retreat where nature seems dark and depraved in a primal English sing-cuckoo way. They also spruced up their acoustic guitar chops in India, learning folkie fingerpicking techniques from fellow pilgrim Donovan, giving the songs some kind of ancient mystic chill.

More than any other Beatle music, the White Album feels like a map tracing the points from boyhood to manhood—it has kiddie sing-songs; teenage lust; adult breakdowns of sex, death, destruction, religion, insomnia, and despair; ending with Ringo crooning a schmaltzy Old Hollywood lullaby. It's grown men trying to speak the lost language of children. Yet for all the rancor, you can hear all four tap into that old team spirit. As John said, "Dylan broke his neck and we went to India. Everybody did their bit. And now we're all just coming out, coming out of a shell, in a new way, kind of saying: 'Remember what it was like to play.' "

MY PARENTS HAD THE FIRST HALF OF THE WHITE ALBUM. I'M not sure why—it was in the sleeve of a Brazilian bossa nova album. They must have loaned the bossa nova LP to someone who returned it with the wrong disc inside. So I grew up knowing the first half much better. The best of its many scratches was in "Rocky Raccoon," where Paul sang "she called herself Nell and she called herself Nell and she

called herself" until I lifted the needle. I added plenty more scratches, especially the places I tried spinning backwards. I developed an intense love for the songs that begin and end Side Two—"Martha My Dear" and "Julia," two songs about women, one extremely Paul and the other extremely John. None of the other Beatles plays on "Martha My Dear" besides Paul, just as nobody plays on "Julia" besides John. (It's the *only* Beatles song that's solo John.) They're alone with these women.

"Martha My Dear" and "Julia" are sung by very different boys. When I hear "Martha My Dear," I'm the silly girl Paul is singing to. When I hear "Julia," I'm the solemn boy singing it. I don't think I've ever heard it and felt like Julia; I'm always John in that song. I wish I were Paul in "Martha My Dear," wish I were that witty and breezy and jaunty and dashing, but I find his confidence and ease appealing. It's a song that brightens my mind in rough times, reminds me to calm down and hold my head up. Julia is a deep girl, entrusted with John's secrets. It's hard work being somebody's Julia; it's less responsibility being a Martha. All Paul wants is to cheer her up so she can hold her hand out and help herself to some adventures and romance. He tells her to look around (like John tells Prudence) and live a little. It's light on its feet—the song wouldn't work if Paul had anything heavy to tell Martha.

I have never convinced anyone to dote upon "Martha My Dear" or "Julia" as much as I do, so my life is a failure, and yet I am unable to surrender my fixation on these songs. "Martha My Dear" and "Julia" are the split halves of my soul. Paul's White Album songs are full of his affection for the silly girls and wise old women who inspire him, and that includes his sheepdog Martha, making this the finest musical tribute to a real-life canine companion. (Second place: Led Zeppelin's

"Bron-Y-Aur Stomp.") You can see Martha in the "Strawberry Fields Forever" video; he used to walk her around London, long after he'd gotten too famous for that, because he could hide behind her and people would figure he was just another guy taking the dog to the park.

One of John's loveliest songs from the Esher demos is "Child of Nature," a song he wrote about India. ("On the road to Rishikesh, I was dreaming more or less.") He ended up keeping the melody from "Child of Nature" but changing the words to "Jealous Guy"—a love song to Yoko. (On "Julia," the White Album song he named after his mother, he calls her "ocean child," a rough English translation of "Yoko Ono.") Instead of the familiar "I'm just a jealous guy" refrain, John sings, "I'm just a child of nature / I'm one of nature's children." John was not exactly a back-to-the-garden type. He was a city boy who couldn't escape to New York fast enough, in contrast to his fellow Mother Nature's Son who took to country life. Unlike so many rock stars who bought farms in the earth-papa days, Paul actually lived on his; the most metropolitan Beatle was the one who might have milked a cow in real life. But Paul's ram-fondling years were still ahead of him when he sang "Mother Nature's Son." The two of them at this point just sang about nature as a fantasy they shared, a family they could join to be brothers again. "Child of Nature" and "Mother Nature's Son" have virtually nothing do with nature—but much to do with each other, and the dream that everything they've broken together can be healed.

JOHN BROUGHT PLENTY OF SECRETS TO INDIA; HE WAS THERE with Cynthia, but he'd fallen in love with Yoko. On the first day of the sessions, he didn't just bring Yoko to the studio, he

put her on the microphone, uttering the words "You become naked" that later got used in "Revolution 9." Like he said, he was "coming out of a shell," emerging from the acid-and-TV cocoon of his Kenwood years, regaining his sarcastic edge. All the Beatles were on fire. Even Ringo finished off his first solo composition, the excellent country hoedown "Don't Pass Me By," which he'd been working on for five years.

George goes three for four: "While My Guitar Gently Weeps," "Savoy Truffle," and "Long, Long, Long" are among his greatest songs, the latter two nowhere near as famous as they deserve to be. "Long, Long, Long" is morbidly quiet, forcing you to turn up the volume, until the fantastically creepy ending when the Blue Nun wine bottle rattles on the speaker. (So many nuns in Beatle songs!) "Savoy Truffle" is a prime example of George in salt-queen mode. "It's no point in Mr. Martin being uptight," he snaps in one of the outtakes. "I mean, you're very negative." Speaking of negative, there's also "Piggies," George's very own "Maxwell's Silver Hammer."

There are moments of genuine unity all over the album—especially hard rockers like "Happiness Is a Warm Gun" and "Helter Skelter," where they enjoyed the challenge of learning a song together. They started "Helter Skelter" the day after they attended the *Yellow Submarine* premiere, so maybe they had to purge the kid stuff from their systems. They cut "Yer Blues" after cramming themselves into a tape storage cupboard. McCartney did the most explicitly political songs—"Blackbird," inspired by the U.S. civil rights movement, and "Ob-La-Di, Ob-La-Da," a celebration of West Indian immigrant life in London—a contentious topic in the summer of 1968, after Enoch Powell's racist "rivers of blood" speech condemning black immigrants. He recorded "Blackbird" in Studio Two, while John and Yoko were down the hall assembling

"Revolution 9" in Studio Three. He used bird chirps from the Abbey Road sound-effects vault, while John was raiding the same vault for "Revolution 9" effects like the Royal Academy of Music instructor who speaks the words "number nine." When Ringo fled to the Mediterranean, a Greek sailor told him how octopi build gardens underwater. That inspired Ringo to write a song that ended up on *Abbey Road*—a song about asking your friends to come play under the sea. Back in London, the boys cut "Dear Prudence." During their two weeks apart, Ringo and the Beatles came up with two of their finest childhood songs, inspired by how much they missed each other. "Remember what it was like to play."

Every Beatle fan has different picks for the most useless tracks. Yet I hate the idea of a filler-free White Album, and I'm glad they didn't edit it into one disc, since "Rocky Raccoon" surely would have been the first to go, and I hate to picture a world without that song. I don't know how many White Album mix tapes I made over the years—I still have one from 1981, another from 2002, and I can't account for why I started loving "Helter Skelter" any more than I can defend what I used to hear in "Birthday." I still can't warm up to "I Will," which sounds like it should be my kind of thing and remains a favorite for some of my friends. I always assumed it was a joke, dashed off to answer "Why Don't We Do It in the Road?" Yet "I Will" required sixty-eight takes—for an acoustic ditty that barely lasts a minute. It's strange enough that Paul flogged himself through this, but Ringo added minimal percussion while John kept time on a piece of wood. Their suffering can only be imagined. The White Album became a whole new beast when it went digital—it was now easy to skip "Helter Skelter," mischievously placed in between "Sexy Sadie" and "Long, Long, Long" yet much louder than either. It

used to require a quick trigger finger on the tape deck's record button to keep "Helter Skelter" out of your White Album. Now avoiding "Helter Skelter" was easy, which was when I began to love it.

I guarantee I've never programmed a White Album without "I'm So Tired," with John's whisper-to-a-scream vocals, so funny yet so harrowing. Paul joins in for the last line, doing the John imitation he also does so well in "Come Together." The song is over in less than two minutes, both men wildly amused by one another, even as John screams "I'm going insane!" What an intense moment it must have been to share a laugh like "I'm So Tired." To get blazed up by that comic presence. And to lose this presence, and know you're losing it, to see it slipping away right in front of you.

"HELTER SKELTER"

(1968)

December 1969: the White Album gets a whole new kind of notoriety via a cover story in *Life* magazine, as L.A. district attorney Vincent Bugliosi introduces America to a new superstar: Charles Manson. The previously unknown creep with the psycho eyes is officially credited with a string of horrific killings in L.A, and what drove him to massacre people? He listened to the Beatles and lost his mind. With a whole hippie sex-and-murder cult primed to trigger a race war all over this land. Could your children be next?

America loved this story. President Richard Nixon announced on live TV that Manson was guilty, despite the fact that the trial was still going on. It was too good *not* to be true, right? It proved every nightmare America had about the Beatles. The Sixties were over, and Manson was the guy who killed them. When U2 covered "Helter Skelter," Bono announced, "This is a song Charles Manson stole from the Beatles. We're stealin' it back!"

Within days of the *Life* cover, the Rolling Stones offered another ready-made end to the Sixties story, with their disastrous free concert in Altamont, up near the San Francisco Bay Area. The Stones had little to do with Altamont—they'd never set foot in the place. The advance work was done by their West Coast attorney Melvin Belli, who made the deal to relocate the concert to the rundown Altamont Speedway at the last minute, even though there was no stage and no time to build one. Nothing secretive about Belli's involvement—he was a high roller who gave great press conferences and gets the funniest scenes in *Gimme Shelter*. The local Hell's Angels chapter was in charge of security. The Angels' fee: $500 worth of beer. Everybody knows how that turned out: 300,000 kids crammed into a decrepit speedway that couldn't hold them, a hastily rigged stage three feet off the ground, no food, no water, no facilities, no escape, no shelter. The Angels loaded on acid and speed and alcohol, charging their bikes into the crowd, mauling fans with pool cues, beating musicians to a pulp onstage. Four deaths. One homicide. Crosby. Stills. Nash. War, children, it's just a shot away, with a Hollywood crew on hand to film every minute. In the immortal word of Jerry Garcia: "Bummer."

The man who made the plans for Altamont had a long strange association with federal law enforcement, which naturally has raised questions. Belli shows up often in conspiracy lit, because of the coincidence that he was the defense attorney for both Jack Ruby and Sirhan Sirhan—a fact that probably didn't cross Mick Jagger's mind onstage when he shouted out "Who killed the Kennedys?" Conspiracy theorists have even argued Altamont was an FBI operation to destabilize the counterculture. (The most compelling case is Alex Constantine's book *The Covert War Against Rock*. The book

also suggests Michael Hutchence was assassinated for supporting Greenpeace, so caveat emptor.) If so, the Man must have been hoping for a bigger disaster—only one murder caught on film?—but it sure gave bang for the buck. Manson-and-Altamont became the new Beatles-and-Stones, providing Nixon's America with the perfect twin metaphor for why kids today were in need of some restraints. You still see Manson and Altamont cited as examples of why freedom doesn't work. They're why you never go with a hippie to a second location.

The Stones got the blame, to the point where they embraced it as part of their legend. "Altamont, it could only happen to the Stones, man," Keith Richards said in 1971. "Let's face it—it wouldn't happen to the Bee Gees." But just as the Stones were never quite as big as the Beatles, Altamont would never be as big as Manson. Bugliosi turned his *Life* revelations into the best-seller *Helter Skelter*, our culture's favorite crime story. Manson remains America's most popular—no other word for it—murderer, even though by all accounts he never killed anybody and wasn't present when anybody was killed. Hollywood speed dealer Tex Watson might seem more like the leading man—he was there both nights, did the actual killings etc. But Bugliosi made the decision to give Watson's friend and accomplice Charlie the auteur credit—again, no other word. Tex was all wrong for the part. He had short hair and boy-next-door looks—a high school football hero, for crissakes. Manson was a longhair, wild-eyed cartoon villain who belonged in a cage.

You can't blame Bugliosi for wanting to make Manson the star of the story—but the surprise is how well he succeeded. The "Watson murders" do not exist. Ask a hundred people on the street who Manson is—ninety-nine will tell you he's the hippie freak who stabbed a bunch of people after playing

the White Album backwards. N.W.A. began their career with the boast, "Here's a murder rap to keep you dancin' / With a crime record like Charles Manson." His bios are still huge best-sellers, even though they all have the embarrassed paragraph where they have to mention he didn't take part in the killings. It doesn't matter. The whole story has gotten bigger than Bugliosi could have hoped.

To build his prosecution around Manson, the D.A. announced a magical-mystery theory: the Beatles made him do it. In the *Life* cover story, rolling out the state of California's case, Charlie was given credit for an elaborate yet cohesive philosophy inspired by the White Album, interpreting lyrics in a consistent pattern to form his revolutionary plan. Manson never showed much ability to articulate or even understand his own theory; as he admitted, he was from the Bing Crosby generation. In the 1970 *Rolling Stone* cover story that introduced Manson to the counterculture as a hippie insider— "The Most Dangerous Man Alive"—Bugliosi had to shoo him away from the reporters and explain the philosophy himself. In retrospect this might look fishy—but then it's always been strange how little concrete detail there is to the theory, beyond Manson's nauseating personality. He was delighted to embrace stardom; after a career as a hopelessly incompetent small-time crook, spending more than half his life in jail, he loved being on TV. According to *Helter Skelter*, he wasn't merely a criminal mastermind, he had magic powers—one day during the trial, he made Bugliosi's watch stop just by staring at it. (Eeek!)

Not being qualified to offer any legal or historical (or magic) expertise on the case, I'll just note cautiously that people *love* the whole Helter Skelter story, and very much want to believe it, asking for little in the way of corroboration. "It was the big-

gest publicity case the D.A.'s office ever had," Bugliosi says in the 2015 CNN documentary miniseries *The Seventies*. "The problem is that Manson did not physically participate in the murders. But only Manson had a motive to make these murders, 'Helter Skelter.' I told the jury that when these words were found printed in blood at the murder scene, it was tantamount to finding Manson's fingerprints." Quite an admission for a prosecutor, but Bugliosi told the tale this way countless times over the years, more or less verbatim, and it made him the nation's first and only celebrity D.A. (The Manson episode of *The Seventies* is dedicated to Bugliosi's memory. Watson is not mentioned at any point in it.)

But nobody really minds how much smoke and mirrors might be in the legend. L.A. celebrities began polishing their "Hey, I was invited to that party" or "I jammed with that guy once" stories. Charlie remains world famous, while the other killers became footnotes. When Manson made the cover of *Life*, Watson, incredibly, wasn't even in Bugliosi's custody yet; he was still in his home state of Texas, as he and his lawyers spent nine months negotiating the terms of his extradition. They did a good job with that. (He got a separate trial, wrote a book about finding Jesus in jail, and still has his own Christian ministry. He fathered four children in conjugal visits.)

Manson-and-Altamont remain chart-toppers after all these years. Somewhere in your town, right now, somebody is singing along with "American Pie," a song where Manson gets just one line but Altamont has its own verse, as the flames climb high into the night to moonlight the sacrificial rite. The only remotely interesting thing about Manson is his enduring popularity as a political and cultural weapon for law-and-order types, a relic of an era when America needed a demon Beatle. He's still the standard against which every celebrity criminal

is measured. During the O. J. Simpson trial, an L.A. classic-rock station put up a billboard of O.J. and Manson with the headline "BAD COMPANY," until the Juice's legal team complained. The band Bad Company released a statement defending the billboard. Just as Altamont could only happen to the Stones, Manson could only happen to the Beatles.

"SOMETHING" (1969) VS. "MY LOVE" (1971)

There's an outtake from the *Get Back* sessions where you can hear George compose "Something," playing an unfinished version for his mates and modestly seeking advice. He asks, "What should I do, Paul?" George has the first line, via James Taylor—"something in the way she moves"—but he's stuck trying to finish the second. "Attracts me like . . ." like what? John says, "Just sing whatever comes into your head. 'Attracts me like a cauliflower.' " Later in the session, George changes it to "attracts me like a pomegrante." We can all agree it was a wise move to go for "no other lover."

"Something" became George's greatest hit, as well as the one that made John and Paul most jealous. It was the first time the Quiet One got the A-side of a single. Oh, how it must have burned Paul he didn't write this song. And that's how "My Love" happened.

I was hoping to leave "My Love" out of this book entirely, but there's no way to ignore it. "My Love" is the worst song

any of the Beatles had anything to do with. Sure, there are uglier listening experiences tucked away on their solo albums, but they have the decency to stay hidden, whereas "My Love" has no decency at all—it became a worldwide radio menace for years. Paul wrote many clunkers for *Red Rose Speedway*, but "My Love" was the one he released as a single, the Number One hit that gave Wings a bad name with the punch line, "My love does it *gooood*." So it commands attention and a certain respect. Really, the contrast between "Something" vs. "My Love" is the whole George/Paul dynamic in a nutshell.

What must have driven Paul nuts was how much "Something" sounds like him. You can't fault him for wanting to write his own version, yet he's so rattled by "Something" that it throws him off his game. Especially the most brilliant detail of "Something": the wordless chorus that consists of a six-note guitar hook. It's not a singer's song, which is why every cover version sounds silly, even the famous Frank Sinatra remake where the Chairman says, "You stick around, Jack, it might show." Only George could have trusted letting the guitar carry the chorus. There's no way Paul could have let that go. He would have put six words to that guitar hook, probably "that's what my love does good" or "my love, she does it good." He couldn't have left it alone. That's why he never could have written "Something."

George only wrote this song once; he doesn't have other wedding ballads in his book. "Something" isn't about the woman, just the feelings she gives him, but the barely there lyric is perfect for his voice. He can't find words to describe her, so he shuts up and hides behind his guitar. It's a love song for Quiet Ones. It works because it sounds like he wrote it in ten minutes. But writing tunes in ten minutes was Paul's department, as were silly love songs in general, so he must

have taken it as a challenge. (Listen to his hyperactive bass line, where he's effectively saying, "I'm Paul McCartney and I approved this message.") Two years after *Abbey Road*, Paul came out with his knockoff "My Love," but replacing the guitar hook with the words "my love does it good" was a horrific mistake, like everything else about it. George knew it too—hence his nastily funny 1974 parody, "Maya Love."

"My Love" is a fascinating disaster, if you happen to love Paul, because it's a string of very un-Paul-like mistakes. He forgets all the Paul tricks he knows better than anyone else ever has. In fact, he goes so wrong here breaking his own rules, it's an index of everything he usually gets right. His lifelong attention to pronouns fails him—this is a love ballad where the word "you" does not appear, nor do "she" or "her," not even "we." It's all "I," "me," "my." You can't call this a rookie mistake since rookies know better, mostly because rookies are imitating Paul. So he wrote a love song and left out the woman; he also invited an orchestra, without giving them anything to play. He adds a colossally terrible guitar solo, when the track's already way too long (four minutes, practically a minute per word). Not his own guitar solo: he lets a sideman barge in to make this butt-ugly (and no doubt sincerely self-expressive) noise. A ghastly sax solo would have made a certain sense, but this is a bluesy guitar solo, with no place in a lounge ballad like this.

"My Love" saves the worst for last. Paul takes a dramatic pause for breath and belts the final word, which unfortunately is "me," or as Paul sings it, "*Meeeeeee-wo-wo-wo-wo-wo-ho, wo-ho, whooooa!*" No singer has ever expended such a tragic effort on the word "me," stretching it out forever while the orchestra blares, making that climax a whopper of unintentional comedy, the cherry on top of an already-abundant

suck sundae. It's like he's trying to sing the piano chord at the end of "A Day in the Life." I used to put that "me" on mixtapes to fill blank space—an eighteen-second bonus, labeled as a Paul McCartney song titled "Me." The comedian Dickie Goodman used it as the punch line of his 1973 novelty single "Watergrate." After interviewing Richard Nixon about his collapsing administration, Goodman poses a final question to the vice president. "Sir, can you tell us: who will be the next President of the United States?" Cue the sound of Paul's voice: "MEEEEEE!"

It's unfair, since Paul is hardly a "me"-centric songwriter— really the ultimate "she"/"you"/"her" songwriter. But rock and roll is unfair. You might even wonder if "Something" was George planting a land mine that he knew Paul would trip over, years down the line. You don't have to hate "My Love" to love "Something." But it helps. And make no mistake, game recognizes game. Paul still plays "Something" every night onstage as his tribute, on a ukelele George gave him.

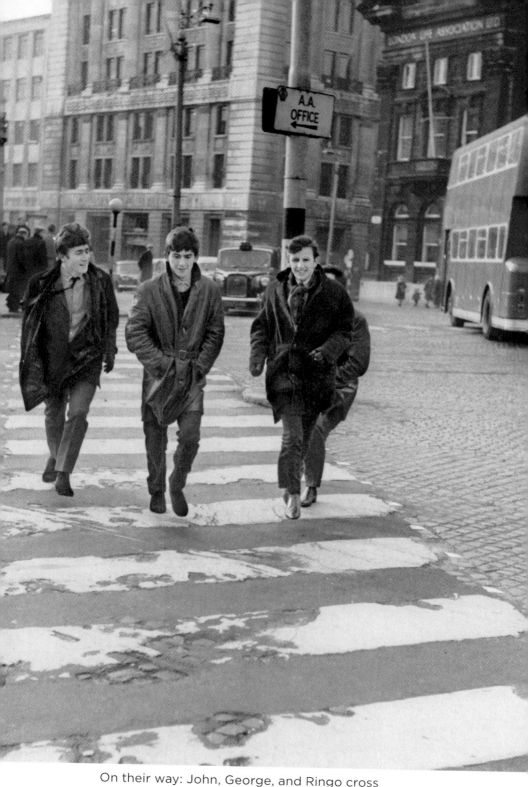

On their way: John, George, and Ringo cross
the street in Liverpool, February 1963.
(Photo by Michael Ward/Getty Images)

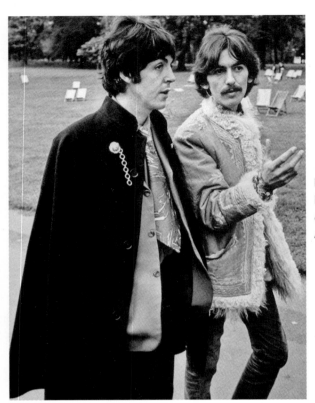

Paul and George stroll through London's Hyde Park, May 1967
(Photo by Marvin Lichtner/The LIFE Images Collection/Getty Images)

There's more to life than books, you know.
A break during the filming of *Help!*, 1965.
(Photo by Bob Whitaker/Getty Images)

John in his Dylan cap, looking at sketches for a Beatle cartoon series, November 1964. *(Photo by Mark and Colleen Hayward/Getty Images)*

"Hold your head up, you silly girl." Paul plays flugelhorn for his beloved sheepdog Martha, June 1968. *(Photo by SSPL/Getty Images)*

George and his guitar. "You won't interfere
with the basic rugged concept of my
personality, will you?" (*Bettman*)

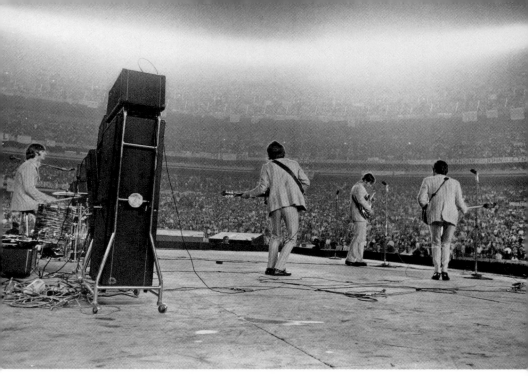

Shea Stadium, August 1966: The Beatles stare into the Scream. It is shining. *(Photo by Koh Hasebe/Shinko Music/Getty Images)*

Early 1970: Ringo at a London cabaret to film the promotional video for his lounge ballad "Sentimental Journey." *(Photo by © Shepard Sherbell/CORBIS SABA/Corbis via Getty Images)*

Here, there, and everywhere, 1966. As always, Paul knows where the camera is.

(Photo by ullstein bild viz Getty Images)

John signs autographs as the Magical Mystery Tour bus stops for lunch.
(Photo by Jim Gray/Keystone/ Getty Images)

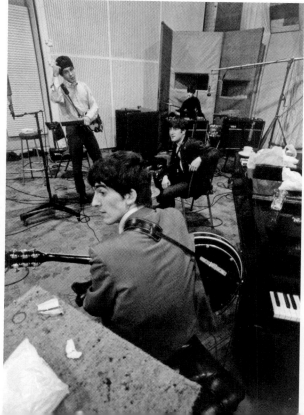

At Abbey Road recording *With the Beatles*, September 1963.
(Photo by © Norman Parkinson Ltd./ courtesy Norman Parkinson Archive/ Corbis/Sygma via Getty Images)

John and Paul on a Cornish beach during the
making of *Magical Mystery Tour*, September 1967.
(Photo by Mark and Colleen Hayward/Redferns)

THE COVER OF *ABBEY ROAD*

(1969)

There's an outtake from the *Abbey Road* photo shoot, on August 8, 1969, a Friday morning. They're sitting on the stairs, hanging out as they wait for the session to start. The photo they pose for that day will become one of their most famous images, a cultural icon known around the world. In a few minutes these boys will get up and cross the street and then their lives will be very different. In one more hour, they leave this room and hit that road. Right now they are four boys on the stairs.

You wouldn't call it an un-self-conscious photo by any means. They do not look relaxed or comfortable—John and Paul adopt the same clenched body posture, shoulders hunched, legs apart, faces turned right to look at George. Paul holds his cigarette at a rakish angle that says he's trying a little too hard to look nonchalant. A professional body-language analyst (the kind who decodes celebrity photos for *Us Weekly*) might note the instinctively kindhearted way Ringo sits so as

to take up as little room as possible to make more space for the other three, even though there's plenty of room on the stoop for him to spread out a bit. Everyone is turned to focus a little too intently on George, which isn't comfortable for any of them, especially since it means that the other three are looking directly into the sun.

There's an intimacy in the picture, and an excitement, a sense of "here we are, so now what," à la Dustin Hoffman and Katherine Ross on the bus at the end of *The Graduate*. It's not the final Beatle meeting or even the final photo shoot, but by their accounts, they know they're making their last album, and they know this is the cover photo. So here they are on the stoop of the EMI Studios at Abbey Road, and after the shoot, they'll head inside for the afternoon session, to work on "I Want You (She's So Heavy)." One of these days they'll finish the record, then they'll never be inside together again and it'll be a place they can't go back to. They all like the new album well enough—they're not on the same page musically (everybody hates "Maxwell's Silver Hammer") or personally (Yoko ate one of George's chocolate biscuits without asking), but it's not like the White Album or *Let It Be*, constantly at each other's throats. They get along relatively smoothly, because they know it's the last one. George Martin agreed to come back and produce only if the boys promised him their best behavior. No scenes, no need for it: they already have their lawyers doing the fighting for them. They're rarely in the studio at the same time; whoever's there is usually getting work done.

Ever since their teens, the Beatles have been accustomed to being watched in public; all four assume everybody around them is rubbernecking and looking for clues of what goes on in their minds. So it's rare to see them look so nervous in a photo. In the snaps from Abbey Road, they're putting out a

chummy vibe for the onlookers. All four Beatles are dressed up, in character, looking cool: John in his white suit, Paul in a dark one, Ringo in a psychedelic tie that unfortunately doesn't show in the final album-cover photo, George in blue denim. Paul's the only one without a beard; George is the only one without a jacket.

The whole reason they're doing this on Abbey Road is because they didn't feel like schlepping out to the Himalayas. They've been jokingly calling the album *Everest*, after the brand of cigarettes Geoff Emerick smokes. Then they change their minds, not out of modesty but because they can't stomach the idea of traveling together to pose anywhere near Mount Everest. So they decide to knock off the cover photo right there at Abbey Road, the most convenient and ordinary and neutral turf possible, crossing the street where they have to show up for work anyhow. The street is not famous yet, but within a few months it'll be the most famous street in England. EMI Studios will officially rename itself "Abbey Road" because of this picture. Fifty years later, every London tourist wants a selfie in the same crosswalk. Why not? Really, Everest, so what—if Everest weren't the tallest mountain on Earth, something else would be. But Abbey Road: that's someplace special. Things happened there. You know that street well.

In the cover photo, the Beatles walk tall, with notably good posture, all stepping into the pose, which doesn't require any eye contact. They walk in line, which takes the pressure off them in terms of staying out of each other's way. They cross the street several times; a cop holds up traffic. Photographer Iain Macmillan perches on a stepladder. Paul wears shoes in some of the snaps, but not in the one they (he, of course) picked for the cover. The "Paul is dead" freaks will notice that he's out of step, also barefoot (a sign of mourning in Sicily!)

and smoking (a sign of mourning in Lower Gullible). The Volkswagen Beetle with the 28 IF license plate just happens to be parked there. Bloody neighbors. Paul was twenty-seven, not twenty-eight, but people were easily amused back then.

Right now, they're lounging on the stairs. In that outtake, none of them look like they're in a hurry to get up and cross the street. They don't know what's on the other side. That's where the end is, and they can already tell it's the place they will begin a lot more hard work. Soon we'll be away from here, step on the gas and wipe that tear away.

It takes only ten minutes. They get the photo finished early, so they have a couple of hours to kill before the afternoon recording session. George goes to the zoo. Ringo goes shopping. John and Paul head off together to hang out at Paul's house on Cavendish Avenue, the two of them.

TURN ME ON, DEAD MAN

The "Paul is dead" craze didn't begin gradually or on a grass-roots level. It started in October 1969, when Detroit DJ Russ Gibb got a mysterious phone call giving him clues to investigate. Gibb played the "number nine, number nine" bit from "Revolution 9" backwards on the air—and like his WKNR-FM listeners, clearly heard, "Turn me on, dead man." The mumbles on Side Two of the White Album, between "I'm So Tired" and "Blackbird," when spun backward, revealed the message, "Paul is dead, man, miss him, miss him." And there's John at the end of "Strawberry Fields," announcing "I buried Paul." The word spread fast. Two days later, the *Michigan Daily* ran a review of *Abbey Road* that explained the cover as a funeral procession: John as the preacher (in white), Ringo as the undertaker (in black), George as the gravedigger (in jeans), and Paul as the corpse.

And you know what the Greek word for corpse is? Walrus. As in, "Here's another clue for you all: the Walrus was Paul."

"I Am the Walrus" ends with the sound of a fatal swordfight, taped from a BBC broadcast of *King Lear*. ("If ever thou wilt thrive, bury my body.") The chirps on "Blackbird"? Actually a grouse, associated with death in English folklore. "Goo goo goo joob"? The dying words of that eggman Humpty Dumpty, right before he falls off the wall in James Joyce's *Finnegans Wake*.

It's hard to tell how seriously anyone ever bought it, but the rumor remained wildly popular all through the Seventies, when literally nobody believed Paul was dead, just because these clues were so fascinating. It was a ritual of fan culture—if you searched, maybe you could spot some detail the rest of the Beatlological community missed. Nicholas Schaffner's *The Beatles Forever* gave a handy rundown: Paul died on the number-ninth of November 1966, when he blew his mind out in a late-night car crash, after getting behind the wheel in the final hours of "stupid bloody Tuesday." (As Ringo the undertaker sang, "You were in a car crash and you lost your hair.") He died there in the road, waiting for the van to come. George's finger points to the words "Wednesday morning at five o'clock" on the *Pepper* cover, because that's when Paul was Officially Pronounced Dead. (On the front cover, Paul wears an "OPD" patch, right in front of the freshly dug grave.) Instead of announcing this tragedy, the Beatles decided (as ever) to do things their own way, and replaced Paul with an imposter, while dropping labyrinthine hints to their devoted fans in the "Beatle code" John used to talk about. As Schaffner said, the rumor was "a genuine folk tale of the mass communications era."

The Beatles themselves seemed to find the whole thing a giggle. Paul was off on his secluded Scottish farm when the story hit the papers, but he made the coy statement, "If I were

dead I'd be the last to know." (Not quite a denial, is it?) Defense attorney F. Lee Bailey hosted an investigative TV special, calling witnesses like Allen Klein and Peter Asher, both of whom testified that Paul was still kicking (something Mr. Klein's lawyers would learn all too well). Ringo announced, "I'm not going to say anything because nobody believes me when I do."

Even if Beatle fans didn't believe Paul was dead—and it had to be admitted, the imposter was doing a damn fine job, considering he wrote "Hey Jude" and "Golden Slumbers" and "Penny Lane"—they felt *something* was going on. How could so many clues be accidental? Maybe the Beatles were amusing themselves (like how they roguishly sang "tit tit tit" in "Girl"), or rewarding fans who paid extra attention. Maybe (a popular Eighties theory) John dropped these hints to express his contempt for Paul's dead-ass talent. Or maybe there were demons and religion involved. (The cartoon of John makes the proto-Dio devil-horn gesture on the cover of *Yellow Submarine*.) Either way, "Paul is dead" became a permanent part of fan lore. Urban legends like this have blown up many times since then—hip-hop fans hunting for clues to prove Tupac is alive, stoners believing Jim Morrison faked his death and fled to Ethiopia, Stevie Wonder truthers collecting YouTube footage to prove he's been faking his blindness all these years.

Things like this celebrate a pop fandom as an interpretive community. Any Directioner can give you an exegesis of Harry Styles's tattoos, from the mermaid on his torso to "I can't change" on his wrist (which he got covered with an anchor), from the "never gonna" on his right foot to the "dance again" on his left. When Taylor Swift writes a hit about Harry called "Style," 1D reply with a hit about her called "Perfect" that nicks the melody from "Style," while Harry writes a great song named "Olivia" after Taylor's cat (which is also the name

of Harry's sister's cat). Whether any of this is intentional is beside the point—it's all about the fandom's collective power to decide what the artifacts mean. Taylor Swift is just a particularly brilliant example of a pop artist who plants Easter eggs like this, capitalizing stray letters on her lyric sheet to spell out what the songs secretly mean to her. (The last time Taylor dropped an album, my niece Sarah sent me the coded messages by lunchtime, deciphered during algebra. She is definitely related to me.)

But "Paul is dead" remains the most famous of them all. "It's the most stupid rumor I've ever heard," John said in October 1969, on the Detroit radio station that started the whole mess. "Sure, you can play anything backwards and you're going to get different connotations, 'cause it's backwards. I don't know what Beatle records sound like backwards. I never play them backwards." So how do we know who the Walrus is? Paul might have originally worn the tusks, but two years after John sang "the Walrus was Paul," he changed his mind to "I was the Walrus, but now I'm John." George announced, "I'm the Walrus too." Gentlemen, this is getting out of hand.

But it was a sign that the Beatles didn't own their work anymore, because a planet full of devotees was keen to invent new meanings. This was collaborative fan fiction, skywriting by word of mouth, gossip too juicy not to pass along. Walrus doesn't mean corpse, of course; we fell for that one, just as we fell for "goo goo goo joob," which isn't in *Finnegans Wake*, though there's a "googoo goosth" on page 557, right next to "four hoarsemen on their apolkaloops." The "Blackbird" chirps really are a blackbird (the grouse I made up). Yet every time a rumor was squashed, new ones sprouted. The OPD patch was explained as a gift from the Ottawa Police Department, but who the hell keeps souvenirs from Ottawa? Why

would Paul sew this patch onto an expensive costume he got specifically for an album cover? " 'Carry That Weight' backwards is Etruscan for 'He sleeps with the fishes,' " Richard Price says in his classic 1984 *Rolling Stone* memoir of Beatlemania. As a college student in 1969, he hears a call-in radio show where fans share their tips with the DJ. " 'Here Comes the Sun' played backwards at 78 rpm says, 'Woe is Paul.' 'Come Together' played under water gurgles, 'Paul is fucked.' If you translate the brass notes of 'Maxwell's Silver Hammer' into longs and shorts, they Morse-code out into R.I.P. R.I.P. R.I.P. All the phone-ins sound earnest—everybody's trying to come off like he's not having a ball." Price wants to get in on the game, impress the hippie girls out there. "Yeah, hi, uh, I just thought of this," he tells the DJ. "I don't know what it means . . . but you know what eighty-four per cent of all the coffins in England are made of? . . . It might even be eighty-seven per cent . . . Norwegian Wood."

There was also a suspicion the Beatles were teasing fans to sell their back catalog. Their older albums climbed back on the charts, which was probably why the record company didn't deny a thing and just respected the McCartney family's privacy at this difficult time. *Mad* magazine surmised, "Ringo, Paul, George, and John / Played a trick and put us on / Dropped hints Paul was dead as nails / And rocketed their record sales." A slew of Paulsploitation death porn hit the market, like Terry Knight's "Saint Paul" (he went on to manage Grand Funk Railroad), José Feliciano's "So Long Paul" (under the psuedonym Werbley Finster), or "We're All Paulbearers" by the superbly named Zacherias and the Tree People.

I never believed Paul was dead, though I admit I did sincerely think Jim Morrison was alive, and I've at least wondered

about Stevie. (Nobody ever saw the body, you know. Jim's, I mean. Only Pamela and the French doctor who signed a fake name on the death certificate, and Pamela was dead a year later.) The ex-Beatles rightly came to take pride in the fan phenomenon. Paul called one of his concert albums *Paul Is Live*. John sneered "Those freaks was right when they said you was dead" in his diatribe "How Do You Sleep?" In the wake of the Kennedy and King assassinations, the audience was primed to look for conspiracy narratives, but with increasingly popular drugs wreaking new forms of paranoid schizophrenia on underdefended brains, this sort of thing became one of the sicklier strains of fan culture, whether it was occult nuts counting the Freemasons on the *Pepper* cover or UFO spotters suffering from the "there's nothing you can see that isn't shown" fallacy. Religious scam artists began spinning records backwards, as in the Judas Priest "Subliminal Criminals" trial of 1990, where the band was accused in a Nevada courtroom of hiding messages like "do it" in their songs. Singer Rob Halford took the stand to play his own music backwards, finding other hidden messages like, "I asked for a peppermint." The case was dismissed.

That's part of what people have always turned to rock stars for, though—a little sinister mystery, wondering if Led Zeppelin really did practice black magic or if Ozzy dined on bat heads or if Peter Frampton made his guitar say "I want to *fwuuuuwwwnnnnk* you." There had been Beatle death rumors from the beginning—as early as 1961, a *Mersey Beat* reader wrote in to ask if it was true one of them had been killed in a car wreck. That mystery is a fix people go to rock and roll for, but it's also a way of taming the unbearable mystery in the music. Finding "Paul is dead" clues is a way of saying, "This music spooks me, yet I am the enchanter, not the enchantee, so

I hereby cast my spell over it, explaining how the trick works to render it harmless." The brain finds it comforting to impose patterns on chaos, especially when the patterns are silly and harmless. The country is currently full of folks who claim to believe the moon landings were a hoax, a claim that cannot possibly stand up to thirty seconds of scrutiny, yet people adopt it because it's droll and it flatters their hardheadedness. Ten years from now, nobody will believe this, just as nobody now looks for the letters "s-e-x" airbrushed into shampoo ads or sees Elvis at the supermarket. But people enjoy trivial secret conspiracies; they're less scary than obvious real ones.

And that's probably why the "Paul is dead" lore got even more popular after the Beatles broke up—it was a way to keep them alive. After all, the cataclysm that happened on November 9, 1966, was that John went to an art exhibit at the Indica Gallery, and met the artist. Her name was Yoko Ono.

"PAUL IS DEAD" IS FONDLY RECALLED AS A RELIC OF THE DAYS before the Interglut came along to standardize rock mythology, which is a loss for us all. It wasn't too long ago you could argue for hours over mysteries such as what Black Sabbath's "N.I.B." stood for (I thought it was "name in blood," others thought "nativity in black"), or whether Steely Dan's "My Old School" was about the Annandale in northern Virginia or the one in the Hudson Valley. These are arguments sadly lost to history, because now people just look up things on their phones and believe the first Officially Pronounced answer they see. Rock stars love to butt in and tell us how to interpret their work. Geezer Butler says it's "Nativity in Black," while Donald Fagen has Steely Dansplained how "My Old School" is about Bard, despite Virginia signifers

like oleanders, William & Mary, or Gary U.S. Bonds. The mystery is over, because the rock stars have settled the matter.

Which just goes to show how hopeless rock stars are at settling things.

Because what if the rock stars don't know what their own songs are about? What if they don't get these mysteries any better than we do? What if Geezer Butler or Donald Fagen doesn't remember the Seventies? Or what if they've undergone personal travails, or perhaps legal ones, that make them pick an answer and stick with it? That's a familiar pattern for males of a certain age; you choose a version of the story that makes sense and tell it that way forever. But what if we reject their authority and say it's not *your* song, it's *our* song? Virtually anybody reading this book has listened to "I Am the Walrus" more times than John did in his life. Why aren't we the ones who can say who the Walrus is? Part of the mystique of a classic Seventies drug album like David Bowie's *Station to Station* is the fact that the artist was so blitzed out he couldn't recall making it. As he said, "I honestly have no idea what I thought between 1975 and 1977." So we can argue whether he sings "The European canon is here," "The European candidate's here," or even "The European Kennedy's here," because Bowie, proving as always he was a genius, refused to explain.

Rock stars have always played these mind games, ever since the Beatles proved how fun it was. Bob Dylan drops obscure film quotes into his songs and then waits decades for people to catch on (countless Dylan freaks spent their lives pondering "to live outside the law you must be honest" before anyone knew it was from a movie) in the same spirit that James Joyce, his next-door neighbor on the *Pepper* cover, packed enough cryptic jokes into every page of *Ulysses* to keep scholars buzzing for centuries. Every Smiths fan knows the experi-

ence of stumbling across a line in a book or film and saying, "Oh, *that's* where it comes from." I once sat on a plane reading a Joe Orton anthology, spotted the line "death at one's elbow," and practically danced on my fellow passengers' heads in delight—even though "Death at One's Elbow" was a song I'd hated for twenty years. Morrissey and Johnny Marr scattered more riddles in their music than any of us will live long enough to solve.

But the "Paul is dead" phenomenon raises the taboo question—what if the rock stars don't know and have never known the secrets? Would we be quite prepared for that eventuality? What if they're reading lines off the teleprompter, probably just a hasty guess from some legal clerk years ago? It's not like they transcribe their own lyrics. (For the Beatles, that was Neil Aspinall's job.) If you're arguing about Dylan, you can't just consult your phone, because his official transcripts remain full of mistakes he's never made any move to fix. (No, it's not "don't try No-Doz"—it's "don't tie no bows.") Mick Jagger would laugh in interviewers' faces when they asked him to decode his songs. "Ah, the imagination of teenagers!" Mick told *Rolling Stone* in 1968. "If a person is that hung up on lyrics he can go and buy the sheet music because it's all there, all wrong of course. You should see the one for 'Dandelion,' they made up another song!"

It's comforting to think the rock stars know what they're doing. Sometimes it sounds like they leave clues to make us feel better, to assure us these mysteries are solvable and so is life. In this, as in so many other things, rock stars are lying to us. What these clues really say is that we *can't* get to the bottom of it. Because Beatle fans love to argue, and because people argue about the Beatles more than any other band, these debates never die. When John sings "hold you in his

armchair you can feel his disease," you might have theories about his furniture symbolism—or you might be the kind of fan who insists there *isn't* a chair because it's "hold you in his arms, yeah." I've wasted plenty of time debating the Armchair Controversy and loved every minute. Believe me, I've had stupider arguments over a lot less.

John was the last guy who'd claim to know whether he sang "armchair" or not; even in the Hamburg days, he couldn't remember his own words and cheated by scribbling them on the back of his hand. He'd wing it, as in "You've Got to Hide Your Love Away," where he sang "two foot small" instead of "two foot tall" in the studio by mistake and just kept it. John never closed the book on the Armchair Controversy, and thus gave us a song we can argue over forever. He gave us many gifts like this. The Beatles left music that no amount of Interglut homogenization can ever explain away, and for that we should be grateful. We are all the Walrus.

THE BEATLES' LAST ALBUM

(1970)

January 3, 1970: Paul, George, and Ringo go into the studio to record a new tune called "I Me Mine," for their next album, *Let It Be*. The final Beatle session. Not a quality song—barely over a minute, so Phil Spector has to cheat and repeat one of the verses to make it a respectable length. By the time it's released, the Beatles have broken up. Nobody likes to think of this as the end. So we, as a tribe, have retconned the story so *Abbey Road* is regarded as their swan song. It would make a lot more sense, historically and emotionally, if they went out with a bang, à la *Abbey Road*.

So what's the final Beatles album? *Abbey Road* or *Let It Be*?

It's always been a hot-button philosophical question, the kind that defines what breed of Beatlemaniac you are. Though it may seem like a ridiculously arcane debate, damn right it matters. Because it's the Beatles. If you're a fan, you've had at least one chemically assisted late-night argument about this, because that's what we do. *Abbey Road* was the last album

they *recorded*, but *Let It Be* was the last they *released*. So did they ever bid farewell with "Her Majesty" or "Get Back"? Which counts as the finale?

Sentimentally, *Abbey Road* has the edge, but in cold chronological terms it's debatable. The case for *Abbey Road*: (1) almost all of *Let It Be* was in the can before the *Abbey Road* sessions began; (2) *Abbey Road* feels more like a classic Beatles record; (3) "I Want You (She's So Heavy)" was the last time all four played in the studio together; (4) the last song on *Abbey Road* is called "The End"; (5) except for "Her Majesty"; (6) rebounding from the *Let It Be* debacle was the main reason the lads summoned up their old solidarity for *Abbey Road*; (7) "Her Majesty" is awesome; (8) in the end the love you take is equal to the love; (9) you make.

The case for *Let It Be*: (1) It came out in 1970, which was after 1969; (2) all four Beatles kept working on *Let It Be* long after *Abbey Road* came out. Ringo was recording drum tracks as late as April 1970—barely a month before *Let It Be* was released. So alas, it can't be written off as a pre–*Abbey Road* slopfest that the heartless record company dumped out there as a posthumous cash grab. The Beatles wanted this album to come out, and worked hard to make sure it did.

But on some level, you could argue *Let It Be* isn't so much a Beatle *album* as a Beatle *project*. It's a movie soundtrack that only became an official album because it came out when they broke up. If they'd released it on schedule, before *Abbey Road*, it would be roughly as famous as the *Yellow Submarine* soundtrack. Both have a handful of songs, plus a load of epiphenomena that belongs in a movie. *Yellow Submarine* is full of George Martin orchestral fluff, *Let It Be* is full of half-assed jams. Neither record holds up all the way through, but the keepers are great: "Two of Us," "Dig a Pony," and "I've

Got a Feeling" rate with "It's All Too Much"; "For You Blue" rates with "Hey Bulldog"; and so on. The studio chitchat on *Let It Be* is even more extraneous than "Attack of the Blue Meanies" or "Pepperland Laid Waste."

Most of *Let It Be* (then titled *Get Back*) was recorded in January 1969. The tapes gathered dust while they made *Abbey Road*, released in October 1969. Then they went back to fighting over the production (and release date) (and everything) of *Let It Be*, dressing up as The Band for the publicity photos because The Band inspired the drab journeyman authenticity they were straining for. Spector botched the production so badly, Paul held a grudge, refusing to shake Spector's hand at award ceremonies and releasing his own 2002 remix, *Let It Be . . . Naked*. (Note the superbly Pauline irony of spending thirty-two years futzing over an album called *Let It Be*.) It remains an oddity in their discography, comparable to *Hey Jude*, a U.S.-only hodgepodge from early 1970; the band had nothing to do with assembling it, but it was presented as a new album, collecting random songs like "Paperback Writer," "Rain," and "Don't Let Me Down." (Wait—why wasn't that on *Let It Be*?)

What counts as an album and what's merely a project is a gray area. In the 1970s, fans argued over whether *Hey Jude* and *Hollywood Bowl* were official albums. Nobody argues about that anymore. The label would probably like to err on the side of counting projects as albums, although they still show heroic restraint and taste when it comes to respecting the core canon. (Like they count *Yellow Submarine*, but they know better than to make claims for *Reel Music*.) If you want to claim the Beatles made eleven proper albums, because *Let It Be* and *Yellow Submarine* are soundtracks, I can see that. *Magical Mystery Tour* is another borderline case, but it's been

a long time since I've heard anybody try to read it out of the canon, and it's a case where sheer quality makes a difference. (Not even a strict-constructionist hardliner would claim the EP is *better* because it leaves out "Strawberry Fields Forever"). Counting *Yellow Submarine* but not *Magical Mystery Tour* would be silly, since *Magical* has six new songs and *Yellow* just four. But you could write off all three soundtracks— *Magical Mystery Tour, Yellow Submarine, Let It Be*—as side projects. If I wanted to make a winning argument for *Abbey Road*, that's the argument I would make. (What is it attorneys say? If the facts are against you, argue the law; if the law is against you, argue the facts; if "Polythene Pam" is against you, argue "Maggie Mae.") But I am merely here to try the case, even though I don't like how the evidence is stacking up.

So let's put it this way. *Let It Be* is the final Beatle album, not *Abbey Road* . . . only *if* it counts as a Beatle album. Can you argue *Let It Be* is a Beatle album, yet not the Beatles' *final* album? No, not really, because it includes a tiny amount of music they made in 1970. So here's my reluctant conclusion: I like *Abbey Road* better. Sentimentally, it's the one I think of as the end. However, unfortunately, *Let It Be* is the last Beatles album. Trust me, we will keep arguing about this. It's what we do. And if there's no way to settle the debate over where the Beatle canon ends, that's ultimately because there's no ending at all.

"MAYBE I'M AMAZED"

(1970)

And then the Beatles broke up. Paul announced the news first. George's official response was genius: "It looks like we need a new bass player."

There are two famous reasons. The first is their wives, specifically Yoko and Linda. The other is Paul's first solo album. The ladies make sense as a breaking point: as Mick Jagger says in the Rutles movie, *cherchez la femme*. But Paul's solo album doesn't compute at all as a reason to break up the band. Given different timing, it'd be remembered as a pleasant oddity of half-finished stoner sketches with one major song, "Maybe I'm Amazed." Instead it's remembered chiefly for coming with the press release where Paul announced his split from the Beatles, with the actual album as a BTW footnote.

The chronology goes like this: In the fall of 1969, the Beatles release *Abbey Road*, an immediate worldwide hit. The Beatles keep working on *Let It Be*. Paul buys a home studio, busks a few ditties to test the equipment, and decides to release a solo

album in April within a week of *Let It Be*. The others natu-
rally object, so they send a scathingly condescending letter (in
John's handwriting) informing him they've already gone over
his head and told EMI to block his release date until June.
("We're sorry it worked out this way—it's nothing personal.
Love, John and George. Hare Krishna. A Mantra a Day Keeps
MAYA! Away.") They put it in an envelope marked "From
Us, To You" and send Ringo over to Paul's house to deliver it
by hand, which means they know how inflammatory the tone
is, despite its more-than-fair demands; they're counting on
Ringo's charm to soften the blow, or else they just don't want
to take the heat. Either way Paul has a tantrum for the ages,
wagging his finger in Ringo's face and screaming things like
"I'll finish you" and "I'll show you all!" Ringo, a mensch as
always, goes back to the other two and talks them into letting
Paul have his way. So they push back *Let It Be*. On April 9,
Paul sends out press copies of *McCartney*—and includes a
Q&A announcing his break from the Beatles. "We got some
people at the office to ask some questions" was the way he
spun it, although the questions were so indiscreet people had
to assume he was both Q and A.

> **Q:** Were you influenced by John's adventures with the
> Plastic Ono Band, and Ringo's solo LP?
> **A:** Sort of, but not really.
> **Q:** Are you pleased with your work?
> **A:** Yes.
> **Q:** Will the other Beatles receive the first copies?
> **A:** Wait and see.
> **Q:** Did you miss the other Beatles and George Martin?
> Was there a moment, e.g., when you thought: "Wish
> Ringo was here for this break"?

A: No.

Q: Are you planning a new album or single with the Beatles?

A: No.

Q: Is your break with the Beatles temporary or permanent, due to musical differences or personal ones?

A: Personal differences, business differences, musical differences, but most of all because I have a better time with my family. Temporary or permanent? I don't know.

Q: Do you foresee a time when Lennon-McCartney becomes an active songwriting partnership again?

A: No.

Q: What are your plans now? A holiday? A musical? A movie? Retirement?

A: My only plan is to grow up.

Paul's press release is so notorious for these bombshells, but when you read the whole thing, it's remarkably dull, lots of how-I-made-the-album blather about technical equipment, his lack of V.U. meters or mixers, "the steel-guitar sound is my Telecaster played with a drum peg," etc. He buries the lede, as they say in the biz; it takes a while to get to the money quotes. It's easy to imagine a scenario where nobody troubled to read that far and nobody noticed the news—except Paul curiously chose to do some advance hype for his own press kit. He told *Rolling Stone*, "We're doing a kit with the album which is an information thing. It should be nice to receive, the way we're playing it. All the answers to this whole thing we're doing are really supposed to be in the record and what goes on around it. That's the idea, that's the fun of it. It's to just sort of lay something on you."

It says something about the fog of intra-band warfare that

Paul, knowing what was in this press kit, could jauntily assure the world it would be "nice to receive."

"NICE" IS DEFINITELY THE WORD FOR THE *MCCARTNEY* ALBUM, a case study in the moral and artistic limitations of niceness, especially considering the nasty job he asked the album to do, i.e., jump out in front and spin the split as his idea. *McCartney* has some whimsical tunes—"Every Night," "Junk," "That Would Be Something"—along with Linda's iconic photo of Bearded Paul cradling a baby in his leather jacket. But he ditched the Beatles for *this*? It would have been one thing if he'd attached his press kit to an imitation *Abbey Road*, or a song cycle as ambitious as *Ram*. But the mismatch of the music and the announcement was the PR disaster of a lifetime, one he never fully recovered from. *McCartney* became an obscurity—you couldn't call it one of his famous records—yet it defined how people would talk about him from now on, dismissing him as the shallow, self-amused craftsman. It sold millions of copies to fans still giddy from *Abbey Road*, but it might be the most catastrophic multi-platinum success in history; every copy was another heart hardened against him for years to come. It made him the villain in the breakup. Even Beatle fans who've never listened to *McCartney*, which has to be 98 percent of them, essentially judge Paul on the basis of this album.

The Beatles had made solo records before, most of them extreme (and extremely bad) art statements. George cheekily charged full retail for his synth diddles on *Electronic Sound* (not titled *Electronic Music*) and *Wonderwall Music* (not titled *Adequate Music*, though it inspired Oasis's best hit). Ringo did his *Sentimental Journey* of show-biz chestnuts, gallantly

announcing, "I did it for me mum," then went to Nashville for *Beaucoups of Blues*. John made albums of electronic noise, including one packaged in a paparazzi shot of his drug bust, plus he and Yoko reading their press clips, speaking each other's names, etc. They also dropped trou for the cover of *Two Virgins*. "By natural turn of events, I wound up being naked in the picture too," John explained. "When we were taking the picture, I got a funny feeling when I looked down at me cock. Hello, I thought, we're on."

If the Beatles broke up over *Two Virgins*, it would have made a certain poetic sense—it was shocking, divisive, appropriately momentous. (Paul wrote the liner notes: "When two great Saints meet it is a humbling experience.") Yoko was a big deal—as the man who knew her best sang, she was so *heav-aaay*, and unlistenable dreck though it might have been, *Two Virgins* flaunted that heaviness. But breaking up over *McCartney* just insulted people. There was no way to finesse it as some kind of "an artist's gotta do what an artist's gotta do" statement. "Cold Turkey" was John's latest solo single, and that also might have made sense as the breaking point: a noisy junkie bummer. He broke the long-running Lennon-McCartney byline, taking solo credit. "Cold Turkey" was as trivial as the Macca album, except more self-important; John addresses the topic of heroin, which probably struck him as edgy, but the habit he was trying to kick was the Beatles. If you compare "Cold Turkey" to "Yer Blues" or "I Want You (She's So Heavy)," it just sounds corny—tailoring his hard-rock sound for the Beatles inspired John in a way this song didn't. The irony is that Paul's parody of this song in "Let Me Roll It" was not only superior but more John-sounding (as was John's parody of Paul's parody, "I'm Losing You").

The others resented how Paul jumped the gun—John fumed,

"I put four albums out last year and I didn't say a fucking word about quitting." But there was no way to keep up the absurd official denial. *Let It Be*, released a month after *McCartney*, had liner notes calling it a "new phase Beatle album." All four refused to attend the movie premiere. They were clumsy amateurs at this kind of thing. They'd been sheltered all those years by Mr. Epstein, who was often clueless at business decisions, but not as clueless as they proved to be. The way they bungled the breakup proved that. The band should have been ripped apart by a *Two Virgins* or an *All Things Must Pass*, even a "Cold Turkey"—something historic. It's like George said in 1990, after John was murdered: "If John had been killed by Elvis, it would have at least had meaning!"

"MAYBE I'M AMAZED" TOOK YEARS TO ESCAPE THE SHADOW of its parent album. Paul opted not to release it as a single. "Maybe I'm Amazed" expresses not just his fear of no longer being a Beatle but also his terror at finding a love he could not escape in one piece. Paul and John grew up dreaming of exotic French pastry like Brigitte Bardot. Instead, they married tough New York broads, artists not intimidated by them in the slightest, women who'd already rumbled through marriage and divorce and motherhood. Paul's love for Linda was heavy in ways this song revealed, which might have been why he backed away after he wrote it. It was only after her death that "Maybe I'm Amazed" came into its own as a tribute to her.

"Maybe I'm Amazed" is the most anomalously Beatle-ish track—it's soulful, pained, labored with love in a way that defines his Beatle work but not his solo work. He went to Abbey Road to give it the full-on studio treatment none of the other

songs got (or could have sustained, since there was so little to them musically). For his next album, *Ram*, he buffed his image as a pastoral hippie, groping his livestock on the cover—in the words of Wings dude Denny Laine, "a farmer who plays guitar." But *Ram* was mostly recorded in NYC, in a top-dollar studio during nine-to-five business hours, with two sidemen he'd never met before. It was a professional approach to music designed to sound unprofessional. It worked, too, with Hugh McCracken playing that great guitar break in "Too Many People." (My favorite McCracken solo, except maybe Steely Dan's "Hey Nineteen.")

For Paul, country life meant stretching himself. He kept featuring his wife as part of his band. (As Linda told *Playboy* in 1984, "Look, this acting-and-singing thing is not—I'm not really a talent in those fields.") Despite all the idiotic things people said and still say about Paul not feeling things deeply enough for their taste, Paul's loyalty to Linda was the real deal. "It was just I liked being with her, quite frankly," he said years after her death. "I always think of Linda still as my girlfriend. That's how we started out in the Sixties, just as friends." And that's how their partnership endured. "Everyone had every reason to slag her off. In fact, there was no reason for anyone to support her. But I knew what I was doing—as did John, having Yoko on his records. He didn't think she was Aretha Franklin. He was in love and he wanted to make something new—something of his own making." But if all John or Paul wanted had been a protegée to mold, they would have married soft clay: simpler, safer women. Instead, they chose Yoko and Linda, who insisted on amazing them.

"GOD"

(1970)

Two of my favorite John songs: "God" and "Girl," both songs crying out in pain, the kind of pain that makes needy boys believe in the wrong things and fall for the cheapest lies. John could have done a song called "Girl Is a Concept by Which We Measure Our Pain." "God" is the showstopper from John's greatest solo album, *Plastic Ono Band*, made in 1970 to announce that the Beatles were dead, the one where he renounces everything he's ever believed in and the weakness that makes him such a sucker. In "God," he boasts about an utterly confident level of disbelief that I would love to feel, even though the Beatles might be the thing I've believed in most purely and passionately in my life. But for John, falling out of love with being a Beatle meant giving up on everything he thought was true.

How do you break up with something you believed in? I always loved this sentence in *Our Bodies, Ourselves*, the Eighties edition I had in college: "The previous edition of *Our*

Bodies, Ourselves included a brief section on astrological birth control, which just doesn't work." So much going on in that sentence, dispatched with no drama. Maybe a shade of irony, but no hand-wringing—just a change of mind announced as efficiently and discreetly and decisively as possible.

Not John Lennon's style.

John was deeply attracted to conversion experiences and renunciation scenes. He's the Beatle who loved to embrace idols and then melodramatically break up with them. Every time John broke up with a religion, he sounded stern and final. He liked to be the one to walk out on his gods, rather than waiting around for them to die on him. Nobody wants to be the last one to notice that the lights have changed. He was the only Beatle to denounce the Maharishi, but he did it in such a noisy way, everybody assumed the whole band joined him. The documentary *The Compleat Beatles* credulously reports that the Beatles went home from India feeling betrayed, with the punch line: "Besides, Ringo didn't like the food."

But while John felt betrayed, the others didn't. George remained a loyal Maharishi supporter and Transcendental Meditation believer for life. Paul enjoyed his Rishikesh retreat, probably got crazy laid, and still speaks fondly of the Mahareesh. And Ringo? He really didn't like the food. Yet he still plays benefits for David Lynch's TM foundation to this day.

John, a supposed former infatuation junkie if there ever was one, felt horribly disillusioned by false gossip about the guru's sex drive. He wrote a bitter ballad about what a phony the Maharishi was, but changed the name from "Maharishi" to "Sexy Sadie," which made it a much stronger song. Sexy Sadie is an adversary who moves John in ways the real-life guru never did. George might have talked him into the name change, and John might have done it out of brotherly respect,

but nobody has ever claimed that softened the punch. Sadie's a worthier idol to believe in and feel betrayed by. She really gets him hot. If I were a guru or a god, I would love the idea that I could make an apostate write this song.

As he so often did, John took inspiration from Smokey Robinson, playing on opening lines from the Miracles' "I've Been Good to You," a song he kept rewriting his whole life, from "This Boy" to "Starting Over." (Whatever else he believed, John never lost faith in Smokey.) "You made a fool of everyone" might be overstating the case, since the grand total was just him. But every line is funny—not the words themselves, but the deadpan vocal, the dry consonants, the blue notes, the self-mocking falsetto at the end, the way he rolls the "x" in "sexy" around in his mouth, as if it's a toothpick he's about to spit. And on lead guitar, who's that playing his ass off? Why, it's George Harrison, who probably chanted his mantra on his way to the studio.

The sarcasm dripping out of John's voice is the meanest and funniest recorded evidence of his nasty streak. If religion could make John this mad, it must be good for something.

FOR JOHN, THE GODS WERE JUST GROUPIES. RELIGIONS WERE a high he was addicted to, something he could pick up and then reject, compulsively discarding them to reassure himself how tough he was. For years he boasted about his great zinger as he walked out on the Maharishi: "If you're so cosmic, you'll know why." It wasn't *that* great. But he needed to fall in love with the next savior, decide *this is the one*, then kick it to the curb, congratulating himself once again for being the one to break it off. The whole conversion/deprogramming cycle was a cover for the addiction he couldn't

break, to the Beatles. He could never dump the boys the way he dumped the gods, even after the band ended. When being Beatle John made him feel stupid or helpless, god-baiting made him feel in control.

By the time of songs like "Mind Games," John had picked up a sense of humor about his religion-shopping as a rock-star cliché. Like so many other 1970s celebrities, he was in the market to buy a stairway to heaven. But he had a lot more to spend than other stars, in terms of his credibility; if John believed in you for a weekend, you got permanently famous. To this day, everybody in the English-speaking world knows what "primal scream" means, just because it was a thing John was into for a few months.

Were Lennon fans who heard "Mind Games" in 1973 scandalized that John was now pro-mantra, three years after "God"? Talk about re-enchantment: John is not only now down with mantra and magic, but also karma, druids, rituals, saying "Yes" to every crackpot religious concept ever dreamed up by anyone, because Yes equals Surrender equals Peace and Love. John also believes in (if my ears are getting this right) "absolute elsewhere in the stones of your mind," which even a Lennon apologist like me has to admit is a tough sell in the theosophy department. We can feel lucky the song fades out after four minutes before John gets around to endorsing unicorns, mood rings, and astrological birth control. (He got to leprechauns already, with "Luck of the Irish" on his solo album *Some Time in New York City*, a terrible song I've loved since Shonen Knife covered it. I suppose I should be offended by the Celt stereotyping, but if anything sums up New York City to me, it's a Japanese avant-garde artist singing about the Blarney Stone.)

Even George Clinton sounded befuddled by "Mind Games" when he covered it on the very odd 1995 tribute album *Working Class Hero*, where he joined the likes of Blues Traveler and the Red Hot Chili Peppers to raise money for the cause of spaying cats and dogs. (You'd think the sound of Toad the Wet Sprocket doing "Instant Karma" would be enough to neuter any animal.) But "Mind Games," unlike "God," is meant to be funny. John rattles off his spiritual flings, as if he's Mick Jagger cataloging his ladies in waiting—"Mind Games" is to "Sexy Sadie" what "Some Girls" is to "Under My Thumb." His voice oozes benevolent self-absorption. The grand joke of "Mind Games" is how he dares you to accuse him of being full of crap, then makes it no fun to do so.

But "God" is the best song any Beatle wrote about religion, with all due respect to George's "My Sweet Lord." Both were produced by Phil Spector the same year—with Ringo on drums. (Talk about ecumenical.) "God" is where John does his most beautiful singing, reaching for a doo-wop tremble straight out of his beloved Rosie and the Originals, with that "Elvis echo" on his voice. It's one of the two or three songs I'd play if I had ten minutes to convince a jury that John was the greatest of rock and roll singers-as-singers. Along with "Girl," and maybe "Ticket to Ride." Or "You Can't Do That"? "Money"? "I Want to Hold Your Hand"? "Happiness Is a Warm Gun"? "Oh My Love"? "I'm So Tired"?

John reserved the right to change his mind about anything, sometimes in midsentence. (Don't you know that you can count him out? In.) But in "God," he tries to break the cycle, getting the Beatles and religion and his youth out of his system. As in "Ticket to Ride," he's saying it out loud to make sure it's real. As often happens when someone is trying to break an

addiction, there's a ritual element to repeating the story aloud, in front of listeners who have been under the same spell.

THE LITANY IN "GOD": JOHN TRIES TO PURGE HIMSELF OF false faiths. It's like the cover of *Sgt. Pepper*, except he's assembled these icons to smash them. When I hear the song, I start out rooting for John, but I get more uncomfortable as he goes on, calling the names of things he does not believe in.

Magic. Me neither!

I Ching. I don't have a clear idea what this is.

Bible. Like all Catholics, I have a wildly contradictory relationship with this wildly contradictory book, as my people have ever since the Edict of Thessalonia.

Tarot. Nothing is more comical to a cradle Catholic than seeing kids who grew up without rosary beads use hippie playing cards to simulate all the freaky papist occult devotions they missed out on.

Hitler. A too-easy target.

Jesus. The moment that is always uneasy for me to hear. Whatever the state of my own erratic religiosity, whichever way my candle is sputtering, it always disturbs me a little to hear how devoutly he sings this line.

Kennedy. I voted for Ted in the 1988 Senate race.

Buddha. Never heard anyone else pronounce it this way.

Mantra. I learned "mantra" from you, John. We all did, silly goose.

Gita. Again, I learned this word from John (along with "tarot," "I Ching," and "Zimmerman," which was Bob Dylan's birth name).

Yoga. These days, this is probably the most shocking line in the song.

Kings. Again, a cheap target, out of place in this song, though John had no way of knowing Her Majesty had at least another five decades to go before the British would see their next king. But "kings" is an effective setup for the next idol, who is:

Elvis. Not so fast.

Zimmerman. Hold it right there.

Beatles. Mike drop.

The buildup to "Beatles" and the shocked hush afterward should seem overdramatic in theory, but it doesn't sound that way. Whatever above-it-all smugness I bring to the song is gone by that point. It's like hearing Kurt Cobain sing the word "shiver" or Otis Redding sing the word "tenderly" or Corin Tucker sing the word "anonymous."

He enunciates each name differently—the one he has the hardest time getting out is *"Elviiiis."* That's where he has doubts midsyllable and tries to gulp it back. And I love Ringo's drumroll after "Elvis," as if to say, *Speak for yourself, heathen.* He's witheringly contemptuous of "tarot" and "mantra." He's a little mean to "Buddha." I wish he'd included "karma." The one-syllable "kings" falls flat; maybe that was Krishna's slot, till he changed his mind at the last second out of respect to George. But all these names, trivial or heartfelt, are all just ways of expressing a loss of faith, whether that means getting divorced or turning thirty or deciding that you're not the man you used to be. "I don't know when I realized I was putting down all these things I didn't believe in," John said. "I could have gone on, it was like a Christmas card list. I thought. 'Where do I end?' Churchill . . . and who have I missed out . . . it got like that, you know, and I thought I had to stop. I was going to leave a gap and say just fill in your own, you know, and put whoever you don't believe in."

"God" wouldn't fool anyone into thinking John is a non-believer in Elvis (he sings it with his "Heartbreak Hotel" echo) or Zimmerman (he means Dylan, who invented this kind of anaphora as pop-song form, as in "Hattie Carroll" or "Hard Rain"). He enjoyed blasphemy for kicks—"The Ballad of John and Yoko" had to be the first Top Ten hit to use Christ's name as an expletive, and the last for years. Yet he never believed in Christ, so it's a cheap profanity that doesn't cost him anything and makes the song sound phony. Some of the blasphemies in "God" are like that. But some cost him plenty, especially the Beatles, a more jealous and possessive deity than he realized. (They outlasted the I Ching, didn't they?) He sings "God" like he really *needs* to be free, like Nietzsche talking about breaking his addiction to Wagner's music: "My greatest experience was a recovery. Wagner is merely one of my sicknesses." He wanted to snap his followers out of it. But he had no idea what the Beatles would mean to people around the world, generations yet unborn, who would live their whole lives and die without a minute's curiosity about Jesus or Buddha but would hear themselves in songs like this one.

PAUL HAS NO SCRAP OF RELIGIOSITY DISCERNIBLE IN HIM—HE has no grudge against it, certainly. But he seems like one of those enviable cases who never wooed or jilted a god, never got haunted by one, never struggled to get free of one. He just never seems to have been troubled by the idea. His freedom from religion is effortless. John and George made a thing about the quest for God and cosmic mysteries; Paul didn't (without making a thing of *that*). His moral opinions were pragmatic, e.g., he didn't agonize over eating meat, he just stopped because he decided it was the wrong thing to

do. He stopped skirt-chasing because he got a better offer. He was born without those hang-ups about sin and guilt and revelation that John and George had to live with. They must have envied him for that. I do. It's like a scene from Joe Orton, the playwright the Beatles commissioned to write their next movie after *Help!*, the never-produced *Up Against It*. The Irish Catholic criminal in *Loot* gets jealous at his Jewish partner's irreligiosity: "That's typical of your upbringing, baby. Every luxury was lavished on you—atheism, breast-feeding, circumcision. I had to make my own way."

I would submit that Paul's disinterest in religion is one of his great unsung gifts to the world. How frightful to imagine him with even a bit of godliness. "With a Little Luck" with a prayer in it? "Wonderful Christmastime" with a manger scene? The closest he got was "Let It Be" (though close enough to make me grateful he didn't get closer). He wasn't even tempted to fake it.

George, whose head-over-heels jump into religion certainly would have tempted any skeptic to doubt how long it would last, ended up a lifelong devotee of the Inner Light. The same fall as *Plastic Ono Band*, *All Things Must Pass* had a "God"-like renunciation of their shared history from a different spiritual perspective, "Isn't It a Pity," building to a gorgeous parody of "Hey Jude." George quoted those "na na na na"s the same way John threw the word "yesterday" into the end of "God." No wonder these two kept playing on each other's records. They were sick to death of Paul's bullshit—lifelong friendships have been built on less.

I was a passionate and dogmatic Catholic teen, and I was not comfortable with "God," to say the least. Yet it seemed more honest and therefore more devout than "My Sweet Lord"—I identified with the romantic yearning in that one,

but I identified more with the soul-searching and blasphemy of "God." If anything, "God" was too zealous for me, interrogating me about what I believed. If my faith couldn't meet the challenge of "God," then it meant my faith was a childish sentimental faith, not the real thing. If his questions gave me doubts, then I never authentically believed. If hearing one of my heroes announce "I don't believe in Jesus" made me quake, I wasn't worthy of this quest. The faith I aspired to would be one where I could confront every possible challenge and stare it down. John was a real fucking Jesuit about these things. A religious debate with him made me realize I was a boy wrestling a man.

I wanted to meet the challenge in "God," I guess, for the same reasons George wanted to play guitar on "Sexy Sadie." I had no problem with "God is a concept by which we measure our pain," but the final minutes of the song made me suspect I didn't feel these things as intensely as John did, or probe them with the same rigor. It made me feel like a lightweight, a dilettante about my own spiritual questions. It stoked my desire to demand answers from the universe (you know, *true* ones), to be more of an ascetic, to take these things more solemnly. (A lamentable influence on my insufferable teen self, but that's hardly the song's fault.)

This kind of religiosity was a sickness I had to recover from, and by my early twenties, I was the kind of John fan who wrote off "God" and all of *Plastic Ono Band* as a self-indulgent period piece, historically significant but a bit showy and teen-tantrum-y. I'm sure I didn't listen to it once in my thirties. The year I turned forty, I heard it in a bar; I was drinking beer with a friend when the bartender put on *Plastic Ono Band*. Turned out we both could remember the litany. My opinions about these names had fluctuated in the intervening years, and

while I no longer agonized over any of them, I fell hard for the song, his piano, the drums, most of all the vocal. I karaoked it for my wife, who'd never heard it and loved it. Yet "God" still makes me uneasy—I've never been as secure in my beliefs (whatever I happened to believe in, at whatever phase of my life) as John was in his disbelief.

THE ROOTS' QUESTLOVE TELLS A STORY ABOUT DRUMMING for Prince, who'd become a devoutly religious man who kept a swear jar in his studio—if you used profanity in Paisley Park, you paid a fine. When Questlove dropped a curse word, Prince demanded twenty bucks. "I was like, 'For what?' He said, 'You cussed. You can't cuss here.' I said, 'Motherfucker, do you know how much punishment I went through because of you? You *taught* me those words!' "

That's how I feel about "God." John is renouncing the whole Sixties spiritual quest that he did so much to popularize. He is the one who cast the spell he's trying to break. Even when he confesses, "I was the dream-weaver," the ache in his voice makes the dream sound lovelier than ever. John has a touch of the berserk in him, like a certain girl he used to know back in India. People go berserk in the presence of the sacred. Or the stupid. It can be hard to tell apart the sacred and the stupid—that's one of the many Beatle truisms they taught us by living out.

PAUL IS A CONCEPT
BY WHICH WE MEASURE
OUR PAIN

Paul is the most Beatlesque of the Beatles. If you dislike the Beatles, it's because you dislike Paul. If you love them despite their flaws, you mean Paul's flaws. If they're overrated, it's because Paul is overrated. Whatever problem you have with the Beatles, it's Paul's fault. That's fine—it's the essence of Paul-ness, and nobody's trying to change that, not even me. But it's a huge reason I'm obsessed with him. You can't really love Paul without facing the question of why people have such toxic feelings about him. Paul is the only Beatle anyone bothers to hate. He's the one to bring up if you're looking to start an argument. He's the most mysterious and disturbing figure in the story. Tell me your Paul McCartney and I will tell you who you are.

He was the Beatle who worked harder, got to the studio earlier, nagged them into writing their songs. He was the boss bitch who flogged three other men to live out the Beatle fantasy, after it stopped meaning that much to them. He was

the only one who never quit, right up until 1970. And then, of course, he was the one who had to quit in a big hissy fit, whereas the others exited so discreetly that nobody found out until he coaxed them back. He never found it a drag to be a Beatle, never seemed to notice that for the others, he *was* the drag. I recently heard Casey Kasem on a vintage American Top 40 from 1974 introducing a Wings song: "Here's the man who plays guitar with his left hand and counts his money with his right!" When Casey Kasem is giving you shade, you have officially convinced the world you're fair game.

Paul has a compulsive need to feed his enemies all the ammunition they could want. The software of "don't take the bait" was never installed in his system. No celebrity has ever been easier to goad into gaffes. I love that. He's still settling scores against Stu Sutcliffe, who died in 1962. We can all point to prize moments of Paul vanity on display—that's too easy—but the fact is that any other human being with his talent would have twice as much ego. *Lots* of rock stars have more obtrusive egos than Paul McCartney, and none of them wrote "Here, There and Everywhere." As Chris Rock said when asked about Lorne Michaels's arrogance, "Hey, man, I know arrogant cabdrivers." You'll meet bigger divas than Paul every day of your life. It doesn't matter. Something about him still gives otherwise calm-blooded people the urge to take him down a notch.

BECAUSE I SHARE MOST OF MCCARTNEY'S FLAWS, AND BARELY any of his virtues, I find him a threatening figure. Like many people, I love John because I respond to his strengths—smart-ass bravado, rebelliousness, spontaneity, moral will-to-power—traits I will never share. I let my more John-like friends adopt these qualities. (Every drama-queen John

needs a Paul to sweep up after him. It's tough for two Johns to be friends, which is why Johns find themselves entangled with Pauls who disappoint them.) But everything about Paul baffles me. He did less to fuck up his good luck than any rock star ever. He had the discipline to take on tasks like learning to be a husband and dad—hard work that does zero for a rock star's cool quotient. Yet he also appreciated things that came easy—he composed "Yesterday" literally in his sleep. "There's a bit of rubbish," he admitted in 1989, looking back on his songbook. "I hear some of them and I think, 'Blimey, you should finish that one someday, son.' Like my dad would say if a girl was revealing too much, 'That'll be a nice dress when it's finished.' And some of them are a bit, 'That'll be a nice song when it's finished.' "

Paul insists on seeing the job through, even when the job is pop drivel. It did him no favors with the rest of the Beatles. The cover of *Revolver*, designed by their old Hamburg friend Klaus Voorman, shows Paul pitching a bitchy face while John and Ringo smirk at him and George ignores him; the photo collage has a close-up of Paul crying like a baby. In their brotherhood anthem "All You Need Is Love," they end by singing piss-take spoofs of "Yesterday" and "She Loves You." There were moments where hating Paul was all the others had in common.

Yet when John and Yoko made *Two Virgins*, the most deliberately offensive consumer item any pop star ever released, who did they ask to write the liner notes? Paul. (He said yes.) When John and Yoko broke up in the mid-70s, who did she send on a mission to L.A. to advise John how to win her back? Paul. (He said yes.) When John cut a self-indulgent rant called "The Ballad of John and Yoko," comparing himself to Christ while accusing the audience and the government and the press of conspiring

to crucify him, who did he call in to play all the other instruments? Yes, yes, he said yes yet again. That's what Pauls do.

And complaining about Paul is what the rest of us do. That's his role in our lives. We prosecute Paul for the flaws we despise in ourselves. In real life I've always been attracted to Paul types because they don't sit around and talk about the shit they're going to do—they get it done. They're quick to say "good enough" and move on. Paul was a closer, not a tinker-forever artist like Brian Wilson, who set out to top *Sgt. Pepper* with *Smile* but failed because he couldn't tell himself "pencils down" and let go. He couldn't stop doing retakes of tracks he'd already finished. The musicians' joke at the *Smile* sessions: "Perfect, just one more." Brian had the melodies, but lacked the killer instinct. So people decided Brian was a heavier artist. There's something uncool about closers. It's hard to trust them.

Even in the early days, before Brian Epstein came along, Paul was this way. "I'd always been the keeny." He enjoyed deadline pressure. "Paul used to be the one to get everything together," Ringo said in 1970. "He'd phone us up—John and I would be sitting in the garden, he'd phone up and say, 'Well, should we do an album?' We'd say, 'Oh yeah, okay, because what are we doing just sitting in the garden? We'll go and do an album, you know.' He used to be the one to get things moving." It's not a trait that makes people like you. There's a *Scarface* "say goodnight to the bad guy" element in Paul—he stands in for sins we fear we might share, betrayals and compromises we suspect in our own lives. I totally get why people want to put him on trial for any number of crimes and convict him in absentia.

Yet this judge does not agree. And if quoting "Maxwell's Silver Hammer" doesn't prove I'm sympathetic to the prosecution's case, nothing would.

CARY GRANT IS THE MCCARTNEY OF MOVIE STARS—HIS STORY has much to tell us about Paul's. They share a spiritual connection, beyond their pronunciation of "Judy." (Paul described his "hey Judy-Judy-Judy" ad libs as "Cary Grant on heat.") They dazzled Americans as the ultimate English dream dates—yet both were self-inventions, street guys who taught themselves to pose as posh charmers. Both grew up working-class in hardscrabble industrial cities; both lost their mothers at a young age. (Grant, whose real name was Archibald Leach, was nine when he was told his mother had gone on a trip; more than twenty years later, after he was famous, he learned she was locked up in an institution and got her released.) Both dropped out of school to fight their way into the sleaziest sewers of show biz—Grant joined a troupe of traveling acrobats, which must have been an even rougher scene than the Reeperbahn—yet to them it was a world of freedom and excitement. But both found lasting fame by turning on the charm for Americans who saw them as dapper gentlemen. "Everyone wants to be Cary Grant," Grant once said. "Even I want to be Cary Grant."

Both were driven artists who preferred to come across as easygoing entertainers; they knew and respected how much the audience enjoyed the sight of them having fun. Both were early adopters when it came to psychedelic drugs. Both had a decade of phenomenal box-office success (the 1930s for Grant) and spent the rest of their long careers playing their standard role, popular even when going through the motions. Both became hardheaded businessmen. They made it look easy (and gravitated to projects where it really *was* easy), seldom letting themselves get miscast—the movie where Cary Grant plays a Virginia frontiersman in a coonskin cap is his equivalent to Paul's disco

records. Both kept a lid on their inner conflicts. As Pauline Kael says in her classic essay "The Man from Dream City," "We didn't expect emotional revelations from Cary Grant."

When I'm watching Cary Grant, I know how hard he worked to turn himself into that guy, yet the strain doesn't show; even in movies as tense as *North by Northwest* or *Only Angels Have Wings*, playing a gangster in *Mr. Lucky* or a firebrand anarchist in *The Talk of the Town*, the pose depends on devil-may-care nonchalance. That's why he isn't on the prowl for women; they're chasing him. (He got discovered by Mae West, who claimed she cast him in *She Done Him Wrong* after spotting him across the street and saying, "If this one can talk, I'll take him.") There's a story in Marc Eliot's bio where Grant refuses to play the washed-up alcoholic actor in *A Star Is Born*, the role that went to James Mason. When director George Cukor argues, "This is the part you were born to play," Grant replies, "Of course. That's why I won't." As Kael points out, "The suave, accomplished actors were usually poor boys who went into a trade and trained themselves to become perfect gentlemen. They're the ones who seem to have 'class.' Cary Grant achieved Mrs. Leach's ideal, and it turned out to be the world's ideal." Not so far from Mrs. McCartney's ideal.

"I copied other styles I knew until I became a conglomerate of people and ultimately myself," Grant said late in his life. "I played at someone I wanted to be until I became that person. Or he became me."

DID YOU KNOW PAUL SENT A TELEGRAM TO MARGARET Thatcher in 1982? He did. It wasn't friendly. He lost his temper over her treatment of health workers and fired off a long outraged message, comparing her to Ted Heath, the

prime minister (tweaked in "Taxman") felled by the 1974 coal strike. McCartney warned, "What the miners did to Ted Heath, the nurses will do to you."

This controversy is a curiously obscure footnote to his life—it seldom gets mentioned in even the fattest biographies. He doesn't discuss it in *Many Years from Now*. I only know about it because I read it as a Random Note in *Rolling Stone*, not exactly a hotbed of pro-Paul propaganda at the time. (The item began, "Reports that Paul McCartney is intellectually brain-dead appear to have been premature.") But the telegram was a major U.K. scandal, with Tory politicians denouncing him. In October 1982, Thatcher was at the height of her power, in the wake of her Falkland Islands blitz. Many rock stars talked shit about Maggie—Elvis Costello, Morrissey, Paul Weller—but Paul was the one more famous than she was. He had something to lose by hitting send on this, and nothing to gain. What, you think he was trying for coolness points? This is Paul McCartney, remember? He was in the middle of making *Give My Regards to Broad Street*. He could have clawed Thatcher's still-beating heart out of her rib cage, impaled it on his Hofner on live TV, and everybody would have said, "Yeah, but 'Silly Love Songs' though."

Why did he feel so intensely about the nurses? He didn't mention his mother in the telegram, but he must have been thinking of Mary McCartney's life and death. So he snapped, even though it was off-message. (He was busy that week doing interviews for the twentieth anniversary of "Love Me Do"— the moment called for Cozy Lovable Paul, not Angry Paul.) He didn't boast about it later, though fans today would be impressed that *any* English rock star of that generation—let alone Paul—had the gumption to send this. You can make a case that it was a braver, riskier, and more politically relevant move than

John sending his MBE medal back to the Queen in 1970. Still, John's gesture went down in history and Paul's didn't, though his fans would probably admire the move if they knew about it.

He couldn't win. He was Paul. All he could do was piss people off.

PAUL IS SOMEBODY WHO DOES THINGS WITH ENTHUSIASM, which makes people feel appalled and insulted at things he chooses to do. If you're under thirty, you have never heard of a song called "Spies Like Us," and I am a horrible person for being the one to tell you. It was the theme for a big-budget Hollywood spy comedy starring Chevy Chase and Dan Aykroyd. Nobody saw the movie, but Paul's theme was worse than the movie could have been. MTV played it constantly during the 1985 holiday season, though radio wouldn't touch it. Paul does a rap that goes something like, "Oooh oooh, no one can dance like you." In the video he plays multiple roles as members of a studio band, mugging and biting his lower lip. The drumming is where his cheeky-chappy act gets profoundly upsetting. You see this video, you're going to be depressed for at least ten minutes about the existential condition of Paul-dom. His enthusiasm makes you doubt the sincerity of his other public displays. It makes you doubt yourself. You might think it's a cheap laugh but it will cost you something.

And that's before you get to the final scene, where Paul, Dan, and Chevy remake the cover of *Abbey Road*—that's right, those three crossing the street. Really? This is what it was all for? Hanging with movie stars, hyping a spy movie? Chevy as John, Dan as George? This is what Abbey Road means to Paul?

If you want to understand the anti-Paul hysteria of the

Eighties, this video is where to go, although I can't recommend watching it. All through the decade, no shot at him was too cheap. Virtually all his fellow Sixties rockers lost their way, making records every bit as bad as "Spies Like Us" (well, almost) but none inspired this much vituperation. Even Phil Collins piled on, in the days when he was producing everyone from Eric Clapton to Robert Plant to Adam Ant. In his 1985 *Rolling Stone* cover story, he offered to take on Paul as a charity case: "He's still got it. He just needs someone to knock it out of him. I'd love to knock it out of him."

This was the state of Paul McCartney's reputation in the 1980s. Phil Collins could issue a public plea for you to let him perform emergency cred rehab.

PAUL HAD A MINOR HIT IN 1983 CALLED "SO BAD," A BALLAD he never thought was anything special (he's never sung it live). If you ever composed a melody this beautiful—trust me, you haven't—you would boast about it to your dying day. It's a lost Macca gem nobody else could have written or sung: that piercing bittersweet tune, the way his voice soars in the high notes ("there was a *paaaain*"), the ache of the chorus. The Eighties production goop is hard to stomach (from George Martin, no less), the backing vocals are appalling (always a Paul weakness), and the lyric is barely a first draft, but it's the kind of Paul melody other songwriters spent the Eighties banging their heads against the wall striving to attain— though once he caught it, he took no care to make anything of it. "So Bad" was forgotten the day it slipped off the charts, and nobody had any reason to mourn.

The music might or might not make you feel something— but the video would probably make you mad if you saw it.

He performs with a foursome in Beatle suits, on a *Hard Day's Night*-style soundstage. It's not Wings, because he'd abandoned that brand. So who's in this group? Paul, Linda, Ringo on drums, and some anonymous session guy. (Not Denny Laine—just a mulleted guitarist, nobody I recognized then or now.) All four get lip-synching close-ups, including Anono-Sesh. Something about this quartet is decidedly off. Anono-Sesh is there just to bring up the body count. Linda and Ringo belong in this video, but putting that fourth guy on camera is a con to push our Beatle buttons in the most cynical way. Paul is reassembling the Fab Four for a video, replacing George with the guy who carried his bag at the airport.

"So Bad" is an index of things Paul does better than anyone ever (write a melody, sing lovesick high notes, bat his eyes) but also the things he doesn't do well (make decisions about production, choose his supporting cast, finish the damn song). If Sting had written this tune, he would have attached it to lyrics about Nabokov and the Bermuda Triangle, rhyming "so bad" with "Stalingrad" or "*Cien Anos de Soledad*," and sung it with a smoldering frown. We would have scoffed, but we would have remembered it the next day. We would have believed it *mattered* to Sting. Not Paul.

"So Bad" is a tune that crosses my mind when I question why Paul means so much to me. I have hummed it to myself in times of trouble. But I go back and watch the video and it makes me feel like I got taken, like he went out of his way to flaunt how little he cared. It makes me wonder if I'm just a sap who gets led astray by a pretty face of a melody so easily I fall for all sorts of smarmy contemptuous bullshit from the artist, bullshit that's not an accident but a statement of all he believes in. It makes me trust Paul less and it makes me respect myself less. And that, I guess, is another reason Paul matters to me.

IN 1984, A *PLAYBOY* INTERVIEWER ASKED PAUL ABOUT A TOPIC he rarely discusses, his eight-day stay in a Japanese jail cell for marijuana. Paul's exact words: "It was hell. But I only remember the good bits." Then he tells some cute stories about the brighter side of being locked up in a Tokyo prison, i.e., what he's just called hell. How do you even begin unpacking this statement? At what point does a commitment to niceness become the kind of mentality that refuses to remember anything but pleasant memories of prison? And at what point does this stop seeming like a pitiful evasion and turn into some kind of admirable emotional discipline?

"I'd seen *Bridge on the River Kwai*; I knew what you had to do when you were a prisoner of war! You had to laugh a lot and keep cheery and keep yourself up, 'cause that's all you had. So I did a lot of that." Is he still talking about his jail term—or his career?

THESE DAYS, PEOPLE LIKE TO COMPLAIN ABOUT DAVE GROHL the way they complain about Paul McCartney. Both got famous in bands where they played with a tortured genius who died young, and both moved on to long careers where they were almost freakishly untortured. You can count on them to say kind words about whoever just died or whoever's getting a lifetime-achievement award. Paul jammed with Grohl (and the other surviving Nirvana members) at the 2012 Hurricane Sandy benefit, playing the new song they'd written together ("Cut Me Some Slack") along with a fantastic set of Beatle oldies. They won a Grammy, and it was so strange seeing them smile up on the podium together. Both pride themselves on being bandleaders, going to ridiculous lengths to pretend

there are other people in their groups. (It's easier to think of a third Wing than a second Foo Fighter.) They're not haunted by whatever tormented their edgier (but not as nice) (and definitely dead) bandmates. We hold it against them.

THE ANTI-PAUL HYSTERIA ABATED IN THE 1990S. HE TOOK A few years off after 1989's *Flowers in the Dirt* (a good one— not a hit, but a cred move containing quality Elvis Costello collaborations, superior to the ones Costello recorded). He stopped aiming for pop hits, made smaller-stakes music on his own quirky terms. Some records turned out better than others: *Off the Ground* quite rotten, *Flaming Pie* and *New* and *Chaos and Creation in the Backyard* quite excellent. One of my favorites is *Run Devil Run*, from 1999, the year after Linda died, dismissed as just a bunch of oldies covers—but he's doing songs that remind him of her, songs they shared, songs that filled his young head with promises Linda ended up keeping. It's an intensely emotional album of mourning, a concept album about widowhood as powerful as Yoko's *Season of Glass*. But who wants intense emotion from McCartney—or even notices when it's there? Nobody bought *Run Devil Run*, played it on the radio, or paid any attention at all, and for all we know that's how Paul wanted it.

He still writes great songs, though these are useless in career terms. It's not like he needs them for his tours; nobody buys a ticket thinking, "Gosh, I hope he plays three or four songs I've never heard." But for him, pop is about right now. He loves the chance to jam with Kanye and Rihanna at the Grammys, or Taylor Swift at the *SNL* afterparty. He made headlines when he couldn't get past the velvet rope at Tyga's 2016 Grammy bash (he didn't have a VIP wristband). When security turned

him away, he turned to his entourage—Woody Harrelson and Beck—and quipped, "We need another hit, guys." He loves the frantic forward motion of pop, the ruthless push on to the next one. In the 1970s, he stuck up for the latest bubblegum teeny-bop bands, even though it was the opposite of what he *should* have said to win his cred back. Paul in 1974, defending the Bay City Rollers or the Jackson Five or maybe the Osmonds: "I always thought, just great, great band, great things, kids screaming, fantastic, fabulous, great, everyone's having a good night out. That sort of thing, basically."

Something about Paul will always make people suspicious. In his twenties, he faced a menu of infinite choices for how he could spend the rest of his life; it was the free-love boom, a boom he'd done quite a bit to create. What he chose to do was marry Linda, raise some kids, and stay uncomplicatedly in love with her through the entire Players Only Love You When They're Playin' era. They never spent a night apart until the week he went to jail. Paul selected a life, closed the menu, and then lived the fuck out of that life without worrying his pretty little head about the other adventures he could be chasing. That's not just rare, it's insane. It is not what you or I would have done. His friends probably felt sorry for him. He brought that same level of follow-through to music. He was writing great songs in 1963—"All My Loving"—and he was still writing great songs fifty years later, like "Queenie Eye." He did a marvelous version of "Queenie Eye" at the Grammy Awards a few years ago, with Ringo on drums, plus the poignant sight of Yoko and Sean dancing in the audience.

I saw his latest tour in the summer of 2016, at a Washington, D.C., hockey rink—just exalting, even by Paul standards. He played three hours, three or four dozen songs, Beatles hits, Wings B-sides, capping it all off by playing Side Two of *Abbey*

Road. The nice lady at the box office upgraded me to a floor seat just because she was amused to see me singing along with the Wings song playing over the speakers before the show, which was "Junior's Farm." (A flier in the lobby: "No Selfie Sticks, GoPros, Containers, Projectiles, Album Covers." Album covers?) He hit the stage with "A Hard Day's Night" and didn't let up. He did "Love Me Do" as a tribute to the just-departed George Martin. He sang "Here Today" for John, "Something" for George," "Maybe I'm Amazed" for Linda, "Foxy Lady" for Jimi. That's some serious baggage—playing your songs every night is hard work, but it must be even tougher when you carry the weight of so many dead friends with you. Especially when your taste in friends is pushy bastards who give you no peace, not even when they're gone. He sang "My Valentine" for his wife Nancy (who was there) and "4-5 Seconds" for Rihanna and Kanye (who weren't). He worked so much harder than he had to, it was slightly scary.

Did he push it just a little too far? Of course he did—he sang "Mr. Kite" as another John tribute, casually mentioning how he helped John write it. Really? You can't even let him have this one? You want to arm-wrestle a dead guy over "Mr. Kite"? But maybe that's part of why Paul keeps putting himself through this every night—the dead friends you keep arguing with are also the ones who make you feel alive. So he made his claim on "Mr. Kite," knowing it would piss people off. What else could he do? He's Paul.

WHEN GEORGE SANG "IN MY LIFE"

(1974)

Few sounds can traumatize a fan's ear quite like George Harrison singing "In My Life," on his 1974 tour. It should have been a warning sign when he began his first solo tour with the announcement, "Having played with other musicians, I don't think the Beatles were that good." Or when he said, "The biggest break in my career was getting into the Beatles in 1963. In retrospect, the biggest break since then was getting out of them." But who wanted to notice warning signs? People were looking for any glimmer of hope. As Scott Miller of the band Game Theory helpfully wrote, explaining the 1970s power-pop of artists like Badfinger and Todd Rundgren, the Beatles seemed more *over* than they do now, further away than they'd ever seem again. Billy Joel sang on *Turnstiles* about a depressed woman who sits around asking why the Beatles can't get back together, and in the Seventies, many people were asking that.

You can hear that melancholy in the bootlegs from George Harrison's live shows—his first proper tour since they waved good night at Candlestick Park in 1966. In the years after the breakup, he looked like the one who had shit figured out. While John and Paul bickered, he serenely scored Number One hits about Krishna ("Give Me Love" even more exquisite than "My Sweet Lord") and organized the concerts for Bangladesh. He also won custody of Dylan in the Beatle divorce, which had to be galling for the others. Now he was hitting the road for two months, with a band of pedigreed pros, Billy Preston on organ and Ravi Shankar's orchestra. Unfortunately, he wasn't up to it, physically or emotionally. His voice was shot from brandy and cocaine. He kept fiddling with the lyrics, singing things like "while my guitar gently smiles" and "something in the way she *mooooves* it." But the most painful moment had to be when he sang "In My Life," only to revise the words: "In my life, I love God more."

Each night's "In My Life" is horrifying in its own way—slow, sludgy, half-loud reggae, jazzy marimba, horns, the world's smarmiest version of the *Saturday Night Live* good-night theme. It's unrecognizable for the first minute, until George begins singing, and you can hear the crowd wake up—hey, *this* one. Suddenly there's an audience in the room. The excitement is electric—it ripples through the air. It lasts for a couple of lines, and then there's an audible chill. He can't sing it. His pipes choke on the low notes ("though some," "compares") or high notes ("not for better," "never lose affection," "lovers and friends"). For the big climax, he rasps, "I love God more." It's like he summoned up an intimate memory for the fans just to tell them it doesn't mean shit to him.

As the tour rolls on, his vocals get wheezier—by the Toronto gig on December 6, he can barely pronounce "places"

or "remember" in the first line. He toys with the words—now it's "people and things I can't recall," then it's "people and things that came and went." He gets cheers when he introduces Billy Preston to play the organ solo. He ends with a benediction: "God bless John, Paul and Ringo, and all the ex-ex-ex-ex-exes." (Some nights it's "ex-ex-exes," other nights it's just "ex-wives." In Seattle, he says, "That was a personal, really, for John Lennon, who wrote that one, because I really love him. He's all right, he's a lumberjack.") It would be one thing if George sounded cynical or dismissive, but he's really trying—this song matters to him. He's coming to terms with his history, but for the renunciation scene to work, he has to perform "In My Life" semicredibly, or even semicompetently, and at the moment it's beyond his ability. All he can do is stand onstage with a sign around his neck saying "This is George Harrison, and I'm about to sing a Lennon-McCartney song, about as well as any random audience member could, even the slob next to you who passed out in a Boone's Farm puddle halfway through 'For You Blue.' "

Every night, he turned over stage time to Preston (who sang his own solo hits) and Shankar (who took over for long orchestral interludes). He complained bitterly about the audience, who got restless during the Shankar sets, and gave stern antidrug lectures. "I didn't force you or anybody at gunpoint to come to see me," he snapped in one press conference. "And I don't care if nobody comes to see me, nobody ever buys another record of me. I don't give a shit." It was the first night of the tour.

It was a terrible time to be George. Patti finally left him for Clapton, a messy split in public. ("In public" doesn't cover it—there's public and then there's "Layla.") He'd sought consolation by having an affair with (of all people) (really, of all people,

instead of the billions of other people on earth) Ringo's wife, Maureen. The drugs didn't help his mood swings or voice. To make it all more of a nightmare, the tour was dogged by Allen Klein's process servers. His new album was *Dark Horse* (or as Robert Christgau waggishly retitled it, *Hoarse Dork*), with the instrumental theme "Hari's on Tour" and a miserable version of the Everly Brothers' "Bye Bye Love" that featured both Clapton and Patti. His religious beliefs did not seem to comfort him. A year earlier, he sang about feeling trapped on Earth, but with a kind word for old friends: "Met them all in the material world / John and Paul here in the material world." Now even that spirit seemed out of reach.

When the tour reached New York, George asked John to join him onstage at Madison Square Garden. John had done it for Elton the week before, so he couldn't refuse—but it wasn't a corker of a time to be John, either, with his mind and marriage in tatters. Since Paul was in town, the three set up a meeting at the Plaza to sign legal documents—the papers formally dissolving the Beatles. But John didn't show. As he explained, "My astrologer told me it wasn't the right day." Instead, he had balloons delivered. George yelled into the phone, "Take those fucking shades off and come over here, you!" Needless to say, John didn't make it onstage that night. He attended the end-of-tour party, along with Paul and Linda. The next day, he flew to Disney World to spend Christmas in the company of his latest temporary father figure, a mobster associated with the Genovese crime family (and son Julian, and new girlfriend May Pang). He ended up signing the dissolution papers at Disney's Polynesian Village, which made as much sense as any other locale. Everybody had a hard year.

George didn't tour again for seventeen years, until a brief

1991 Japan stint with (who else?) Clapton. His 1975 album *Extra Texture* had a bitter song about the Dark Horse Tour, "This Guitar (Can't Keep from Crying)," where he complained that the audience and press missed the point, which was that he needed love. People really did love George and wanted him to be happy, yet the sound of a happy George was a sound he held back, because he thought it was beneath them as well as him. I listen to a song like "Give Me Love," and there's a kindly strength behind his wah-wah, as if he's one hippie dad willing to live his ideals and shepherd this world he feels so sorry for. Whatever sanctimony you might hear in this song (I don't hear any myself) there is no phoniness and no stinginess in the peace he wishes upon the world. No ego trip, either—he's just a musician doing his job, and a believer pestering his god to put in a word for the rest of us. That's why the parenthetical subtitle is all wrong—"Give Me Love (Give Me Peace on Earth)" seems greedy, in a way that doesn't suit the modest beauty of the music.

"Give Me Love" was a hit around the same time as Cat Stevens's "Morning Has Broken," a superficially similar hippie-dad prayer, yet I violently hated "Morning Has Broken," just hated it, despised the choked sobs and prissy whispers, still hate it, because it sounded to my ears (and might still sound, if I had the stomach to investigate) like a phony version of what "Give Me Love" does for real. All four Beatles were surrogate dads to Seventies kids, which partly why we fantasized about them so much, and if George was the dad who's perpetually disappointed in you, "Give Me Love" is a song that did and still does make me fantasize about what a world fathered and raised by George might look like. Yet it's the kind of song George distrusted—a song that could get people's hopes up, making promises he was scared he couldn't keep.

THE SEVENTIES WERE DIFFICULT. IT'S CURIOUS HOW MANY obscure artifacts the Beatles created in the wilderness years. Did you know John directed a movie? He directed several, actually. John was one of the world's most famous people when he made a film called *Self Portrait*, which is nothing but a fifteen-minute close-up of his semierect penis. "My prick, that's all you saw for a long time," John said, summarizing the plot. "The idea was for it to slowly rise and fall—but it didn't." It seems strange to think that John made a movie starring his penis, yet the only reason anyone remembers is Yoko complaining, "The critics won't touch it."

That was something all four ex-Beatles had in common. They were surprised it was so much work. Didn't this used to be simple? Didn't "I hope we passed the audition" used to be a joke? They had to invent the "solo career" as they went along, sweating harder for slighter results, no longer able to blame their failures on one another. McCartney kept recording prolifically and at first so did the others, but they found it a challenge without him spurring them on. And since it wasn't as pressing as other personal challenges they faced, music stopped being a priority. Writing new songs must have felt like Father McKenzie darning his socks in the night when there's nobody there. They felt the pain of Fred Kaps—the magician who had to follow them on *The Ed Sullivan Show*. As a great man sang, it don't come easy.

The Beatles suffered their Seventies ups and downs on separate schedules, making music that resisted fans' best efforts to turn these records into either hits or cult items (though the fans often turned the trick anyhow). As a result, the solo music remains a vast and mangy mess. They made acclaimed albums (John's *Plastic Ono Band* and *Imagine*, Paul's *Band on*

the Run and Ram, George's All Things Must Pass) and others just a notch or two below (John's Double Fantasy and Milk and Honey, Paul's Venus and Mars and Chaos and Creation, George's Material World, and can't forget Ringo). Every fan would nominate a few other pet faves. (I'll grant you the Traveling Wilburys if you'll grant me Wings' Back to the Egg, and can I get an amen for Beaucoups of Blues?) Several years into the twenty-first century, the rock world collectively decided Paul's 1980 nonhit "Temporary Secretary" was a masterpiece, and it says something that a song like that could remain hidden so long before turning into a cult item.

In a heart-shredder scene from Richard Linklater's Boyhood, divorced dad Ethan Hawke makes a mixtape for his son, culling the best songs from the solo records into The Black Album, to explain how divorce works and how love will tear you apart. "Basically I've put the band back together for you," Ethan Hawke tells his son. "They were just twenty-five-year-old boys with a gaggle of babes outside their hotel room door and as much champagne as a young lad could stand. How did they set their minds to such substantive artistic goals? They did it because they were in pain. They knew that love does not last. They knew it as extremely young men."

Part of the poignance is that every fan would compile a different Black Album. Mine would be different from Ethan Hawke's, because I wouldn't let "Mull of Kintyre" anywhere near it, but like his, mine would be a labor of lifelong love. I'd have too much John ("Oh Yoko!," "I'm Steppin' Out," "Oh My Love," "New York City," "Nobody Told Me") and too much Paul ("Jet," "Friends to Go," "Flaming Pie," "Too Many People," "We Got Married," "Simple as That," "Hi, Hi, Hi," "You Gave Me the Answer"). Probably also too much George. How much solo Ringo do you need? I happen to

have exorbitant Ringo needs. His last album had the wonder-ful "Rory and the Hurricanes," a landmark because after de-cades of songs about being a Beatle, Ringo devoted a song to his second-most-famous band. Part of Beatles fandom is liv-ing with these fragments and dreaming up ways to fit them together—even though their brokenness is what gives them meaning.

The Beatles couldn't cut it as Seventies celebrities. They flunked the course of obligatory stupid rock-star misbehavior. Sure, there's John's L.A. "Lost Weekend" binge with Harry Nilsson, the night he drank too many Brandy Alexanders and got thrown out of the Troubadour with a tampon on his head. Yet this story is famous only because (1) it happened to a Beatle, and (2) it happened once. It would have been a slow night for John Bonham or Keith Moon or Steven Tyler. (No-body was even wearing the tampon at the time.) The Stones or Zeppelin or Rod were gathering material, so every night they spent out on the tiles meant another "Star Star" or "Hot Legs" or "The Wanton Song." But the former Beatles, like Dylan, looked out of place in the fleshpots, for better or worse; no-body wanted to hear them sing about groupies, and it's a trib-ute to their integrity they didn't try, though Ringo's "You're Sixteen" remains a career peak, and one of the most morally unacceptable Number One hits of the rock era.

The Beatles broke up while they were still young, so they did not share a decline phase together. There are no bad Seven-ties collective Beatles albums, the way there are bad Seven-ties Stones and Dylan and Neil Young albums. That's a loss, in a way. They didn't pad out their catalog with the flawed oddities fans cherish later. They never made an "is this sloppy Seventies burnout crap or is it great?" album like *Tonight's the Night* or *Desire* or *Black and Blue*. They never made an

"is this overproduced Eighties synth crap or is it great?" album like *Trans* or *Infidels* or *Undercover*. They never did a divorce saga like *Blood on the Tracks* or *Some Girls* or *On the Beach*. They never tried a cheese-pop sellout move as comical as "She Was Hot" or "Tight Connection to My Heart" or "Kinda Fonda Wanda." They never did a grizzled resurgence like *Ragged Glory* or *Tattoo You* or *Love and Theft*. We'll never know what it would have been like to see a new Beatle album in the racks—pastel suits on the cover, recorded in the Bahamas—and think, "Good Lord, *another* one?" We missed out on a lot.

A TOOT AND A SNORE IN '74

(1974)

The John/Paul love/hate relationship took many strange turns. One of the strangest is documented on the bootleg *A Toot and a Snore in '74*, where they hang out in a Burbank recording studio in March 1974, during John's "Lost Weekend" after Yoko kicked him out. Paul on a mission from Yoko to convince him there is still hope for the marriage. It was the first time they'd met in three years—John was in the studio producing Harry Nilsson, when Paul and Linda dropped by. John broke the silence: "Valiant Paul McCartney, I presume?" Paul replied, "Sir Jasper Lennon, I presume?" They had quite the jam session—Stevie Wonder joined in, along with Nilsson, guitarist Jesse Ed Davis, sax man Bobby Keys, Linda on organ, May Pang on tambourine. Ringo and Keith Moon had just left the building, so Paul sat behind Ringo's drum kit. For John and Paul, it was their last time in a studio together.

John offers Stevie Wonder some nose candy—"You want a snort, Steve? A toot? It's going round" (Stevie doesn't accept.)

They bash through some oldies: "Lucille," "Stand by Me," "Sleepwalk," etc. John's in a cantankerous mood, complaining about everybody else's playing ("Somebody's gotta be bossy, right?"), the engineers, and the equipment. "If somebody knows a song that we all know, please say so, because I've been screaming here for hours. It's gotta be a song from the Fifties, or no later than '63, or we ain't gonna know it." He keeps calling for more booze, though even Stevie could see this man's had enough. "Somebody think of a friggin' song. I've done 'Ain't That a Shame' in twenty studios on these jam sessions."

Millions of people around the world would have been thrilled to know this meeting was taking place—but it's better they didn't know, because nothing came out of it but a sloppy tape of two former Beatles, flying on their different drug cocktails, bumbling through songs they're not in shape to perform. Stevie and Harry do a couple of verses of Sam Cooke's "Chain Gang." The only time John and Paul really click is on "Stand by Me," and no matter how drunk or out of tune they are, it definitely bruises your heart to hear them sing this song together. "Anybody who gets bored with me, take over," John announces as he begins playing the riff. They stretch it out to six minutes, trading off lines, calling the words "stand by me" to each other from across the room. "Okay, let's not get too serious," John says. "We're not getting paid. We ain't doing nothing but sitting here together."

John and Paul spent so many years estranged—but the harder they tried to pull away to their opposite corners, the more they resembled each other. Paul had a peculiar Number One hit in the Seventies with "Silly Love Songs," which is not a love song. At its heart, it's the same as John's "Revolution"—a rant against an unseen "you" who thinks he knows what's best for the People. "Silly Love Songs" might have been aimed

at John—the ideologue who thinks the People are fed up with pop bon-bons—just as "Revolution" was a reaction against everything Paul stood for in John's eyes. (Not that Paul was a Maoist agitator, just a pushy and hard-to-please guy who tried to tell John what to do, and he won't stand for that.) But the songs are blood brothers, as their authors are. Both are in favor of love but squeamish about the details, which is why "Silly Love Songs" isn't romantic any more than "Revolution" is revolutionary. Neither is much of a song—yet both are immensely likable, if you have any fondness for these two men.

"Revolution" is John making a statement, though the statement is he's making a statement. He condescends to rock, just as "Silly Love Songs" condescends to pop, pandering to clichés (screaming guitar equals masculine rock authenticity), though paradoxically "Revolution" is the conventional three-minute verse-chorus-verse pop tune, while "Silly Love Songs" wanders on for a bizarre and very unpop six minutes. Paul was passionate about music-making, which is different from being passionate about music. So he dabbled in protest songs out of formal curiosity, the way he tried disco or reggae. Hence "Give Ireland Back to the Irish," on the 1972 Bloody Sunday massacre that also inspired John's "Luck of the Irish" (as well as a more famous U2 song). He really sticks it to the Man: "Great Britain, you are tremendous, and nobody knows like me / But really what are you doing in the land across the sea?" He knew he wasn't good at that sort of thing. Here are the liner notes (complete) he wrote for his album *Venus and Mars*: "Rock on lovers everywhere, because that's basically it."

For John, songs weren't enough unless they expressed a big idea; for Paul, pop *was* the big idea. He cranked out songs without sweating what they meant; one journalist noted he rarely went to the lavatory without bringing his gui-

tar. As Lennon snapped in 1980, after getting asked one too many times if they still spoke, "He's got 25 kids and about 20,000,000 records out. How can he spend time talking? He's always working."

"Revolution" is a song people still turn to for a jolt of facile significance. Rascal Flatts did a country version a few years ago—guess there must be Red Guards in the streets of Nashville, collecting donations for People with Minds That Hate. The Thompson Twins covered it at Live Aid—after "Hold Me Now," a silly love song for the ages, they did "Revolution," changing it to "We all wanna feed the world." But I swear unto my new wave ass, nobody with a Thompson Twins haircut should order anyone else to change their head. I remember how pissed Tom Bailey looked sneering about "Chairman Mao"—I doubt half the audience could have given an answer who Mao was. Yet John had nothing to say about revolutions—he just argues that radicals aren't pop enough. He doesn't say supporting dictators is right or wrong—he argues it's bad PR to admit it because you won't "make it with anyone," and it's an activist's job not to offend people. It's an argument he might accuse Paul of making.

But unlike "Revolution," "Silly Love Songs" is a songwriter standing up for a cause he believes in—a strident defense of dippiness. It spent five weeks at Number One in the summer of 1976, a banner year for pop trash: "Silly Love Songs" joined the ranks of Bicentennial chart-toppers like "Play That Funky Music," "Disco Duck," "Boogie Fever," "A Fifth of Beethoven," "Afternoon Delight," and "Shake Your Booty." Now that's a squad worth fighting for: When you talk about K.C. and the Sunshine Band, don't you know that you can count me in? But 1970s pop trash was stranger than Paul realized. According to the charts, the People were into songs

about streaking, kung fu fighting, doing the hustle, CB radio, muskrat love, cruising at the YMCA, sniffing pots of glue, and killing the entire city of Chicago. Silly death songs were big; *Billboard*'s biggest hits of 1976 included "The Wreck of the Edmund Fitzgerald" (toll: 29), "Don't Fear the Reaper" (toll: 40,000 men and women every day), and "Love Rollercoaster" (as every Seventies schoolkid knew, you can hear an actual homicide at the 2:32 point).

John didn't score his first Number One hit until 1974, the fourth Beatle to reach this milestone (Ringo beat him twice), but he got over with "Whatever Gets You Thru the Night," with a big assist from Elton John. It's not a famous song anymore, for the understandable reason that the final line is "Don't need a gun to blow your mind." After December 1980, "Whatever Gets You Thru the Night" dropped off the radio and hasn't been heard since. But the most shocking thing isn't the gun line—it's the lush pop feel. The song it really resembles is the Wings hit "Listen to What the Man Said," with the same yacht-rock studio sheen. Both serve love-is-the-answer platitudes, though attractively warmhearted ones: "Whatever gets you to the light, 'sall right" vs. "I don't know but I think love is fine." Both hit Number One, for just one week. John's sax solo is Bobby Keys, Paul's is Tom Scott, though they could have traded places without anyone noticing. Yet I loved both songs as a boy, and still do—Elton, always the kindliest-sounding of rock megastars, sings on John's hit, and sounds like the guiding spirit of Paul's, as if he's a yenta nudging them together.

If all you knew of Lennon-McCartney were these chart-toppers (one in November '74, one in July '75) you'd never guess the singers were supposed to be yin-and-yang opposites, much less sworn enemies. But Elton beat them both in January 1975, scoring a bigger smash than either "Whatever Gets You

Thru the Night" or "Listen to What the Man Said": "Lucy in the Sky with Diamonds," starring the world's cokiest reggae xylophone solo. Elton's version was pure drug-fiend drag-queen lysergic burlesque—and it spent two weeks at Number One, marking *Sgt. Pepper*'s one and only visit to the U.S. Top 40. As it turned out, the pop world the Beatles left behind was so rowdy, neither John nor Paul could make any sense of it. The wonder of it all, baby.

ROCK 'N' ROLL MUSIC

(1976)

I n the summer of 1976, a double-vinyl Beatles anthology called *Rock 'n' Roll Music* becomes a smash, and nobody can explain why. It's all fast ones, heavy on the early days, nearly half nonoriginals, no psychedelia, no ballads, with a hideously cheesy *Happy Days/American Graffiti* Fifties-style cover. Capitol releases "Got to Get You into My Life" as a single and it makes the Top Ten, staying on the charts longer than any of the Beatles' original singles except "Hey Jude." The American kids who dig Foghat and Aerosmith love *Rock 'n' Roll Music*. The ex-Beatles themselves are aghast. They hate the packaging. They can't understand why kids want to buy it. They figure it's probably a fluke. They're wrong.

Rock 'n' Roll Music is forgotten today, but it's the defining Beatle artifact of the 1970s. It was a bold statement of the Beatles as something that belonged to Seventies kids—a vision where the Sixties never happened. I mean, look at that silver-foil cover: a cartoon of the moptops, under the kind of

neon logo you'd see on a TV ad for any fly-by-night "Not Sold in Any Store" oldies collection. Since *Happy Days* was the biggest thing on TV, *Rock 'n' Roll Music* sold them as musical Fonzies. The gatefold sleeve has a jukebox full of 45s, a '56 Chevy, Marilyn Monroe on a drive-in screen, cheeseburgers, palm trees. Even Ringo wondered what the hell was going on. "All of us looked at the cover of *Rock 'n' Roll Music* and could hardly bear to see it," he complained at the time. "You'd think we'd get a hand in the way we're recycled . . . I'd like some power over whoever at EMI is putting out these lousy Beatles compilations." When Ringo feels degraded, you know things are out of hand. As he fumed to *Rolling Stone*, "The cover was disgusting. It made us look cheap and we never were cheap. All that Coca-Cola and cars with big fins was the Fifties."

Something else you can see on the cover—the fingers of a kid clutching the record. This artifact already has our fingerprints on it—John Lennon is quite literally under the fan's thumb—adding to the cheesoid populism. *These are not your big brother's Beatles*, the cover says. *Hold them proudly in your young American hands.* (A boy's fingers, it seems—short nails. Whoever did this cartoon sucked at drawing knuckles.) *Your brother won't lecture you on the proper way to hold an LP so you don't leave thumb smudges on his prize Yes and Tull and Floyd vinyl. These are your Beatles. Grab them.*

Oh, the actual music? Rock and roll, remixed by George Martin to sound even bigger. The twenty-eight tunes come in loose chronological order, from "Twist and Shout" to "Get Back." It skips obvious hits (no "Day Tripper," no "I Want to Hold Your Hand") in favor of deep cuts like "Any Time at All" and "Bad Boy." It was the first album to include "I'm Down." Side Two is all covers, while the post-'67 material

gets crammed onto Side Four ("Back in the U.S.S.R.," "Helter Skelter," "Hey Bulldog"). Nothing from *Sgt. Pepper.* The only notable cover missing is "Please Mr. Postman," but to make up for it in terms of sexual politics, there's "Boys" and a Little Richard song about a drag queen ("Long Tall Sally").

Rock 'n' Roll Music makes a sophisticated argument about the Beatles' expansive revisionist concept of rock and roll, from the Shirelles to rockabilly to Motown. But it's understandable Ringo got steamed—there *was* something tauntingly "cheap" about it. (Cheap Trick was the name of a Midwestern bar band still a few months away from their debut, full of Beatle tributes like "Taxman, Mr. Thief"—exactly the sort of record *Rock 'n' Roll Music* fans were primed for.) It sold the Beatles to kids who didn't remember the Summer of Love, a generation neither the band nor their fans were so sure they wanted to embrace. It must have seemed like a dumbed-down Gerald Ford sacrilege, barbarians crashing the party. It was no coincidence Capitol released it just a few months after the lurid (and hugely popular) TV movie of *Helter Skelter,* which depicted the Spahn Ranch gang listening to Beatle songs (remakes, not the originals) and pushed the White Album back onto the charts. "Helter Skelter" was the flip side of the "Got to Get You into My Life" single; you had to suspect Capitol was tempted to make it the A-side but suffered a spasm of conscience.

Rock 'n' Roll Music didn't fit the narrative of what the Beatles were about. But if you were a kid coming to these songs fresh, with no baggage about what you were supposed to like, "Bad Boy" did not sound like blown-off filler, but a shredding John vocal—"Now junior, *behaaaave* yourself!" I loved hearing John sing about this delinquent, especially the line, "He buys every rock and roll book on the magazine stand." (I was

never going to be any good at terrorizing teachers or breaking windows, but if reading books counted in the John lifestyle, there was hope for me.) It wasn't the first time Marilyn smiled on a Beatle record, but where the *Pepper* cover held a knowing joke about sleaze Americana, this was actual sleaze. According to Ringo, "John even offered to do a cover. But they refused. I mean, John has more imagination than all those people at Capitol put together." What Capitol knew how to imagine was all the people buying new packages of previously released material, but with *Rock 'n' Roll Music*, they created (however unwittingly) a new phenomenon that broke off from the flame-keepers, a sign that the music had taken on a new life.

Ringo had a new record in the shops—*Ringo's Rotogravure*, featuring the perky "Cookin' (In the Kitchen of Love)," a song whose awfulness could only be enhanced by the fine print with the songwriter credit, "J. Lennon." Virtually nobody who liked *Rock 'n' Roll Music* noticed *Ringo's Rotogravure*. Poor John—he had just released his own *Rock 'n' Roll*, also with Fifties oldies and a neon cover, but it flopped. The defeat was there to hear in *Rock 'n' Roll*, as John approached these songs with the exasperation of a man who'd popped his quarters into a snack machine, didn't see his candy bar, and started kicking the machine. He wasn't doing an oldies revival; it sounded like the oldies were fighting to revive him.

Paul could boast that he was the only artist big enough to block the Beatles from the Number One spot—*Rock 'n' Roll Music* spent weeks at Number Two, stuck behind *Wings at the Speed of Sound*. He was on his Wings Over America tour, slipping Beatles classics into his set for the first time. The cover of *Time* proclaimed "McCartney Comes Back!" The Christmas 1976 triple-vinyl *Wings Over America* was his big arena-rock move—packaged to look like a 747, with a ten-minute open-

ing fanfare, guitar jams, and way too many showcases for the backup gimps. When Denny Laine croaks a Simon & Garfunkel cover, you can practically hear the fans stampede for their bathroom weed break.

1976 was also the year Lorne Michaels made a personal appeal on *Saturday Night Live*. "Please allow me, if I may, to address myself to just four very special people: John, Paul, George and Ringo, the Beatles. Lately there have been a lot of rumors to the effect that the four of you might be getting back together. That would be great." To lure them onto the show, Michaels presented a check. "If it's money you want, there's no problem here. The National Broadcasting Company has authorized me to offer you this check to be on our show. A certified check for $3,000. Here it is, right here. Dave, can we get a close-up on this?" The check was made out to the Beatles. "You divide it up any way you want. If you want to give Ringo less, it's up to you. I'd rather not get involved." Lorne went back on the air a few weeks later to sweeten NBC's offer to $3,200. Don Pardo chimed in to offer the band free hotel accommodations at the Crosstown Motor Inn. "They'll be treated like royalty as pitchers of ice water are hand-delivered to their rooms, and they can drink that water from glasses sanitized for their convenience!"

As everybody found out years later, John and Paul were watching together that first night, at the Dakota, with Yoko and Linda. For a minute they talked about grabbing their guitars and heading downtown to join the fun. "We nearly got into a cab," John said. "But we were actually too tired."

ROCK 'N' ROLL MUSIC GOT QUIETLY ERASED FROM HISTORY IN the fall of 1980. Capitol found a clever way to make the stink

go away—they changed the artwork to a sepia-toned portrait that made it look respectable, even tasteful, and therefore worthless. The Seventies were over and there was no longer any percentage in pitching the Fabs to the Kiss Army. But it was too late to put that splattered eggman back together again. *Rock 'n' Roll Music* had proved the former Beatles and the kids had opposite agendas. We wanted more Beatles, and if they wouldn't carry on, it was up to us to make up our own canons, using unauthorized, semiauthorized, and downright fraudulent versions of the story.

Capitol got the message and released *Love Songs*, for the sensitive big sisters of kids who bought *Rock 'n' Roll Music*, thus dividing the catalog neatly into "songs that rock" and "songs about girls." *Love Songs* was all originals except Buddy Holly's "Words of Love," with a mock-leather earth-tone cover and embossed gold lettering. I still play my copy of *Love Songs*, even if it cheats on the concept; only a perv from the motor trade thinks "She's Leaving Home" is a love song. *The Beatles at the Hollywood Bowl* came out in the summer of '77. That year also had the cruddy-sounding *Live! at the Star-Club in Hamburg, Germany; 1962*, one of the decade's most annoyingly punctuated titles. If you had the patience to listen, you could tell they were phoning it in—by 1962 they were getting attention back home and no longer jazzed about Hamburg. The Beatles tried to block its release, as they did with *The Beatle Tapes*, surprisingly replayable interviews with the BBC's David Wiggs, beloved by Ringophiles since he comes off as the Smart One. Even in July 1970, Ringo's deflecting queries about a reunion. "We'd have to get all that makeup on—high-heeled sneakers! I'm not shaving me beard off for anyone. Maybe I'll just have it dyed gold." At one point, he gets pushed about when all four will play together again.

RINGO: There's no answer to that.
INTERVIEWER: It's in the lap of the gods?
RINGO: No, we're the gods.

They were confused gods, though, which was why they made perfect gods for the Seventies. Their art had meant collaborating with an audience, but the audience kept expanding in ways they didn't recognize. The canonical sets became *1962–1966* and *1967–1970* (colloquially known as the Red and Blue Albums), compiled by Allen Klein in 1973. The early Seventies were a gold rush for double-vinyl samplers from Sixties heavyweights—the Stones' 1971 *Hot Rocks*, the Kinks' 1972 *Kink Kronikles*, the Doors' 1972 *Weird Scenes Inside the Gold Mine*, the Beach Boys' 1974 *Endless Summer*. Best of all: Bob Dylan's 1971 *Greatest Hits Volume II*, with virtually no hits, just deep cuts chosen by the artist. It made me a lifelong Dylan fanatic, just as *Hot Rocks* got me and everyone I knew into the Stones. Yet *Hot Rocks*, like the Red and Blue albums, was assembled by Klein, and happened only because the Stones (like the Beatles) were foolish enough to toss him the keys to their life's work. Given Klein's reputation, it's worth noting these albums remained so popular because they gave generous value for money, with iconic artwork and long running times. Side One of *1967–1970* is up there with Side Three of *Hot Rocks* in the annals of great vinyl sides. ("Strawberry Fields," "Penny Lane," "Sgt. Pepper," "With a Little Help," "Lucy," "A Day in the Life," and "All You Need Is Love" vs. "Jumpin' Jack Flash," "Street Fighting Man," "Sympathy for the Devil," "Honky Tonk Women," and "Gimme Shelter." Damn.) For the Beatles, it was just another rip-off repackage. "Christ, man, I was there," Ringo said in 1976. "I played on those records and do you know how much trouble we used to

go to just getting the running order right, so those tempos of songs are nicely planned and everything?" But it was out of his hands and in the lap of the gods.

A TV movie called *Birth of the Beatles* happened in November 1979, from Dick Clark Productions, with Pete Best as consultant. (Director Richard Marquand went on to direct *Return of the Jedi*.) It aired on a Friday night, which meant I chose to watch it instead of *Dukes of Hazzard*. As the first flick version, *Birth of the Beatles* had its sentimental moments, and since I was only thirteen, it may have been shoddier than I remember, but I could tell it wasn't condescending to me. This movie was how I learned Brian Epstein was gay. (John tells him, "Don't worry, Eppy. Anything that's loving between two people is all right." Sentiments like this were never expressed on Seventies TV.) *Birth of the Beatles* chronicles the early days, especially the sacking of Pete Best. "Pete's out? Why?" Brian asks. "He's too conventional," John sneers, not to mention too darn handsome, and Pete responds by yelling, "I'm a better drummer than he is! All of Liverpool knows it!" At their next Cavern gig, the angry mob of Pete fans is only partly appeased by a long Ringo drum solo.

The first time I saw the Beatles live—the first time I saw any rock band—was *Beatlemania*, a Broadway musical that debuted in 1977, a revue with four musicians playing the hits. "Not the Beatles, But an Incredible Simulation!" screamed the ads. I found a ticket in my stocking Christmas morning (my other present: *Wings Greatest*); my little sisters and I saw a matinee in downtown Boston, the three of us huddled together in our seats. (Our mom dropped us off and picked us up when it was done.) It was a euphoric experience, right from the opening moments when the announcer said, "Please, no smoking—*anything*—in the theater." The Paul guy did the

most talking, asking, "How are you people in the orchestra seats?" (That meant us!) I've seen countless Beatle tribute bands since then, but the whole concept was so new that it became a major controversy. I still remember the *Playbill* in my hands, the footage of a Vietnamese monk setting himself on fire (to "The Fool on the Hill," I think), my disappointment as the fun young Beatles gave way to the serious mustachey Beatles, the faux John stabbing his fingers into the keyboard during "I Am the Walrus," the news montages building to the headline "BEATLES BREAK UP."

In 1979, the Beatles announced they were finally getting back together—for a meeting to plan their lawsuit to shut down *Beatlemania*. This was going too far. It had to be stopped. About this, all four could agree. There was something exciting about the idea they were even having these conversations. (Flash back to Ringo's words: "All of us looked at the cover of *Rock 'n' Roll Music* and could hardly bear to see it." Imagine how that "all of us" thrilled people.) I think somebody could make a great movie out of this meeting—all four in the same room for the first time since 1969, with their lawyers and entourages. I've fantasized the scene many times. It would look just like the convocation of Mafia dons in *The Godfather*. John would bang his fist on the table and say, "How did things ever get so far?" (Paul would be Don Barzini, of course. George would be the guy who shrugs, "They're animals anyway, so let them lose their souls. Hare Krishna.") Each Beatle would air grievances. How could these kids treat us so thoughtlessly? We gave them most of our lives. Sacrificed most of our lives. We gave them everything money could buy.

The meeting with all four Beatles never happened, but the lawsuit did (and eventually won). John Lennon met with Apple's lawyers in New York at the end of November 1980, a

few days after Thanksgiving, to give his sworn affidavit. His statement was curious indeed. Lennon testified that *Beatlemania* would hurt him financially because "I and the three other former Beatles have plans to stage a reunion concert, to be recorded, filmed and marketed around the world." Was this mere loose talk, albeit under oath? The world will never know. A few days later, Lennon was dead, murdered by a psychopathic stranger with a legally purchased handgun who'd just a few hours earlier asked him to autograph a copy of *Double Fantasy*.

"SILVER HORSE"

(1981)

After John Lennon was killed, rock stars tripped over each other to do tributes, but the most moving came from the two who loved him most stubbornly: Yoko's "Silver Horse" and Paul's "Here Today." (One of the worst might have been Bob Dylan's "Roll On, John," which he didn't get around to until 2012.) These weren't hits—the hit was George's "All Those Years Ago," a studio reunion with Paul and Ringo, bouncy synth-pop with lyrics in meatball mode (the murderer was "Someone the devil's best friend / Someone who offended all"). That was okay—the radio was in the mood for something insipidly cheery and moralizing. The clumsiness made it human; George felt the same grief we did, without turning back into a genius. "All Those Years Ago" reminds us all to be nicer to God—"He's the only reason we *exiiiist*"—and imputes this notion to John, not the Christian fundamentalist who shot him.

Season of Glass was an album that for a new wave kid like

me meant Yoko was One of Us, with its cover photo of John's glasses, still blood-spattered, sitting on Yoko's kitchen table overlooking Central Park. This was some bad-ass postpunk angst for sure. *Season of Glass* was her response to John's murder—she shrieks away in "No No No," after the sound of four gunshots, and mourns him in songs like "Nobody Sees Me Like You Do" and "She Gets Down on Her Knees." "Walking on Thin Ice," the single she and John were working on the night he was killed, reworks the B-52's and Lene Lovich. *Season of Glass* appealed to my melodramatic teenage idea of how it might feel to be a fifty-ish widow in the throes of grief and rage. But much of the album was incomprehensible to me, not because it was morbid or harsh, but because it was so playful. "Silver Horse" was a lilting pop ballad, just plain beautiful, in fact, and that didn't make sense—where was the primal scream? Where was the noise? I puzzled over this song, forgot about it.

I got obsessed with *Season of Glass* in my first couple years of being a widower, in my thirties, when this album meant more to me than it did before or ever would again. Yoko speaks to widows, in ways difficult to describe to nonwidows, but she had to grieve in public while knowing most people resented her being part of this story at all. Yoko was always a divisive figure—just mentioning her name can set reasonable people off on tirades—but although I always liked her (while also being scared of her) I could no longer remember what Yoko meant to me before I was a widow. Now she was my old lady in black, wearing the shades that used to look pretentiously glamorous (until I learned that for widows it is a pragmatic necessity to wear eye protection when you leave the house). I went back to *Season of Glass*, eager to hear some of the antisocial angst of the blood-spattered cover. But the song

I obsessed over was the nonraging "Silver Horse," which I'd forgotten. It was still opaque and threatening, but in ways I now identified with, listening on headphones while walking aimlessly through the woods in the Virginia winter, on a tape with *Season of Glass* on one side and Neil Young's *Comes a Time* on the other.

"Silver Horse" is a muted doo-wop ballad, the kind of song John kept straining to pull off in the Seventies, but nailed sometimes—especially on *Milk and Honey*, the posthumous (and even better) sequel to *Double Fantasy*. It resembles the midlife guitar ballads Lou Reed was writing around this time, on albums like *The Blue Mask*. Yoko had never written a rock and roll song like this—why should she? That was his department. In "Silver Horse" she tries on a musical language that doesn't quite fit, like trying on your dead spouse's sweater (which sometimes soothes your pain and other times just makes you sneeze). She sings about a dream she just remembered, before she's had a chance to gather her thoughts and get her story straight and decide if it's worth telling. The guitar has the same weariness as her voice as she warbles, "When I come in my dream to a house I've never seen before / I have a tendency to look for the exit door." In this dream, she sees a silver horse that she thinks might fly her away somewhere (like the story John liked to tell about the dream with the flaming pie), except the horse doesn't have any wings. "And that's the story of a wandering soul, a story of a dreamer," she concludes, having told no story at all, as if she's just tired of talking and has started looking around for that exit door. She did her bit to be sociable, showed up for the conversation, tried to fit in, said something that seemed harmless but gave everyone the creeps and now she'll show herself out.

I once passed Yoko on the street in New York City. I was

walking down West Twelfth Street, near St. Vincent's Hospital, and saw a petite old Japanese woman with a black beret. I smiled, very wide, involuntarily, and she gave me the heartiest smile back. The smiles lingered with me for a long time, both hers and mine. Days later, I figured I must have overreacted—this could have been any elderly pedestrian, right? I casually asked one of my editors at *Rolling Stone*, who knew her socially, if this might have been Yoko. He asked, "Was she with some smoking hot Latino gay dudes?" Ah, yes, actually. "Then it was Yoko."

Paul's "Here Today" has the same understated touch as "Silver Horse"—not the big weeper ballad he could have done as a guaranteed hit. It sounds like he devised it to be as tiny as possible, not even a chorus, to ensure it couldn't accidentally get promoted into a hit against his will. He sings about his memories of growing up with John, how they met and played hard to get, the intimacies they shared ("the night we cried, because there wasn't any reason left to keep it all inside"), and admits he never really figured his friend out. As he said, "It's one of those 'Come out from behind yer glasses, John, and look at me' kind of things." It's confessional in a way he usually didn't permit, a song he persisted in doing live even though he couldn't settle on any degree of composure to bring to it. There's no resolution; he just trails off at the end.

Yoko and Paul, who went through a phase of talking on the phone a lot and wondering if maybe this shared tragedy would finally make them friends (it didn't), both tell the story in the form of a riddle they puzzle out as they sing. Did they really know this person? They haven't gleaned any meanings from their grief. They feel stupid and small and quiet. They didn't come away with any revelations to share. They have learned nothing, except that what they lost will remain lost.

Despite their vastly different personalities, both saw themselves as cheerleaders with a duty to uplift and inspire. Paul called his next album *Starpeace*, or maybe that was Yoko's *Pipes of Peace*, or maybe it was *It's Alright (I See Rainbows)* or *Flowers in the Dirt*—at any rate, both were control freaks who liked to keep things positive. Neither wanted to write a song like this and both would have ducked it if they could—they would have much rather treated John's death like a teachable moment the way George did. Not a soul would have blamed them if they'd been tempted to fake it. But they didn't fake it, which says something about whatever kind of honesty John represented to them. These songs are two fragments of a broken story, not even complementary halves—just pieces of something they shared.

THE BALLAD OF EIGHTIES BEATLES VS. NINETIES BEATLES

In a way, the Nineties were the best thing that ever happened to the Beatles. They sounded cooler and mattered more than ever. It was the Nineties that invented the Beatles as we know them today, and the Nineties Beatles we've listened to ever since. The Seventies Beatles were so fraught with a neurotic sense of deprivation—how are we supposed to live without them?—while the Eighties Beatles were laden with pathetic generational melancholy—where have all the flowers gone? Why can't we get back to the garden? The Beatles had always symbolized so much—their era, their ideals, youth itself—but the Nineties is when the sound surged past the symbolism. I'm sure the Sixties Beatles were great. But I bet not as great as the Nineties Beatles.

For most of the Eighties, the baby-boomer nostalgia-industrial complex loomed over the band, turning them into the musical equivalent of the fireman's pocket portrait of the Queen. They were hailed for embodying their grooviest of

generations. Those of us who weren't boomers would never get it. As journalist Keith Harris has put it, "Being a teen Beatles fan in the Eighties was like trying to eat ice cream while weird older men insisted on lecturing you about the historical significance of ice cream." But the Nineties was when they broke free of their era. That's when they "cleared their neighborhood," as astronomers say. It's when Americans began chummily referring to Paul as "Macca," a major turning point—he'd never had a cool nickname before. In the Eighties, the idea of giving Paul a nickname would have seemed like an abomination. The experts slowly realized you didn't need to live through the Sixties to participate in the Beatles, just as you didn't need to witness the French Revolution to love Wordsworth. Yet it took time.

AFTER DECEMBER 1980, THERE WERE NO MORE CALLS FOR A reunion—instead, the grief curdled into an elegiac torpor. Rather than pray the lads would return, the flame-keepers fixated on preserving the past—making sure the band was defined in terms of the Sixties. The great hagiography of the Eighties, Philip Norman's *Shout!*, bore the subtitle *The Beatles in Their Generation*, just as its successor, Ian MacDonald's *Revolution in the Head*, was subtitled *The Beatles' Records and the Sixties*. Hunter Davies's original bio has a blurb on the back: "The Book That Defines a Band That Defines a Generation." None of this was meant to belittle—au contraire, sentiments like "the Beatles are virtually synonymous with the Sixties" were meant as a compliment. But inevitably, the gatekeepers came to seem like scolds. As MacDonald put it, "Anyone unlucky enough not to have been aged between

14 and 30 during 1966–67 will never know the excitement of those years in popular culture. A sunny optimism permeated everything and possibility seemed limitless."

Harmless sentiments, up to a point, though it's fun to fill in the blanks—I pity anyone unlucky enough not to have been aged between thirty and thirty-five when Marilyn Manson's "I Don't Like the Drugs but the Drugs Like Me" captured the sunny nihilism of 1998. But not really an adequate vocabulary for talking about this music. In the 1982 documentary *The Compleat Beatles*, George Martin says, "The great thing about the Beatles is that they were of their time. Their timing was right. They didn't choose it; someone chose it for them. But the timing was right and they left their mark in history because of it." Mr. Martin isn't trying to be cute, and he isn't putting the lads down. He's a scrupulously honest man as always, speaking the truth as he sees it. This was a common fallacy then. It took a while to adjust to the radical notion that the Beatles might *not* depend on the Sixties for enjoyment or elucidation, or that the Beatles might *not* have been at all typical of their generation. Yet the explanation seemed obvious: Right time. Right place. Clever boys. As their old pal Bobby D might say, they just happened to be there, that's all.

But the Beatles were praised for making the present irrelevant. If their "Yesterday" sounded so alive, that could only prove today was dead. Ian MacDonald ends *Revolution in the Head* with a lament that music turned to garbage when the band broke up, for no less a reason than "something in the soul of Western culture began to die during the late Sixties." Pop suffered its "catastrophic decline" in 1970, after peaking in 1966 (when the author was eighteen), and "only the soulless or tone-deaf" could fail to agree. MacDonald deserves credit

for coming right out and saying what many others considered self-evident truths. After all, where were the Beatles of the Eighties?

The answer might have been, "Yeah, well, where were the Beatles of the Sixties? Because there weren't any, besides the Beatles." But the Fabs' ongoing vitality cast a pall. When Joe Strummer spat "phony Beatlemania has bitten the dust," he was trying to open space for anyone with a future to live. It was easy to resent the whole institution. Tom Carson summed up this mind-set in the *Village Voice*: "What would be the point of having an opinion about the Beatles? That'd be like having an opinion about McDonald's or *Gilligan's Island*. As soon as you're born, you learn: Here's how 'Ob-La-Di, Ob-La-Da' goes. Here's how a Big Mac tastes. They never get off the island. Now you're on your own."

There'll always be people who argue music peaked in the past, i.e., during their adolescence. Yet in the words of a singer I adored madly in *my* adolescence, I don't subscribe to this point of view. It became a noxious cliché in the Eighties—the good old days, when the music really mattered. (Is that *Freedom Rock*? Turn it up, man!) The *Big Chill* soundtrack started a boom for oldies radio. The movie's about Sixties campus radicals who reunite for a funeral, mourning their lost youth while wearing dangerously tight running shorts and making pained faces to sing "Ain't Too Proud to Beg." In the most unintentionally comic scene, they're getting stoned to Procol Harum. Jeff Goldblum asks to hear some other music, you know, from this century. Kevin Kline gets mad. "There IS no other music, not in my house." Jeff protests, "There's been a lot of terrific music in the last ten years." Kevin calls his bluff. "Like what?" Silence.

Since I was a teenager at the time, I found this scene

hilarious—imagine, being alive in 1983 and not appreciating the genius of Kajagoogoo. I mean, they had more good songs on *White Feathers* than Procol Harum had in their whole career! And there was a radio hit that spring called "Little Red Corvette," by a kid named Prince, who was barely out of his teens but had written more great songs than Procol Harum had vestal virgins. What was *wrong* with these people? Were they on dope? I resisted the temptation to scream "Kajagoogoo!" in a crowded theater, but I did drive home from the multiplex pitying them (though I would not have wasted any sympathy on Kevin Kline if I knew he'd marry Phoebe Cates in real life). Since everybody my age who loved Prince or Kajagoogoo also loved Motown and the Beatles, it was bewildering to realize it wasn't a two-way street—that some elders who owned their own stereos and could play music as loud as they wanted after midnight would choose, of their own volition, *not* to celebrate the music being made all around them, *not* to investigate it, would choose instead to resent sharing the planet with it. Gosh, there was something about sunny optimism and limitless possibility that brought out the Nancy Reagan in some people.

I had no trouble finding manic pop thrills in the Eighties, but it was customary, indeed mandatory, to believe we were living through the end times. Young critics like me who wrote raves about our favorite new bands were seen as contrarian, if not insane. Elvis Costello, who made so many of the era's best records, dubbed it "the decade music forgot." Mainstream rock radio turned into a corporate dinosaur garden; if there's an uglier way to spend four minutes than Don Henley rasping "All She Wants to Do Is Dance," I can't imagine what it is (though I bet it involves Don Henley some other way). Julian Lennon had a string of hits, including the great "Valotte" (though his

best came in 1991, with "Saltwater"). You'd think Julian might have been resented as a rich kid going into the family business, but I rooted for him and I think a lot of us did—like any other kid, he just wanted to be part of this story. He had a crushingly sad moment in the 1987 Chuck Berry concert flick *Hail! Hail! Rock 'n' Roll*, after he sings "Johnny B. Goode." "Look at him," Chuck tells the crowd. "Ain't he like his pa?" It's a lousy performance, but then something awful happens and your heart goes out to him. Chuck hugs him and yells, "Oh, yeeeaaah! John—uh, *Julian* Lennon!" Oh, the shattered look on his face. How could it be more obvious? We were not and never would be invited. Ringo played a creepy fashion designer in the TV trash classic *Princess Daisy* and hosted a children's radio show, *Ringo's Yellow Submarine*. A Nike sneaker ad that used "Revolution" caused a brief controversy, as did a muckraking bio called *The Lives of John Lennon*—now remembered as the only book to inspire a beatdown threat from Bono.

In 1988, the Beatles were inducted into the Rock & Roll Hall of Fame. Paul boycotted the ceremony, because he was mad at Ringo about something or other—yet another self-inflicted Paul humiliation in a decade full of them. You can find footage on YouTube, but nobody can top Keith Harris's description: "A stage clogged with several Wu-Tang Clan's worth of drunken middle-aged white superstars milling around with guitars while Paul Shaffer plays 'I Saw Her Standing There' on keytar and Ringo stares at his drum kit with the Keanu-like bafflement of a man confronted with an unassembled 1000-piece jigsaw puzzle of a monochrome Rauschenberg print. 'Well, she was just seventeen,' sings Billy Joel, the youngest old man in the room. At that time, Joel's current wife was seven."

The reverence that smothered the band did not apply to Paul, everyone's favorite punching bag. Back in the late Seventies, it had still made sense for *Rolling Stone* to commission a lavish oversize coffee-table history of the Beatles—cover art by Andy Warhol, introduction by Leonard Bernstein—and put Paul's smiling face on the front cover, with John relegated to the back. The book was published in November 1980, the last possible moment when it would have been thinkable. It was the worst-timed Christmas product since Jesus was still alive.

Shout! set the tone for the Eighties Beatles—everybody read it, since it was the most tough-minded bio yet, with dirt on the early Hamburg days. The premise: "John was three-quarters of the Beatles." *Shout!* hasn't dated well because the author gets childishly emotional on the subject of Paul, like when he accuses him of being an ugly infant or hints he wasn't that sad when his mom died. In this view, Paul's continued existence was not just an insult to John's memory but an affront to all that was sacred. (At the time, Paul was not making the strongest case for his own defense.) In a cruelly fortuitous bit of timing, *Shout!* came out in April 1981, right after Lennon's murder. Framing the Fabs as John's backup group made it easier to see his death as "The Day the Music Died," as the cover of *Time* put it.

That grief loomed over the Eighties Beatles story. In a better world—really just a better America, where corporate gun manufacturers hadn't bought up the legislators—John would have kept on being a pain in the ass, on whatever terms he chose. There's a great scene in *Hot Tub Time Machine*—well, there are about a hundred great scenes in *Hot Tub Time Machine*. John Cusack, Rob Corddry, and Craig Robinson go back in time to the Eighties, to figure out how their lives went

so wrong. Corddry climbs up on the roof late at night, drunk and depressed in his old Iron Maiden T-shirt. He takes a swig from a bottle of Jack Daniel's. He hates what a joke his adult life will turn out to be. He hates the Eighties teens whooping it up on the lawn below. He wants to spoil the party, so he yells at them. "*Heeeey!* John Lennon gets shot!" Then he blinks. "Wait, did that already happen?" It happened. He sits back down, gets depressed all over again, takes another swig.

SOMETHING THE NINETIES PROVED: IF FOR YOU ROCK AND roll is about nostalgia, the Beatles are your best weapon. If for you rock and roll is the long, hard fight against nostalgia, the Beatles are also your best weapon.

Kurt Cobain liked to say he wrote his first great song, "About a Girl," after holing up all day and playing *Meet the Beatles* in his room. There was hipster one-upmanship in this claim—and in the way Kurt called *Meet the Beatles* his favorite record rather than *Sgt. Pepper* or for that matter *With the Beatles*. Kurt prized the pop Beatles, not the rock Beatles. It was a clever way to define himself against the previous generation. By the time "About a Girl" became a hit in 1994, nobody was claiming music was dead, though by then Kurt was. The Nineties music boom meant fans didn't feel threatened by the past—there was too much happening right now.

Whatever music you were into, it was exploding in the Nineties. Guitar bands, hip-hop, R&B, techno, country, Britpop, trip-hop, blip-hop, ambient, illbient, jungle, ska, swing, Belgian jam bands, Welsh gangsta rap—every music genre you could name (or couldn't)—(and a few that probably didn't really exist)—was on a roll that made the Sixties look picayune and provincial. We can argue all day whether Nineties mu-

sic holds up, but fans devoured—and paid for—more music than ever before or since. The average citizen purchased CDs in numbers that look shocking now, and even shocking then. Every week, thousands of people bought new copies of the *Grease* soundtrack, from 1978, and nobody knew why. Even critics had trouble finding things to complain about (though we sure tried).

The Beatles were also booming. The audience was full of fans who'd never known a world without them. The hot young celebrity couple du jour: Jude Law and Sadie Frost, movie stars named after songs their parents liked. Jude had a tattoo on his arm that said "Sexy Sadie, you came along to turn on everyone," and half the women I knew would have lined up to lick it. (The other half would have rather licked Sadie.) In such a bountiful present, you could play around in the past without worrying it would ensnare you. Thom Yorke could utter the dreaded words "I wish it was the Sixties" on the title anthem of Radiohead's *The Bends* and know his audience would hear it as a sarcastic joke. It would have been too dangerous to sing that line in the Eighties—too many people felt that way, secretly or not.

Revolution in the Head, an excellent book even more aggressively retro than *Shout!*, came out right after Oasis released their debut *Definitely Maybe*—in terms of timing, as apt as *Shout!* in the wake of Lennon's death. Ian MacDonald's argument was that Paul, not John, was the genius, yet you didn't have to buy that claim to enjoy the book. Paul was suddenly the cool Beatle, a decidedly unprecedented state of affairs. He regained his charm; he must have uttered the quip "We were a good little band, y'know" several dozen times a year. Macca (as we now called him) mugged for the camera with new mates like Noel Gallagher. The first time I heard Oasis's debut hit

"Supersonic," I thought, *Hey, the guitar hook from "Dizzy Miss Lizzy,"* and then the almost simultaneous thoughts of *this sounds amazing* and *why the hell would anyone rip off "Dizzy Miss Lizzy"*? Their Beatleisms grew more comic, to the point where "Don't Look Back in Anger" could name-check *Revolution in the Head.* The Gallagher brothers had spent a lifetime loving "Magical Mystery Tour" without ever wondering what it meant, and there was something beautifully liberating about that. The Beatles were part of a living moment, not the past. New sounds rose from the tiniest scraps of their legacy, like the way Radiohead seemed to build a space-rock language around the "Sexy Sadie" piano hook. "The Beatles are timeless dudes doing timeless things," said the Wu-Tang Clan's Raekwon the Chef. "We're the black Beatles. You can call me Chef McCartney 'cause I'm the same way—I'm just like Paul."

Nobody asked, "Where are the Beatles of the Nineties?" partly because the air was full of so much innovation (where were the Nirvana, the Biggie, the Bikini Kill, the Missy, the Wu, the Beasties or Sleater-Kinney or Aphex Twin of the Sixties?) but also because we still had the fucking Beatles, more benignly omnipresent than ever. It was now obvious they were out of whack with history. In the 1990s, the Rolling Stones were still raking it in, yet nobody would claim the Stones were in the same ballpark, league, or sport as their former rivals, who'd been broken up for two decades. The Beatles were no longer playing the same game as these people, not Elvis, not Michael, not Elton, not Zeppelin, maybe not all of them combined.

It all culminated in the 1995 *Anthology*, which would have seemed like an embarrassing defeat only a few years earlier. The record company had figured out how to treat the catalog as a prestige item; the 1982 *Reel Music* compilation was

the final U.S. release that could be described as a rip-off. The "drop-T" logo belatedly became a thing, with its elegant serifs—it never appeared on any original Beatle albums, but in the Nineties it became a brand as powerful (in a different way) as the Black Flag bars. The 1994 *Live at the BBC*, two CDs of radio tapes (proving, as Robert Christgau wrote, "in addition to everything else, they were the funniest rock stars ever"), was a tantalizing hint of how many goodies still remained in the vaults.

The world couldn't have been hungrier for *Anthology*, with a ten-hour documentary and three huge-selling volumes of out-takes, turning into a joyous global celebration. The *Anthology* double-CD packages might have been more purchased than played (everybody back then bought more music than they had time to listen to). They included two new songs, Lennon tape fragments that the others finished: "Free as a Bird" and "Real Love." The flaw was Jeff Lynne's production—George Martin wasn't invited, because Harrison flatly refused to work with him. It's ironic that when you watch *Anthology*, the only music that sounds dated is from 1995. But no matter how blasphemous the idea seemed, both songs were disarmingly beautiful, as was the documentary, to the point where you could drop in on any random hour (or binge all ten) and enjoy.

One of the wisest decisions of *Anthology* was not to present it as the happy loving reunion everybody knew it wouldn't be. Yoko screened it using a stopwatch to calculate precisely how much screen time each Beatle got. (What a shocker: Paul got more than the others.) George visibly found it difficult to tolerate being in the same room as Paul, yet Ringo's calming presence kept it civilized. Behind the scenes they butted heads for years about what to call it (no way was George willing to sign off on *The Long and Winding Road*, a Paul song) or

whether to include Paul's 1967 avant-psych experiment "Carnival of Light" (George got his way) or the choice of producer (again, George got his way). George's personal money problems caused considerable tension; he went into *Anthology* with needs that were financial rather than emotional, the opposite of Paul's situation, but Paul couldn't get the happy all-together-now ending he was hoping for without meeting George more than halfway. Like the old riddle of the fox, the goose, and the corn, it was tricky to pair any two surviving Beatles together, but with all three in the room, there were moments of affection and camaraderie. They tried recording more material, but it didn't work because Ringo split after doing his drum parts, leaving Paul and George in the studio, which didn't take long to disintegrate. With his typical wit, George explained why he walked out: "It's just like being in the Beatles." Hare Krishna.

Clearly, we'd reached the final frontier of Beatle obsession. How could it go any further? How could they get any bigger? Everybody figured the lads cashed the keg this time. They'd gotten millions of people to feel privileged at the chance to buy rejects from the freaking White Album—a record that had room for "Bungalow Bill." As McCartney said, "George Martin reckons if we put anything out after this, it'll have to be issued with a government health warning." *Anthology* seemed like a graceful way to squeeze those last few droplets out of the cow. But then they capped their biggest decade with a November 2000 comp called *1*, which had no reason at all to exist. *1* was a collection of songs everybody already owned, hits before anyone's mother was born. It shocked the industry by selling 30 million, 40 million, something like that. It was the blockbuster of Christmas 2000, the fastest-selling album of all time, boosting their belated *Anthology* coffee-

table book, burying the holiday competition from Britney, the Backstreet Boys, and N'Sync. The Fab Four were bigger than Jesus, bigger than Justin.

The reasons were simple enough: for one thing, it was a bargain (27 Number One hits on one CD for $12.99, even if one of them was "Hello Goodbye"). Like countless other people, I heard *1* all that Christmas—my sister got it as a stocking stuffer, a holiday soundtrack the whole family could agree on. *1* was no-frills product: no angle, no real title, not even a picture on the cover, just a remarkably ugly numeral. It's doubtful much thought went into it. It didn't matter. It was the biggest-selling album of 2000. And the biggest-selling album of 2001. The Beatles were the toppermost of yet another poppermost.

1 was expected to sell, but nowhere near *this* well, and the scale of it shocked even jaded industry vets who'd seen Beatle blockbusters before. As so often happened in the 1960s, 1970s, and today, the experts thought we might have finally reached the point of Peak Beatles. Fat chance. Once again, the music made the experts look as confused as Rocky Raccoon's doctor. *1* saved the business from a disastrous Christmas—though it turned out the music ecosystem was collapsing, and would never see a nondisastrous Christmas again. In a winter that was terrible for both the industry and the world (both about to get worse), *1* proved that three things never change: (1) people love the Beatles, (2) it's a little weird and scary how much people love the Beatles, and (3) even people who love the Beatles keep underestimating how much people love the Beatles.

As fans, we're always trying to imagine how big the Beatles could possibly get, looking for the boundaries where the music stops and the world's desire begins. We want to size them

up, draw the line, measure their impact. Yet we always get it wrong, because we're always lowballing. The Nineties audience felt sure we'd figured them out. We believed we studied them closer and loved them harder than other fans. We finally got them right. And like every other era that has ever claimed the Beatles as its own property, the Nineties got left behind as the Beatles broke free and moved on. Their music had other places and times to visit, across the universe.

THE END: SORRY WE HURT YOUR FIELD, MISTER

Two postulates: (1) *a long memory is a source of knowledge*, and (2) *a short memory is also a source of knowledge*.

Everybody hears the Beatles with a short memory—they're probably not the very first music you ever heard, but they're probably not far off. And everybody hears the Beatles with a long memory—they're probably not the music you've heard most recently, but again, not far off. I bet you've heard them somewhere in the past few days. As your life grows longer and your memory gets fuller, the Beatles come with you and mutate along the way. They define the extremes of your memory—they're with you when you're just discovering music, too young to know better, and they remain with you on top of all the other heartnoise crowding your chemistry, after you're supposedly too old for surprises.

The lads had a private joke at their Sixties press conferences—they'd ask each other, "What will you do when

the bubble bursts?"—a question they'd heard enough to start mocking by 1964. But it's funny how we're still asking the question. How many more human ears can hear themselves in this music? Yet we don't know, because the music won't tell us. Getting so much—*something*—all the time. Bigger, better, who knows? But changing. And moving. And growing. All the time.

It was that hidden guest on the *Sgt. Pepper* cover, Albert Einstein, who first mathematically predicted the universe was expanding, as good an explanation as any.

IT FIGURES THE ONLY BEATLE SONG WITH "YES" IN THE TITLE IS the most morbid and disturbing thing they ever recorded. "Yes It Is" is a melancholy sign you're closing in on the final hours of a Beatle A–Z Weekend on the radio, which is how I first heard it. Darn—that means "Yesterday" will be next. Then the "you" songs. How many of those are there? Why can't they just play "Yellow Submarine" again? "Yes It Is" wafted out of my radio on an early Sunday evening during one of those weekends, and it creeped me out in ways I did not like one tiny bit. What an unpleasant way to spend a precious three minutes of however much alphabet was left. Was this some kind of Celtic folk ballad—all that "scarlet were the ribbons" stuff I skipped on my parents' Clancy Brothers records? I decided I disliked this song and successfully avoided it for the next decade or so, until my college friend Marc got a Beatles LP called *Rarities*. We sat around his dorm room one afternoon, hypnotized by "Yes It Is," playing it on repeat. We only left the room to go downstairs to the dining hall, where we sang it to each other over baked ziti, before

going back upstairs to listen more. As twenty-year-old boys, this song meant something to us.

It was still a profoundly melancholy sound, though right in tune with where my hormonal infrastructure was at. John sings about two girls—one alive, one dead—and explains to the living girl he has chosen the dead one. "Please don't wear red tonight," he tells her. Red is the color the other girl used to wear, and in her death he loves her more. It's a song about weighing the past vs. the present, and opting to stay in love with the past. You are allowed to be alive in John's presence, but don't wear red, because it will make him blue, in spite of you. I love you but I've chosen darkness. This was some sicko goth fetish shit, the kind of thing I was soaking up from the Victorian and Romantic poets I worshipped, except here it was on a Beatles record, somewhere between Tennyson's "Rizpah" and Rossetti's *The House of Life*, between Keats's "Isabella" and Yeats's "Ego Dominus Tuus." The three-part close harmonies are piercing, as is George's ghostly pedal-steel guitar. John is beyond consolation; anything beautiful about this world will only remind him of the girl he mourns, so he turns down the chance to love again, and he asks the world (politely, with calm detachment) to be slightly less beautiful.

John has another song where he's in this same love triangle, "Baby's in Black," except from another corner—he's the living boy who can't understand why the girl remains so deeply in love with the dead boy. She thinks of him, so she dresses in black, and though he'll never come back, baby's in black and John's feeling blue. Another faux-Celtic folk dirge with intense vocal harmonies, this one in waltz time—marginally cheerier, which is why I liked it long before I warmed to "Yes It Is." For reasons they never really elucidated, the Beatles

loved "Baby's in Black," a good deal more than anyone else did. It was one of their most-played live tunes, despite how musically eccentric and vocally kinky it sounds. Once they wrote it in the summer of 1964, they kept it in their live set to the end, performing it at Shea Stadium and Candlestick Park. "It's a waltz, remember that," Paul tells the crowd at Shea. "This song is called, hopefully enough, 'Baby's in Black.' "

John and Paul, of course, knew this terrain emotionally. They lived it out as boys, when they were learning to write and sing together. John's mother was still alive; when Paul remembers her in *Many Years from Now*, he mentions her red hair. (The girl in "Yes It Is" does *not* necessarily have red hair, just scarlet clothes.) "Yes It Is" and "Baby's in Black" have never been famous tunes, neither quite radio-ready, a twin set of morbidities with matching color fetishes. The boy in "Yes It Is" and the girl in "Baby's in Black" ought to be set up on a date so they can ignore each other except to sniffle and compare funeral stories. Both live in a trap where John and Paul decided not to linger, either in their lives or their music.

John and Paul loved to sing "Baby's in Black" together, sharing a microphone onstage, but not "Yes It Is," which came a few months later and got released as the B-side of "Ticket to Ride." John dismissed it as a bad imitation of "This Boy"— the kind of comparison you'd make if you scared yourself so much with a song you wrote, you'd compare it to the most harmless trifle you could think of (though "This Boy" was also much deeper than John was willing to admit). "Baby's in Black" was one of the many they wrote on tour in hotels, eyeball to eyeball, singing into each other's mouths; "Yes It Is" was John rushing to meet a deadline. He didn't even seem to think it was funny this was the song he gave such an affirmative title—not even after the evening he attended Yoko's

art exhibit at the Indica Gallery, where he was taken by her piece featuring a ladder and a spyglass. He climbed the ladder, looked through the glass, and read the word *Yes*.

Something "Yes It Is" and "Baby's in Black" have in common: neither one is a boy singing alone. These are harmony ballads, untranslatable to a solo voice. They're songs about saying *no* to life, *no* to the future, yet they don't begin until the singers say *yes* to each other.

WHEN I WAS GROWING UP, THE BEATLES' U.S. SPLASHDOWN was hardly ever discussed without a reference to the JFK assassination. In the months after November 22, 1963, America was desperate to laugh. The grief-stricken country found what it was looking for: a group of four cheeky outsiders who became a national obsession, arriving with all their irreverent humor and unspoiled optimism. Ladies and gentlemen, the Beverly Hillbillies!

As TV historian Ron Simon has intriguingly pointed out, "No show in the history of television ever dominated the ratings for three months like *The Beverly Hillbillies* did from January to March 1964. The ratings were absolutely insane." It's not like *The Beverly Hillbillies* was new—it was already the Number One show of 1962 and 1963. But in this period, America took to the fab four of Jed, Jethro, Ellie Mae, and Granny, setting new records for the sitcom about a mountain man who strikes oil and moves his family to Beverly. (Hills, that is. Swimming pools, movie stars.) "On January 8, the episode 'The Giant Jackrabbit' went through the roof, establishing the ratings record that the Beatles would top a month later. *The Beverly Hillbillies* rating was so ridiculously high that it remains in the Top 40 most-watched shows ever." "The Giant

Jackrabbit" is a very strange episode where Granny tries to capture and eat a kangaroo that's escaped from the zoo; it features a guest appearance from Sharon Tate.

I used to find it facile and irritating when the Beatles were explained away as a reaction to the assassination—as if *Meet the Beatles* were merely the girl in the red dress in "Yes It Is" who tries to lure John back to life. Still, it makes sense that Clampettmania happened at the same time—both were soothing fantasies that spoke to post-JFK anxieties about the state of the nation. The Clampetts get rich overnight and move into their mansion on the hill, yet they're not corrupted— they keep their down-home innocence and make the squares around them uptight. Jed is John, Granny is Paul, Ellie Mae is George, and Jethro is Ringo. Mr. Drysdale is George Martin, Miss Hathaway must be Brian Epstein, and *The Andy Griffith Show* is the Rolling Stones—which is probably where we should depart this line of inquiry.

SOME STUFF IS JUST BUILT BETTER. WHEN I USED TO TEACH English at the University of Virginia, I got to witness a taste of Beatlemania every spring in the lit survey ENG 382, when we got to Jane Austen week. It was inspiring to talk *Pride and Prejudice* in a room full of students reading it for the first time and seeing all the lightbulbs crackle overhead as they said, *Yes. This. This is my shit.* It wasn't my charismatic teaching style, it wasn't the Colin Firth BBC version (which hadn't happened yet), and it wasn't even my enthusiasm for the book. When I was their age, I was into maniac poets, Blake and Keats and Yeats, Dickinson and Stevens and Whitman; *Pride and Prejudice* was just another novel. So teaching Jane Austen was a revelation. I would have much rather seen

the class get fired up for Wordsworth week—Lord knows I worked harder to pimp *The Prelude*. Every semester, I might see two or three students flip for Wordsworth the way I did in my teens; there'd also be a Christian student (always female) who had a heavy experience reading George Herbert and wrote heartbreakingly beautiful prose about him. Nobody got into Spenser, not even once. But teaching *Pride and Prejudice*, seeing it clobber first-timers from different backgrounds and cultures and personality types, noticing who got switched on halfway through the discussion (which meant they hadn't read it before they came to class)—that was unlike teaching anything else. It was always a highlight when Sweet Jane Week rolled around; I tried stretching it to two weeks. Austen taught the fuck out of me. (Believe me, moving on to *Bleak House* was a buzzkill.) With *Pride and Prejudice*, I felt the way a DJ must feel about a surefire floor-filler—a mixture of gratitude (whew, they're finally dancing) with resentment (why wouldn't they go for my personal micro-grime remixes?) but ultimately *awe*: some things just *work*.

That's the realm these songs are in. There's no sense they belong to the past, because they don't. The Beatles sell a million albums a year—the closest rock band is Led Zeppelin, at 800,000, then Pink Floyd and Fleetwood Mac at about half that. When my friends have kids, they inevitably initiate the "it freaks me out how much my toddler loves the Beatles" conversation, though I have the kind of friends who would rather get the kids into Big Star or Shuggie Otis. To complete the music, the band needed a world to echo the music back to them, in warped and distorted ways. You can hear their "yeah yeah yeah" everywhere from Prince's lubricious "yeah yeah yeah" in "Alphabet Street" to Jeff Lynne's forlorn "yeah

yeah yeah" in ELO's "Telephone Line," from the New York
Dolls' "awoooo! yeah yeah yeah, no no no no no no no no!"
in "Personality Crisis" to Morrissey's "no no yeah yeah no, oh
whoa, oh yeah no yeah, oh whoa no no yeah no yeah" in "The
Last of the Famous International Playboys." The Beatles gave
the world their infinite calibrations of yeah, and the world
keeps yeahing back.

In 1987, Mark Lewisohn asked Paul McCartney a crucial
question—does he mind talking about old Beatles B-sides and
outtakes, when people aren't asking about his new songs? "No
no no, I really don't. What I'm finding about all that stuff,
all my own contemporary B-sides and strange tracks, is that
it takes time. People are only just discovering the B-sides of
Beatles singles. They're only just discovering things like 'You
Know My Name (Look Up the Number)'—probably my fa-
vorite Beatles track!" Whatever you think of "You Know My
Name," which nobody else has ever called their favorite any-
thing (and as far as I know, Paul never made this claim a sec-
ond time), he has a point here. Listening to music—*it takes
time.* Human bodies respond to music over time in different
ways, and that's where the surprises are.

A very different interview from 1964, seen in *The Compleat
Beatles*—Paul is asked what he'll do when the bubble bursts.
He explains he and John will write songs for other artists,
though "who knows, at 40 we might not know how to write
songs anymore." It's touching for a number of reasons—40
was the age when John was killed, shortly after writing Ringo
a song called "Life Begins at 40"—but mainly for the way Paul
predicts he and John will outlast the Beatles as a team. When
they're done performing, he and John will hover behind the
scenes, giving their music away to younger people. In so many
ways, this is exactly what happened.

I'VE BEEN LUCKY ENOUGH TO SEE *A HARD DAY'S NIGHT* IN A few different contexts—with friends and lovers, all alone on TV late at night, up on the big screen with audiences. There's a scene that never fails to get a rise out of whoever's watching: the Beatles escape from their rehearsals and find a grassy field to run around and play and jump to "Can't Buy Me Love." The mean old guy walks out to say, "I suppose you realize this is private property." As the boys leave, George calls, "Sorry we hurt your field, mister."

It's odd what an impact this line has in the movie—it's a payoff of emotional release and laughter that always seems bigger than it should. I do love Salty George, but this isn't a glaringly funny or clever line—the screenplay has at least five or six dozen more quotable quotes. "Can't Buy Me Love" isn't one of the stronger songs; it's just a good one for running and jumping. So much of this moment comes down to the field itself—one of the few outdoor scenes in a movie built around claustrophobic studios and trains. In the cramped hallways of the Scala Theatre, they turn away from the SILENCE sign, push through the door onto the fire escape, and Ringo yells "We're out!" It's the one scene where the four of them get a moment to themselves. Not a particularly lovely field—a helicopter launching pad, surrounded by postwar prefab houses, downright ordinary. The footage was cobbled together from two different places, Isleworth's Thornbury Fields and Gatwick Airport. But it's big, plenty of room on the grass for their joyful dancing and wrestling and footracing. Their hair flops around in the open air. (The film's French title: *Quatre Garcons Dans Le Vent*, or "Four Boys in the Wind.") We know when watching the movie the Beatles will never set foot in this field of grass again, even before the old man in the muddy

boots orders them off. They don't argue—they've already won whatever game he's playing. The idea that they could hurt this field is a laugh. He's the only person who isn't smiling, just another of the movie's grumpy old villains, the railroad passenger who orders the Beatles to shut their radio off ("Give us a kiss," John responds; Paul's retort is "Let's have some coffee and leave the kennel to Lassie"), the director, the producer who wants George to endorse his shirts. This authority figure has never gone away, and he's still around to get territorial about the Beatles. Even now you hear people argue that the Beatles are ancient history, that yesterday's fans already closed the book, there's no room left in this music, it belongs to the past. And the music's reply is always, *Sorry we hurt your field, mister.*

When the Beatles stormed off the field and declared the game over at the end of the Sixties, they were mystified the grass was so green without them, and that so many people wanted to keep playing on it. The Beatles themselves went through phases where they played the role of the grouchy groundskeeper, as most of us do at some point, complaining the young people aren't treating the field properly. But when someone tells you that the Beatles are used up, you don't even need to bury that argument, because grass is already growing out of it. The field always wins. It grows over the lines we paint on it. That's one of the things the Beatles keep forcing us to relearn. The field is forever.

ACKNOWLEDGMENTS

Thanks to everybody who has helped me write this book, which is nearly everyone in my life—it would be quicker to list people who *didn't* help. But I thank all my friends for adding your inspiration and enthusiasm and humor to the book, knowingly or not. If you've known me more than ten minutes, I've probably dragged you into a *Rubber Soul* vs. *Revolver* debate, so you're in here. John Lennon defined the band as "inspired humans to make the noise," and this book is the noise we make together.

Thanks to her fabness Carrie Thornton and all the other inspired humans at Dey Street Books, especially Lynn Grady, Michael Barrs, Kendra Newton, Jessie Edwards, Ploy Siripant, Nyamekye Waliyaya, Andrea Molitor, and the heroic Sean Newcott. Thanks to Daniel Greenberg and all at Levine Greenberg Rostam. This book is dedicated to my friend Gavin Edwards, for wisdom and kindness across eleven thousand

days in the life—as John would say, thanks for giving me the courage to come screaming in.

I'm grateful to my colleagues at *Rolling Stone*, where we've battled over the Beatles a time or two. I couldn't have done it without my inspirational editor Sean Woods. Andy Greene is a sage with an eight-sided White Album of a mind. Alison Weinflash is a samurai. Thanks to all at *Stone* past and present, especially Jason Fine, Christian Hoard, Hank Shteamer, Jon Dolan, Gus Wenner, Brittany Spanos, Patrick Doyle, Ellen Nelson, Brian Hiatt, Jason Newman, David Browne, Jenny Eliscu, Mikal Gilmore, David Fear, Kory Grow, Suzy Exposito, Jeff Goodell, Hannah Murphy, Nathan Brackett, Annie Licata, Sarah Grant, Alexis Sottile, Peter Travers, Coco McPherson, Gaylord Fields, Alan Light, Anthony DeCurtis, Tom Nawrocki, David Fricke, so many more. Special thanks to Jann S. Wenner, who did so much to turn me into a fierce young Beatlemaniac and always remains game for an argument about why "The Night Before" is underrated.

Thanks to Greil Marcus for a million kinds of inspiration, including the story he told me about hearing "Eleanor Rigby" on the radio in 1966 as his friend said, "That's John on the first violin." Robert Christgau, when told of this book, instantly asked, "Are you mentioning that Greil's 1980 piece is the best thing written on them? Even though he's wrong on *Sgt. Pepper*?" Consider it done. Reading Christgau as a teen hit me like hearing Lennon's voice. I've said it before and will never not say it—I was lucky to read Marcus and Christgau at a tender age, and I'm grateful for their encouragement as well as their wisdom.

This book is not an argument settler, it's an argument starter—or a foldback speaker—so thanks to my Beatle friends for all the dustups. Marc Weidenbaum and Jeffrey Stock, dev-

otees since our mixtape days. (Jeffrey loves Paul so much he played me "My Love" on piano trying to convince me it's a worthy song. That's hardcore.) Chuck Klosterman, for rigorous saloon symposia, and also for making sure I didn't leave out "Scandinavian Skies." The late Nicholas Schaffner, whose 1977 classic *The Beatles Forever* opened my ears. The late Scott Miller, whose Game Theory records and book *Music: What Happened?* taught me new ways of hearing this music. John Taylor of Duran Duran, who offered crucial insight as well as convincing me my original title was rubbish. Jennifer Ballantyne, true believer, and all who tend the flame at Capitol, EMI, and Apple.

Thanks to all libraries and librarians, especially the Milton Public Library in Milton, Massachusetts, a treasure then and now; all record stores and radio stations and bookstores. Here's to Mark Lewisohn, the Sun King of Beatle scholars. Richie Unterberger turned me on to the world of Beatle bootlegs in 1988, in the Seattle zine *Swellsville*, and his *Unreleased Beatles* remains a must. Here's to the late lamented Second Coming Records in Cambridge, where I found so many Beatle boots (and Dylan boots, and Patti and Television and the Velvets). And YouTube, where you can now hear the arcana we used to spend years hunting down, from the Esher demos to Sinatra's birthday song for Mo Starr. Grateful bows to Joe Gross, Amanda Petrusich, Caryn Ganz, Maria Sherman, Joe Levy, Sean Howe, Matthew Perpetua, Erica Tavera, Will Dana, Flynn Monks (the originator), Darcey Steinke, Simon Vozick-Levinson (how I yearned to steal your *Life of Pablo McCartney* joke), Stacey Anderson, Jonathan Lethem, Evie Nagy, Phil Dellio, Paula Mejia, Keith Harris, Chris O'Leary, Jenn Pelly, Karl Precoda, Chris Molanphy, Julie Klausner, Jill Mapes, Mark Richardson, Tim Riley, Andrew Harrison,

Cady Drell, Patton Oswalt, Stephen Thomas Erlewine, Lisa Randall, Bill Tipper, Sarah Fonder, Craig Marks, Liz Pelly, Steven Hyden, Bob Ethington, Kelly Carlin, Lizzy Goodman, Ed Park, Abbey Bender, Stephanie Wells, Peter Holsapple, David Giffels, Jeff Wilson, Gauraa Shekhar, Greg Tate, Melissa Eltringham, WTJU, Craig Finn. Shine on, Marc Spitz. Marisa Bettencourt, for the stellar photo. Everyone at Enid's for the soundtrack. Jen Sudul Edwards; Strummer and Dashiell; Drema, Ruby, Simon, and Buddy. Nadine Crist is loved and is missed.

My sisters were the first fans I shared this music with: love always to Ann Sheffield ("I've Just Seen a Face"), Tracey Mackey ("If I Fell") and Caroline Hanlon ("Across the Universe"). Thanks to my mom and dad, Bob and Mary Sheffield, for always teaching me more about love; my brothers John, Bryant, and John; my whole family. In the past few weeks I've heard my niece play "Blackbird" on guitar and seen my nephew build a Lego Yellow Submarine, so here's to the sprout of a new generation: Charlie, Sarah, Allison, David, Sydney, Jackie, Mallory, and Maggie. Love to Donna and Joe Needham, #1 Beatle fan; Sean and Jake; Jonathan, Karianne, Ashley, and Amber Polak; Tony and Shirley Viera.

Most of all, eternal thanks and eternal love to Ally, the girl who came to stay, for being my favorite thing about the universe, for teaching me how goth Stu Sutcliffe is, for reciting the *King Lear* dialogue with me when we karaoke "I Am the Walrus," for the road behind and the road that stretches out ahead. Two of us.

NOTES

DRAMATIS PERSONAE

"In his mansion": Lou Reed, "Fallen Knights and Fallen Ladies," from *No One Waved Goodbye*, 1970, reprinted in Clinton Heylin, *The Da Capo Book of Rock & Roll Writing* (Da Capo, 2000), 379.

PRELUDE: "THANKS MO"

"Get Back": Mark Lewisohn, *The Complete Beatles Recording Sessions* (1988; Sterling, 2013), 169. Maureen Cox Starr: Mark Lewisohn: *Tune In: All These Years, Vol. 1* (Crown, 2013). Sinatra: Chris O'Dell, *Miss O'Dell* (Touchstone, 2009), 48. "Why not show Paul": Philip Norman, *Shout!* (Fireside, 1981), 347. "Not only is he a brilliant songwriter": Richard DiLello, *The Longest Cocktail Party* (1972; Alfred, 2015), 232.

MEET THE BEATLES

"We reckoned": *Rolling Stone*, 1/21/70. "The kids of AD 2000": Derek Taylor, liner notes to *Beatles for Sale*, 1964. "There they were in America": Maureen Cleave, "Paul all alone: running hard to catch up with the music," *Evening Standard*, 3/25/66. "You'll stay": Barry Miles, *Paul McCartney: Many Years from Now* (Henry Holt, 1997). Robin Gibb: Mitchell Glazer, "The Rise and Fall of the Brothers Gibb" in *Playboy*, January 1978. *Hollywood Bowl*: Greil Marcus, "Beatledata: They Should Have Known Better," *Village Voice*, 6/13/77. "You used to record them": George Martin, liner notes to *Hollywood Bowl*, 1977.

"DEAR PRUDENCE"

August 22, 1968: Lewisohn, *Recording Sessions*. "You're the best": *Anthology*.
"They were trying to be cheerful": Prudence Farrow in *Mojo*, September
2008, 84; also her book *Dear Prudence* and *Rolling Stone*, 9/4/15. John
Farrow: Lee Server, *Robert Mitchum: "Baby I Don't Care"* (St. Martin's,
2001), 208.

"I CALL YOUR NAME"

"It's me remembering": Simon Vozick-Levinson, "Paul McCartney: The Long and
Winding Q&A," *Rolling Stone*, 7/17/14. "John and I," "fairly obvious" and
"the necks of our guitars": *Many Years from Now*. Morrissey and Marr: Tony
Fletcher, *A Light That Never Goes Out: The Enduring Saga of the Smiths*
(Three Rivers Press, 2013). "That was my song": September 1980 interview with
David Sheff in *Playboy*, published January 1981. Thompson: Jann S. Wenner
and Corey Seymour, *Gonzo: The Life of Hunter S. Thompson* (Wenner, 2007),
12. "If I took up": *Rolling Stone*, 6/5/72. Kanye West: Ryan Seacrest interview,
2/10/15. "Meeting Paul": Hunter Davies, *The Beatles* (1968; W.W. Norton,
2009), 45. "I like that theory": McCartney on *The Howard Stern Show*, 10/8/13.

PLEASE PLEASE ME

"We had never seen a group work right through their lunch break": Lewisohn,
Recording Sessions. "You'd kill": Derek Taylor, liner notes to *Anthology*.
Lemmy: *Mojo*, July 2006, 78. "First of all, Paul and I wanted": Lennon
interview with Jann S. Wenner in *Rolling Stone*, 1970, in *Lennon Remembers*
(Verso, 2000). "It was actually a bit of a joke": *Many Years from Now*.
"British-composed R&B number": "The Rollin' Stones: Genuine R&B!" in
Record Mirror, 5/11/63, via Rock's Back Pages. "We weren't going to give them
anything *great*, right?": *Playboy*, 1980. "At first we wanted": *Melody Maker*,
quoted in "Beatles Splitting? Maybe, Says John," *Rolling Stone*, 1/21/70.

THE MYSTERY INSIDE OF GEORGE

"When George was a kid," "the invisible man" and "George's relationship":
Playboy, 1980. "I eventually said," "he knew more chords," "how can I do
my ballet" and "George himself": Davies. "It's really a method": March 1969
interview with David Wigg, *The Beatle Tapes* (Polydor, 1976). "You don't
talk": Ian MacDonald, *Revolution in the Head* (1994; Chicago Review Press,
2007), 343. "I was always rather beastly": *Shout!*, 259. "The whole Beatles
thing": Geoffrey Giuliano, *The Lost Beatles Interviews* (Dutton, 1994).
"Everyone else has played": Jayson Greene, "Notes You Never Hear: The
Metaphysical Loneliness of George Harrison," *Pitchfork*, 10/13/14. "Don't
Pass Me By": *Tune In*. "I wanted to see the movie": *Rolling Stone*, 4/19/79.

"IT WON'T BE LONG"

"In the early Sixties": Gerry Goffin in the PBS documentary *Rock & Roll*,
"Chapter Two: In the Groove," 1995. "We did the Shirelles": *Many Years
from Now*. "Nobody bothered them": Leonie Cooper, "You Have to Speak

Up: Ronnie Spector on Ke$ha, 60s Stardom and the Ronettes," *Broadly*, 4/4/16. "Will You Still Love Me Tomorrow" and "Mama Said": *Tune In*. "Soldier Boy" session: Fred Bronson in *The Billboard Book of Number One Hits* (Billboard, 2003). "Eight Days a Week": Lewisohn, *Recording Sessions*. "Talking World War III Blues": this version from the classic boot *Halloween Masque* as well as *The Bootleg Series, Vol. 6*, the same show where he says "Don't let that scare ya—it's just Halloween. I have my Bob Dylan mask on."

THE IMPORTANCE OF BEING RINGO

"Especially his poems": Michael Braun, *Love Me Do* (Penguin, 1964). "Ringo is our representative on the Beatles": Robert Christgau, "Now That We Can't Be Beatle Fans Anymore," *Village Voice*, 9/30/71, reprinted as "Living Without The Beatles" in *Any Old Way You Choose It*. "Knockabout uncle," "I was an only child" and "I only have": *Anthology*. "Give me the courage": various *Get Back* bootlegs. Compton: "Ringo Starr: Beatles Legend Compares Liverpool to U.S. Gangland Murder Capital," *The Daily Star*, 10/13/15. Ringo's background in Liverpool and Hamburg: *Tune In*. "Ringo was a star": *Playboy* 1980. "I'm Mister Show Business" and "We'll always be tied": *The Beatles Tapes*. "Diplomatic liaison officer": Ron Wood in Victor Bockris, *Keith Richards: A Biography* (Da Capo, 2003), 269. "He liked my eyebrows": David Fricke, "R.E.M.'s Southern-Fried Art," *Rolling Stone*, 11/7/85. John Cleese: the 2009 documentary *Monty Python: Almost The Truth—The Lawyer's Cut*. "Mike was always the one": Douglas Adams in David Morgan, *Monty Python Speaks* (Avon, 1999), 222. Lauren Bacall: DiLello, 220–221. "We were just": McCartney's speech inducting Ringo into the Rock & Roll Hall of Fame, 4/18/15. "It's out of left field": Max Weinberg, *The Big Beat* (Hudson, 2004), 181. *Beaucoups of Blues*: David Browne, *Fire and Rain* (Da Capo, 2012).

THE SCREAM

"They used us": *Anthology*. "No 'fold back' speakers," George Martin, *Hollywood Bowl*. Olivia Harrison: *Mojo*, October 2016. "*Quiet*": *The 4 Complete Ed Sullivan Shows Starring The Beatles*. The first night's closing credits include an announcement that the Kaps segment was pre-recorded. "We ain't written no poetry": The Mayles brothers' 1964 documentary *What's Happening!* "This is about a naughty lady": Richie Unterberger, *The Unreleased Beatles* (Backbeat, 2006), 149–153. "Sprout of a New Generation": *The Compleat Beatles*. Simon Napier-Bell: Debbie Geller, *In My Life: The Brian Epstein Story* (St. Martin's, 2000), 110.

"TICKET TO RIDE"

"I don't mind": Richard Pryor: *Is It Something I Said?* (Warner Brothers, 1975). The connections between Pryor's voice and Lennon's run deep.

"THINK FOR YOURSELF"

November 8, 1965: Lewisohn, *Recording Sessions* and Unterberger, *The Unreleased Beatles.*

RUBBER SOUL

"Finally we took over," "I meant it," "trying to write about an affair," and "blink or make a certain noise": *Lennon Remembers.* Bill Clinton: *Rolling Stone,* 9/17/92. October 12: Lewisohn, *Recording Sessions.* "We prayed": Don Was's 1995 Brian Wilson documentary *I Just Wasn't Made for These Times.* "Cheap pine," "suddenly there was a girl": *Many Years from Now.* "It was getting" and "fully-fledged potheads": *Anthology.* "About five words": Los Angeles press conference, 8/24/66. "Almost no buzz": Geoff Emerick, *Here, There and Everywhere* (Gotham, 2006), 107. "More than ever": Charles Perry, *The Haight-Ashbury* (Wenner, 2005), 36.

INSTRUMENTAL BREAK: 26 SONGS ABOUT THE BEATLES

"We were hicksville": *Lennon Remembers.* "Swingin' Fitzgerald": *Billboard,* 12/12/64. "Can Buy Me Love": *Many Years from Now.* "The cartoon is this": *Rolling Stone,* 5/14/70. "Brown Beatles": Richard Price, "It's Never Too Late," *Rolling Stone,* 2/16/84. "It was important": Nancy Sinatra in *Mojo,* July 2006, 62. Isley Brothers: Jon Bream, "Ernie Isley Rememembers Jimi Hendrix," *Seattle Times,* 3/20/10. "Are you scared": Mark Lewisohn, *The Beatles Live* (Henry Holt, 1986), 177. "Everything is the opposite": *Playboy,* 1980. "What do you think?": *Rolling* Stone, 11/23/68.

"TOMORROW NEVER KNOWS"

"John had complex ideas": Jim Irvin, "The Big Bang," *Mojo,* March 2007, 78–79. "Tape solo": Lewisohn, *Recording Sessions*; Emerick; Barry Miles, "The Tripping Point," *Mojo,* July 2006, 73–74. "If—as is likely": Clinton Heylin, *The Act You've Known for All These Years* (Canongate, 2007), 12. "I swear to God": *Lennon Remembers.* "I was too embarrassed": "Revealed: The real Lucy in the sky with diamonds," *The Daily Mail,* 6/1/07.

REVOLVER

"We have met some new people," "I've changed," "I have to see the others" and "We do need each other" in Davies. "Disgusting": "Library puts Beatles' handwritten lyrics on display by request," *The Daily Northwestern,* 4/2/08. Northwestern's Music Library has posted the note on Instagram. "I vaguely mind": Maureen Cleave, "Paul all alone: running hard to catch up with the music," *Evening Standard,* 3/25/66. Sweater: Emerick. "Prostitutes" and "All girls are fickle": Los Angeles press conference, 8/24/66. "He was always experimenting": Irvin, "The Big Bang." "Not very cool": Miles, "The Tripping Point." "Dreadful melancholy": *Many Years.* "Abbey Road was somewhere we *loved* to go": *Q,* June 1997.

"STRAWBERRY FIELDS FOREVER"

Ozzy Osbourne: *Rolling Stone*, 12/9/10. "I did try," "What I would like," "I was never so glad," "We talk in code" and "No, I can't remember where": Davies. The Moody Blues: Miles, "The Tripping Point." "There was a moment": Emerick, 135. Marianne Faithfull: *Many Years from Now*, 376–380. Spiro Agnew: J. Anthony Lukas, *Nightmare* (Viking, 1976) and Richard Reeves, *President Nixon* (Simon & Schuster, 2001). "Trying to top": *Rolling Stone*, 11/23/68.

THE COVER OF *SGT. PEPPER*

"Whatever the lads want": Peter Blake, "The Cover Story" in *Mojo*, March 2007, 84–85; Steve Turner, "*Sgt. Pepper*: The Inside Story," Q, July 1987; Lewisohn, *Chronicle*. Bardot in pencil sketch: *Many Years from Now*, 336.

SGT. PEPPER'S LONELY HEARTS CLUB BAND

"The most important record": Doggett, *You Never Give Me Your Money*, 290–291. "The 10 Greatest Rock & Roll Albums Of All Time!!!": *Bananas* #13, Fall 1977, 34. WRKO: http://surveys.wrko.org/wrko_surveyp/wrko_78t100htm. Keith Richards quotes: *Esquire*, September 2015. "Very self-indulgent": Heylin, 245. "You'd better hurry up": Brian Wilson with Todd Gold, *Wouldn't It Be Nice* (HarperCollins, 1991). The English music press: Alan Walsh, "The Danger Facing Pop: No contact with fans... are the stars leaving them behind?" in *Melody Maker*, 5/20/67. "Let's get Antonioni": John Harris, "The Day the World Turned Day-Glo" in *Mojo*, March 2007. "I thought the Beatles": *Mojo*, February 2015, 36. "Yes": Greg Barrios, "An Interview with Sterling Morrison," *Fusion* #28, 3/6/70, reprinted in Clinton Heylin: *All Yesterday's Parties: The Velvet Underground in Print 1966–1971* (Da Capo 2005), 150–151. Mono mix: Heylin, *The Act*; Lewisohn, *Recording Sessions*. "I've got these three": Paul Du Noyer, "McCartney/Lennon," Q, *The Beatles: Band of the Century*, December 1999. "If this extraordinary music": Greil Marcus, "The Beatles" in *The Rolling Stone Illustrated History of Rock and Roll*. "Elvis echo" and "I'm knackered": Emerick. "A bit of a *2001*" and "a good piece of work": *Rolling Stone*, 11/23/68. "I don't want you to climax": Irvin. "The general public": Hal Cook in *Billboard*, 7/20/63. "Very twelve-inch": Mark Hertsgaard, *A Day in the Life* (Delta, 1996), 165.

"IT'S ALL TOO MUCH"

"The song got the better of me": Pattie Boyd (her current spelling), *Wonderful Tonight*. "Very happy": Nicholas Schaffner, *The Beatles Forever* (McGraw-Hill, 1977). Wedding: Clapton, *Clapton* (Century, 2007).

MAGICAL MYSTERY TOUR

"We walked into the village pub": Irvin. "We've been very negative": *Let It Be*. Epstein's final days: Debbie Geller, *In My Life* (St. Martin's, 2000). Bangor: Lewisohn and Davies. "Nearly the last useful thing": Heylin, 116. "I'm a

tidy sort of bloke" and "Fuckin' Ada": Schaffner. Pilcher: Stan Toocher, *Baby You're a Rich Man* (ForeEdge, 2015), 115. "It was a mistake": *Rolling Stone*, 2/10/68.

BEATLES OR STONES?

"We were like kings of the jungle" and "He was one": *Lennon Remembers*. "MICK IS SEX," "we never thought," "we're not gonna make Beatles movies," "under the influence of bail": Stanley Booth, *The True Adventures of the Rolling Stones* (Vintage, 1985). "There were no hit groups" and "Godard is a very nice man": *Rolling Stone*, 10/12/68. "Ringo with a gun": *Melody Maker*, 5/28/66. *Lord of the Rings*: Denis O'Dell, *At the Apple's Core* (Peter Owen, 2003), and Peter Jackson to *Wellington Evening Post*, quoted in *People*, 3/29/02. Godard and *One Plus One*: Richard Brody, *Everything Is Cinema: The Working Life of Jean-Luc Godard* (Metropolitan, 2008), 326–327 and 338–341.

THE WHITE ALBUM

"Granny music shit" and "I am fucking stoned": Emerick, 246–248. "We sat in the mountains": *Playboy* 1980. "Dylan broke his neck": *Rolling Stone*, 11/23/68.

"HELTER SKELTER"

"Charles Manson stole from the Beatles": U2's *Rattle and Hum*, 1988. Conventional accounts include Jeff Guinn, *Manson* (Simon & Schuster, 2014); Ed Sanders, *The Family* (Dutton, 1971); Charles "Tex" Watson, *Will You Die for Me?* (Revell, 1978); Vincent Bugliosi and Curt Gentry, *Helter Skelter* (W. W. Norton, 1974); David Felton and David Dalton, "Charles Manson: The Incredible Story of the Most Dangerous Man Alive," *Rolling Stone*, 6/25/70. "Bummer": *Gimme Shelter*. Altamont: Joel Selvin, *Altamont* (Dey Street, 2016); "The Rolling Stones Disaster at Altamont: Let It Bleed," *Rolling Stone*, 1/21/70. "It could only happen to the Stones": *Rolling Stone*, 8/19/71. O. J. Simpson vs. Bad Company: *Billboard*, 7/8/95, 84.

"SOMETHING" (1969) VS. "MY LOVE" (1971)

"What should I do": studio dialogue from various bootlegs and Unterberger, *The Unreleased Beatles*.

THE COVER OF *ABBEY ROAD*

Photo shoot: Lewisohn, *Recording Sessions* and *Chronicle*. Everest: Emerick, 297–298.

TURN ME ON, DEAD MAN

"If I were dead" and "I'm not going to say anything": Schaffner. DiLello's *The Longest Cocktail Party* has the background on how Paul's official statement was fabricated, along with Apple's confusion as the rumor spread, 237–240. "If ever thou wilt thrive": *King Lear*, Act 4 Scene 6. "It's the most stupid": Lennon interview on WKNR, 10/19/69, via Andru J. Reeve, *Turn Me*

On, Dead Man (AuthorHouse, 2004), 148. "I'm the walrus, too": BBC interview, 10/8/69. "'Carry That Weight' backwards": Price, "It's Never Too Late." "Ringo, Paul, George, and John": *Mad*, April 1970. *Mersey Beat* reader: Lewisohn, *Tune In*. "I honestly have no idea": David Bowie in "When Rock Stars Go Crazy," Q, May 2000, 84. "To live outside the law": Jonathan Lethem, "The Ecstasy of Influence: A Plagiarism," in *Harpers*, February 2007, reprinted in *The Ecstasy of Influence* (Vintage, 2011). "Ah, the imagination of teenagers": *Rolling Stone*, 10/12/68. A last word from Paul in *Mojo*, October 2009: "The worst thing that happened was that I could see people sort of looking at me more closely: 'Were his ears *always* like that?'"

THE LAST BEATLE ALBUM

"I Me Mine" and *Let It Be*: Lewisohn, *Recording Sessions*.

"MAYBE I'M AMAZED"

"It looks like we need a new bass player": David Browne, *Fire and Rain*. "We're sorry it worked out this way": the letter is reproduced in *Anthology*, 351. Paul's full press release is in DiLello, 273–282. "We're doing a kit": "McCartney, Solo, Clearing Up a Few Things" in *Rolling Stone*, 4/30/70. "By natural turn of events": "Bedding In for Peace" in *Rolling Stone*, 6/28/69. "I put four albums out": *Rolling Stone*, 5/14/70. "If John had been killed by Elvis": Mark Rowland, "The Quiet Wilbury," *Musician*, March 1990, quoted by Greil Marcus in *Village Voice*, 4/3/90, reprinted in *Real Life Rock: The Complete Top Ten Columns, 1986–2014* (Yale, 2015). "A farmer who plays guitar": Tom Doyle, *Man on the Run* (Ballantine, 2014). "Look, this acting-and-singing thing": *Playboy*, April 1984. "I liked being with her": McCartney interviewed by Chrissie Hynde in *USA Weekend*, 10/30/98. "Every reason to slag her off": *The Guardian*, 11/6/10.

"GOD"

"The previous edition": The Boston Women's Health Book Collective, *The New Our Bodies, Ourselves* (Simon & Schuster, 1984). "I was putting down": *Lennon Remembers*. "You *taught* me those words": Questlove interview with Josh Eels, *Rolling Stone*, 12/26/11.

PAUL IS A CONCEPT BY WHICH WE MEASURE OUR PAIN

"There's a bit of rubbish": Q, July 1989. "Perfect, just one more": Heylin, 183. "I'd always been the keeny": Davies. "Paul used to be the one": *The Beatle Tapes*. "Cary Grant on heat": *Many Years*. Grant quotes: Marc Eliot, *Cary Grant: A Biography* (Three Rivers Press, 2004). "What the miners did to Ted Heath": *Rolling Stone*, 11/25/82. "It was hell": *Playboy*, April 1984. "We didn't expect emotional revelations": Pauline Kael, "The Man from Dream City," *The New Yorker*, 7/14/75, reprinted in *For Keeps* (Dutton, 1994). Phil Collins: *Rolling Stone*, 5/23/85. "I always thought": *Rolling Stone*, 1/31/74.

WHEN GEORGE SANG "IN MY LIFE"

"Having played" and "the biggest break": Doggett, *You Never Give Me Your Money.* "I didn't force you": *Rolling Stone*, 12/19/74. Maureen [Starr]: Boyd, *Wonderful Tonight* and O'Dell, *Miss O'Dell.* "My astrologer told me" and "Take those fucking shades off": Doggett, 227–228. "My prick": J. Hoberman, "The Films of John and Yoko," in *The Ballad of John and Yoko,* ed. Jonathan Cott and Christine Doudna (Rolling Stone/Doubleday/ Dolphin, 1982), 267–268. "The critics won't touch it": DiLello, 231.

A TOOT AND A SNORE IN '74

"Valiant Paul McCartney": Christopher Sandford, *McCartney* (Century, 2006). Lavatory: Davies, 344. "He's got 25 kids": *Playboy* 1980. The biggest hits of 1976 computed by Fred Bronson in *Billboard's Hottest Hot 100 Hits* (Billboard, 1991).

ROCK 'N' ROLL MUSIC

"All of us looked" and "Christ, man, I was there": Ringo to Ray Coleman in *Melody Maker*, 9/20/76. Capitol: Greil Marcus, "Refried Beatles," *Rolling Stone*, 7/15/76. "We'd have to get all that makeup": *The Beatle Tapes.* "Please allow me": *Saturday Night Live*, 4/24/76 and 5/22/76. "We were actually too tired": *Playboy* 1980. "I and the three other former Beatles": Doggett, 268.

"SILVER HORSE"

"It's one of those": *Q*, July 1989.

THE BALLAD OF EIGHTIES BEATLES VS. NINETIES BEATLES

"Being a teen Beatles fan in the Eighties" and "A stage clogged": Keith Harris, "The Mall Gaze: When Tiffany's 'I Saw Him Standing There' Looked Back at the Beatles," 2015 Pop Conference. "What would be the point": Tom Carson, review of *Anthology* in the *Village Voice*, 1995. Elvis Costello: "Costello's 500," *Vanity Fair*, November 2000. "John was three-quarters of the Beatles": Norman, *Shout!* The book's money line was only added to the paperback as part of its Yoko-interview epilogue. Kurt Cobain: Michael Azerrad, *Come As You Are: The Story of Nirvana* (Three Rivers Press, 1993). Raekwon: *NME*, 3/21/15. "In addition to everything else": Christgau, "Consumer Guide," *Village Voice*, 1/17/95. Stopwatch and "It's just like being in the Beatles": Doggett, 315. "George Martin reckons": *Q*, December 1995.

THE END: SORRY WE HURT YOUR FIELD, MISTER

"It's a waltz, this one": Shea Stadium, 8/15/65, *Anthology.* "No show in the history": Ron Simon, "The Beatles Meet 'Collective Depression'? Think Again," The Paley Center for Media, February 2014. Sales: Jim Farber, "Rock and roll is the biggest seller in the music world," *New York Daily News*, 2/13/15. "No no no": Lewisohn, *Recording Sessions*, 15. The field: Lewisohn, *Chronicle* and Paul Du Noyer, "Action!" in *Mojo*, November 2002.

BIBLIOGRAPHY

THE TOPPERMOST

The Beatles, *Anthology*. Chronicle, 2000.

Michael Braun, *Love Me Do: The Beatles' Progress*. Penguin, 1964.

Robert Christgau and John Piccarella, "Portrait of the Artist as a Rock & Roll Star," in *The Ballad of John and Yoko*, ed. Jonathan Cott and Christine Doudna. Rolling Stone/Doubleday/Dolphin, 1982.

Hunter Davies, *The Beatles*. 1968; W.W. Norton, 2009.

Richard DiLello, *The Longest Cocktail Party*. 1972; Alfred, 2015.

Peter Doggett, *You Never Give Me Your Money: The Beatles After The Breakup*. It, 2011.

Geoff Emerick: *Here, There and Everywhere: My Life Recording the Music of the Beatles*. Gotham, 2006.

Debbie Geller, *In My Life: The Brian Epstein Story*, ed. Anthony Wall. St. Martin's, 2000.

Clinton Heylin, *The Act You've Known for All These Years: The Life, and Afterlife, of Sgt. Pepper*. Canongate, 2007.

Mark Lewisohn, *The Complete Beatles Chronicle: The Definitive Day-By-Day Guide to the Beatles' Entire Career*. 1992; Chicago Review, 2010.

Mark Lewisohn, *The Complete Beatles Recording Sessions: The Official Story of the Abbey Road Years 1962–1970*. 1988; Sterling, 2013.

Mark Lewisohn, *Tune In: All These Years, Vol. 1*. Crown, 2013.

Ian MacDonald, *Revolution in the Head: The Beatles' Records and the Sixties*. 1994; Chicago Review Press, 2007.

Greil Marcus, "The Beatles," in *The Rolling Stone Illustrated History of Rock and Roll*, ed. Jim Miller. Random House, 1980.

Barry Miles, *Paul McCartney: Many Years From Now*, Henry Holt, 1997.

Philip Norman, *Shout! The Beatles in Their Generation*. Fireside, 1981.

Nicholas Schaffner, *The Beatles Forever*. McGraw-Hill, 1977.

David Sheff, *All We Are Saying: The Last Major Interview with John Lennon and Yoko Ono*. St. Martin's, 2010.

Richie Unterberger, *The Unreleased Beatles: Music and Film*. Backbeat, 2006.

Jann S. Wenner, *Lennon Remembers: The Complete Rolling Stone Interviews Since 1970*. 1971; Verso, 2000.

ALSO CRUCIAL

Andy Babiuk, *The Beatles Gear*. Backbeat, 2001.

Keith Badman, *The Beatles: After the Break-Up 1970–2000*. Omnibus, 2000.

Keith Badman, *The Beatles: Off the Record*. Omnibus, 2000.

Pete Best, *Beatle!* Plexus, 1985.

Stanley Booth, *The True Adventures of the Rolling Stones*. Vintage, 1985.

Pattie Boyd, *Wonderful Tonight*. Harmony, 2007.

Tony Bramwell, *Magical Mystery Tours: My Life with the Beatles*. Portico, 2005.

Peter Brown and Stephen Gaines, *The Love You Make*. McGraw-Hill, 1983.

David Browne, *Fire and Rain: The Beatles, Simon and Garfunkel, James Taylor, CSNY and the Lost Story of 1970*. Da Capo, 2012.

Prudence Farrow Bruns, *Dear Prudence*. CreateSpace, 2015.

Roy Carr and Tony Tyler, *The Beatles: An Illustrated Record*. Harmony Books, 1975.

Robert Christgau, *Any Old Way You Choose It*. 1973; Cooper Square, 2000.

Robert Christgau, *Rock Albums of the 70s*. Da Capo, 1990.

Rich Cohen, *The Sun & The Moon & The Rolling Stones*. Penguin, 2016.

Ray Coleman, *Lennon*. Macmillan, 1984.

Alex Constantine, *The Covert War Against Rock*. Feral House, 2000.

Jonathan Cott and David Dalton, *The Beatles Get Back*. Apple, 1970.

Peter Doggett: *Abbey Road/Let It Be*. Schirmer, 1998.

Peter Doggett, *The Art and Music of John Lennon*. Omnibus, 2005.

Tom Doyle, *Man on the Run: Paul McCartney in the 1970s*. Ballantine, 2014.

Brian Epstein, *A Cellarful of Noise*. Pyramid, 1965.

Mike Evans (editor), *The Beatles: Paperback Writer: 40 Years of Classic Writing*. Plexus, 2004.

Julius Fast, *The Beatles: The Real Story*. G. Putnam, 1968.

Anthony Fawcett, *One Day at a Time*. Grove, 1976.

Chet Flippo, *It's Only Rock & Roll*. St. Martin's, 1985.

Chet Flippo, *McCartney*. Doubleday, 1988.

Ben Fong-Torres, ed. *The Rolling Stone Rock & Roll Reader*. Bantam, 1971.

Paul Gambaccini, *Paul McCartney in His Own Words*. Omnibus, 1976.

Paul Gambaccini, *Rock Critics' Choice: The Top 200 Albums*. Music Sales, 1978.

Vic Garbarini and Brian Cullman with Barbara Graustark, *Strawberry Fields Forever: John Lennon Remembered*. Bantam, 1981.

Geoffrey Giuliano, *The Lost Beatles Interviews*. Dutton, 1994.

Jonathan Gould, *Can't Buy Me Love*. Three Rivers Press, 2008.

Jonathon Green, *Days in the Life—Voices from the English Underground 1961– 1971*. Heinemann, 1988.

George Harrison, *I Me Mine*. Genesis, 1980.

Louise Harrison, *My Kid Brother's Band*. Acclaim, 2014.

Mark Hertsgaard, *A Day in the Life: The Music and Artistry of the Beatles*. Delta, 1996.

Kevin Howlett, *The Beatles: The BBC Archives 1962–1970*. Harper Design, 2013.

Steven Hyden, *Your Favorite Band Is Killing Me: What Pop Music Rivalries Reveal about the Meaning of Life*. Back Bay, 2016.

Andrew Grant Jackson, *Still the Greatest*. Taylor, 2014.

Cynthia Lennon, *John*. Hodder & Stoughton, 2005.

John Lennon, *In His Own Write*. Simon & Schuster, 1964.

John Lennon, *A Spaniard in the Works*. Simon & Schuster, 1965.

Mark Lewisohn, *The Beatles Live*. Henry Holt, 1986.

Shaun Levy, *Ready, Steady, Go!* Broadway, 2003

Greil Marcus, *The History of Rock & Roll in Ten Songs*. Yale, 2014.

Dave Marsh, *The Beatles' Second Album*. Rodale, 2007.

George Martin, *All You Need Is Ears*. Macmillan, 1979.

George Martin, *With a Little Help from My Friends: The Making of Sgt. Pepper*. Little Brown, 1995.

Peter McCabe and Robert D. Schonfeld, *Apple to the Core*. Pocket Books, 1972.

Devin McKinney, *Magic Circles: The Beatles in Dream and History*. Harvard, 2003.

John McMillian, *Beatles vs. Stones*. Simon & Schuster, 2014.

Barry Miles, *The Beatles Diary*. Omnibus, 2001.

Barry Miles, *In the Sixties*. Jonathan Cape, 2002.

Scott Miller, *Music: What Happened?* 125 Records, 2012.

Simon Napier-Bell, *You Don't Have to Say You Love Me*. New English Library, 1982.

David A. Noebel, *Communism, Hypnotism, and the Beatles*. Christian Crusade, 1965.

Chris O'Dell with Katherine Ketcham, *Miss O'Dell: My Hard Days and Long Nights with the Beatles, The Stones, Bob Dylan, Eric Clapton and the Women They Loved*. Touchstone, 2009.

Denis O'Dell with Bob Neaverson, *At the Apple's Core: The Beatles from the Inside*. Peter Owen, 2003.

Robert Palmer, *The Rolling Stones*. Doubleday, 1983.

May Pang, *Loving John*. Warner, 1983.

Charles Perry, *The Haight-Ashbury: A History*. Wenner, 2005.

Andru J. Reeve, *Turn Me On Dead Man: The Complete Story of the Paul McCartney Death Hoax*. Popular Culture Ink, 1994.

Russell Reising (editor), *Every Sound There Is: Revolver and the Transformation of Rock & Roll*. Routledge, 2002.

Tim Riley, *Lennon, the Man, the Myth, the Music—The Definitive Life*. Hyperion, 2011.

Tim Riley, *Tell Me Why: The Beatles Album by Album, Song by Song, The Sixties and After*. 1988; Da Capo, 2009.

Christopher Sandford, *McCartney*. Century, 2006.

Jon Savage, *1966: The Year the Decade Exploded*. Faber & Faber, 2016.

Ken Scott with Bobby Owsinsksi, *Abbey Road to Ziggy Stardust: Off the Record with the Beatles, Bowie, Elton & So Much More*. Alfred, 2012.

Joel Selvin, *Altamont: The Rolling Stones, the Hell's Angels and the Inside Story of Rock's Darkest Day*. Dey Street, 2016.

Rob Sheffield, *Talking to Girls About Duran Duran*. Dutton, 2010.

Rob Sheffield, *Turn Around Bright Eyes*. It, 2013.

Pete Shotton with Nicholas Schaffner, *The Beatles, Lennon and Me*. Stein & Day, 1984.

Howard Sounes, *Fab: An Intimate Life of Paul McCartney*. Da Capo, 2010.

Ringo Starr, *Postcards from the Boys*. Cassell, 2004.

Geoffrey Stokes, *The Beatles*. Rolling Stone/Times Books, 1980.

Doug Sulpy and Ray Schweighardt, *Get Back: The Unauthorized Chronicle of the Beatles' "Let It Be" Disaster*. St. Martin's, 1997.

Alastair Taylor, *With the Beatles*. John Blake, 2003.

Derek Taylor, *As Time Goes By*. Straight Arrow, 1973.

Elizabeth Thomson and David Gutman, *The Lennon Companion*. Macmillan, 2007.

Stan Toocher, *Baby You're a Rich Man*. ForeEdge, 2015.

Steve Turner, *A Hard Day's Write*. It, 2005.

Jon Wiener, *Come Together: John Lennon and His Time*. Random House, 1984.

Allan Williams, *The Man Who Gave the Beatles Away*. Macmillan, 1974.

INDEX

Booth, Stanley, 182
"Boots of Spanish Leather," 82
Born to Boogie, 19
Bowie, David, 11, 54, 102, 107, 133, 222
"The Boy," 59
Boyd, Jenny, 174
Boyd, Patti. *See* Harrison, Patti Boyd
Boyd, Paula, 146, 174
Boyhood, 269
"Boys," 37–38, 58, 59, 65, 281
Bramwell, Tony, 162
Brando, Marlon, 153
Bricky Builders, 117
Bron, Eleanor, 47
"Bron-Y-Aur Stomp," 197
Brown, Danny, 104
Browne, Tara, 166
Bruce, Lenny, 154, 155
Bugliosi, Vincent, 201, 203, 204–5
Butcher cover controversy, 129, 135, 139
Butler, Geezer, 221, 222
"Bye Bye Love," 266
Byrds, 91, 132, 136

Candlestick Park, 75–76, 264, 312
"Can't Buy Me Love," 103, 317
Capitol Records, 73, 96–97, 107–8, 135, 139, 178, 279, 281, 282, 283–84
Carey, Timothy, 153
"Carnival of Light," 306
"Carry That Weight," 219
Carson, Tom, 298
Cates, Phoebe, 299
Cavern Club (Liverpool), 2, 42–43, 44, 138, 184, 286
Cerf, Christopher, 105
"Chains," 40
Chantels, 58, 59
Chaos and Creation in the Backyard, 260, 269
Charles, Ray, 43, 67, 159
Chase, Chevy, 256
Cheap Trick, 281
"Cheese and Onions," 114–15

Chemical Brothers, 108
Chicago, 107, 158
Chiffons, 48, 58, 59, 61
"Child of Nature," 194, 197
Christgau, Robert, 64, 161, 266, 305
Churchill, Winston, 122, 147–48, 149, 243
"Citadel," 186
Clancy Brothers, 310
Clapton, Eric, 173, 174, 188, 257, 265, 266, 267
The Clash, 66, 123
Cleave, Maureen, 131, 135
Cleese, John, 66
Clinton, Bill, 89
Clinton, George, 241
A Clockwork Orange (movie), 186, 187
Cloud Nine, 54
Cobain, Kurt, 243, 302
Cochrane, Eddie, 31, 44
"Cold Turkey," 233, 234
Coleman, Ornette, 133
Collins, Phil, 257
"Come Go With Me," 31
"Come Together," 200, 219
Comes a Time, 291
Commodores, 104
The Compleat Beatles (documentary), 76–77, 238, 297, 316
The Complete Beatles Recording Sessions (Lewisohn), 25
The Complete Mono Recordings, 165
Concert for Bangaladesh (movie), 64, 264
"Connection," 182
"Control," 104
Cook, Peter, 114–15
Cooke, Sam, 274
Cookies, 58
"Cookin' (In the Kitchen of Love)," xiii, 282
Cooper, Michael, 151
Corddry, Rob, 302
Costello, Elvis, 255, 260, 299

ABOUT THE AUTHOR

ROB SHEFFIELD is a columnist for *Rolling Stone*, where he has been writing about music, TV, and pop culture since 1997. He is the author of the national bestsellers *Love Is a Mix Tape: Love and Loss, One Song at a Time*, and *Talking to Girls About Duran Duran: One Young Man's Quest for True Love and a Cooler Haircut*. His most recent books are *Turn Around Bright Eyes: A Karaoke Journey of Starting Over, Falling in Love, and Finding Your Voice* and *On Bowie*.